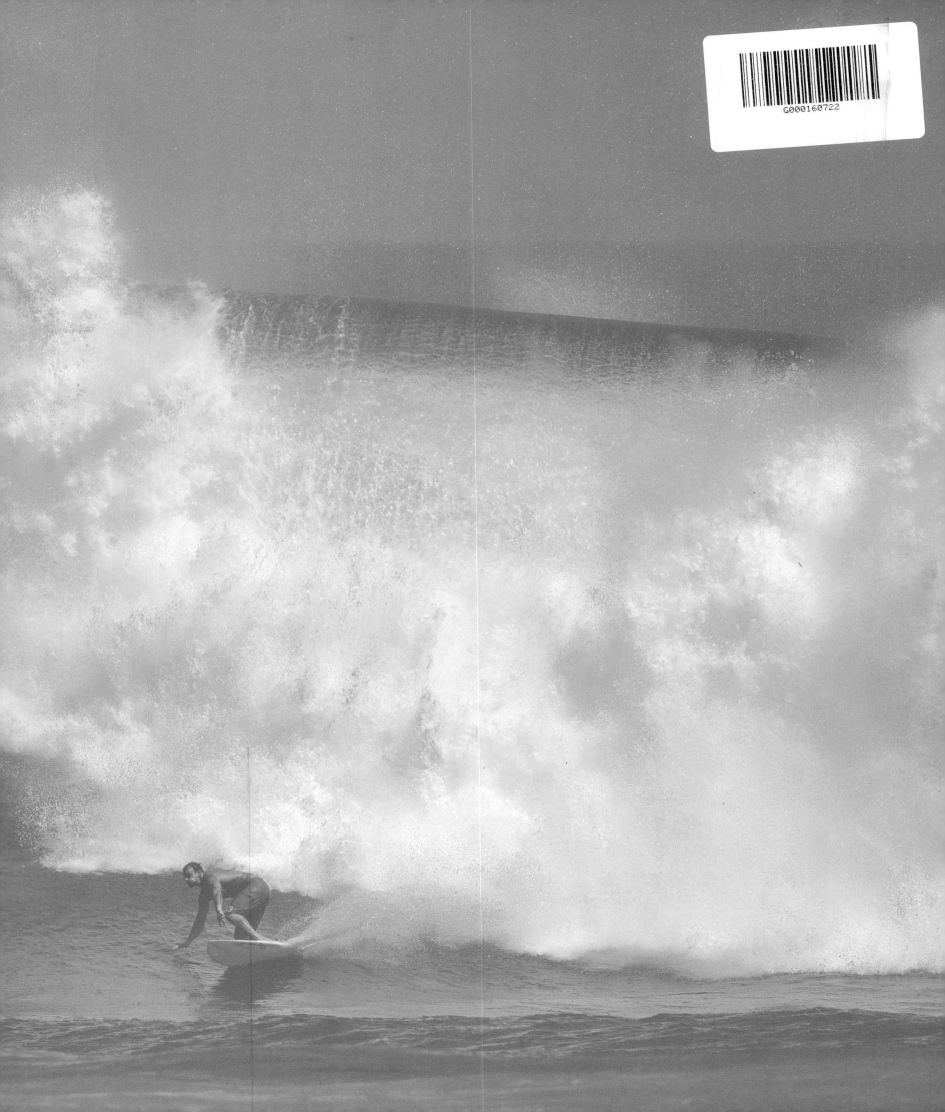

SURF!

IN THE WATER WITH WAVE HUNTERS

WHITE STAR PUBLISHERS

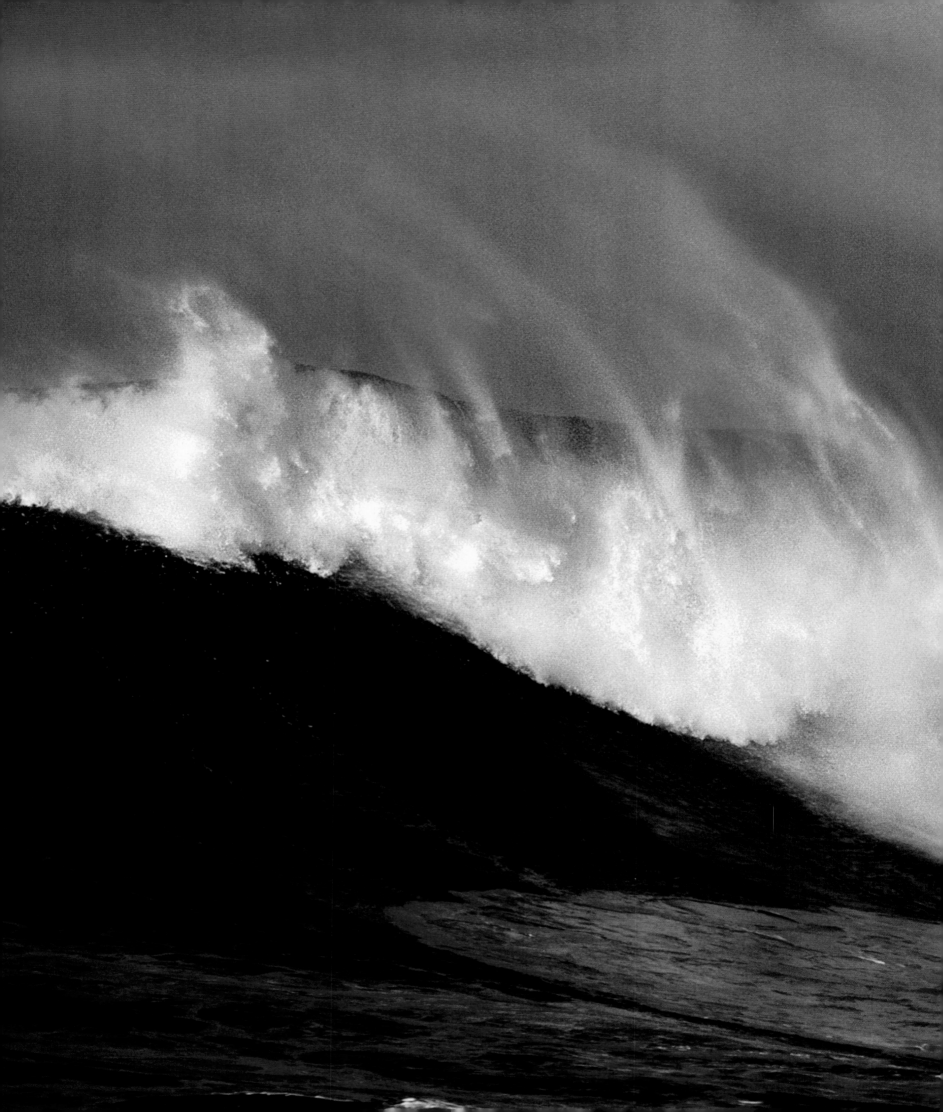

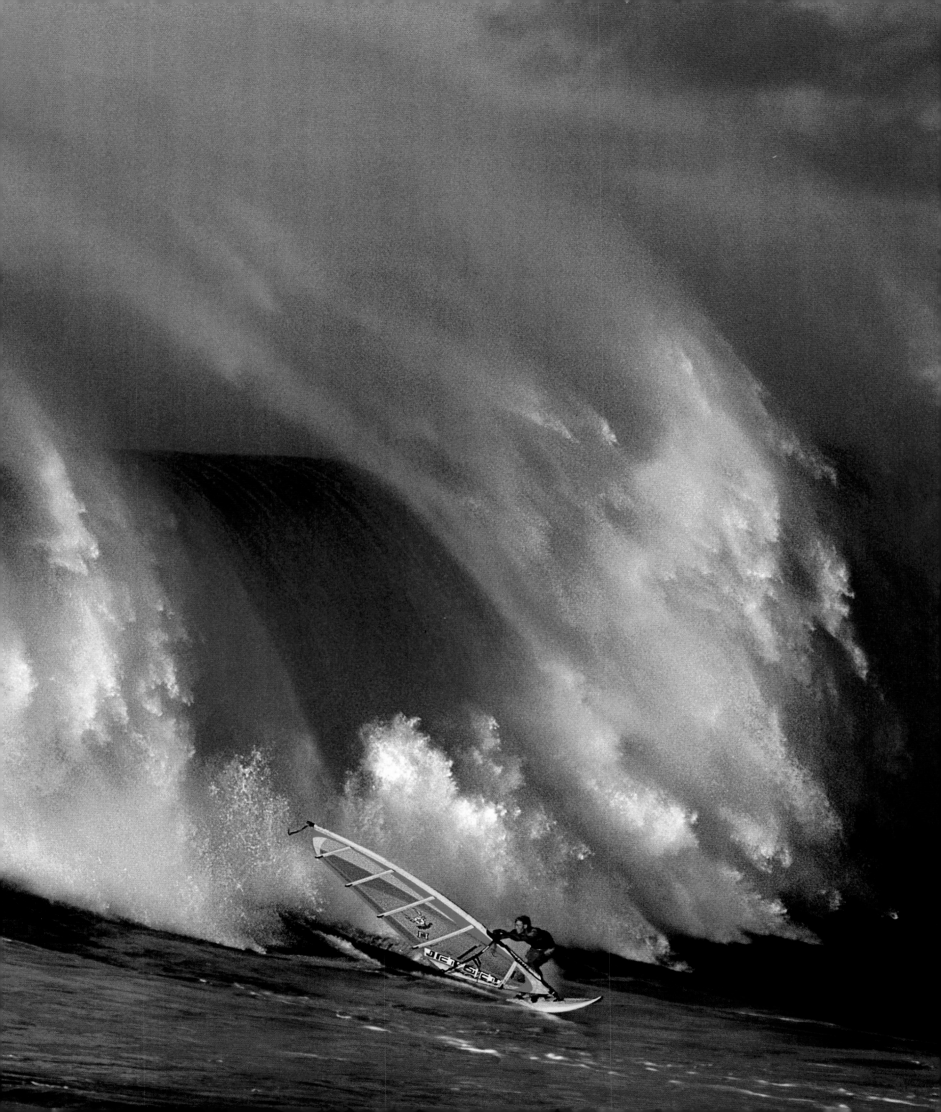

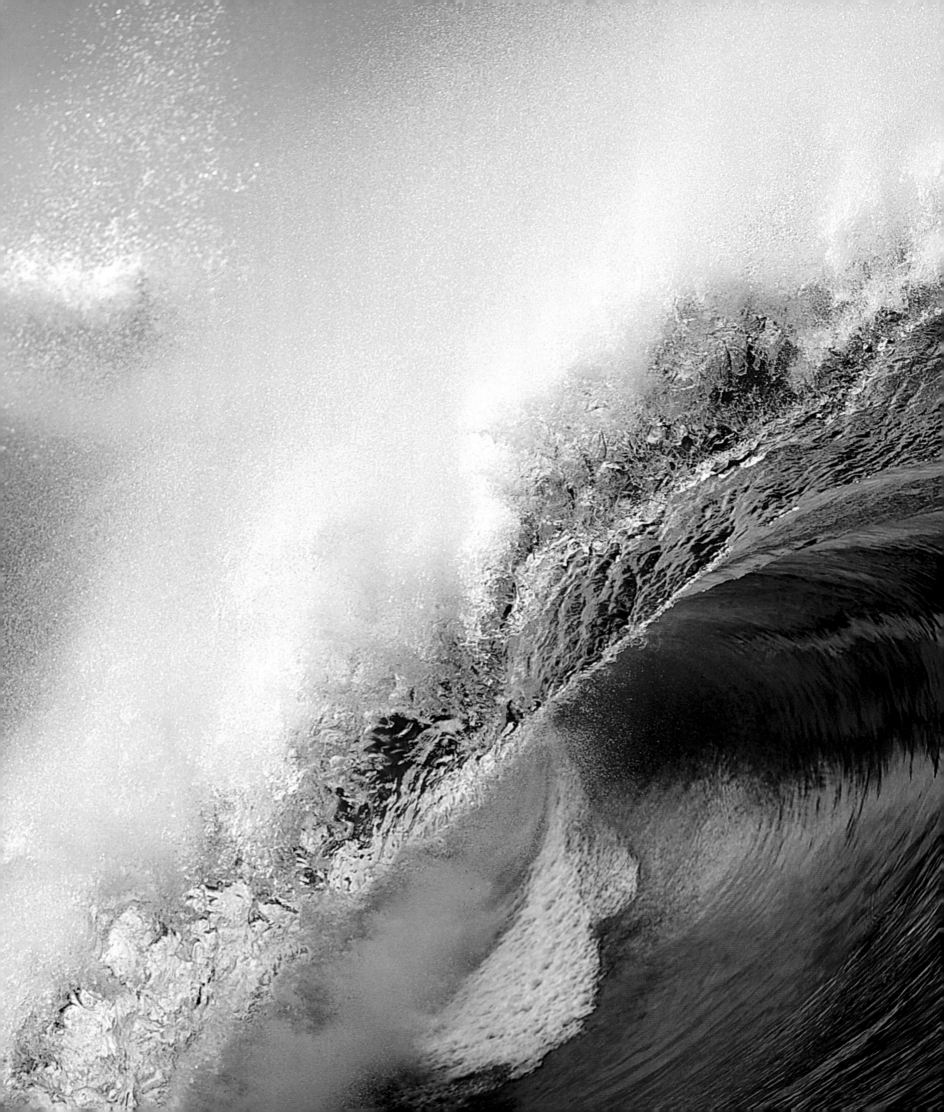

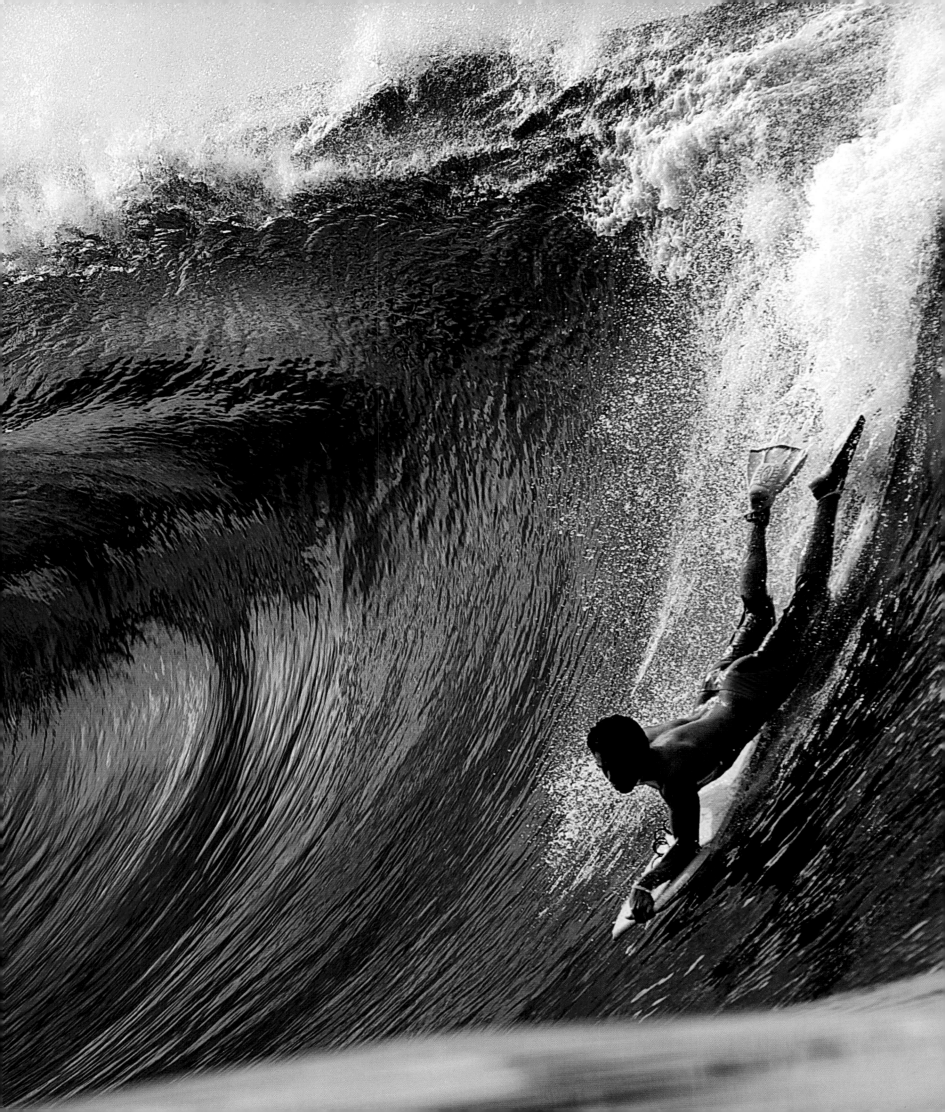

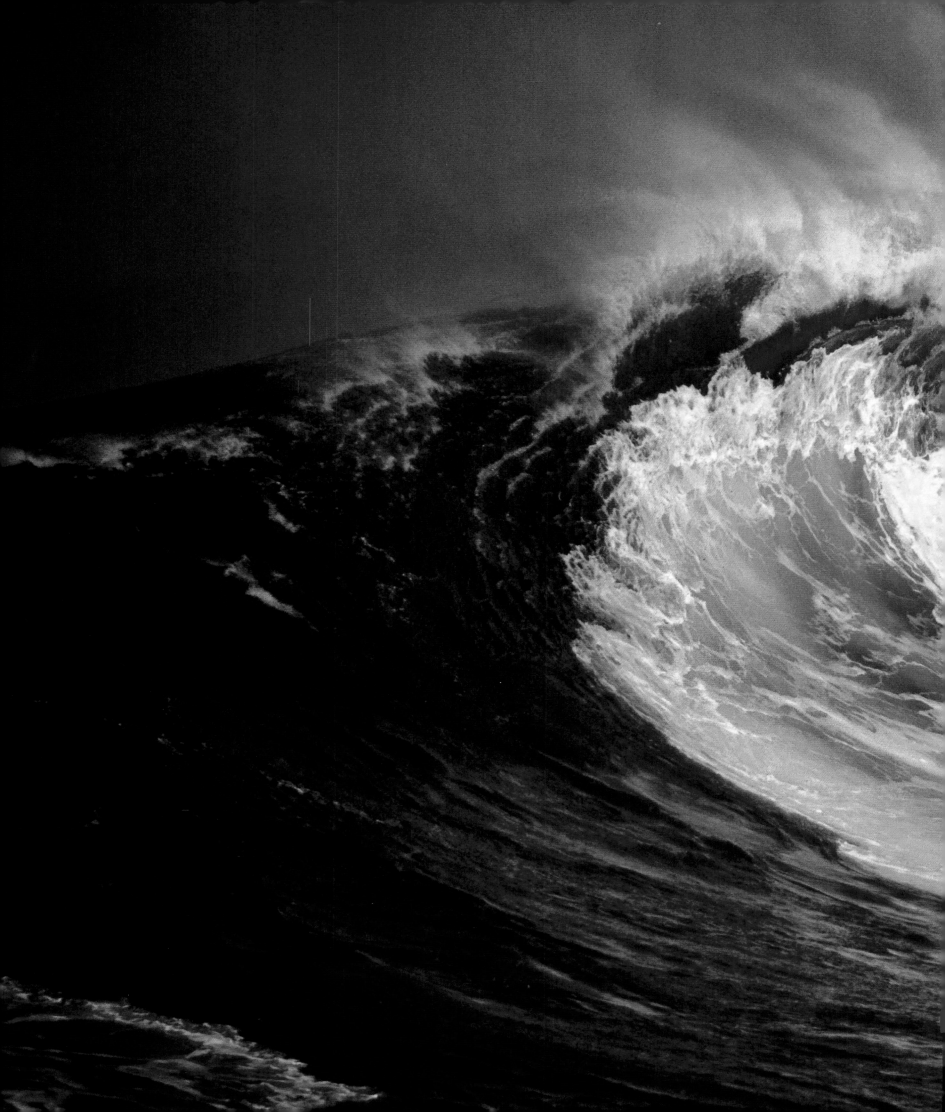

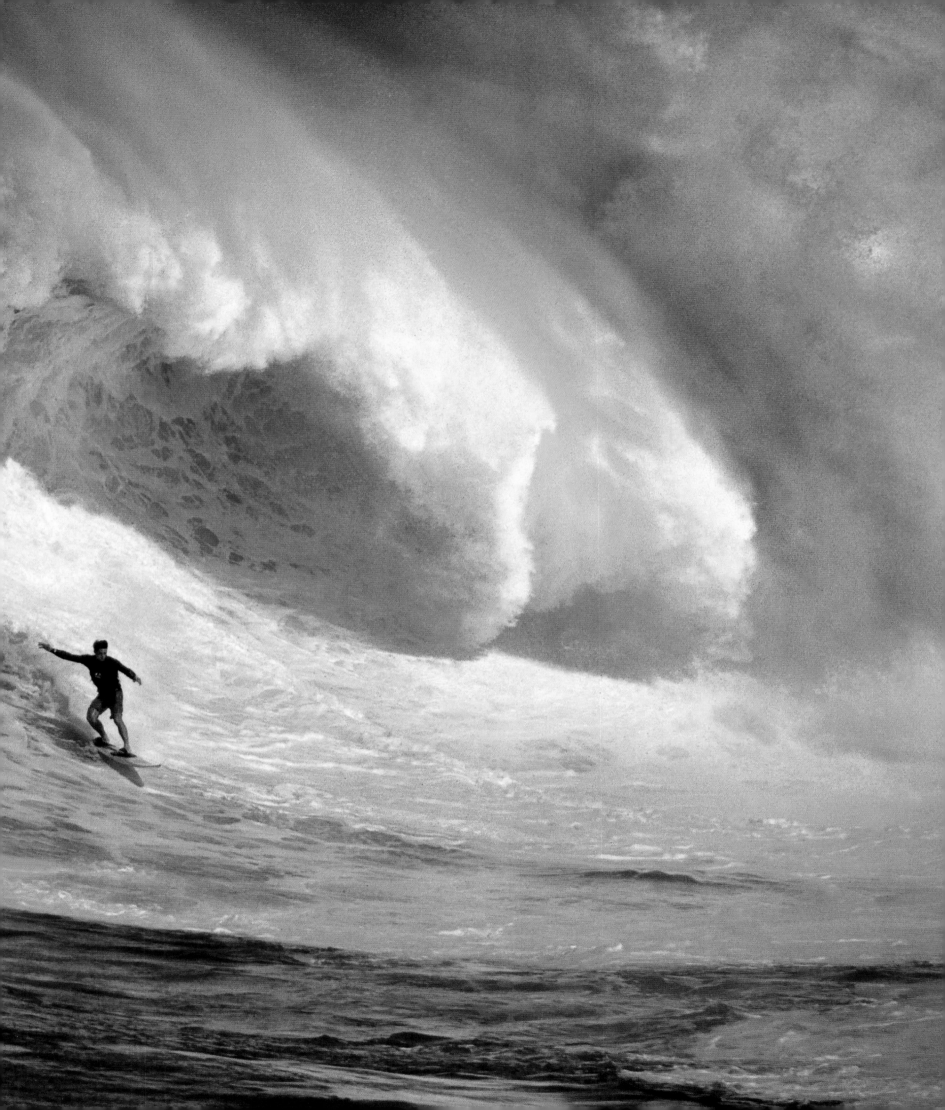

CONTENTS

Project editor VALERIA MANFERTO DE FABIANIS

Text by GUILLAUME DUFAU

Editorial coordination VALENTINA GIANMARINARO - LAURA ACCOMAZZO

Graphic layout PAOLA PIACCO

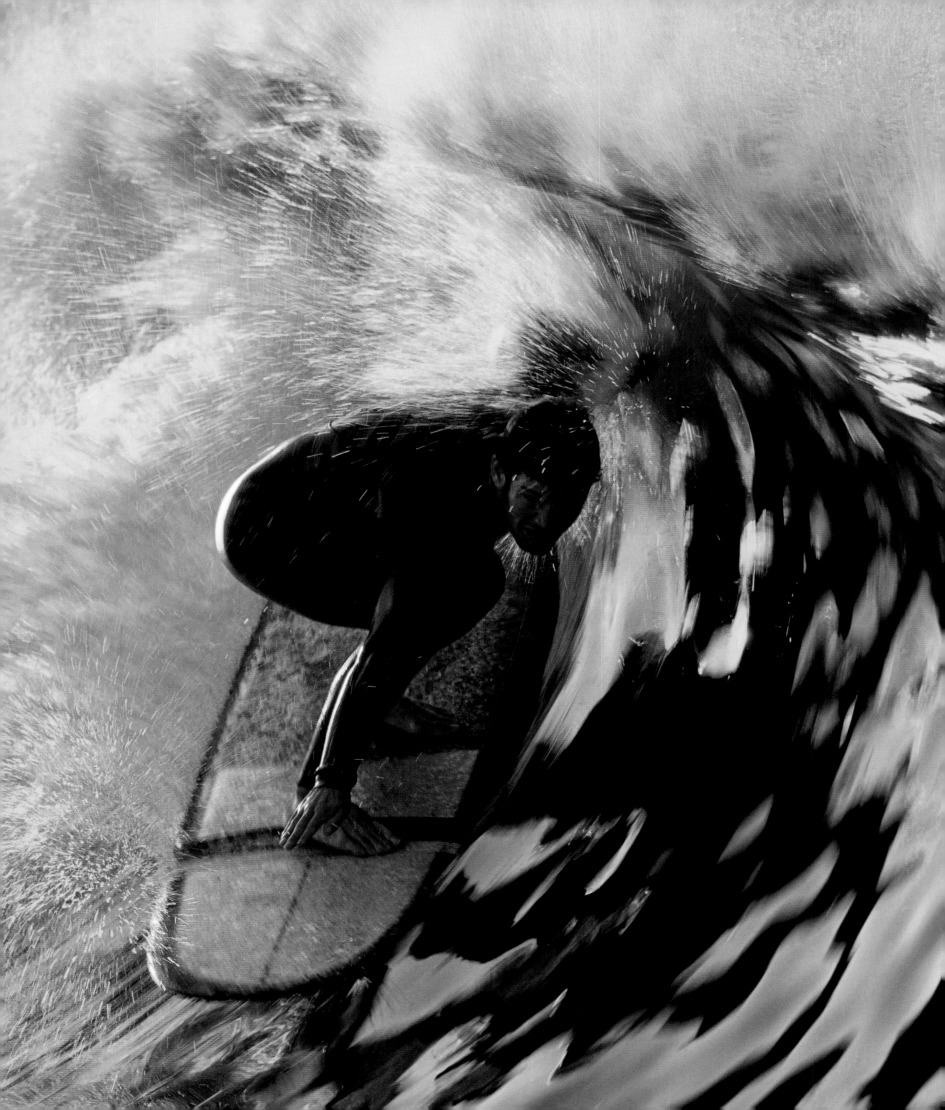

MY EARLIEST MEMORIES ARE OF BEING AT THE BEACH. I AM LUCKY TO HAVE A FAMILY WHO LOVES THE OCEAN AS MUCH AS I DO AND I AM ESPECIALLY LUCKY TO LIVE IN HAWAII. GROWING UP ON THE ISLAND OF MAUI HAS GIVEN ME A DIFFERENT PERSPECTIVE ON THE OCEAN. BESIDES WATCHING SHORTBOARD SURFING, I ALSO WITNESSED SOME OF THE BEST WATERMEN DOING THE WIND SPORTS THAT ARE SO PERFECT FOR OUR BREEZY ISLAND. THE OPEN-MINDED ATTITUDE HERE HAS ALLOWED NEW SPORTS TO BE DEVELOPED LIKE KITESURFING AND STAND UP PADDLE.

I LEARNED TO SURF WHEN I WAS 4, WINDSURF WHEN I WAS 6, STAND UP SURF, KITING AND TOW-IN SURFING WHEN I WAS 9 AND EVERY OTHER OCEAN SPORT IN BETWEEN. GROWING UP IN MAUI, I WATCHED ROBBY NAISH, LAIRD HAMILTON, BUZZY KERBOX, DAVE KALAMA AND OTHERS PUSH THEIR SPORTS TO THE EDGE. WHILE ALL OF MY FRIENDS WERE BUSY WITH TEAM SPORTS LIKE SOCCER OR HANGING OUT PLAYING NINTENDO, I WAS SPENDING ALL OF MY FREE TIME AT THE BEACH DOING WHATEVER THE OCEAN CALLED FOR. I FELT MORE AT HOME BEING ON THE BEACH LISTENING TO STORIES ABOUT BIG WAVES OR TALES OF ATTEMPTED MOVES OR EXPERIMENTS. MY FRIENDS AND MENTORS WERE MY HEROES AND I COULDN'T GET ENOUGH OF WHAT I WAS LEARNING IN AND OUT OF THE WATER. THIS STILL HOLDS TRUE FOR ME TODAY.

I HAVE A REAL LOVE FOR THE OCEAN AND I ALSO RESPECT IT VERY MUCH. EVER SINCE I WAS LITTLE, THE WATER-MEN THAT I LOOK UP TO ALWAYS TAUGHT ME TO TAKE BABY STEPS AND LEARN FROM EACH SESSION IN THE WATER. THEY REMINDED ME TO BE HUMBLE AND RESPECTFUL IN THE WATER. AS I GOT OLDER, THEY WOULD COMMUNICATE WITH ME IN A VERY SPECIAL WAY. MOST OF THE TIMES I WOULD GET ENCOURAGEMENT FROM A LOOK IN THEIR EYES, OR THEY WOULD GIVE A NOD OR EVEN LET ME HAVE A WAVE. THE APPROVAL HAS ALWAYS BEEN A SIGNAL OR A FEEL-ING OF CONFIDENCE.

I WAS 12 YEARS OLD WHEN I ASKED MY DAD WHEN I WOULD BE ABLE TO GO TO THE WAVE OF PEAHI TO TOW AND WINDSURF IT. HE TOLD ME THAT I WAS THE ONLY ONE THAT COULD ANSWER THAT QUESTION. HE ALSO TOLD ME THAT I WOULD HAVE TO FEEL COMFORTABLE WITH MY ABILITIES IN BIG WAVES AND THAT I WOULD HAVE TO BE ABLE TO GET MYSELF OUT OF TROUBLE ON MY OWN. THE LAST THING HE TOLD ME WAS THAT I WOULD HAVE TO GET PERMISSION FROM LAIRD, DAVE OR ROBBY.

THE FIRST TIME I WENT OUT TO JAWS WAS BECAUSE OF AN EARLY-MORNING CALL FROM DAVE KALAMA INVITING ME TO GO FOILBOARDING WITH HIM AND LAIRD. MY SECOND TIME WAS ON DECEMBER 7, 2009, AGAIN WITH DAVE AND LAIRD. LAIRD TOLD ME TO SIT ON THE BOAT IN THE CHANNEL AND I PROCEEDED TO WATCH PEAHI BREAK PER-FECTLY ALL DAY LONG. I WAS REALLY ANXIOUS AND EXCITED TO GET MY TURN. WHEN LAIRD AND DAVE PULLED UP ON THE SKI TO GET ME, LAIRD ANNOUNCED THAT IT WAS OVER AND WE WERE GOING HOME. WOW, WAS I BUMMED!

THE NEXT DAY IT WAS STILL BIG BUT NOT AS PERFECT. LAIRD LOOKED AT ME WITH ALL THE CONFIDENCE IN THE WORLD AND BEFORE I KNEW IT I WAS BEING TOWED INTO THE BIGGEST, BEST WAVES OF MY LIFE. THE EXPERIENCE RE-INFORCED THE LESSON I HAVE KNOWN MY WHOLE LIFE AS A SURFER — BE PATIENT, WATCH, STUDY AND LEARN. AS I TRAVEL AROUND THE WORLD COMPETING AND EXPERIENCING DIFFERENT CULTURES, THE MOST-ASKED QUESTION I GET IS, "KAI, WHAT IS YOUR FAVORITE WATER SPORT?"

YOU WOULD THINK THAT THE ANSWER WOULD BE REALLY SHORT AND SIMPLE, BUT THE TRUTH IS THAT EACH SPORT IS SURFING. WHEN I JIBE ON MY WINDSURFER, IT FEELS LIKE I AM LEANING INTO A BOTTOM TURN. PADDLEBOARD-ING DOWNWIND ALLOWS ME TO FEEL THE OCEAN AS IT LIFTS THE BOARD AND SUDDENLY THE BOARD RELEASES AND TRIMS FOR A GLIDE THAT CONNECTS TO ANOTHER. EACH SPORT OFFERS AN EXPERIENCE THAT I CAN RELATE TO IN DIF-FERENT OCEAN CONDITIONS. A GOOD EXAMPLE IS BEING RANKED NUMBER ONE ON THE SUP WAVE TOUR. THE STAND UP PADDLE IS SO FAMILIAR TO ME BECAUSE I HAVE BEEN TURNING A BIG BOARD SINCE I WAS SIX. MY WIND-SURF EXPERIENCES ARE VERY SIMILAR TO THE SUP.

I GUESS THE BOTTOM LINE IS THAT EACH SPORT ON THE WATER SUPPORTS MY LOVE OF BEING A SURFER, AND SOME-DAY I HOPE TO EARN THE TITLE OF "WATERMAN." ALOHA NUI LOA.

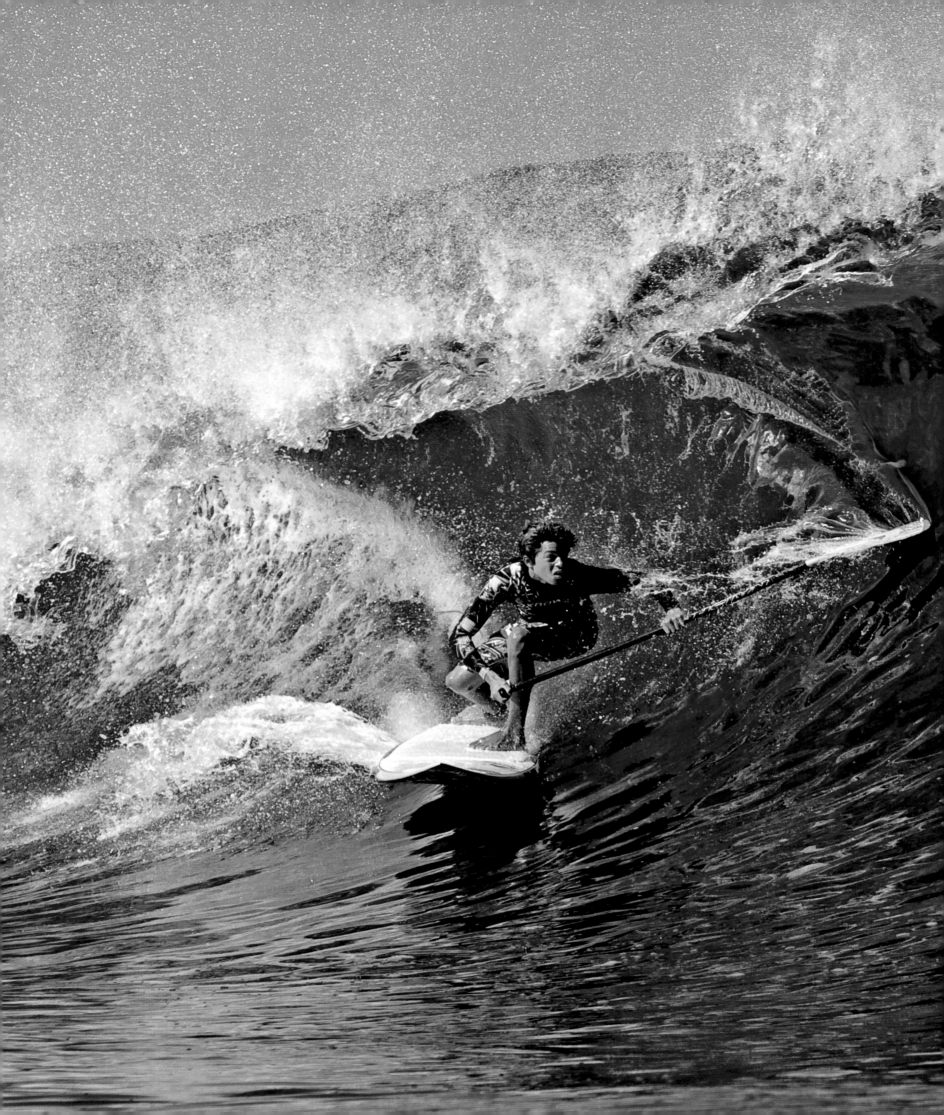

INTRODUCTION

"THREE WAVES..." ALTHOUGH EMBEDDED IN THE VELVET OF AN AUSTRALIAN ACCENT, THESE TWO WORDS SLAM INTO THE AIR WITH A MELANCHOLIC RESONANCE. THE SCENE TAKES PLACE IN DECEMBER 2009 ON JAWS, HAWAII, WHERE YOU CAN FIND SOME OF THE MOST DANGEROUS WAVES ON THE PLANET. JASON POLAKOW, WINDSURFER AND BIG WAVE RIDER EMERITUS, IS NAILED BY AN ALMOST 30-FOOT (10 m) MONSTER. "TONS OF WATER FELL ON ME. EVERYTHING WAS BLACK. I SWAM BACK UP TO THE SURFACE BUT A SECOND WAVE BREAKS BEFORE I GET THERE AND PLUNGES ME BACK INTO THIS NIGHTMARE, THEN I HEAR THE ROAR OF A THIRD WAVE, AND I SAID TO MYSELF, IT'S OVER..."

Miraculously rescued by a teammate on a Jet Ski, Polakow will go down in surf history as the first human to survive a three-wave hold-down at Jaws. Extreme surfing has a habit of creating primal scenes like these. In the channel, a young 17-year-old Hawaiian, Kai Lenny, looks on with a stoicism that commands admiration. Most surfers would have returned to the water's edge to ponder their fragility against the raw power of the ocean. Not him. The twig-shaped surfer had always displayed a will as strong as oak. Minutes after his friend's accident, he embarked on a wave as tall as a five-story building, which he surfed with grace and an innate knowledge of trajectories.

At the helm of the Jet Ski was the master himself, Laird Hamilton, co-inventor of tow-in surfing, a technique that uses water crafts or helicopters to tow surfers into a breaking wave, allowing them to push the boundaries and surf giant waves once thought impossible to tame. *"I have rarely seen a young rider armed with as much courage and so determined to become an important surfer,"* enthuses Laird, who is nevertheless known for keeping inexperienced and untested candidates away from these terrible Maui waves. *"I wouldn't let just anyone have the honor of riding his first big wave at Jaws. Some see this gesture as a passing of the torch between generations of Hawaiian watermen, a rite of passage or an initiation ceremony. I see it simply as an admission of affiliation, a mutual respect, as it is between chess masters and the martial arts."*

Lenny burst onto the scene as a humble adolescent who seemed destined for the top. Experts marvel at the meteoric rise of this brave and precocious rider, who aims to *"mark his time in all disciplines."* In 2009, his first year on the professional windsurfing circuit, he was crowned "Rookie of the Year," a trophy awarded to the best-ranked beginner of the season. On February 2, 2010, he competed on the waves at Sunset Beach, Hawaii, the first event ever of the Waterman League, a newly-created professional stand up paddle circuit.

1 Andy Irons. Teahupoo. The tragic death of the 3-time world champion Hawaiian in November 2010, made orphans of the entire surfing community. This book is dedicated to him.

2-3 Maui, one of the wildest islands of the Hawaiian Archipelago, became the global windsurfing Mecca in the 1980s thanks to an explosive cocktail of giant waves and powerful winds.

However, extreme winds and near-demonic waves forced the judges into a tough decision. Eventually, they would refuse to send surfers into the foam carnage. By then, of course, Lenny had already taken the biggest wave of the competition, which he would end up winning before a panel of experts nearly twice his age. The next day, the front page of the Honolulu Advertiser read: *"Kai Lenny crowned hero and Master at Sunset."*

The aquatic arsenal of this versatile and gifted rider is the synthesis of a thousand years of technological innovations on the crest of waves. Outrigger canoes, surfboards, longboards, paddleboards, windsurfs, kite surfs — Lenny's comprehensive mastery of this array of surf gear is a testament to his knowledge and power of creative imagination. What makes this unique is not the fact that he's excelling in two major disciplines: surfing and windsurfing. Most Hawaiians Lenny's age, after all, practice these at a high level. No, what is already forging an exceptional career is his innate ability to take the best of each discipline, mixing together the maneuvers of classical repertoires to maximize the pleasure of the ride. This revolutionary approach makes him a type of Mozart of the ocean, capable of writing a symphony with any instrument he chooses to brave the waves. *"My philosophy is to not think about the best way to ride a wave before entering the water, but to let the wave dictate its preference,"* Lenny says. *"I like to go from one ride to another many times in one day, and on the same spot. My goal is to become world champion in windsurfing and stand up paddle, but my real ambition is to progress in all disciplines and refine my perception of the waves and the wind."*

Officially, this young rider's name is Kai W. Lenny. The "W" is for Waterman. This honorary term refers to a special type of person capable of paddling, swimming and sailing over long distances, like the ancient Hawaiians, who worshiped the ocean and proudly dared to

4-5 Often considered a leisurely beach activity, bodyboarding has staked its claim for sporting legitimacy, as it has proven to be versatile and reactive in serious wave conditions.

6-7 The invention of tow-in surfing, which propels surfers with the use of a jet ski, has revolutionized big wave surfing by allowing surfers to take on waves once considered impossible to surf.

FACE ITS WRATH. THIS POLYNESIAN ART, WHOSE ORIGIN IS LOST IN TIME, IS PERSONIFIED BY DUKE PAOA KAHANAMOKU, PROPHET OF HAWAIIAN SURF AND SWIMMING, WHO WON SEVERAL MEDALS AT THE OLYMPIC GAMES IN THE EARLY 20TH CENTURY. TWO HEIRS TO DUKE'S THRONE — TWO PHYSICALLY IMPOSING MODERN WATERMEN WHO INFLUENCED THE YOUNG KAI (WHO BEGAN SURFING AT AGE 3 AND WINDSURFING AT AGE 8) — ARE HAWAIIAN LEGENDS WHO HAVE MADE ECLECTICISM ON THE WAVES THEIR MANTRA: LAIRD HAMILTON AND ROBBY NAISH. THE LATTER, WHO HAS WON 24 WORLD CHAMPIONSHIP TITLES IN WINDSURFING AND KITE SURFING, RECOGNIZED, AS HAMILTON DID, THAT THIS KID FROM MAUI WAS A SPIRITUAL SUCCESSOR. LENNY EVEN DISPLAYED THE CODE US1112 ON HIS SAILS, WHICH WAS IN REFERENCE TO NAISH'S OWN LEGENDARY SAIL NUMBER: US1111. VERY SYMBOLIC.

IN KAI LENNY'S RISE, ONE CAN ALSO SEE THE EMERGENCE OF A NEW DYNASTY OF LORDS OF THE WAVES WHO PROFESS A DEEP RESPECT FOR THE MASTERS OF THE PAST, COUPLED WITH A SHARP VISION OF THE FUTURE. ON BEACHES AROUND THE WORLD, THERE ARE MORE AND MORE WHO QUESTION THE ARTIFICIALITY OF THE BORDERS BETWEEN SURFING AND WINDSURFING, BETWEEN ROWING UPRIGHT OR LYING DOWN. THESE PEOPLE HAVE DELIBERATELY IGNORED THE DIVISIONS THAT HAVE MARKED THE EMERGENCE OF NEW WATERSPORTS DERIVED FROM SURFING. WHETHER BY THE MAGIC OF LENNY OR THAT OF HAMILTON, THE SCIENCE OF BODYBOARDER MIKE STEWARD OR THE VERSATILITY OF NAISH, THE ANTAGONISTIC MESSAGE CONVEYED BY PROPONENTS OF EACH DISCIPLINE IS NOW TRANSCENDED BY THE PERFORMANCE OF THESE ATHLETES WHO ARE ADEPT AT CROSSING OVER AND MIXING TECHNIQUES AND STYLES.

IF SURFING HAS, IN ITS ORIGINAL FORM, EXISTED FOR OVER A THOUSAND YEARS, THIS WOULD MAKE IT ONE OF MANKIND'S OLDEST SPORTING ENDEAVORS. WINDSURFING AND BODYBOARDING, INVENTED IN THE 1970S, CANNOT CLAIM THE SAME CULTURAL LEGITIMACY. THESE TECHNOLOGICAL INNOVATIONS HAVE INSTEAD PROMOTED THE DEMOCRATIZATION AND EXPONENTIAL DEVELOPMENT OF SURFACE WATER SPORTS. A DIRECT CONSEQUENCE IS THE EMERGENCE OF MORE INDIVIDUALISTIC VALUES, WHICH HAVE

9 FAR FROM SIMPLY BEING A NOVELTY FOR NOSTALGICS, THE LONGBOARD IS THE ULTIMATE MEANS TO SLIDE WITH STYLE.

11 WINNER OF THE FIRST STAND UP WORLD TOUR IN 2010, KAI LENNY BECAME THE ICON OF THIS GROWING SPORT THAT IS NOW APPEARING ON WAVES AROUND THE WORLD.

TRANSFORMED THE SURFING COMMUNITY AND PROMOTED TERRITORIALITY. THIS "OWNERSHIP" OF NAT-URAL MARINE SPACES, DESIGNATED BY THE TERM *"SPOTS,"* WAS SOMETIMES DEFENDED WITH VIOLENCE. THE CONQUEST OF THESE TERRITORIES QUICKLY CREATED RIVALRIES BETWEEN THE SURFERS THEMSELVES AND A STUBBORN REFUSAL TO CO-EXIST WITH OTHER PRACTITIONERS. WITH MORE AND MORE PEOPLE TAKING TO THE WAVES, THIS AGGRESSIVENESS ALSO SPREAD TO THE WATER, WITH SURFERS BEMOANING THE RETURN OF THE LONGBOARDS (LARGE PLANKS USED BY NOSTALGIC FANS OF THE '50S) AND ACCUS-ING THEM OF CLUTTERING SPOTS. RECENTLY, STAND UP PADDLE SURFING, WHOSE USE OF A PADDLE HAS MADE SURFING MORE ACCESSIBLE, HAS SUFFERED A SIMILAR SMEAR CAMPAIGN.

IN THE '80S, THE PROFESSIONAL SURFING AND WINDSURFING CIRCUITS WERE TORN APART BY THE ME-DIA IN A WAR OF INFLUENCE AND SPONSORS, TURNING TWO INTIMATELY RELATED CULTURES OF THE SEA INTO ENEMIES. WITH THE NOTABLE EXCEPTION OF KAYAK SURFING, WHICH WAS SYSTEMATICALLY BANNED FROM THE WAVES, NO DISCIPLINE HAS SUFFERED MORE DISDAIN FROM THE "SPORT OF KINGS" THAN BODYBOARDING, WHICH USES A LITTLE FOAM BOARD AND HAS BEEN POPULAR WITH BEACH TOURISTS FROM THE MOMENT IT APPEARED IN 1973. *"ALL SPORTS DERIVED FROM SURFING IN THE '70S HAVE BUILT THEIR IDENTITY ON PAIN AND REJECTION,"* SAYS TOM MOREY, WHO INVENTED THE BODYBOARD. *"VICTIMS OF AN INFERIORITY COMPLEX, THEY HAD TO REALLY CULTIVATE AND EMPHASIZE THEIR DIFFERENCES TO FREE THEMSELVES FROM THE OVERWHELMING DOMINATION OF SURFING, BECOMING IN THE PROCESS CHAPELS FOR THEIR FOLLOWERS, WHOSE ORTHODOXY WAS FIERCELY DEFENDED."* THE RESULT: IT'S HARD TO GROUP THIS FAMILY OF SPORTS UNDER ONE BANNER, AND THERE IS NO TERMINOLOGY THAT CAN QUALIFY THEM ALL AS A WHOLE. SOME USE THE TERMS *"BOARDSPORTS," "SURFACE WATER SPORTS"* OR JUST *"WATERSPORTS,"* BUT THOSE SPECIALIZING IN ONE PARTICULAR ACTIVITY REMAIN PRISONERS OF A CONVOLUTED NOMEN-CLATURE OF GENRES AND SUBGENRES.

IN THIS CONTEXT, TWO TRENDS EMERGED AT THE TURN OF THE CENTURY. FIRST, THE SEARCH FOR UN-

KNOWN AND UNSPOILED LANDS SIMILAR TO THE MUTANT WAVES INITIALLY COLONIZED BY BODYBOARD-ERS BEFORE GLORY-HUNTING SURFERS TOOK THEM OVER. AND SECOND, THE NEED TO DEVELOP BOTH SAFETY AND PROFITABILITY THROUGH SCHOOLS AND SURF CAMPS. BEACH OVERCROWDING HAS LED TO THE ORGANIZATION AND REGULATION OF ACCESS TO THE WAVES. BUT IN A SOCIETY WHERE VALUES ARE TRANSFORMED IN REAL TIME AND WHERE DISORDER IS OFTEN THE ORDER OF THE DAY, THE SURFER WHO VACILLATES CONSTANTLY BETWEEN KEEPING BALANCE AND FALLING AND WHO CONVEYS AN IMAGE OF TO-TAL FREEDOM IS UNCOMFORTABLE WITH REGULATIONS AND RULES. THE CHALLENGE IS THEREFORE TO UN-DERSTAND HOW SURFING AND ITS DERIVATIVES CAN TODAY CONCRETELY CONSTRUCT A NEW AND POPU-LAR IDENTITY, A SPACE THAT IS BOTH SOCIAL, GEOGRAPHICAL AND MYTHICAL WITHOUT AVOIDING SOCIO-ECONOMIC AND ENVIRONMENTAL PROBLEMS.

THE ANSWER MIGHT BE IN THE SCIENTIFIC WORK OF JOEL DE ROSNAY, FUTURIST AND MOLECULAR BI-OLOGIST, WHO WAS A SURFING PIONEER IN FRANCE IN THE '60S AND THE BROTHER OF ARNAUD DE ROS-NAY, ONE OF THE EARLY PROPONENTS OF WINDSURFING. *"ALL WATER SURFACE SPORTS OFFER A HARMONY WITH NATURE AND WITH YOURSELF,"* HE WROTE IN THE "TAO OF SURFING." *"RATHER THAN FIGHTING AGAINST SOMEONE OR A TEAM AGAINST ANOTHER, WE TRY, NOT TO FIGHT THE FORCE OF THE OCEAN OR THE WINDS, BUT TO DEVELOP A CERTAIN COMPLICITY WITH THE ELEMENTS, A KIND OF PARTNERSHIP WITH NATURE. BUT THE WAVES ARE NEVER IDENTICAL, AND THE RIDER MUST ADAPT TO THESE CHANGES. HE MUST BE ABLE TO FIND WAYS TO SURF LIFE IN BALANCE, A PERMANENT BALANCE THAT IS DYNAMIC AND THAT CONSTANTLY RE-CONSTRUCTS ITSELF, RATHER THAN ALWAYS TRYING TO ANTICIPATE EVERYTHING, BECAUSE CONDITIONS CHANGE AND THE ENVIRONMENT DOES TOO. WE MUST LEARN TO SURF SITUATIONS THAT ARE CHAOTIC, INTERMITTENT, TRICKY."* FOR THE MOTLEY TRIBE OF WAVE HUNTERS WHO HAVE LONG ADVOCATED A FORM OF SELF-REG-ULATION INSPIRED BY THE POLYNESIAN TRIBAL HERITAGE, IT IS THEREFORE NECESSARY TO LEARN HOW TO REINVENT YOURSELF WAVE AFTER WAVE WITHOUT SACRIFICING ONE'S SOUL ON THE ALTAR OF MODERNITY.

18-19 THE PEAHI WAVE, NICKNAMED JAWS, IS ONE OF THE MOST AMAZING BREAKS EVER DISCOVERED. TO THOSE WHO DARE CONFRONT IT, IT IS QUICK TO DEMAND HUMILITY AND RESPECT FOR THE POWERFUL FORCE OF NATURE.

20-21 A LITTLE RACE BETWEEN FRIENDS ON THE CRYSTALLINE LAGOON OF MORNE BRABANT IN MAURITIUS, ONE OF THE MOST IDYLLIC KITESURFING SPOTS ON THE PLANET.

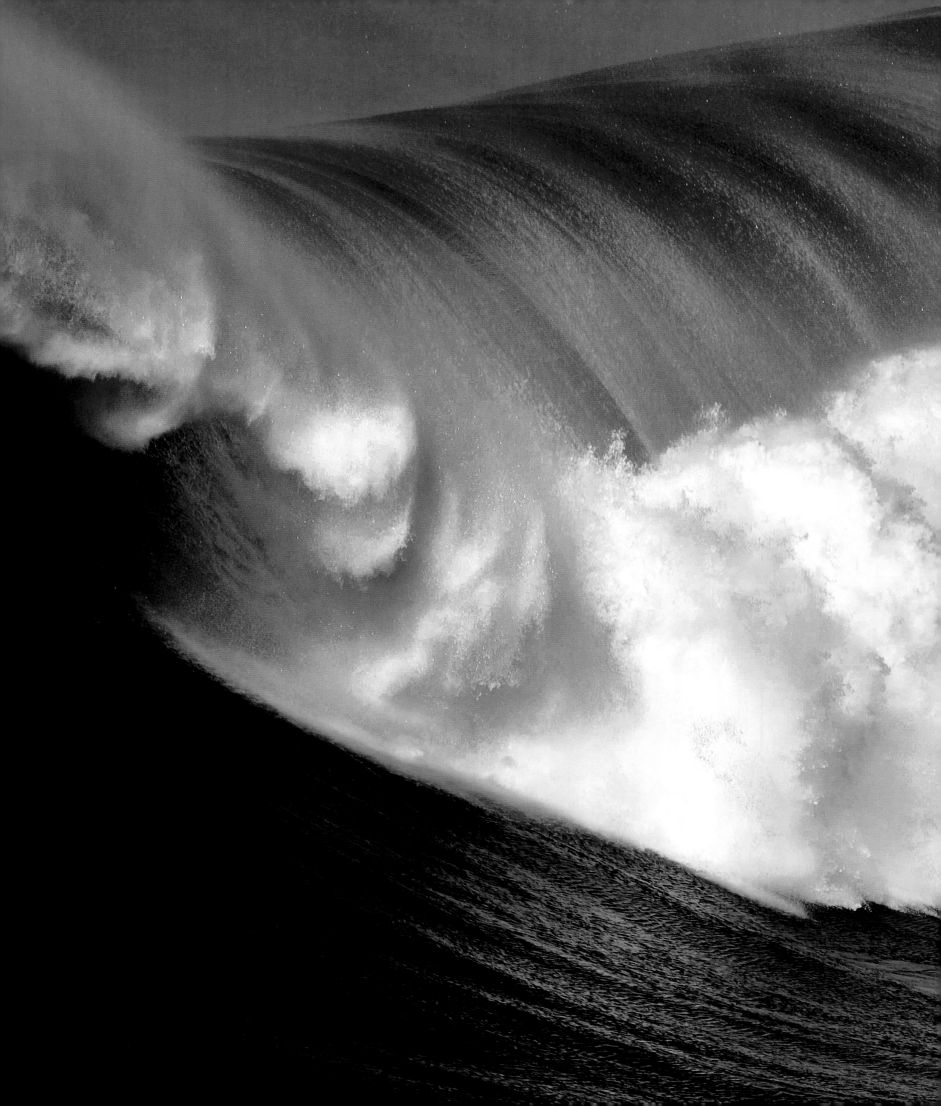

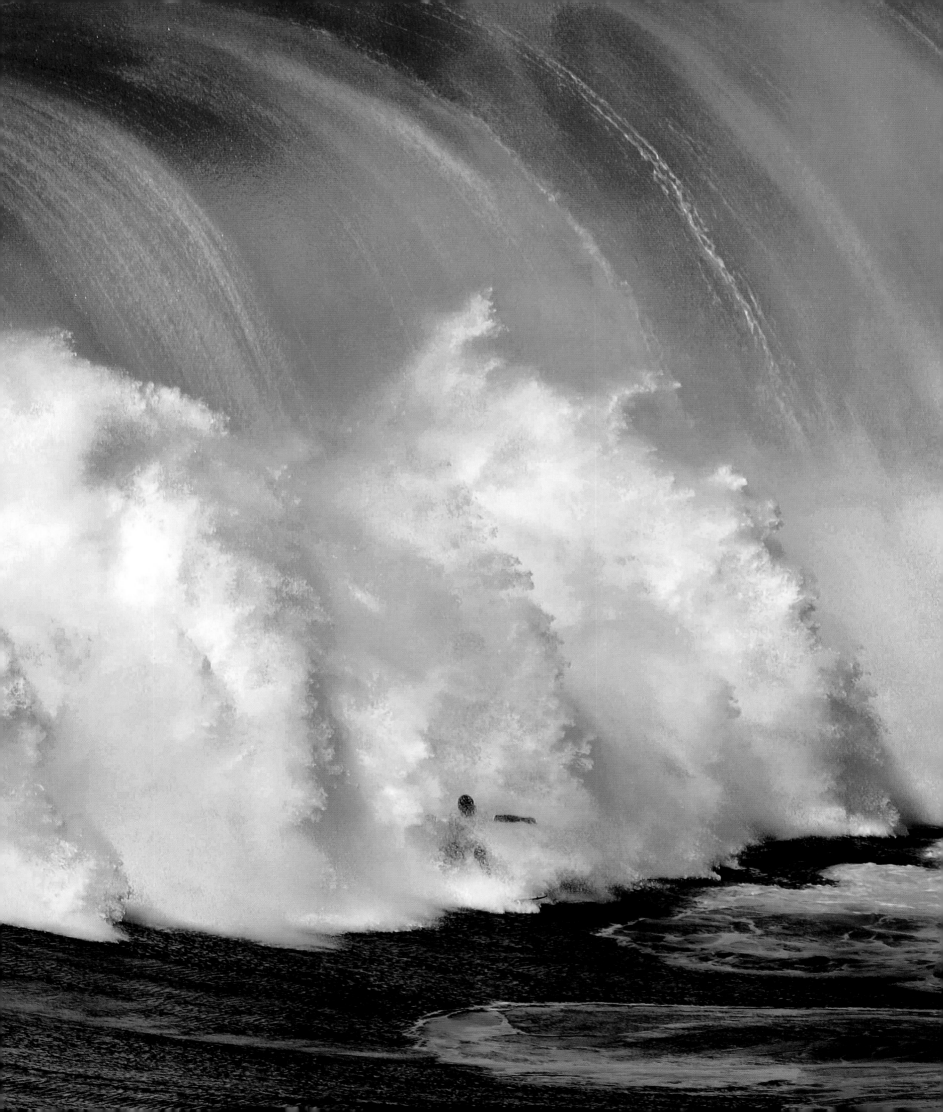

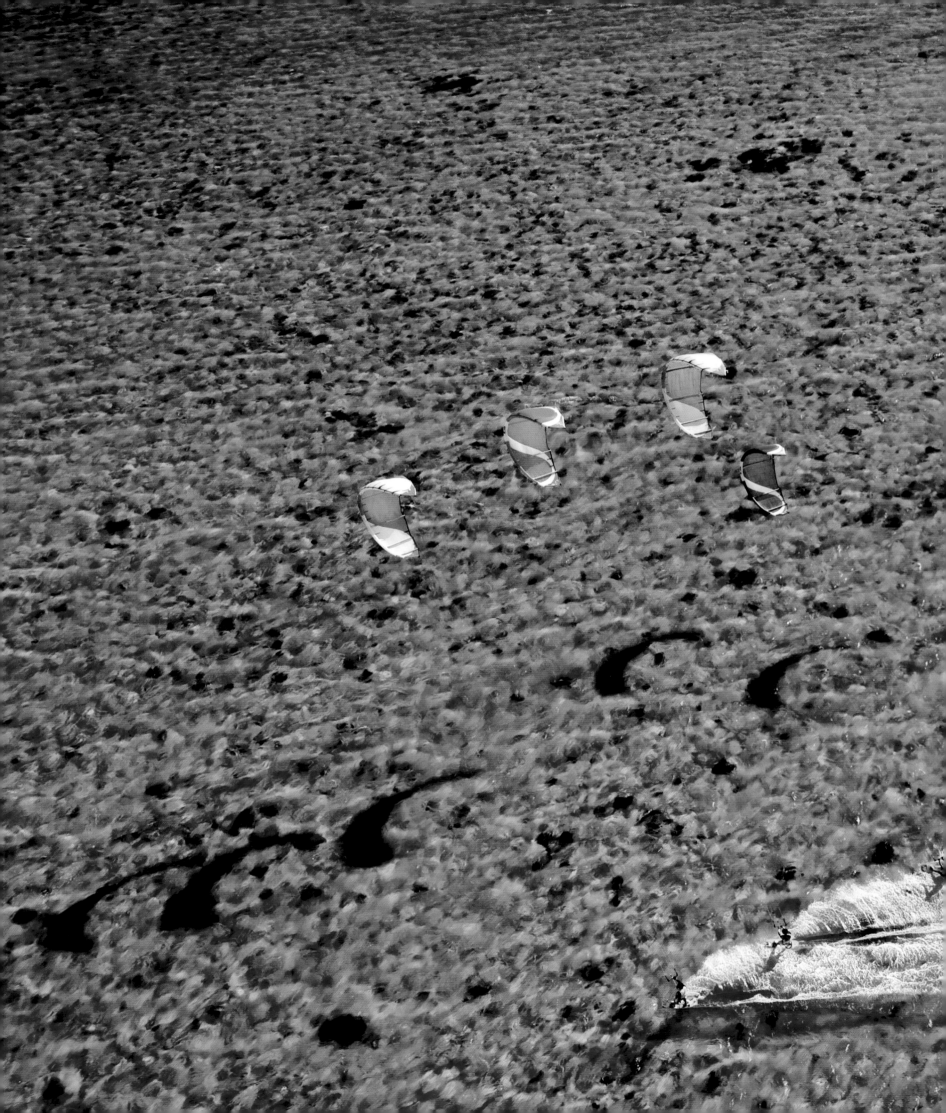

SURFING

"But tomorrow, ah, tomorrow, I shall be out in that wonderful water, and I shall come in standing up, even as Ford and Freeth. And if I fail tomorrow, I shall do it the next day, or the next. Upon one thing I am resolved: the Snark shall not sail from Honolulu until I, too, wing my heels with the swiftness of the sea, and become a sunburned, skin-peeling Mercury."

Jack London,
Riding the South Seas Surf

There is no better guide than a great writer to find your way through the maze of history or forgotten mythology. Jack London passionately loved surfing, its ephemeral glories and bitter sorrows, its irrational shadow cast in the heart of rational Western societies. Through his writings, he proved to be the catalyst for its revival in the early 20th century. The rage, energy and powerful symbolism of this wave-riding art that the Hawaiians called He'e nalu touched the whole of this writer and adventurer's work. In fact, he was so fascinated by the natural and spiritual forces of the South Seas, Duke Kahanamoku felt he had *"the mind of an old Maori."* Surfing, this *"royal sport for the natural kings of earth,"* bacame his metaphor of Hawaii and its people. In his great memoir "The Cruise of the Snark," London rejoices at the *"miraculous"* survival of this Polynesian tradition.

Like Herman Melville and Mark Twain before him, London never stopped affirming, in his own stories, the *"extension into modernity"* of the fascinating He'e nalu myth. A short essay of 4,000 words was published prior to the novel in an American magazine in 1907 under the title "Riding the South Seas Surf." It was preceded by this quotation: *"Both, writer and surfer, as no other form of artistic expression, are as close to incredible wonder as they are to terrible disaster."* For him, surfing was similar to literature because of the effort required, the desire to sublimate and the intimate struggle against oneself. He urged people to surf and invited the reader to jump into the water: *"Go strip off your clothes that are a nuisance in this mellow clime. Get in and wrestle with the sea; wing your heels with the skill and power that reside in you, hit the sea's breakers, master them, and ride upon their backs as a king should."*

Landing in Hawaii aboard his own sailboat, London stayed during the summer of 1907 with his wife Charmian in a bungalow facing the waves of Waikiki. The beach next to Kuhio andfacing the Moana Hotel was the hangout for a clique of bohemians composed of natives like the Kahanomoku brothers; haoles (whites) like Alexander Hume Ford, a journalist residing in Hawaii; and

THE IRISH-HAWAIIAN GEORGE FREETH. WITH AN INTELLIGENT APPROACH, THEY DEVELOPED SURFING TO A POINT WHERE THEY COULD PRACTICE IT AT A LEVEL AS HIGH AS ANY NATIVE OF ANCIENT TIMES.

THEY TRAINED AS PART OF THE WAIKIKI SWIMMING CLUB, WHICH LATER GAVE BIRTH TO THE OUTRIGGER CANOE CLUB AND THE HUI NALU, THE "CLUB OF THE WAVES." LONDON WAS IMMEDIATELY CAPTIVATED BY THE AGILITY SHOWN BY FREETH AND HIS COHORTS AND RECOUNTS HIS OWN BAPTISM ON THE WAVES: "SURFING WAS NOT A SUBSTITUTE FOR ANYTHING. I REMEMBER, IT WAS A PURE DESIRE, A KIND OF IMMORTALITY... "

IT WAS THE MIRACULOUS MEETING OF THESE THREE MEN — LONDON, FORD AND FREETH — WHICH LED TO THE GOLDEN AGE OF SURFING. EACH ONE PLAYED A KEY ROLE. LONDON LEGITIMIZED THE SPORT THROUGH THE INFLUENCE OF HIS CELEBRITY. FORD ORGANIZED CLUBS TO PROMOTE SURFING IN HAWAIIAN SOCIETY AND WROTE ARTICLES FOR THE AMERICAN PRESS, WHILE FREETH, THE BEST SURFER IN THE WORLD AT THAT TIME, WAS INVITED TO REDONDO BEACH IN CALIFORNIA TO DELIVER THE FIRST HAWAII SURF DEMONSTRATION. HE WOULD LATER SETTLE ON THE CALIFORNIA COAST AND BECOME THE FIRST U.S. LIFEGUARD. THE NEWSPAPERS OF THE DAY HERALDED HIM AS "THE MAN WHO WALKS ON WATER." WITH DUKE KAHANAMOKU, AN OLYMPIC SWIMMING CHAMPION IN 1912 AND 1920 WHO LATER BECAME A HOLLYWOOD ACTOR AND THE SHERIFF OF HONOLULU (AND WHO ALSO CAUSED SIMILAR EXCITEMENT WHEN HE SURFED IN AUSTRALIA IN 1915), THEY HAVE COME TO BE KNOWN AS THE FIRST TWO MAJOR WATERMEN OF THE MODERN ERA.

THE DECLINE AND REBIRTH OF HAWAIIAN SURFING PRESENTED A DISTURBING PARALLEL, WITH BOTH ESSENTIALLY THE WORK OF HAOLES. WHEN LITERATURE, UNDER THE INFLUENCE OF EUROPEAN EXPLORERS, REPLACED THE POLYNESIAN ORAL TRADITION, THE FATE OF SURFING WAS SEALED, FOR BETTER OR FOR WORSE. THE FIRST WRITTEN TRACES OF THE HE'E NALU PRACTICE DATE BACK TO 1779 IN TWO PAGES SIGNED BY LIEUTENANT JAMES KING WHO, AFTER THE DEATH OF JAMES COOK IN HAWAII, TOOK OVER THE LOGBOOK OF THE EXPEDITION LED BY THE SHIPS *RESOLUTION* AND *DISCOVERY* IN THE PACIFIC. HE OBSERVES SURFERS IN KEALAKEKUA BAY ON BIG ISLAND AND DESCRIBES THE NATURAL AND ATAVISTIC ATTRACTION HAWAIIANS HAD FOR THE WAVES: "THESE PEOPLE ARE ALMOST AMPHIBIOUS. MEN AND WOMEN SWIM IN THE OCEAN FOR HOURS, RIDING THE FOAM ON LONG BOARDS WITH A DEXTERITY THAT SEEMS NOT OF THIS WORLD, AND THEY SEEM TO DERIVE SUPREME PLEASURE FROM IT."

KING'S ENTHUSIASM WAS MATCHED BY THAT OF COOK HIMSELF. FOLLOWING THE DISCOVERY OF TAHITI IN 1777, HE HAD WATCHED, FASCINATED, AS FISHERMEN RUSHED DOWN ON THEIR OUTRIGGER CANOES TO RIDE THE WAVES THAT BORDERED THE ENTRANCE OF THE PASS BEYOND THE LAGOON. BUT THESE STORIES HAD A PARADOXICALLY NEGATIVE IMPACT ON THE CUSTOMS OF THE ARCHIPELAGO. UPON THE RETURN OF THE EXPEDITION TO ENGLAND AND THE PUBLICATION OF THE LOGBOOK, HAWAII AND SURFING BEGAN A LONG DECLINE OF 150 YEARS, WHICH INCLUDED SURFING'S ABOLITION IN 1819, LESS THAN 50 YEARS AFTER THE FIRST CONTACT BETWEEN COOK AND HAWAIIANS OF THE POLYNESIAN TRIBAL SYSTEM, CALLED THE KAPU, WHO WERE LED BY PRINCE LIHOLIHO, SON OF KING KAMEHAMEHA. FOR SURFING, IT WAS A TIME OF ANARCHY AND THE END OF THE MAKAHIKI CELEBRATION IN HONOR OF THE GOD LONO, IN WHICH SURFING PLAYED A PROMINENT ROLE. STRIPPED OF ITS MYSTICAL SIGNIFICANCE, ITS SONGS, ITS RITUALS AND TABOOS, SURFING GRADUALLY LOST ITS IMPORTANCE AND COLLAPSED.

IT WAS NOT UNTIL ALMOST A CENTURY LATER THAT HE'E NALU REFOUND ITS NOBILITY IN THE WRITINGS OF MELVILLE, TWAIN AND LONDON. THE GENERATION OF WRITERS WHO SUCCEEDED THEM, DURING THE PERIOD BETWEEN THE TWO WORLD WARS, TRIED TO INTEGRATE THE CULTURAL DIMENSION OF THE SPORT IN THE CONTEXT OF A CHANGING WORLD. HOWEVER, THEY NEGLECTED AN AREA OF EXPLORATION THAT MORE DRAMATIC EVENTS SUCH AS WARS, FINANCIAL CRISES AND REVOLUTIONS MADE RIDICULOUS. AFTER THE ENTHUSIASM RAISED BY FREETH IN CALIFORNIA IN 1907 AND DUKE IN AUSTRALIA IN 1915, SURFING DISAPPEARED FROM THE HEADLINES. IN 1935, THE PUBLICATION OF THE BOOK "HAWAIIAN SURFBOARD," THE FIRST WORK DEVOTED TO THE ANCIENT ART OF SHAPE AND BOARD DESIGN, WENT RELATIVELY UNNOTICED. HOWEVER, IT WAS A MAJOR CONTRIBUTION TO SURF CULTURE. ITS AUTHOR, TOM BLAKE, IS CREDITED WITH THE IDEA OF THE FIN AND WAS THE FIRST PHOTOGRAPHER TO SHOOT AQUATIC SCENES WHICH, MORE THAN LITERATURE, HELPED DEFINE THE INCREDIBLE AESTHETIC POWER OF SURFING.

DURING THE '50S, THE CULTURAL EPICENTER OF SURFING MOVED FROM WAIKIKI TO MALIBU. THE EMBLEMATIC FIGURE OF THE DUKE WHO, IN AND OUT OF THE WATER, PRESENTED HIMSELF IN A WAY WORTHY OF THE NOBLEST HAWAIIANS GAVE WAY IN THE UNCONSCIOUS COLLECTIVE TO REBELLIOUS BLOND SURFERS FROM THE

BEACHES OF CALIFORNIA. FOR THE PUBLIC, SURFING WENT FROM STRANGE AND EXOTIC TO STRANGE AND THREAT-
ENING, AS EVIDENCED BY THE OUTRAGED REACTION TO THE 1957 RELEASE OF THE NOVEL *GIDGET* BY FREDERICK
KOHNER. THIS UNPRETENTIOUS NARRATIVE, WHICH RECOUNTS THE TURMOIL OF A TEENAGE FEMALE SURFER, LAID
THE GROUNDWORK FOR CALIFORNIA'S BEACH CULTURE. SURFING BECAME ONE OF THE SEXIEST SPORTS BUT, NEV-
ERTHELESS, IT INSPIRED ONLY MINOR FICTIONAL WORKS WHICH WERE SOMETIMES ADAPTED TO THE SCREEN BY
HOLLYWOOD. FOR THE MOST PART, THEY MISSED THE MARK.

THE YEAR 1960, WITH THE CREATION OF THE "BIBLE OF SURFERS," SURFER MAGAZINE, MARKED THE DAWN OF
A REVOLUTION. REVIVING THE HEROIC STORIES OF THE EARLY CENTURY, JOHN SEVERSON, THE MAGAZINE'S CREATOR,
DISTILLED A FEW LITERARY NUGGETS TO AN AUDIENCE THAT WAS INCREASINGLY AWARE OF SURFING'S FUTURE PROMI-
NENCE. "SURFING IS STILL THE SPICE OF CULTURAL SINGULARITIES. IT HAS ITS SECRET GEOGRAPHIES, ITS LEGENDS, ITS
LITURGY, ITS OWN LANGUAGE. IT IS THE ALIBI OF A FLIGHT OF THE SOUL OVER THE WICKEDNESS OF EVERYDAY," SEV-
ERSON WROTE IN A 1964 EDITORIAL. THE PSYCHEDELIC METAPHOR TOOK ON ITS FULL MEANING IN THE FAMOUS
"SUMMER OF LOVE" OF 1967, STIRRED BY THE "SHORTBOARD REVOLUTION." DOZENS OF ARTICLES, BOOKS AND
FILMS HAVE TRIED, OVER THE LAST FORTY YEARS, TO CLARIFY THIS KEY MOMENT IN THE HISTORY OF SURFING.

AUSTRALIAN NAT YOUNG, A WORLD CHAMPION IN 1966 AND 1970, ALONG WITH HIS FELLOW SURFERS BOB
MAC TAVISH, GEORGE GREENOUGH AND THE HAWAIIAN DICK BREWER, WAS AN INFLUENTIAL ARCHITECT IN THIS
REVOLUTION OF MENTALITY AND BOARDS. YOUNG GAVE HIS OWN VERSION OF THIS PERIOD IN HIS AUTOBIOGRA-
PHY: "FOR THE FIRST TIME, COMPETITIVE SURFING HAD PUSHED THE SPORT INTO ANOTHER DIMENSION. WE
STARTED TO PLOT MANEUVERS WHERE WE ONCE DID DANCE STEPS. ON THESE SMALLER BOARDS, YOU COULD GET
UP LATER, SLIDING IN THE TUBE WITH FULL CONFIDENCE THAT YOU COULD MAKE TURNS WITHOUT LOSING SPEED.
UNDER THE FEET OF AN INSPIRED SURFER, THESE MAGIC BOARDS FOUND ENERGY IN PLACES OF THE WAVE THAT
NO ONE HAD YET THOUGHT TO VENTURE. THIS WAS SURFING'S JAZZ ERA."

THE EVOLUTION OF MATERIALS PROMOTED THE EMERGENCE OF A NEW HAWAIIAN PROPHET, GERRY LOPEZ,
WHO WOULD EVENTUALLY ATTACK THE BANZAI PIPELINE ON THE NORTH SHORE OF OAHU WITH THE STYLE AND
RELAXED AIR OF A ZEN MASTER. THE TUBE BECAME THE OBJECT OF A METAPHYSICAL QUEST, AND THIS "TRIP" OF-

FERED A GENERATION A RITE OF PASSAGE THAT MATCHED ITS SPIRITUAL NEEDS. THE LEGENDARY SURF EXPLORERS KEVIN NAUGHTON AND CRAIG PETERSON HIT THE ROAD AND TOOK UP THE PEN TO REVEAL TO READERS OF SURFER MAGAZINE THEIR FAVORITE SPOTS IN CENTRAL AMERICA, EUROPE AND AFRICA. NAUGHTON WROTE: *"THESE REPORTS WERE WRITTEN ON THE BEACH, AND MAILED FROM BACKWOODS IN PACKAGES COVERED WITH STAMPS, WHICH GUARANTEED SOME FORM OF AUTHENTICITY. WE WERE REALLY IMMERSED, CHECKING POINTS ON THE MAP IN SEARCH OF WAVES. IT WAS A QUEST. WE WANTED TO EXPERIENCE THE JOYS AND FRUSTRATIONS OF EXPLORING UNKNOWN CORNERS AND VIRGIN WAVES."* IN THEIR WAKE, GENERATIONS OF SURFERS TOOK THEIR OWN TRIPS TO EXPLORE THE PRISTINE REEFS OF INDONESIA OR THE WAVES OF FRANCE, MEXICO OR MOROCCO, WHILE THE SURFWEAR INDUSTRY GAINED SOME STRUCTURE AND STARTED TO BECOME A REAL BUSINESS ON A GLOBAL SCALE.

IN THE 1980S, THE GLORIOUS WAVES RECOUNTED BY WRITERS IMPACTED THE SURF CULTURE IN SEVERAL WAYS. THESE WRITTEN ACCOUNTS HELPED REPRESENT THE SUMMIT OF THE ART OF SURFING. THEY PLAYED AN IMPORTANT PART IN THE RECORDING OF SURF HISTORY, WHICH WOULD INFLUENCE THE COURSE OF THE SPORT. AND THEY FORMED A METHOD OF CODIFICATION FOR THE ART OF THE SURFER. AN EXAMPLE OF THE FIRST IS THE THIRD WORLD TITLE WON BY TOM CURREN IN 1990 AND HIS CONVERSION TO SOUL SURFING — SURFING FREED FROM THE CONSTRAINTS OF COMPETITION. AN EXAMPLE OF THE SECOND IS KELLY SLATER'S VICTORY IN THE FACE OF LARGE WAVES AT THE EDDIE AIKAU AT WAIMEA BAY IN 2002, AS THE KING WENT ON TO BE CROWNED WORLD CHAMPION TEN TIMES BETWEEN 1992 AND 2010, CLOSING THE LOOP ON A CENTURY OF EVOLUTION AND JOINING DUKE IN THE PANTHEON OF THE MOST INFLUENTIAL SURFERS OF ALL TIME. AND AN EXAMPLE OF THE THIRD IS THE MILLENNIUM WAVE IN AUGUST 2000, WHEN HAMILTON LAIRD BECAME THE FIRST SURFER TO CONQUER TEAHUPOO'S EVEREST-SCALE WAVES, ONCE CONSIDERED SOMETHING OF AN "UNRIDDEN REALM."

"WHEN THE LEGEND BECOMES FACT, PRINT THE LEGEND." THIS IS THE MORAL PARADOX OF MORE THAN TWO CENTURIES OF SURFING LITERATURE. THE TEXTS IN THIS GREAT SURFING ANTHOLOGY SHARE THE DESIRE TO TELL GREAT HUMAN ADVENTURES, USING SURFING AS AN ENTRY INTO A LARGER CULTURE, TO TREAT THE SPORT WITH RESPECT AND, ABOVE ALL, TO GIVE THE READER A FASCINATING INSIGHT INTO WHAT PUSHES SURFERS TO DEFY THE OCEAN AGAIN AND AGAIN. ALL THE REST IS LITERATURE.

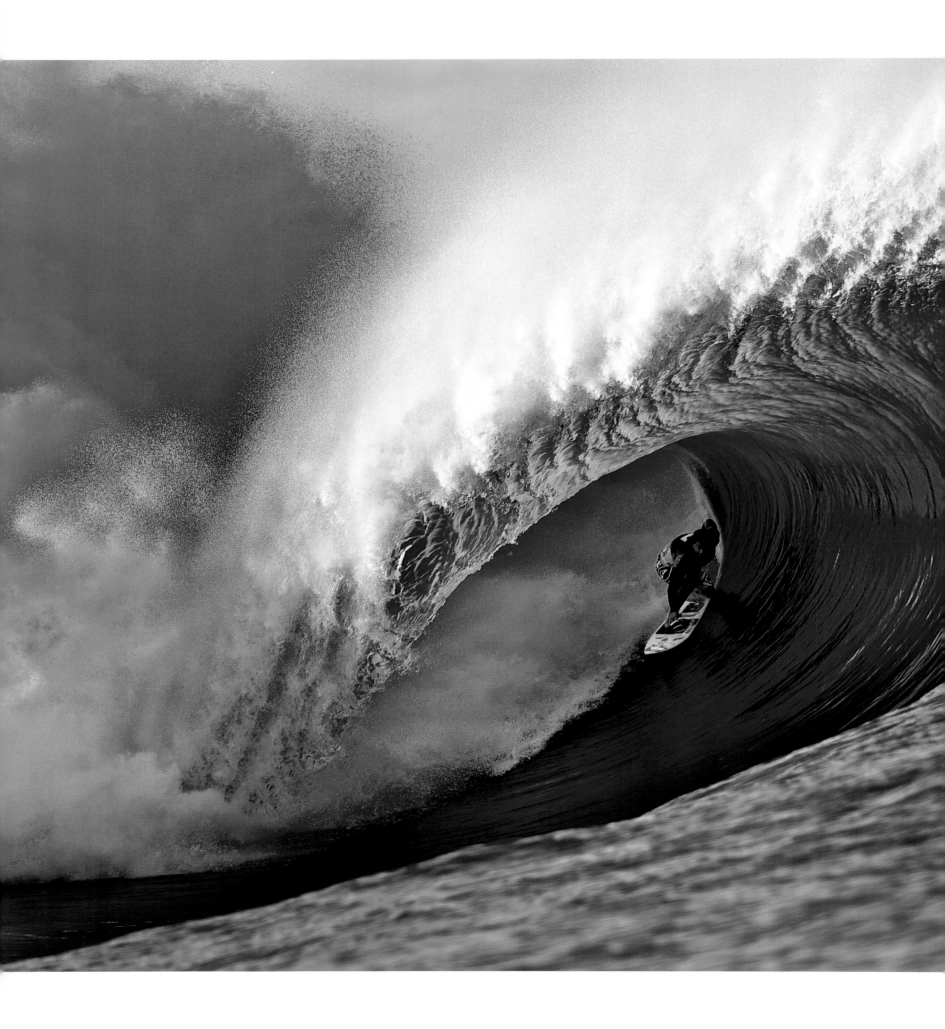

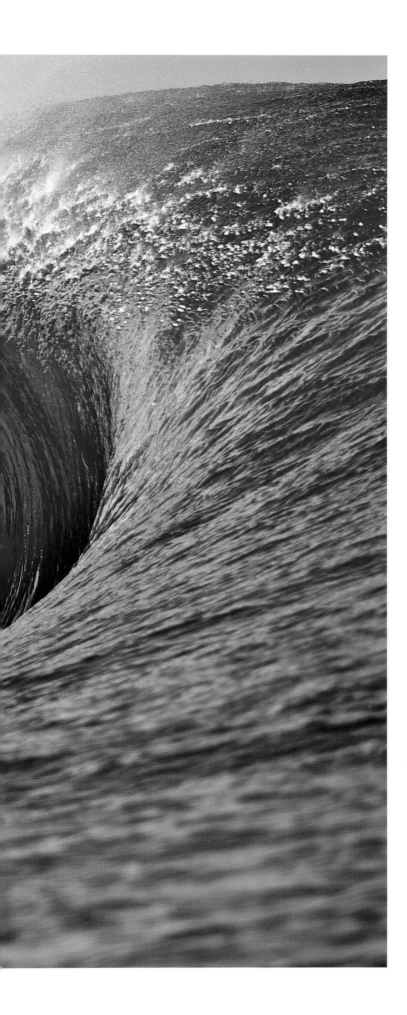

28-29 THE BEAUTY OF THE DEVIL, A WAVE THAT IS AS MONSTROUS AS IT IS PERFECT, IMMORTALIZED ON HALLOWEEN 2007 IN TEAHUPOO ON THE PENINSULA OF TAHITI. THE HEART OF DARKNESS, THE SURFER. LOCAL RAIMANA VAN BASTOLAER.

30-31 The floater, which is a way to fly over a section of a wave that is about to close, is one of the most representative moves of the innovative new school of surfing begun in the '90s.

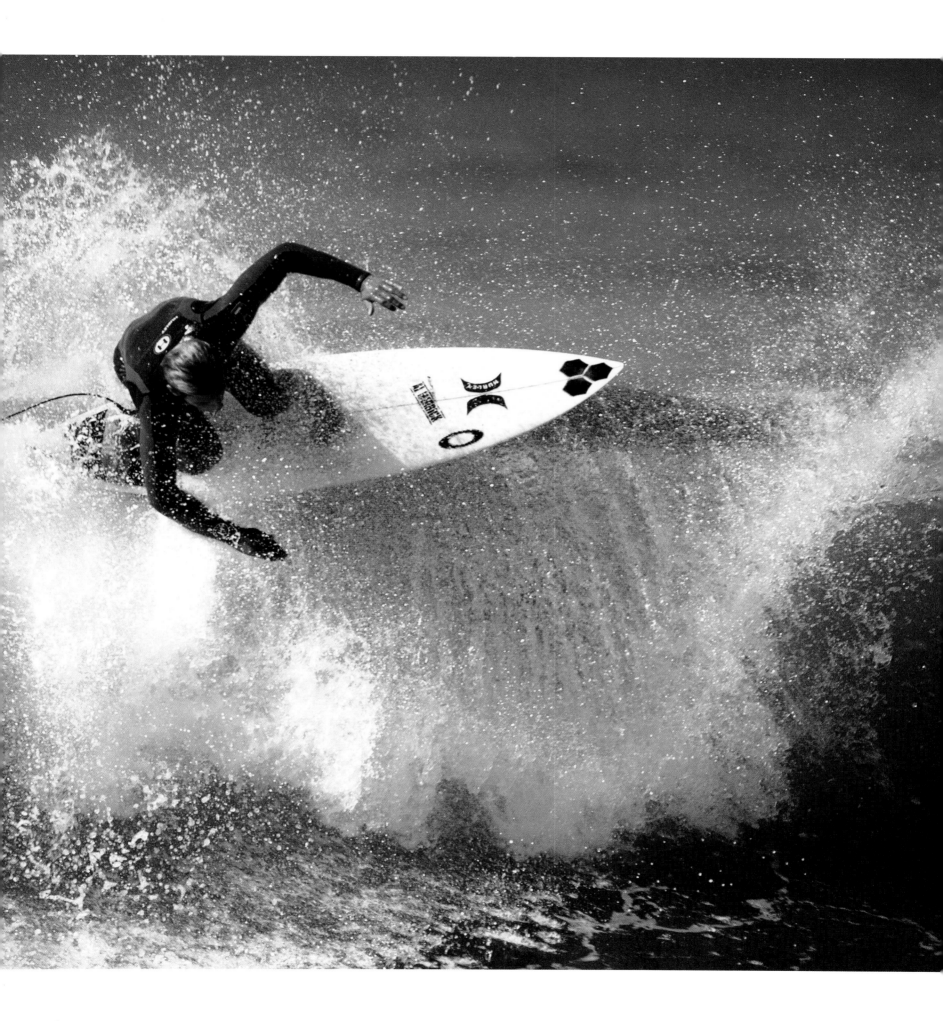

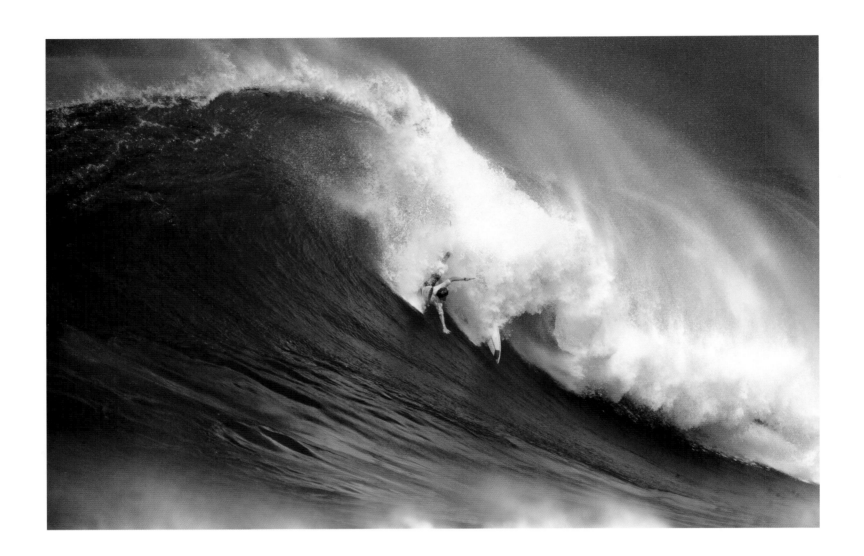

32 THE FALL WILL BE EVEN HARDER...OR THE ART OF KNOWING HOW TO FALL IN ORDER TO SPEND THE LEAST POSSIBLE TIME UNDER WATER.

33 THE BANZAI PIPELINE, WHICH IS WELL-NAMED, IS RESERVED FOR THE KAMIKAZE RIDERS OF THE WAVES.

34-35 THE PROFESSIONAL SURF CIRCUIT'S DREAM TOUR OFFERS THE BEST SURFERS ON THE PLANET THE CHANCE TO COMPETE ON THE WAVES OF THEIR DREAMS. HERE, THE AUSTRALIAN BEDE DURBRIDE IS IN THE TEAHUPOO TUBE.

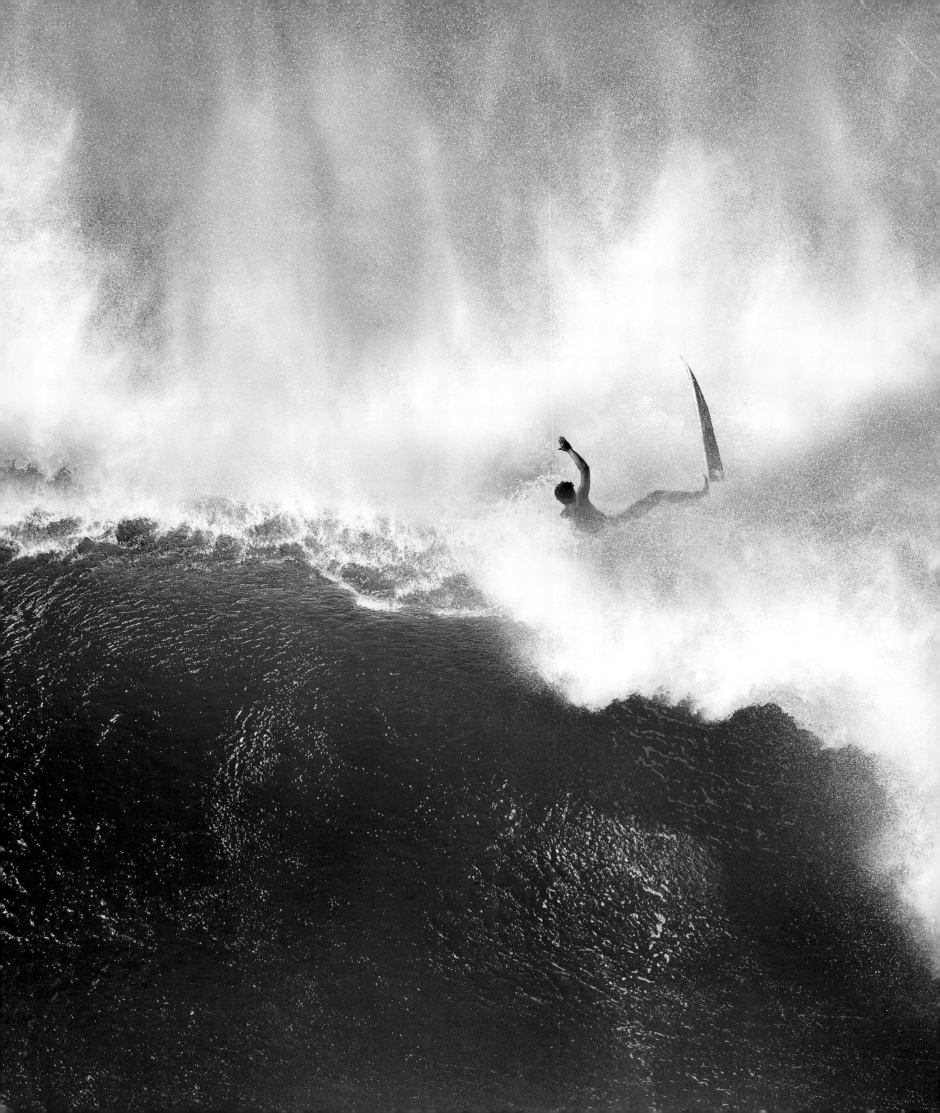

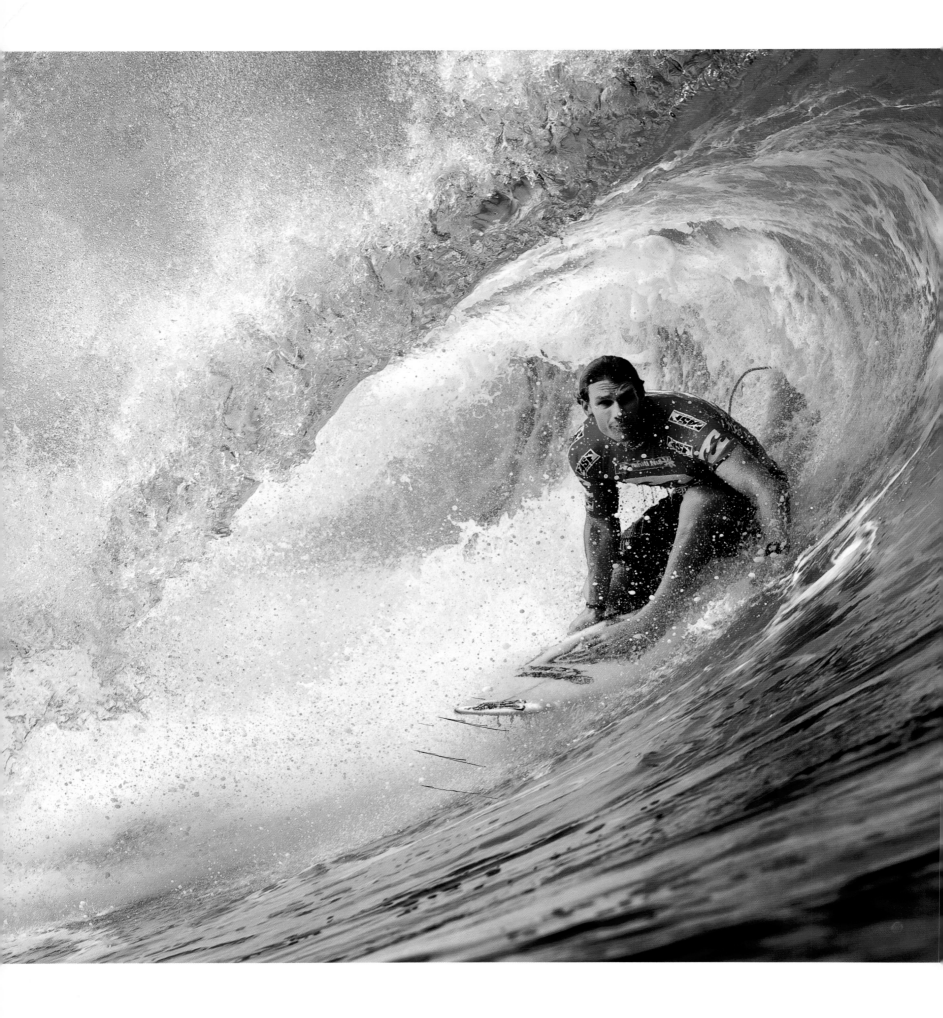

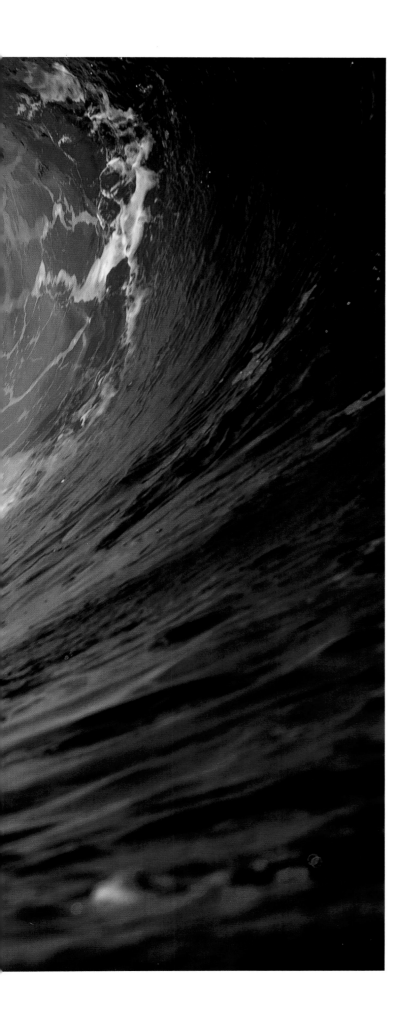

"SURFING, ALONE AMONG SPORTS, GENERATES
LAUGHTER AT ITS VERY SUGGESTION, AND THIS
IS BECAUSE IT TURNS NOT A SKILL INTO AN ART,
BUT AN INEXPLICABLE AND USELESS URGE INTO
A VITAL WAY OF LIFE."

MATT WARSHAW,
MAVERICK'S: THE STORY OF BIG-WAVE SURFING

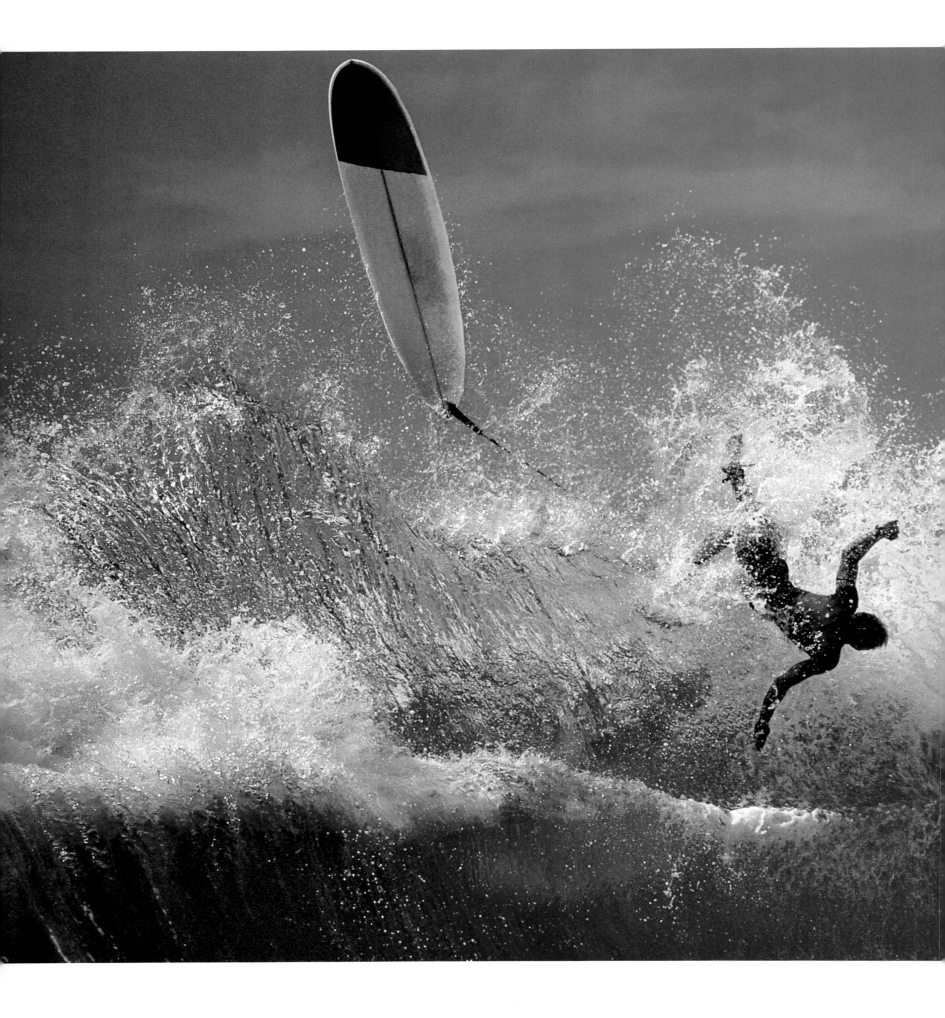

36-37 Never underestimate the power of the waves or try to impose your will on them. To the waves, we are nothing but wisps of straw.

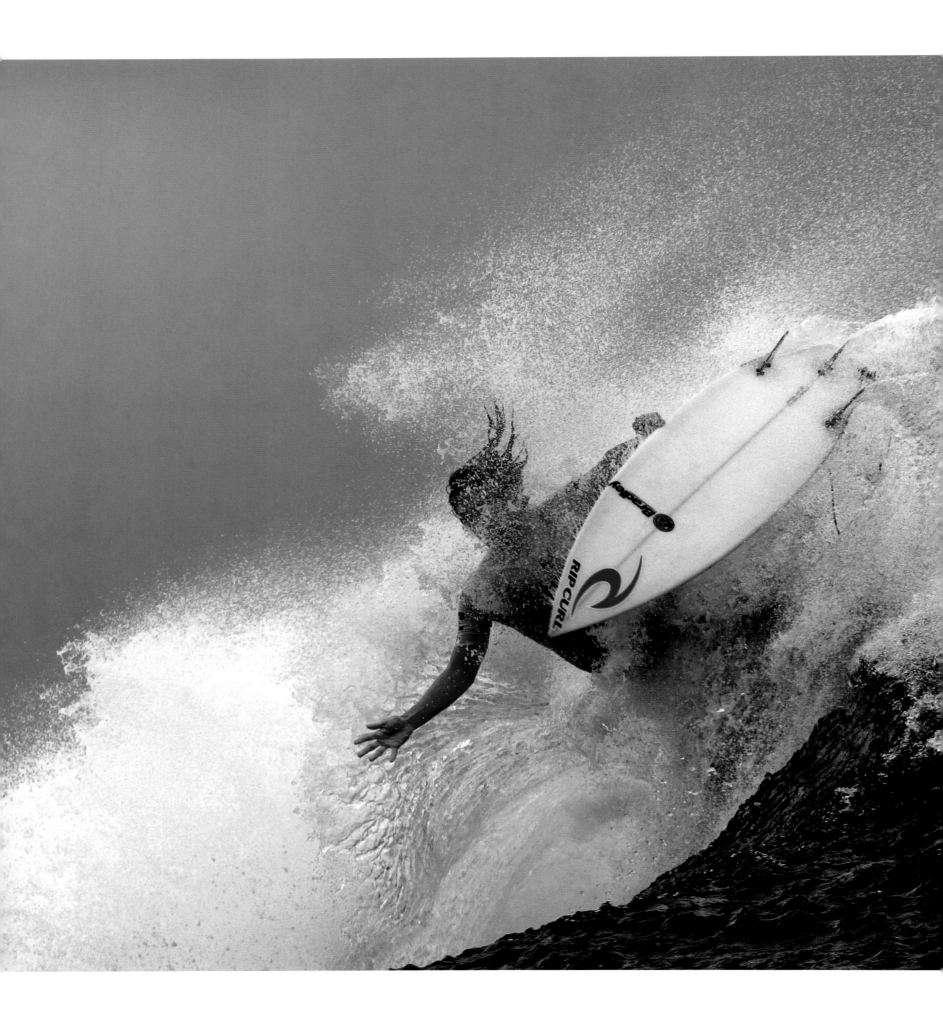

38-39 THE AERIAL, IN WHICH THE WAVE IS USED AS A SPRINGBOARD, IS A GIFT FROM SURFING'S SPIRITUAL LITTLE BROTHER, SKATEBOARDING. MATT WILKINSON. TAHITI.

40-41 BIG WAVE RIDER EVAN SLATER IS ABOUT TO BE CRUSHED BY THE LIP OF A GIANT WAVE AT MAVERICKS, A SPOT IN NORTHERN CALIFORNIA THAT IS FAMOUS FOR ITS ICY WATERS, GIANT WAVES AND SHARKS. BON APPETITE.

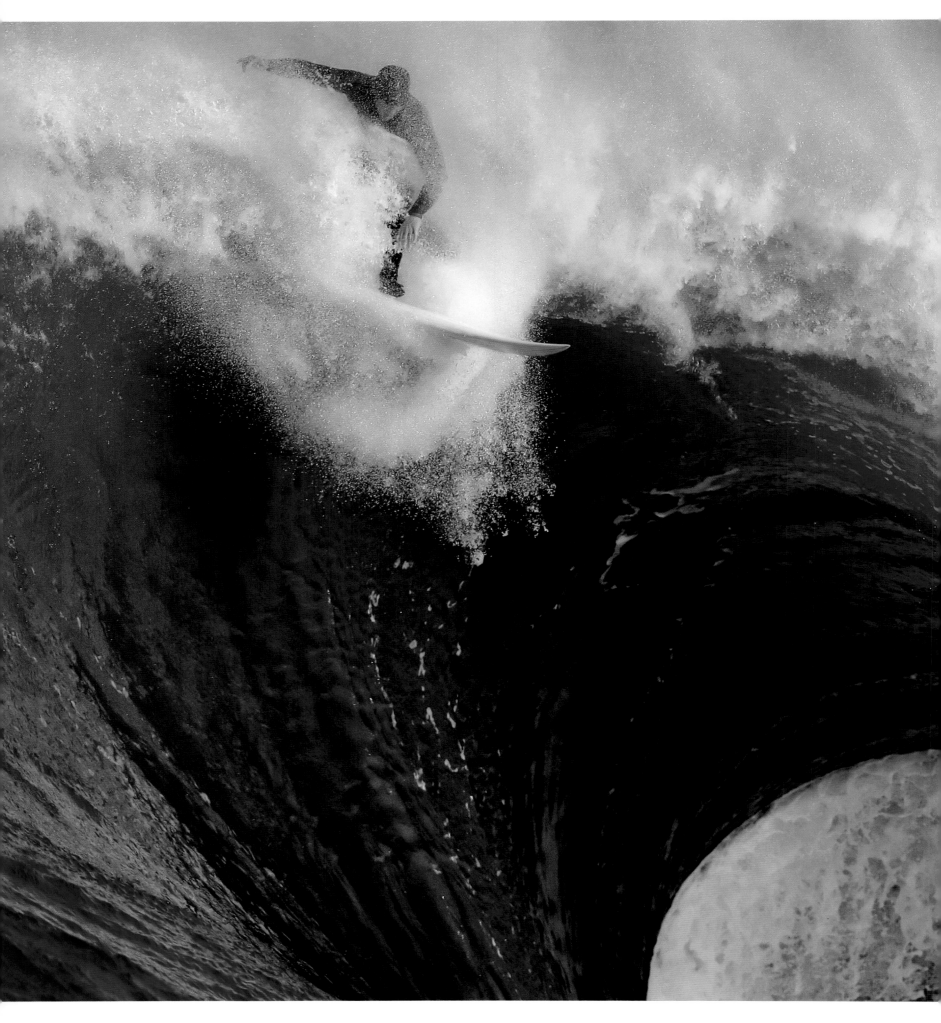

"WAVES ARE NOT MEASURED IN FEET
AND INCHES, THEY ARE MEASURED
IN INCREMENTS OF FEAR."

BUZZY TRENT,
BIG WAVE RIDER

42-43 FRENCHMAN JEREMY FLORES, THE YOUNGEST SURFER IN HISTORY TO QUALIFY FOR THE PROFESSIONAL TOUR, IN THE MIDDLE OF A TRAINING SESSION ON THE MENTAWAII ISLANDS IN INDONESIA.

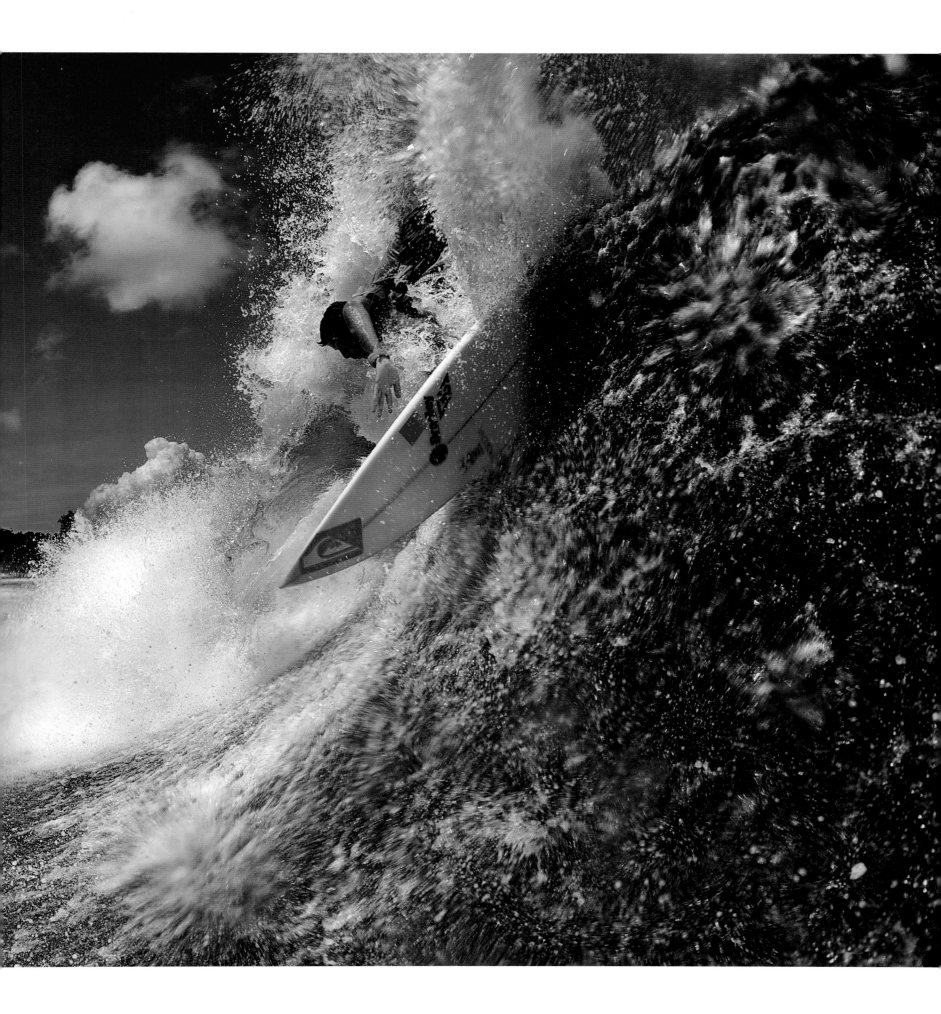

44-45 HAWAIIAN TUBES EMBODY THE ESSENCE OF SURFING, ITS MYSTICAL SIDE AND ITS CHALLENGES, IN THE PUREST SENSE.

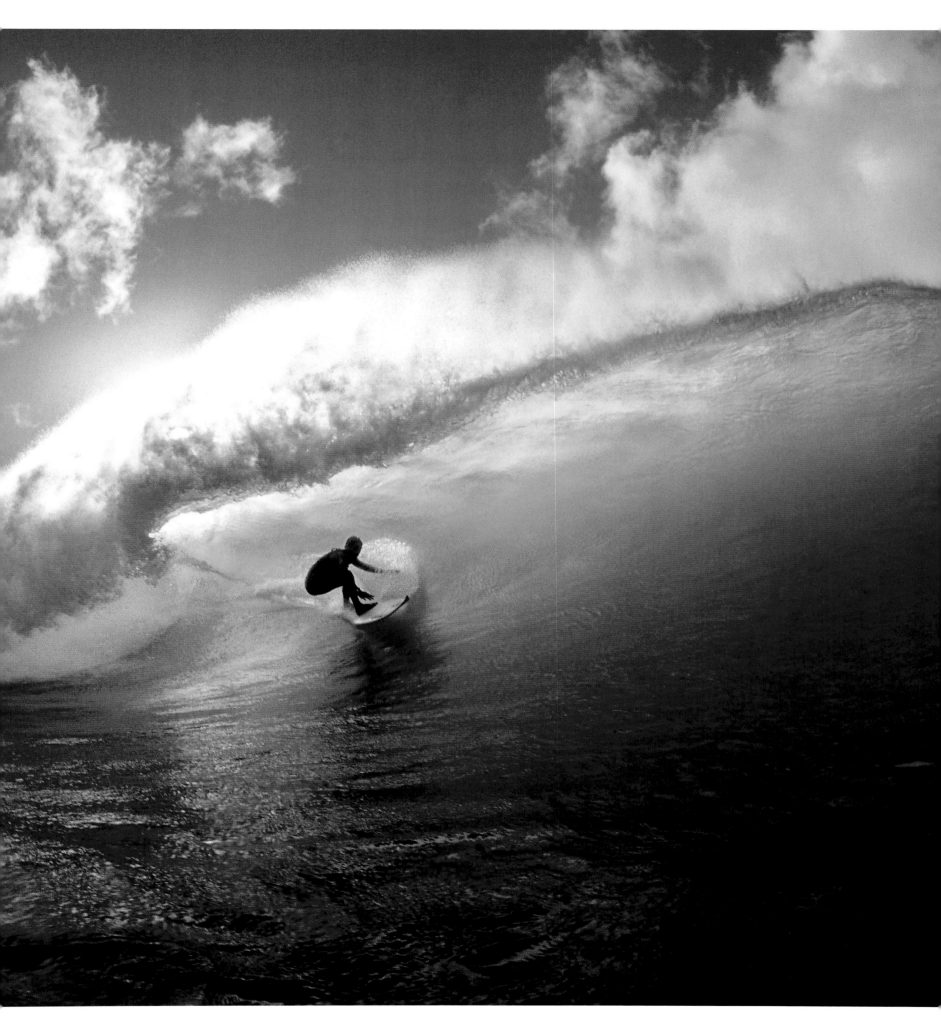

46-47 MALIK JOYEUX, THE "LITTLE PRINCE" OF TAHITI, DISAPPEARED WHILE SURFING IN HAWAII IN DECEMBER 2005. HE HAS BECOME A MARTYR AND A LEGEND.

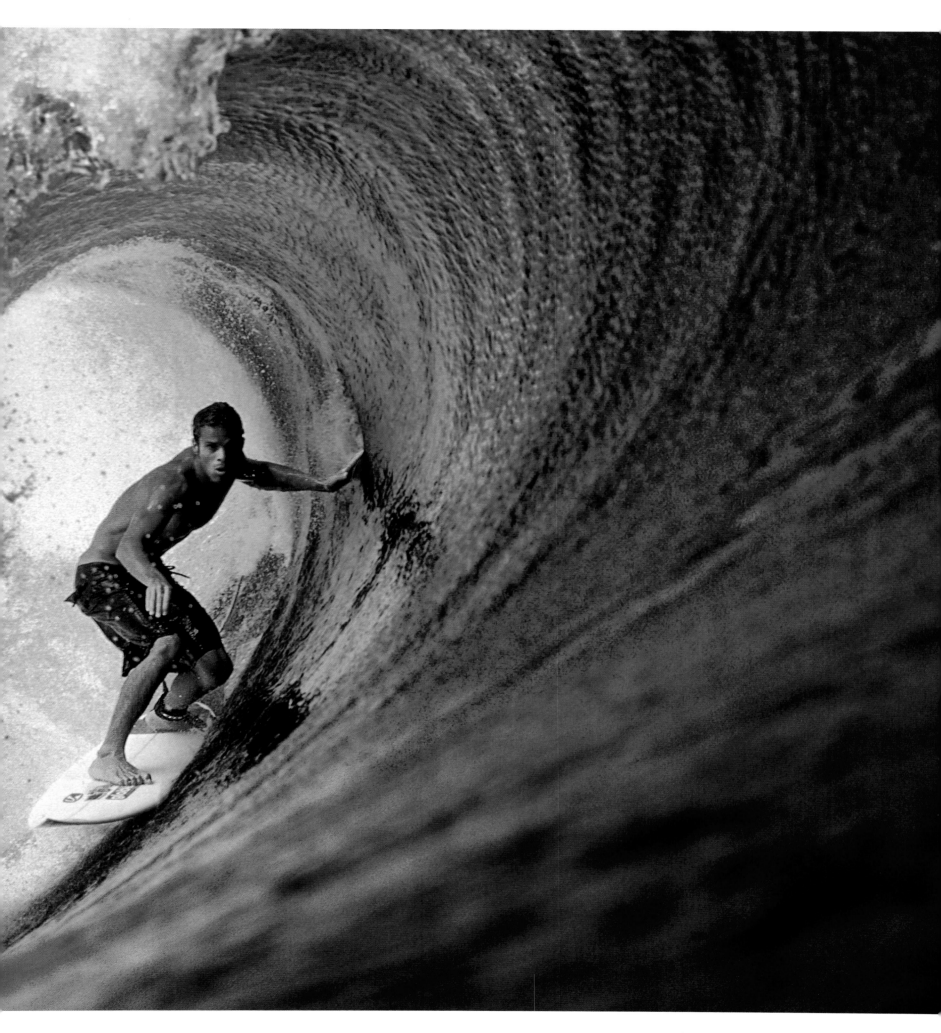

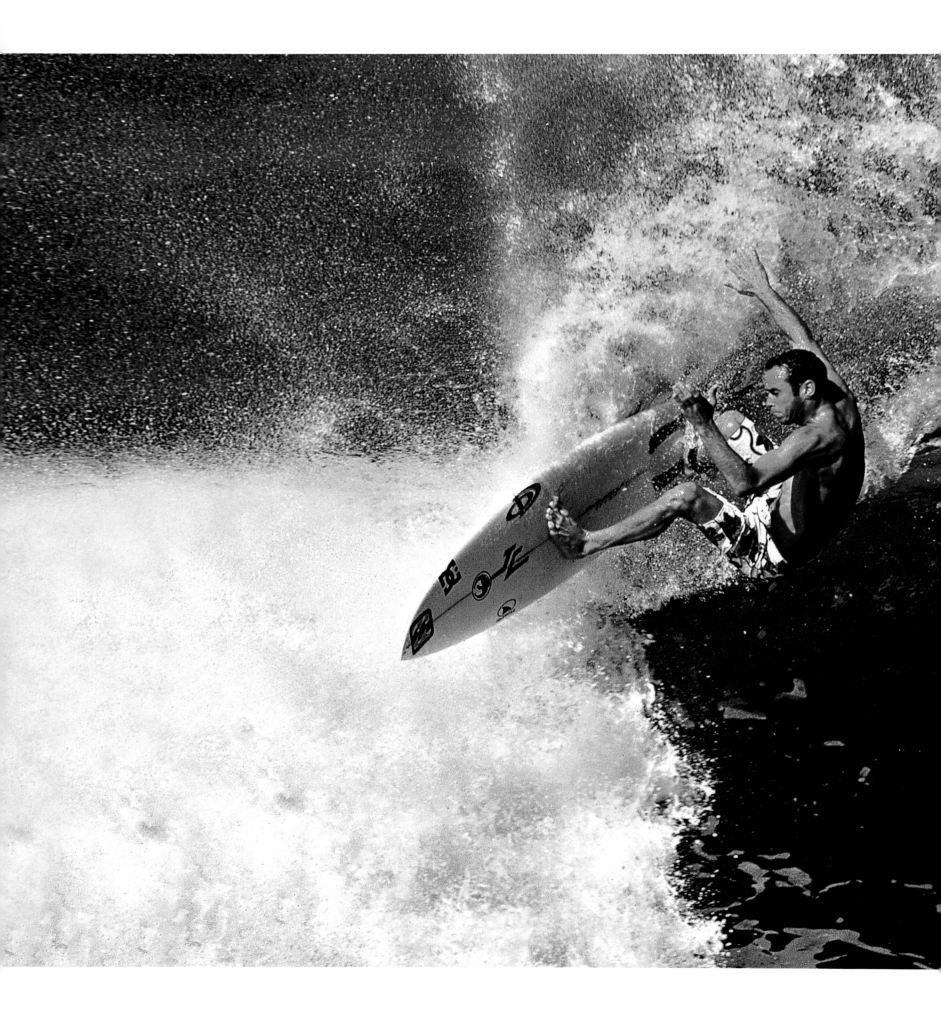

48-49 SHANE DORIAN, ROCKY POINT, HAWAII. NOW RETIRED FROM THE PROFESSIONAL CIRCUIT, HE HAS BECOME ONE OF THE MOST RESPECTED BIG WAVE SURFERS IN THE WORLD.

50-51 BIG WAVE SURFING, AND MOST ESPECIALLY PADDLE-IN SURFING, IS RESERVED FOR SPECIALISTS IN THE FIELD, AS IT REQUIRES AN EXTRAORDINARY PHYSICAL AND MENTAL TOUGHNESS.

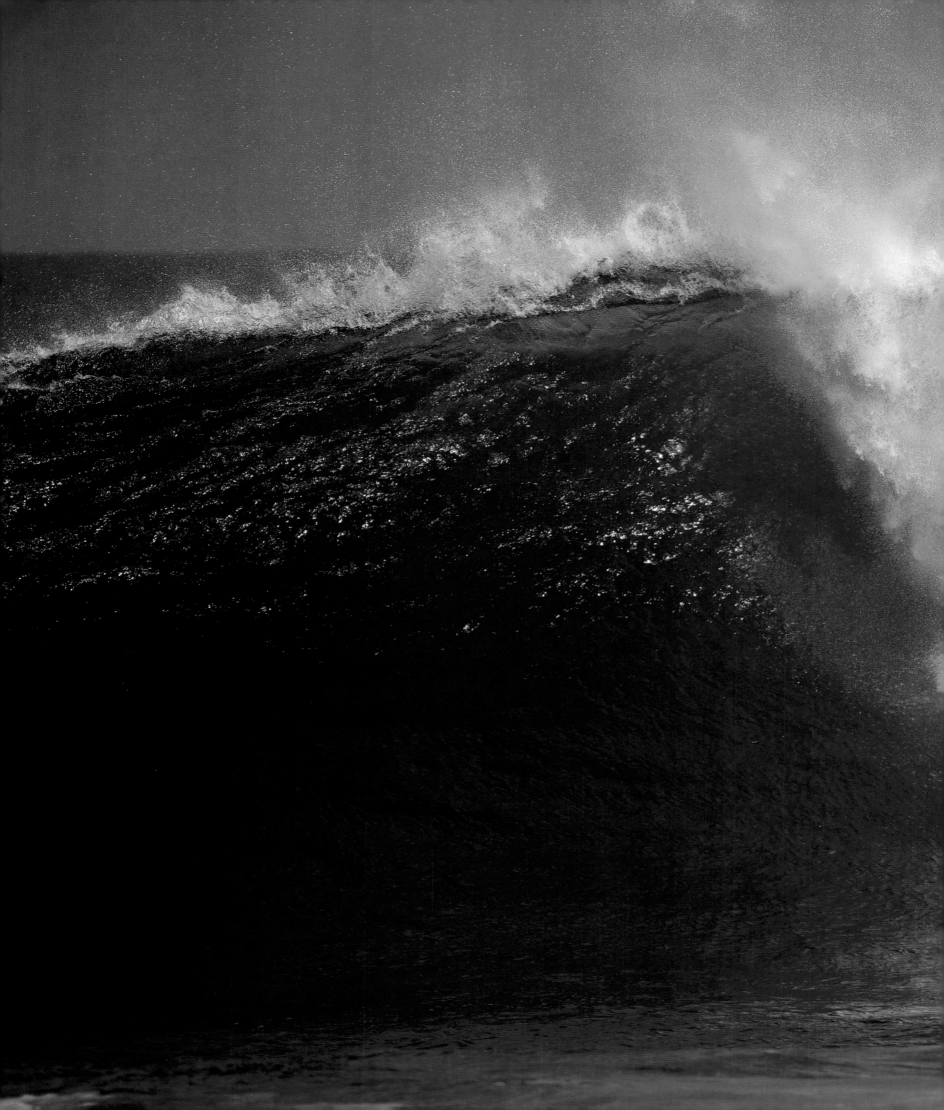

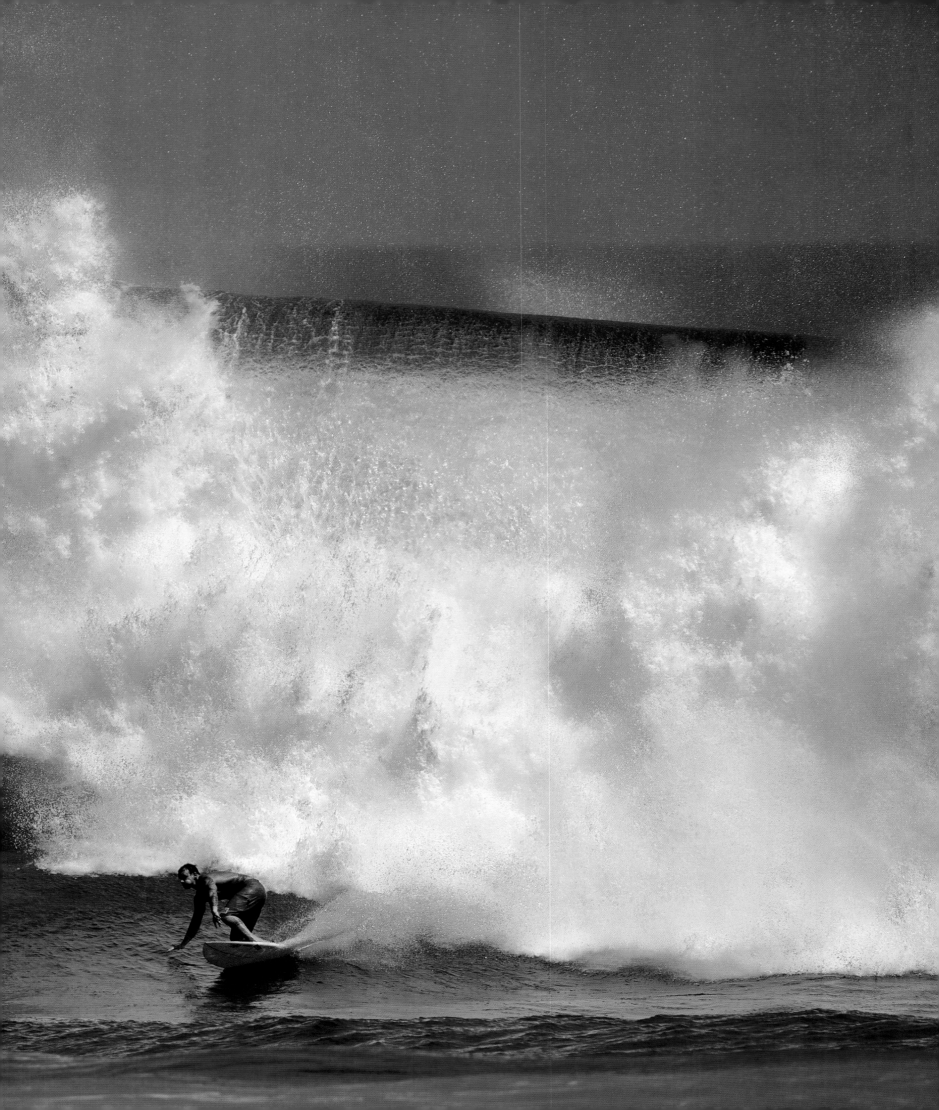

52 and **52-53** Considered "unsurfable," the "Shorebreak" in Waimea draws many candidates every year looking for glory. Many are often severely punished.

54-55 Benjamin "Sancho" Sanchis encapsulates the image of the free surfer, paid to hunt for the largest and most beautiful waves on the planet without the pressure of competition.

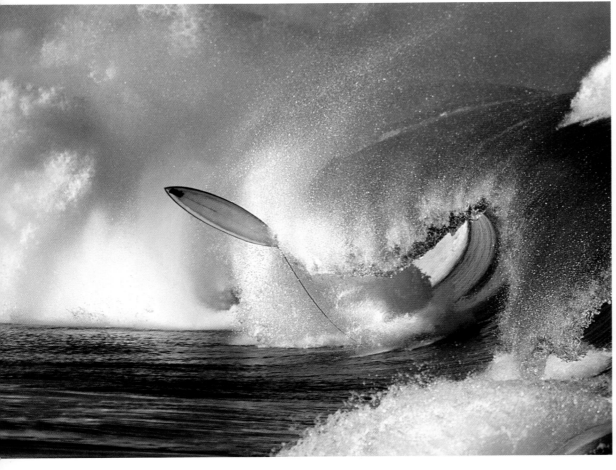

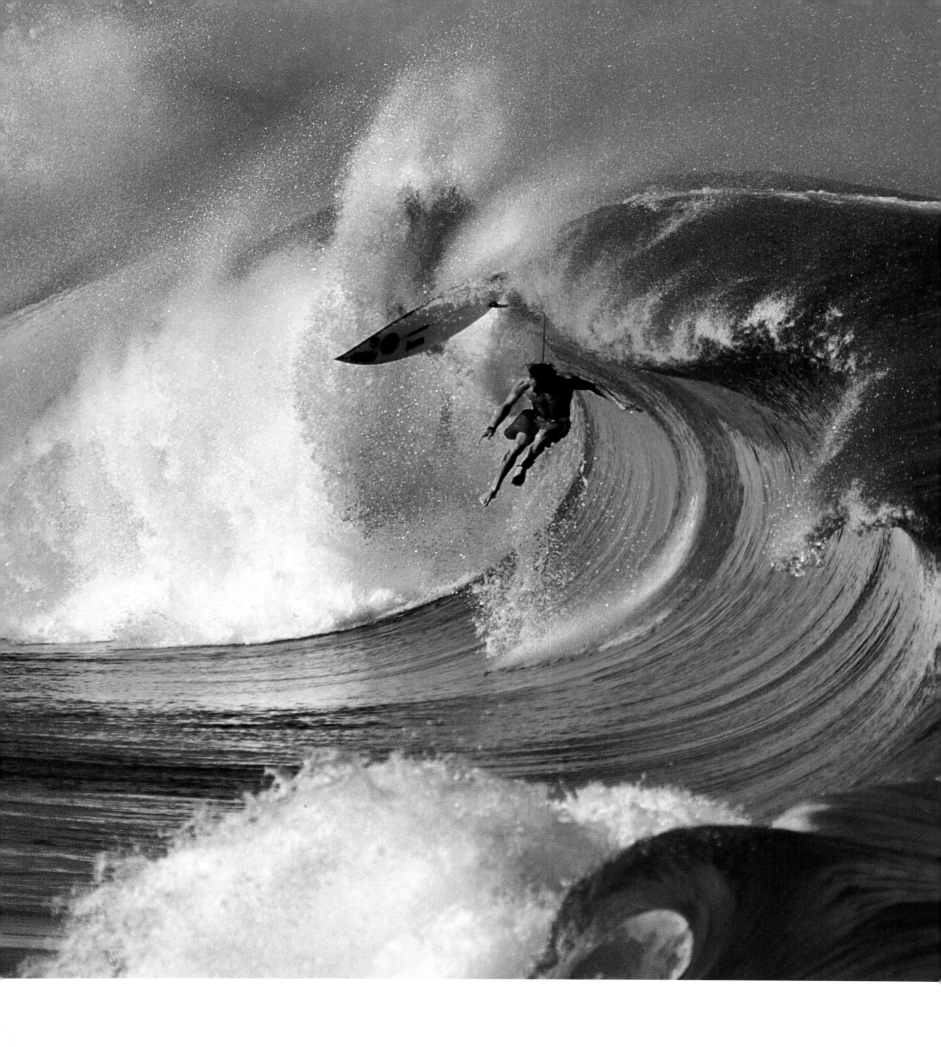

"OUT OF THE WATER,

I AM NOTHING."

DUKE KAHANAMOKU,
PROPHET OF MODERN SURFING

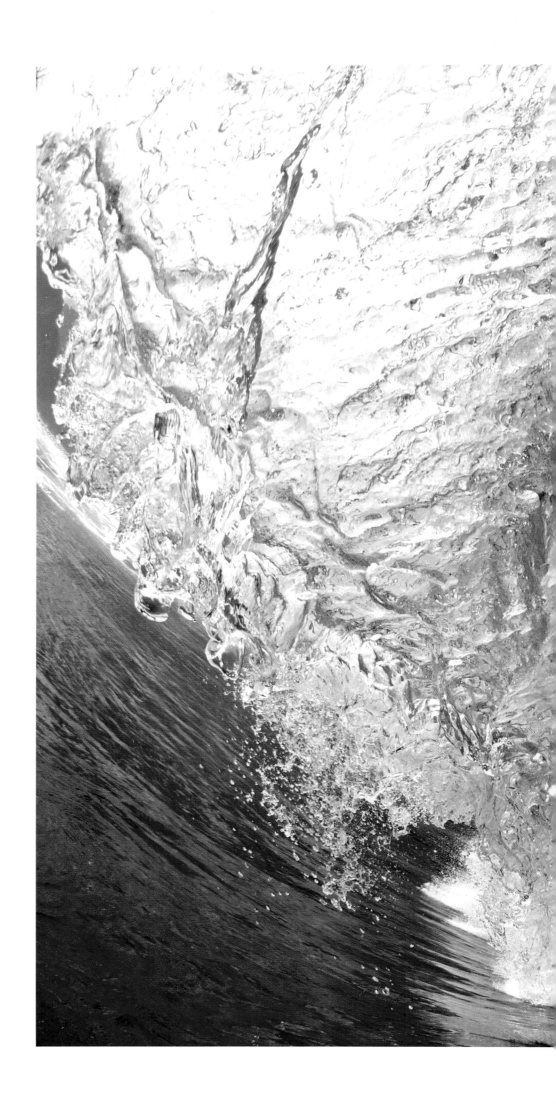

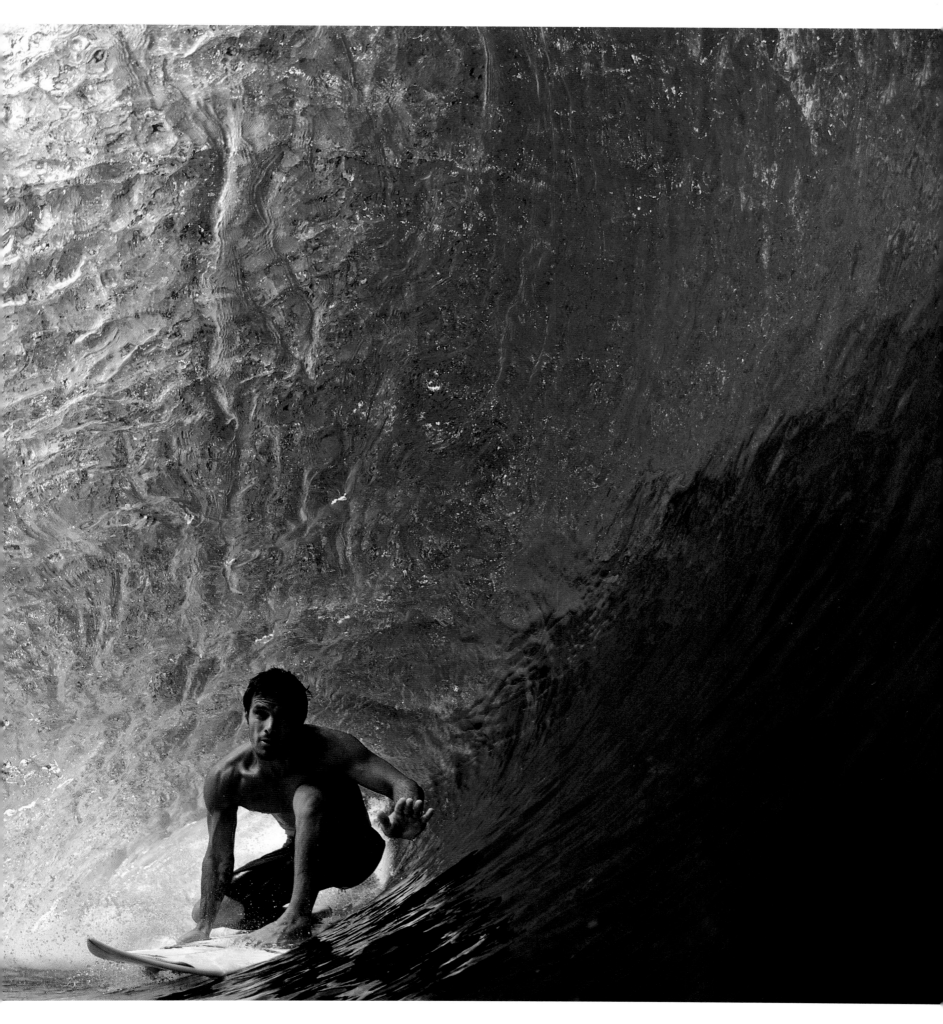

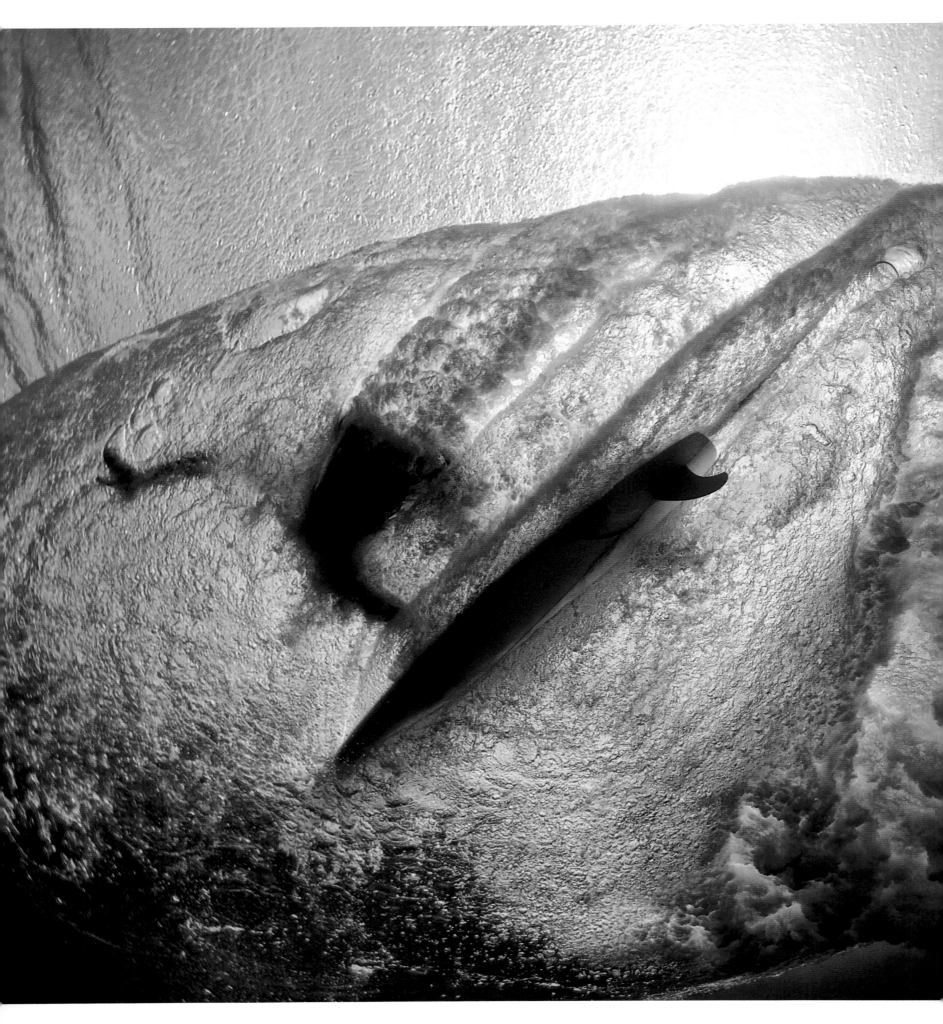

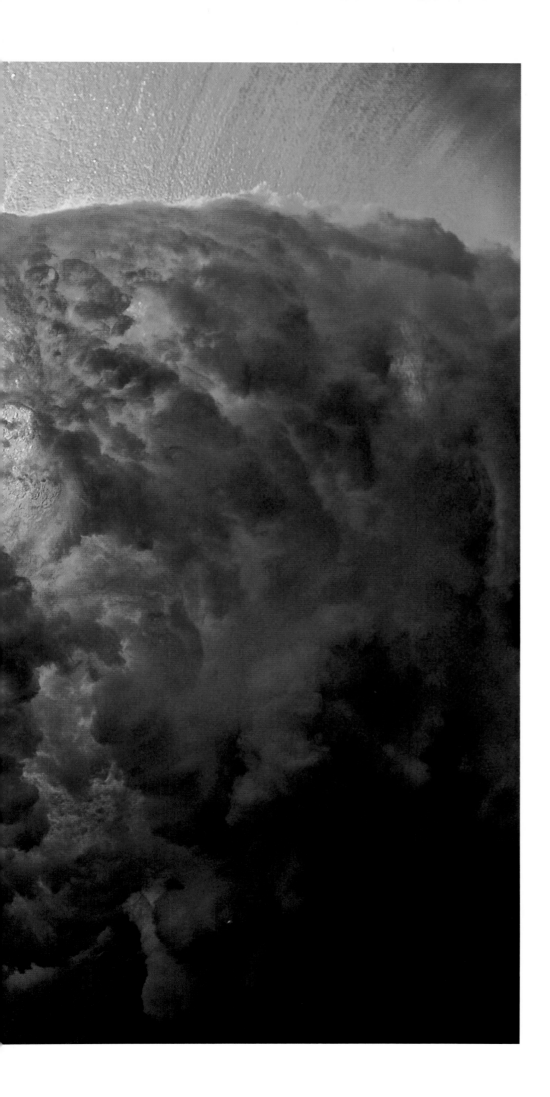

56-57 CAPTURING AQUATIC SCENES IS A SUBTLE AND EPHEMERAL ART WHICH REQUIRES PHYSICAL CONDITIONING AND UNFAILING COURAGE FROM PHOTOGRAPHERS.

BODYBOARD

"Revelation is nothing spooky or weird. There is this 'thing' you looking for, and you don't know what it is until you reveal it. So as far as being an inventor, I'm just a guy who was on the beach with the foam and a knife, and needed something to surf."

Tom Morey,
Father of the Bodyboard

Too jazzy for bluesmen, too bluesy for jazzmen, boogie remains an unclassifiable musical style, one that is influential but controversial and which owes its immense popularity to the improvisational skills of wacky pianists. Its rhythm and its natural explosiveness are perfectly suited to describe boogieboarding, a sport that is less strict and less academic than surfing and which became a worldwide hit thanks to the genius of a passionate visionary.

Every inventor has a day where he questions things that nobody else doubts. The apparent miracle seems logical and even trivial when hindsight reveals the supremacy of the inventor's creation and the cause of its effects. In 1971, Tom Morey, an eccentric surfer in California's Laguna Beach, gave up an engineering career in the Navy to move to Hawaii, where he hoped to build a surf-related business.

On the morning of July 9, he discovered that the waves were perfect on the Honols spot in front of his house in Kailua, but he had no board to take advantage of these waves. Looking for something, he saw an old block of polyethylene foam approximately 9 feet (3 m) long in his garage and pictured a surfer lying down. "I watched the waves, then looked at this piece of foam, and without hesitation, I plugged in an electric knife and cut the foam block in two. At this point, I could not go back. I had to go after my idea. I realized that I could work the foam with a simple iron, provided I placed a newspaper between the iron and the board." Within hours he had made a crude prototype, a 54 inch by 23 inch (140 cm by 60 cm) rectangle shaped like a tombstone with a square bow and rails inclined at 45 degrees. The first bodyboard was born.

Morey brought his prototype across the street and took the plunge. "From the first wave, I knew I had something. I 'felt' the wave through the material in an incredible way. It was unlike anything I had ever experienced surfing. Because of the standing position in surfing, and the volume of the board, you only perceive a fraction of the subtle nuances of the waves. I thought: this thing goes fast, but for it to work perfectly, we have to manufacture them from a durable, light and inexpensive material...It could become a huge success!"

MOREY WAS SO ENTHUSIASTIC THAT HE IMMEDIATELY MADE A SECOND, SMALLER BOARD, WHICH HE SOLD TO A NEIGHBOR FOR $10. "*I NEEDED TO KNOW IF IT COULD SELL. WHEN I SAW THE CURIOSITY IN THE EYES OF MY FIRST CLIENT, I REALIZED THAT THIS WOULD BE THE CASE.*" AT THAT TIME, MOREY WAS A FOLLOWER OF THE BAHA'I FAITH, A RELIGION THAT PROFESSES UNIVERSAL BROTHERHOOD. HE MANAGED TO SCROUNGE $1,000 FROM HIS SPIRITUAL BROTHERS AND PACKED HIS BAGS FOR THE MAINLAND. FIRST IN FLORIDA, THEN IN CALIFORNIA, HE LOOKED FOR PARTNERS. MOREY INITIALLY TEAMED WITH GORDON & SMITH TO DEVELOP THE PRODUCTION OF THE BOARDS. THE FIRST BOARD PRODUCED WAS CALLED S.N.A.K.E. (SIDE NAVEL ARM KNEE ELBOW) IN REFERENCE TO THE BODY PARTS USED IN BODYBOARDING. THE NAME, HOWEVER, DID NOT SOUND RIGHT, AND MOREY, WHO WAS A PASSIONATE FAN OF MUSIC, SOON REPLACED IT WITH BOOGIE.

SOME MAJOR PROBLEMS REMAINED. THE BOARDS LACKED STYLE AND THE RIGHT AMOUNT OF GLIDE, AND THE MATERIAL USED WAS JUST TOO COARSE. ONE DAY, IN THE G&S FACTORY, HE CAME UPON A PILE OF "SKINS," WHICH WERE THE RESULT OF TRIMMING THE FOAM BLOCKS. THESE WERE PERFECTLY SMOOTH AND HE KNEW HE HAD JUST FOUND WHAT WAS MISSING IN THE BOOGIE BOARD: THE "SLICK SKIN," A GLIDING SURFACE IDEALLY SUITED FOR CONTACT WITH A WAVE.

TOM FOUNDED THE MOREY BOOGIE COMPANY AND BEGAN SELLING BOARDS THROUGH AN AD IN SURFING MAGAZINE. DEMAND QUICKLY SOARED. IN 1977, HE SOLD 80,000 OF HIS BODYBOARDS, MAINLY IN THE U.S. MARKET. STYLISH AND AFFORDABLE — FROM $100 FOR THE TOP-OF-THE-LINE BOARD TO $10 FOR A RANGE OF BOARDS SOLD AT THE LOCAL SUPERMARKET — THE MOREY BOOGIE BECAME ALL THE RAGE. WITHOUT FLIPPERS, THEY WERE THE PERFECT TOYS FOR FROLICKING IN THE FOAM. YOU COULD VENTURE WELL BEYOND THE SAND, REGARDLESS OF THE CONDITIONS, TO COMPETE FOR WAVES WITH SURFERS. SOMETIMES YOU COULD EVEN ECLIPSE THOSE UPRIGHT WAVE RIDERS, MOST NOTABLY ON THE FEARSOME WAVES AT THE EDGE OF THE SHORE BREAK. THE BRAND'S LEGENDARY MACH 7-7 CAME TO EUROPE AND FOUND GREAT SUCCESS ON THE BEACHES OF FRANCE, GREAT BRITAIN AND PORTUGAL, COUNTRIES IN TUNE WITH THE OCEAN BUT WHOSE "BEACH CULTURE" WAS STILL IN ITS INFANCY AT THAT TIME.

DESPITE THIS SUCCESS, TOM MOREY WAS NOT A CEO. HE WAS PRIMARILY A SURFER FULL OF DESIGN IDEAS. VERY QUICKLY, HE SOLD HIS COMPANY TO TOY GIANT KRANSCO, WHICH ENSURED A RAPID AND STEADY DEVELOPMENT OF

THE BODYBOARD. THIRTY YEARS AFTER ITS INVENTION, IT IS ESTIMATED THAT NEARLY TWO MILLION BODYBOARDS UNDER A VARIETY OF BRANDS HAVE BEEN SOLD WORLDWIDE. IN THE EARLY 2000S, THE NUMBER OF BODYBOARDS IN CIRCULATION WAS FOUR TIMES GREATER THAN THE NUMBER OF SURFBOARDS.

IT CAN, THEREFORE, BE CONSIDERED THE MOST POPULAR FORM OF SURFING, A TERM THAT MEANS, IN BOTH ENGLISH AND HAWAIIAN, THE ACT OF RIDING, AND NOT NECESSARILY STANDING, ON A WAVE. THERE ARE NO OTHER MEANS OF TRANSPORTATION THAT TAKE MORE WAVES THAN THE BODYBOARD, A FACT THAT POSES A CERTAIN NUMBER OF PROBLEMS WITHIN THE "WAVE-RIDER" COMMUNITY. TOM MOREY, HOWEVER, DID NOT INVENT THE CONCEPT OF PRONE SURFING, WHICH IS THE PERFECT WAY TO ENJOY THE SPORT. FOR THOUSANDS OF YEARS, POLYNESIANS HAVE RIDDEN WAVES LYING FLAT ON THEIR STOMACHS ON SHORT PLANKS OF WOOD, PALM LEAVES AND WOVEN REEDS, OR ANY OTHER SUPPORT STRONG ENOUGH TO ALLOW THEM TO GLIDE OVER THE OCEAN.

AMONG THE MAIN BOARDS INHERITED FROM ANCIENT HAWAII, THREE STAND OUT: THE *OLO*, A HUGE AND HEAVY SURF BOARD MEASURING 18-24 FEET (5-7 M), WHICH WAS RESERVED FOR *ALI'I*, THE KINGS AND PRINCES OF RANK; THE *ALAIA*, THE MOST COMMON BOARD, WITH AN AVERAGE LENGTH OF 8 FEET (2.50 M); AND FINALLY *PAIPO* OR *KIOE*, THE ANCESTOR OF BODYBOARDING AND POPULAR WITH CHILDREN. MEASURING 2-4 FEET (0.50-1.50 M) LONG, THE *PAIPO* NEVER REALLY WENT OUT OF USE. THESE INSTINCTIVE — SOME WOULD SAY RUDIMENTARY — BOARDS APPEARED, IN VARIOUS FORMS, ON BEACHES AROUND THE WORLD IN COUNTRIES IN AFRICA, SOUTH AMERICA AND ON THE INDIAN OCEAN THAT HAD NOT HAD ANY CONTACT WITH SURFING. IN CALIFORNIA, THEY WERE CALLED *BELLYBOARDS*. IN FRANCE, ON THE BASQUE COAST, THEY APPEARED IN THE FORM OF A PLYWOOD BOARD CURVED AT THE FRONT LIKE A SKI, WHICH WAS CALLED *PLANKY*.

BUT IN THE EARLY 1980S, WHEN WAVES AROUND THE WORLD WERE FILLED WITH BODYBOARDERS WHO WERE FOR THE MOST PART BEGINNERS, RESENTMENT TOWARDS THIS "NEW" SPORT GREW WITHIN THE SURFING COMMUNITY. MOST SURFERS REGARDED THESE NEWCOMERS AS SECOND-CLASS RIDERS WHO RODE WAVES IN COMPLETE DISREGARD FOR THE BASIC RULES OF PRIORITY. THE SURFERS USED WORDS LIKE "SPONGERS," "CRIPPLES" AND "SPEED BUMPS" TO DESCRIBE THE BODYBOARDERS. INDEED, TOM MOREY'S INVENTION UPSET THE HIERARCHY OF WAVES. BODYBOARDING REVOLUTIONIZED THE ART OF RIDING, MAKING IT MORE ACCESSIBLE, MORE FUN AND LESS DANGEROUS. MANY WILL

NEVER FORGIVE MOREY FOR THIS ATTEMPT AT DEMOCRATIZING THE SPORT OF KINGS. LEARNING TO SURF REQUIRES TIME, MONEY AND A CERTAIN TEMPERAMENT. ONE NEEDS TO SHOW HUMILITY AND PERSEVERANCE, SINCE MASTERING THE BASIC TECHNIQUES OF THIS DIFFICULT SPORT SOMETIMES TAKES YEARS OF PRACTICE. SUDDENLY, YOUR GRANDMOTHER OR YOUR LITTLE COUSIN, WHO HAD NEVER EVEN SEEN THE SEA, COULD EXPERIENCE RIDING A WAVE AFTER ONLY A FEW DAYS OF LEARNING ON A BODYBOARD. FOR MANY SURFERS, THIS DESIRE TO DEMYSTIFY SURFING WAS ALMOST CRIMINAL, AS, IN THEIR VIEW, BODYBOARDERS HAD NOT SACRIFICED ENOUGH TO MERIT THE WONDERFUL WORLD THAT WAS NOW OPEN TO THEM. THEY DID NOT DESERVE IT.

FOR TOM MOREY, IT'S HERE WHERE THE TRUE INTENTION OF HIS INVENTION LIES: TO DO AWAY WITH THE ARISTOCRACY OF THE WAVES. HE WANTED TO MAKE A BOARD FOR MR. AND MRS. REGULAR JOE AND TO LET MORE PEOPLE EXPERIENCE THE INSIGHT SURFERS FEEL WHEN THEY COME IN CONTACT WITH THE OCEAN. BETWEEN 1980 AND 1995, THE SUCCESS OF BODYBOARDING PROPELLED A LARGE NUMBER OF RIDERS ONTO THE WAVES, AND THE PERIOD PROVED TO BE DECISIVE FOR THE BUSINESSES OF SURFING AND COMPETITIVE SURFING, AS BOTH WERE BOOSTED BY THE "DEMOCRATIZATION" OF SURFACE WATER SPORTS AND THE SPIRIT THEY CONVEYED.

MUCH TO THE DISSATISFACTION OF A FEW SURFING SNOBS, BODYBOARDING WAS HERE TO STAY, AND IT WOULD SOON FIND ITS LEGITIMACY IN COMPETITION. THE FIRST PROFESSIONAL EVENT WAS ORGANIZED IN 1979 IN HUNTINGTON BEACH. AT THAT TIME, BODYBOARDING HAD ITS OWN CLEARLY IDENTIFIED ELITE, STARS LIKE BEN SEVERSON, PAT CALDWELL, JACK LINDHOM (NICKNAMED "THE RIPPER"), DANNY KIM AND KEITH SASAKI. AT SANDY BEACH, CALDWELL PULLED OFF THE FIRST EL ROLLO, HITTING THE LIP OF THE WAVE AND BOUNCING OFF IN A PERFECT ARC BEFORE LANDING IN THE FOAM. THE MANEUVER IS COMMON TODAY. AT THAT TIME, HOWEVER, IT WAS A VERITABLE REVOLUTION. BODYBOARDING BECAME ACROBATIC AND AERIAL, WITH THE INVENTION OF THE ARS (AIR ROLL SPIN) THAT COMBINED AN EL ROLLO WITH A 360° SPIN. THAT MOVE WAS CREATED BY MICHAEL EPPELSTUN, WHO WOULD SOON PULL OFF A 720° SPIN IN THE AIR, ALL WHILE SURFERS WERE STILL TRYING TO DO A SIMPLE ROTATION. JACK "THE RIPPER" LINDHOLM POPULARIZED THE DROP-KNEE, A POSTURE THAT CONSISTS OF SURFING THE BODYBOARD WITH ONE FOOT FORWARD WHILE YOU PUSH THE KNEE OF THE OTHER LEG TO THE BACK TO GUIDE THE BOARD. SPECTACULAR AND PHOTOGENIC, BODYBOARDING GAVE RISE TO AN ABUNDANT, SPECIALIZED PRESS WHICH

TENDS TO EMPHASIZE CONTROVERSY TO LEGITIMIZE A HARDCORE SPIRIT AND INCREASE THE OSTRACIZATION THAT EXISTS BETWEEN SURFERS AND BODYBOARDERS.

IT WAS THE BANZAI PIPELINE, WHICH IS THE STANDARD OF WORLD SURFING AND WHICH ALONE CAN MAKE AND UNMAKE REPUTATIONS, THAT ENABLED BODYBOARDING TO GAIN SOME RECOGNITION. A YOUNG, HUNGRY BODYBOARDER NAMED MIKE STEWART LANDED ON BIG ISLAND, WHERE HE WAS APPRENTICED BY TOM MOREY, AND ATTACKED THE REEF OF THE WORLD'S MOST DEMANDING WAVE WITH AN AGGRESSION THAT DEMANDED THE RESPECT OF LOCAL SURFERS, WHO WERE INFAMOUS FOR GIVING NEWCOMERS A HARD TIME. YEAR AFTER YEAR, STEWART HOISTED HIMSELF TO THE TOP OF THE PIPELINE FOOD CHAIN, GOING DEEPER INTO THE PIPE THAN ANYONE BEFORE HIM AND PLACING UNTOLD AERIALS ON SECTIONS OF THE WAVE THAT TERRORIZED SURFERS. HIS RECORD ON THIS LEGENDARY WAVE SPEAKS FOR ITSELF: 11-TIME WINNER OF THE PIPELINE BODYBOARDING CHALLENGE (LATER RENAMED THE MIKE STEWART PIPELINE PRO IN HIS HONOR) AND 11 BODYSURFING TITLES. "*THESE 22 PIPELINE VICTORIES COUNT MORE TO ME THAN MY 9 WORLD CHAMPION TITLES,*" HE SAID.

IN BODYBOARDING, THE WIDTH AND DANGEROUSNESS OF THE WAVES HAVE ALWAYS TAKEN PRECEDENCE OVER THEIR SHEER SIZE. IN 1989, STEWART WAS THE FIRST FOREIGNER TO SURF THE TERRIFYING WAVE OF TEAHUPOO, TAHITI, PAVING THE WAY FOR A DECADE OF SEVERE CHALLENGES ON WAVES LIKE THE BOX, CYCLOPS AND OURS IN AUSTRALIA, ALL OF WHICH SURFERS WOULD BE UNABLE TO MATCH UNTIL THE INVENTION OF TOW-IN SURFING. "*I FIND IT FASCINATING TO FIND MYSELF CONFRONTED WITH MY PROPER FEARS,*" ADMITTED STEWART. "*IF I WAS NOT A BODYBOARDER, I WOULD BE A STUNTMAN, A RACE CAR DRIVER, A MOUNTAINEER... ALL THOSE DISCIPLINES WHERE THE NOTION OF DANGER IS PRESENT.*" AS AN UNDISPUTED MASTER OF BODYBOARDING AND BODYSURFING — BOTH OF WHICH ARE AMONG THE MOST UNDERVALUED AND FINANCIALLY DISADVANTAGED SURFACE WATER SPORTS — STEWART IS NOW A RESPECTED WATERMAN. NEVERTHELESS, HE HAS NOT MANAGED TO CHANGE THE WAY PEOPLE PERCEIVE HIS SPORT, EVEN IF A QUESTION, POSED BY SURFER MAGAZINE IN AN ARTICLE PUBLISHED IN 1999, REMAINS: "IS MIKE STEWART THE BEST SURFER IN THE WORLD?" FOR MANY, ESPECIALLY THOSE WHO SAW HIM IN A STATE OF GRACE AT PIPELINE OR TEAHUPOO, THE DEBATE IS OPEN.

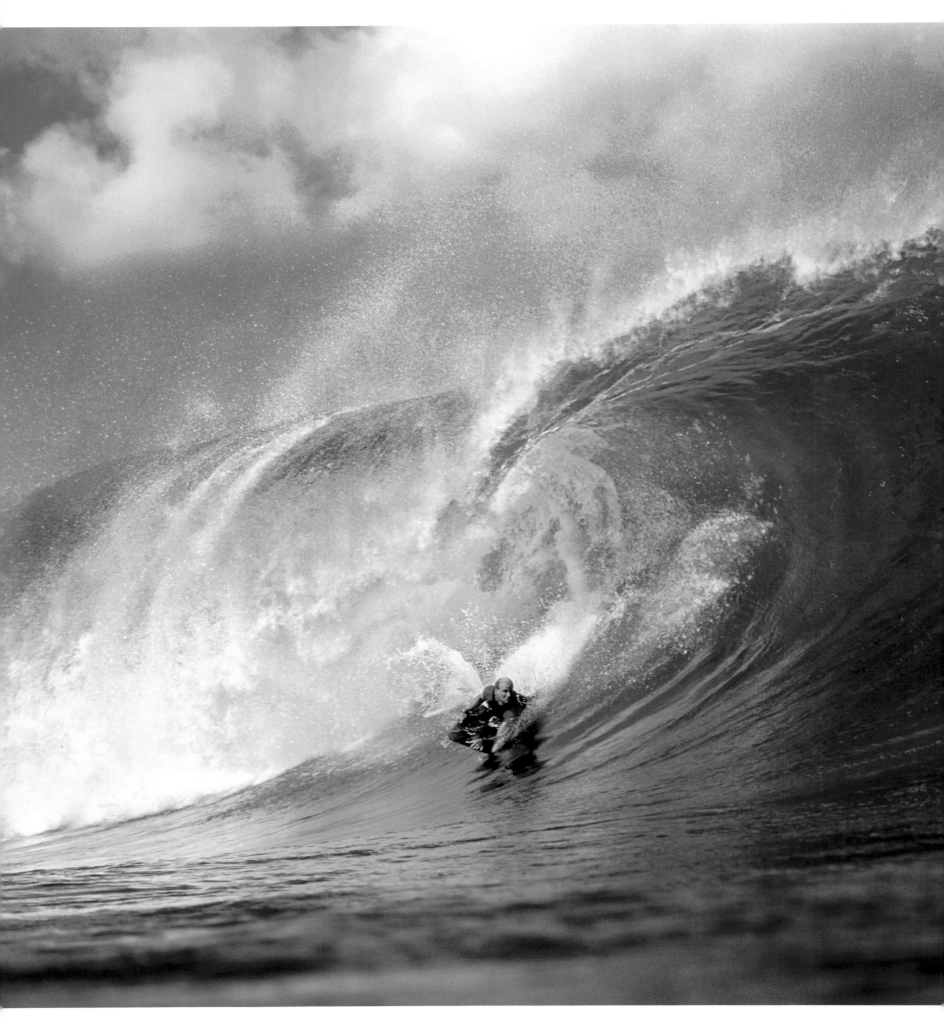

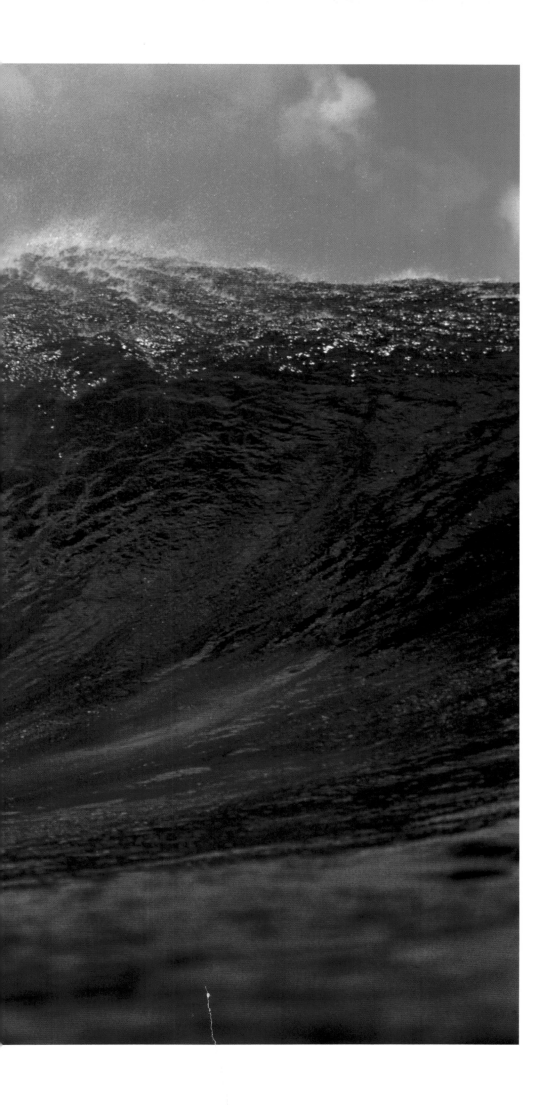

64-65 Hawaiian Mike Stewart, a multiple world champion in bodyboarding and bodysurfing, in a state of grace on "his" wave at Pipeline. His extraordinary performances there earned him the respect of surfers.

66-67 While the tube in surfing is reserved for more experienced surfers, it is much more accessible in bodyboarding, which has sparked antagonism steeped in jealousy between the two tribes.

"IN THE TUBE,
THERE IS MORE THAN AN
ACCELERATION OF TIME,
THERE IS A DENSIFICATION
OF TIME."

JOEL DE ROSNAY,
SCIENTIST AND SURFER

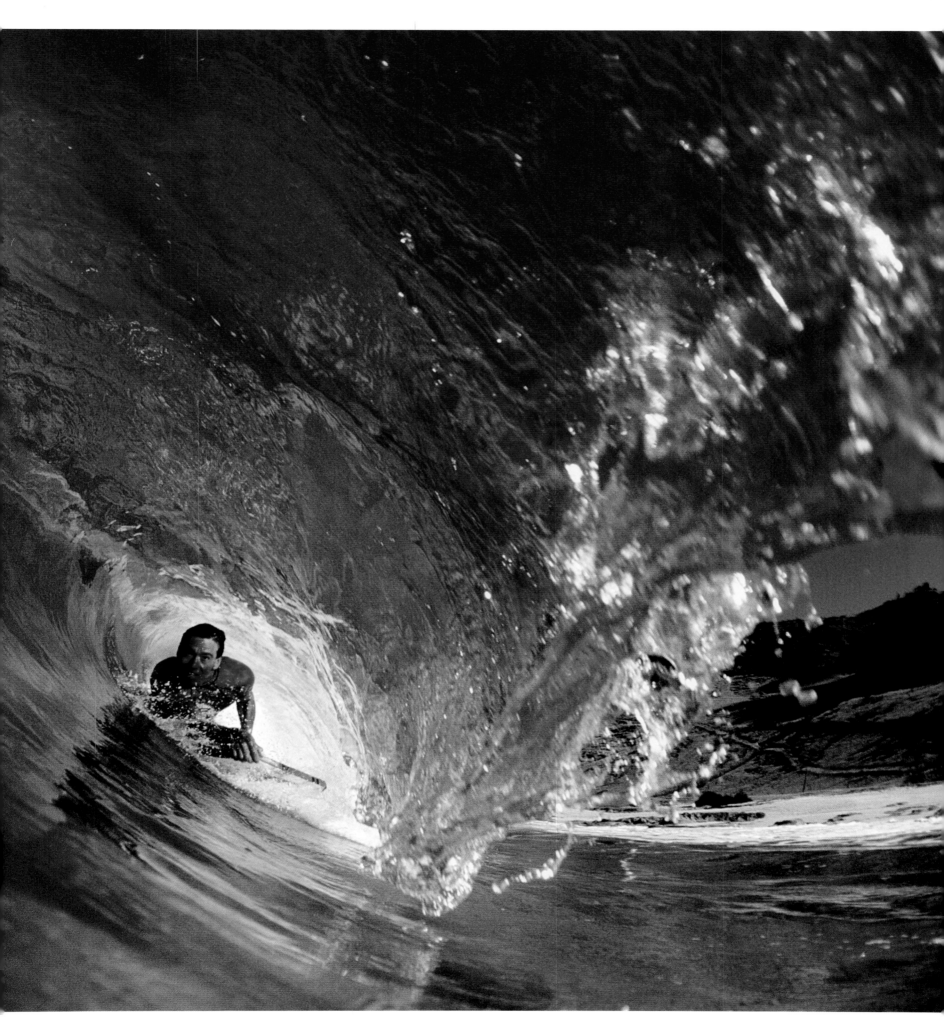

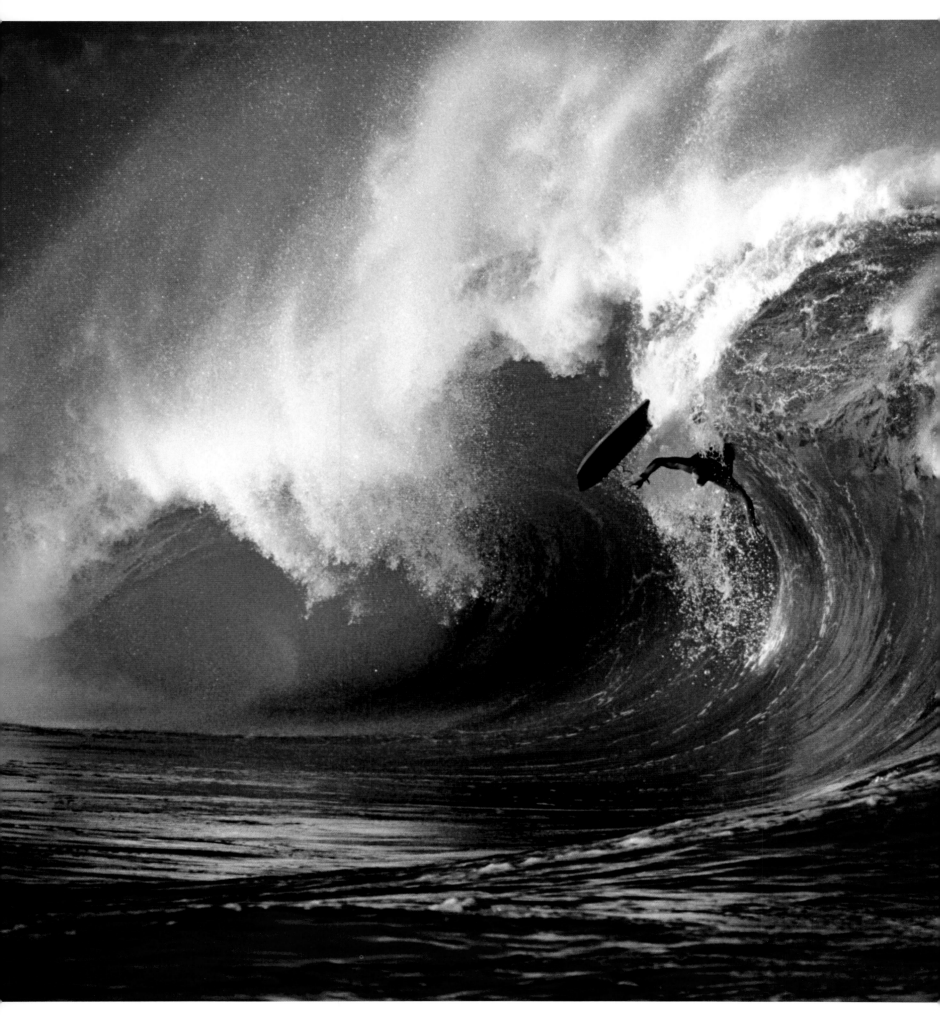

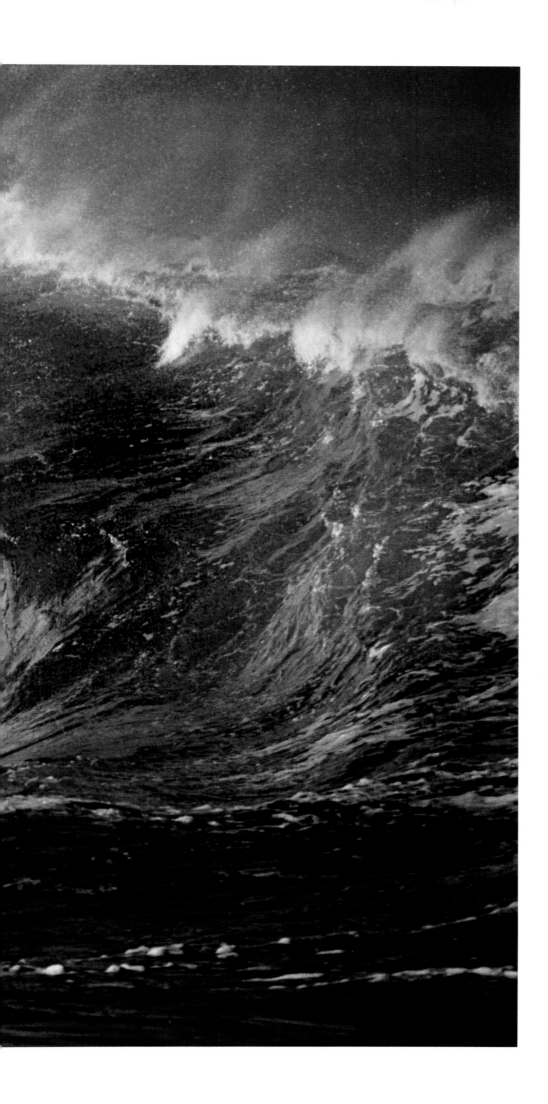

68-69 The ultimate punishment for a bodyboarder on the Waimea Shorebreak, the bottom is only a few inches from the surface.

70 AND **70-71** FREED FROM THE PRESSURE OF HAVING TO STAND UP, BODYBOARDERS ARE ABLE TO FACE THE WAVES "SQUARELY," WHICH IS NOT POSSIBLE FOR MOST SURFERS.

72-73 A POPULAR MOVE IN BODYBOARDING, EL ROLLO MAKES IT POSSIBLE TO BOUNCE ON THE LIP OF THE WAVE TO INITIATE A SPIN BEFORE LANDING IN THE FOAM. NEWPORT BEACH, CALIFORNIA.

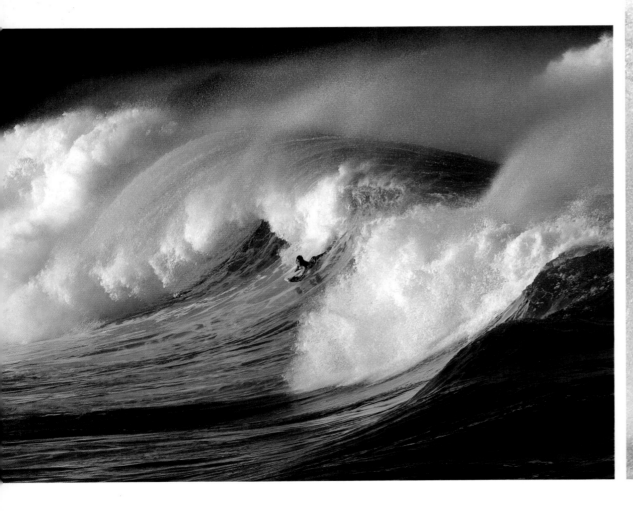

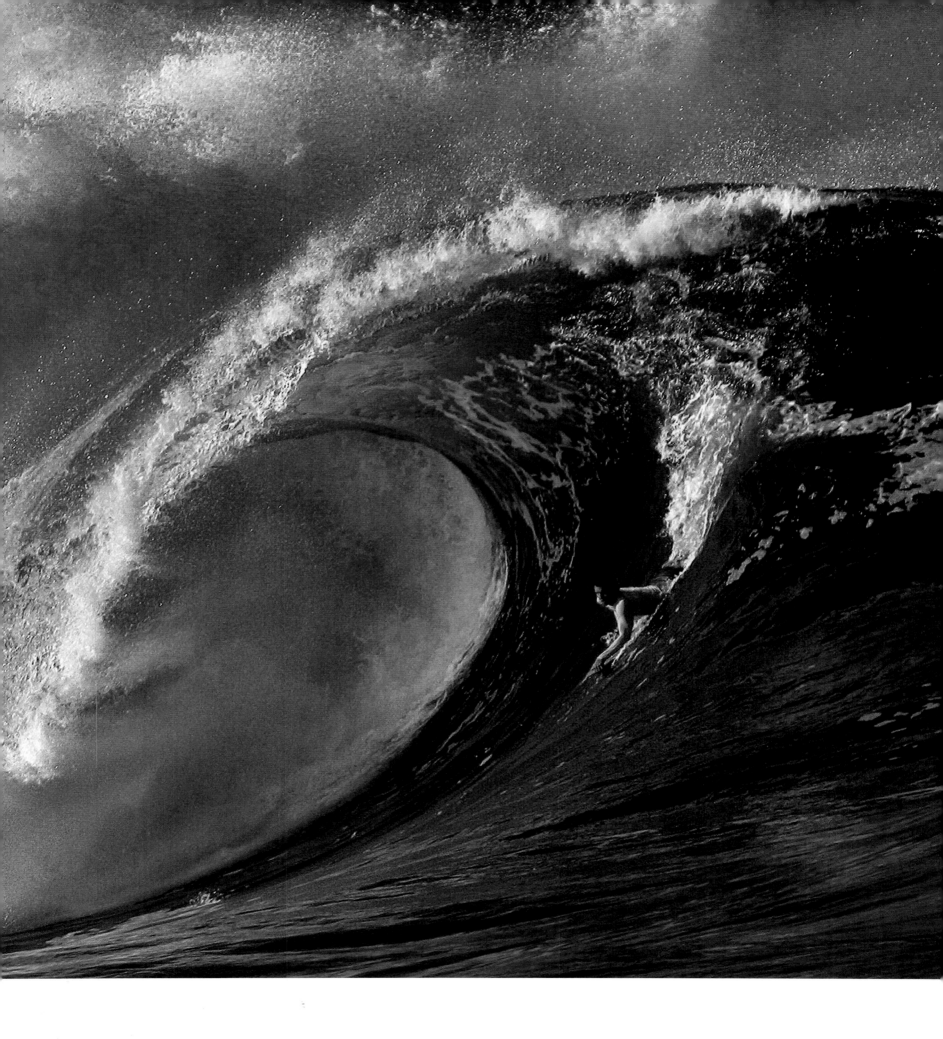

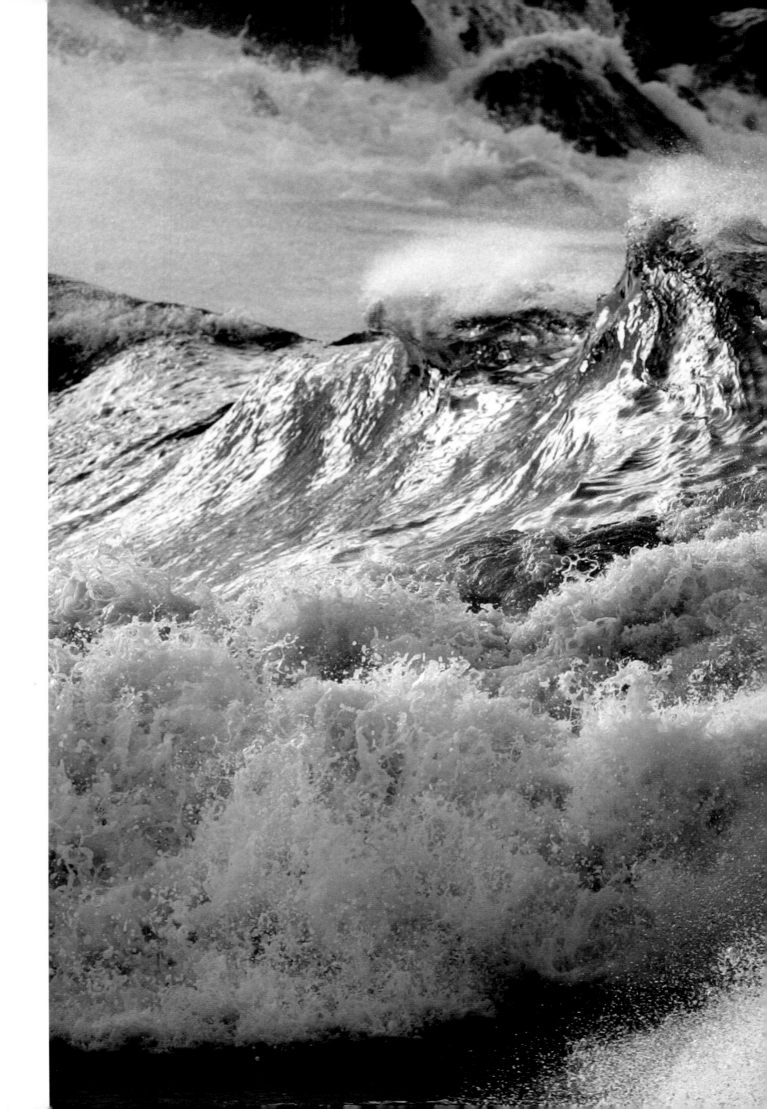

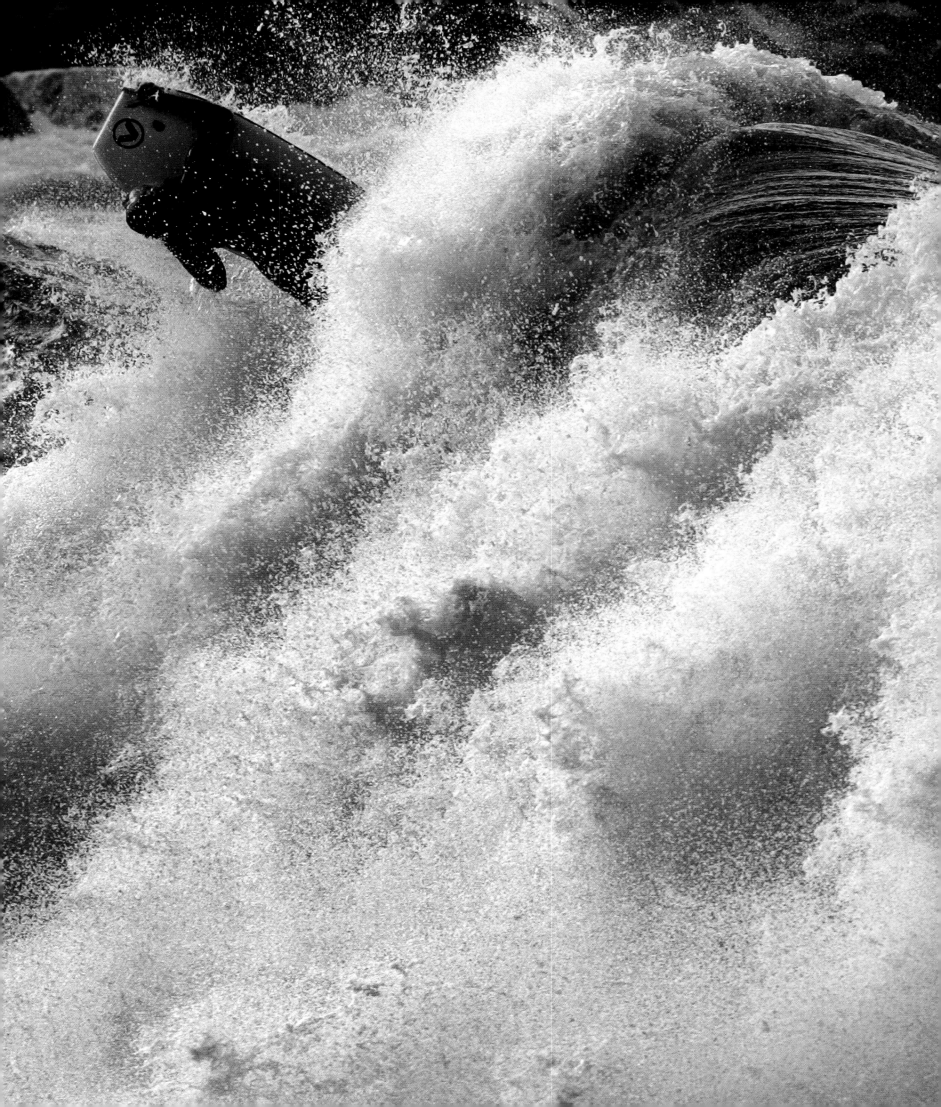

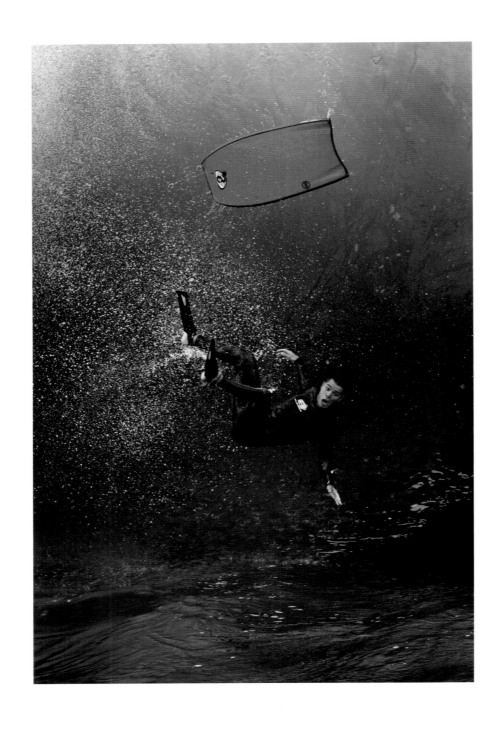

74 No matter what form of aquatic gear you use, a wave can crush you. The ocean makes no distinction between the categories of surfers.

75 A bodyboarder in action on a wave generated by Tropical storm Gordon in the mouth of the Urumea River in the city of San Sebastien, Basque country, Spain.

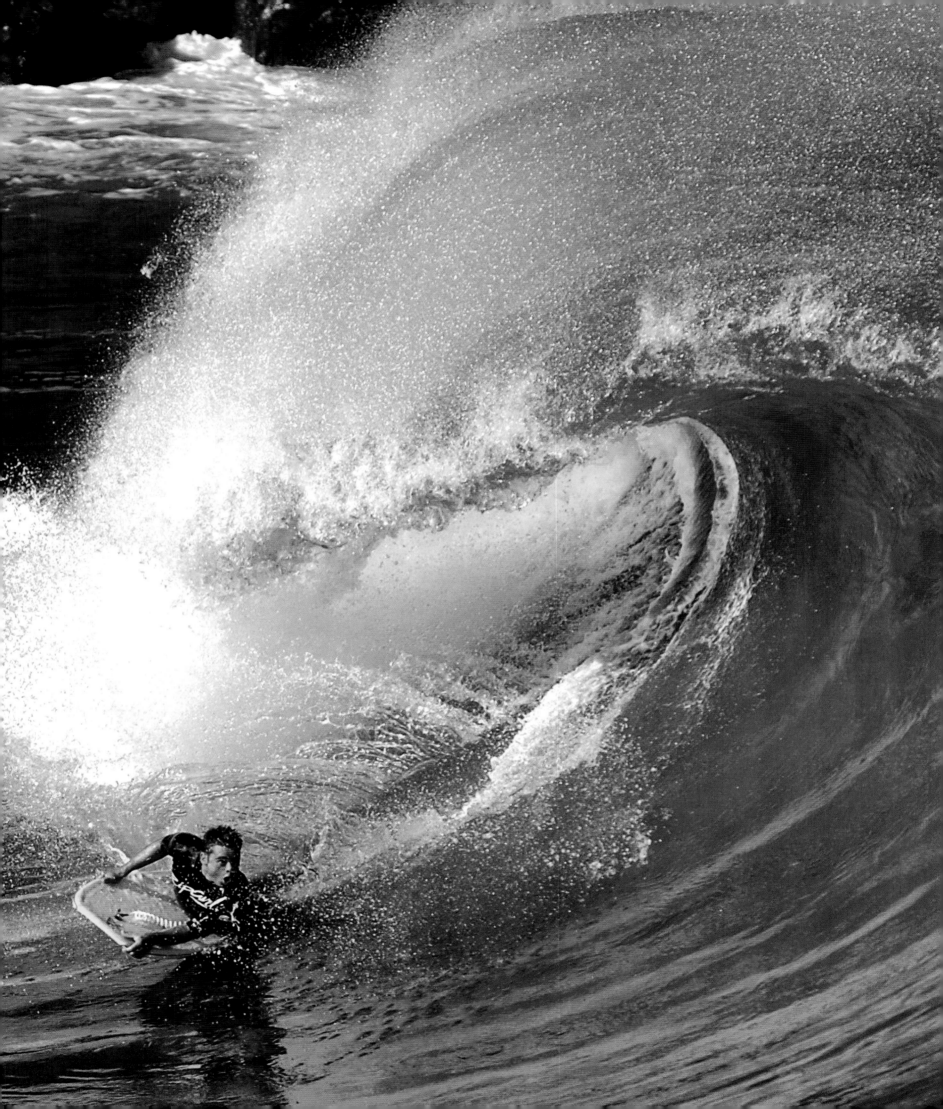

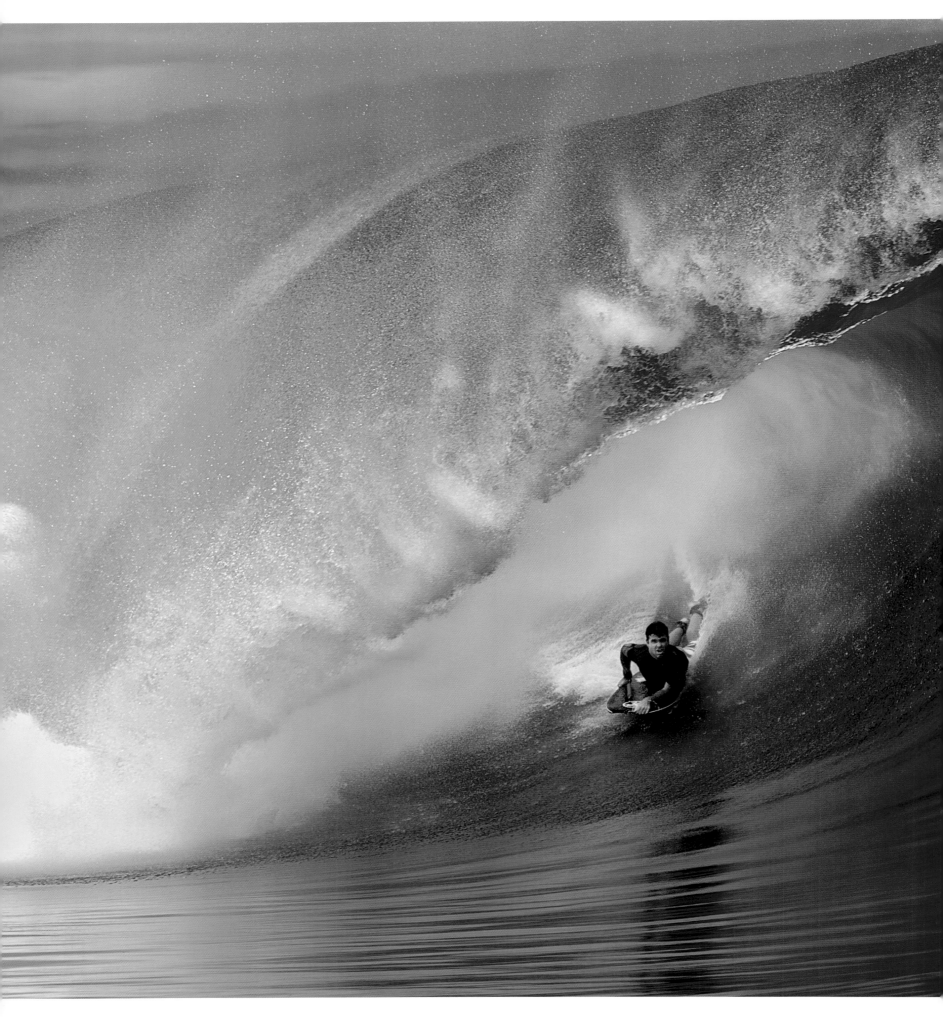

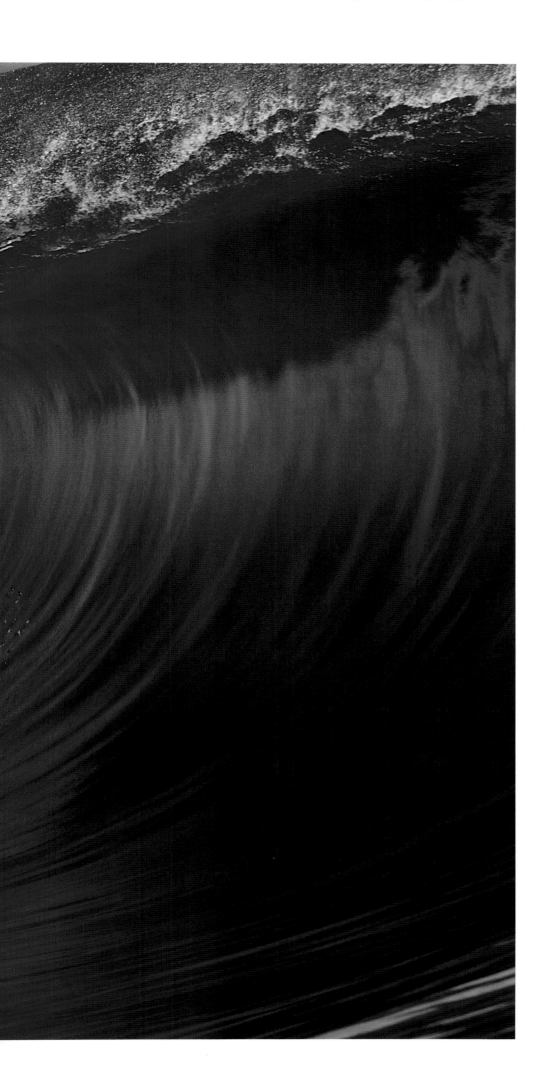

76-77 Many mutant waves like Teahupoo have sometimes been conquered by bodyboarders before surfers. The gauntlet has been thrown down.

78-79 Andre botha in full ARS (air roll spin). This move is as dangerous as it is spectacular.

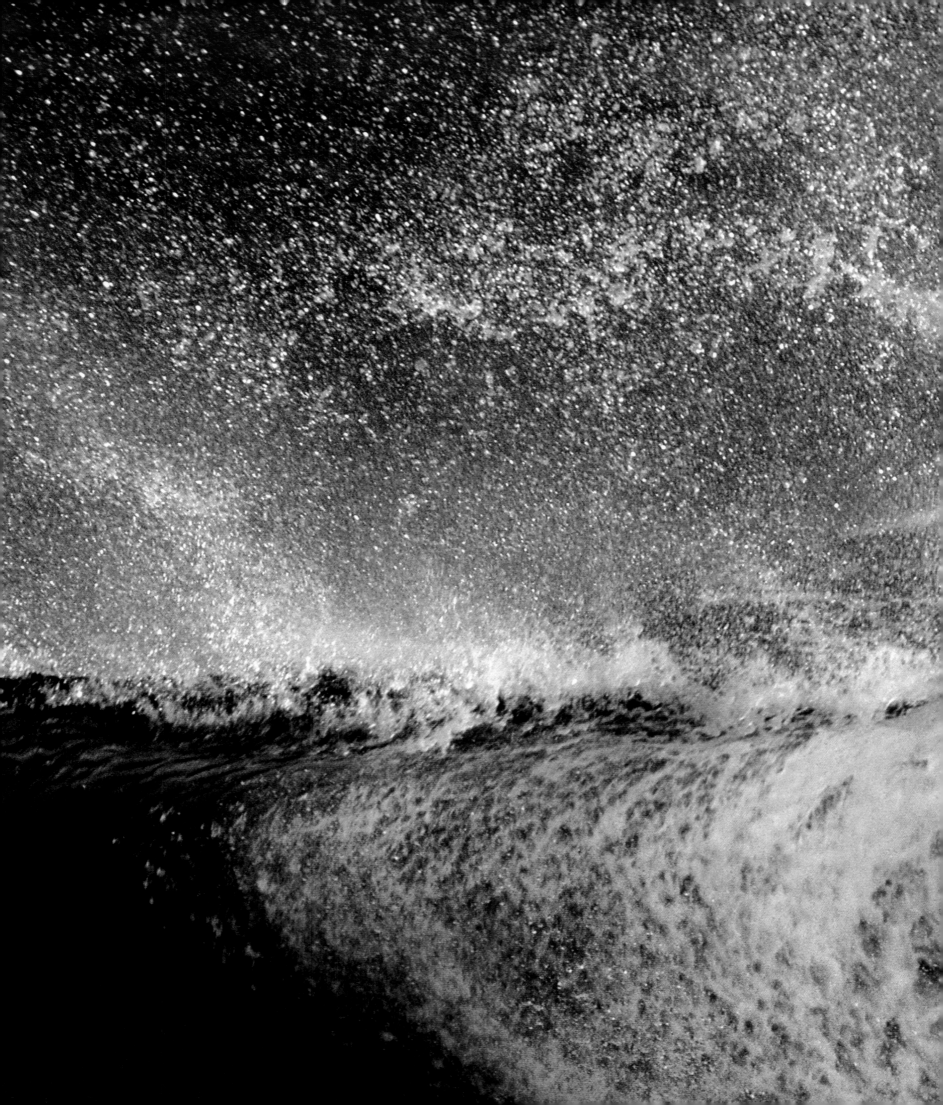

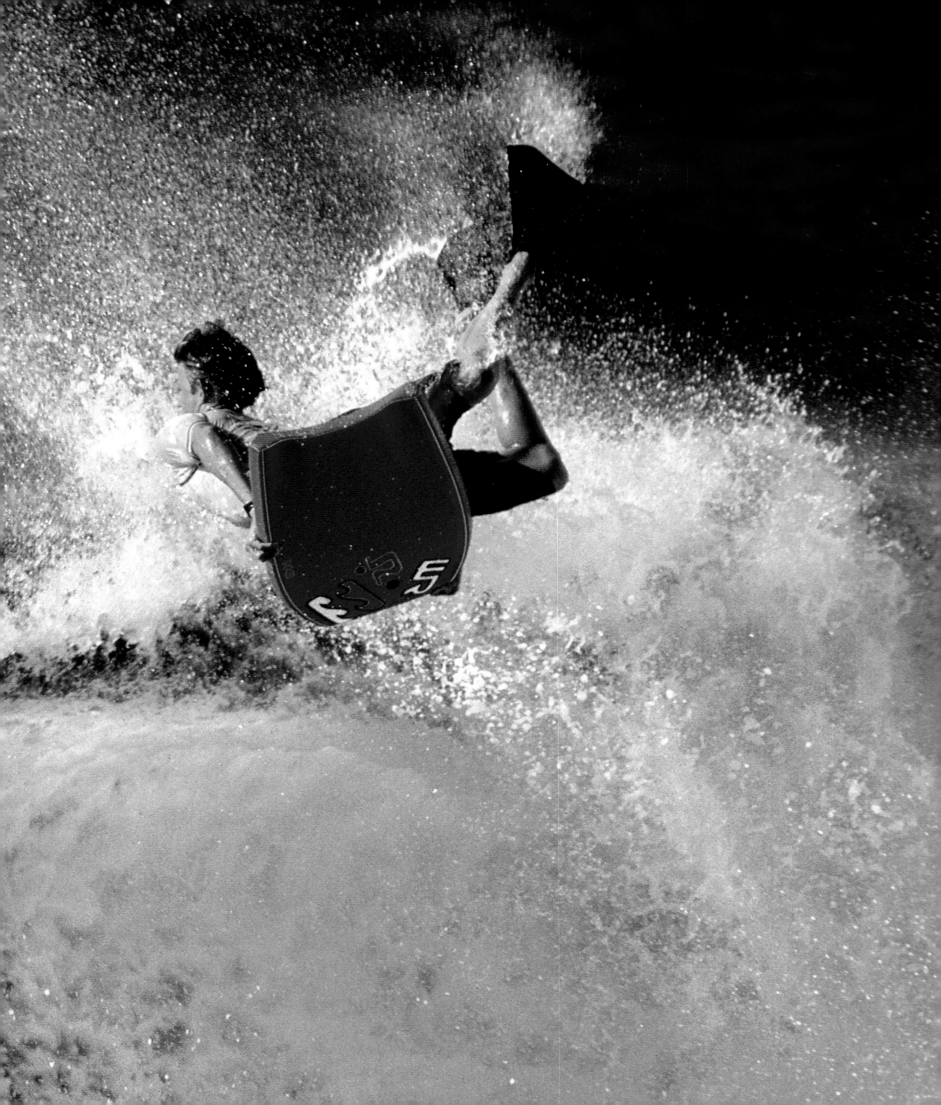

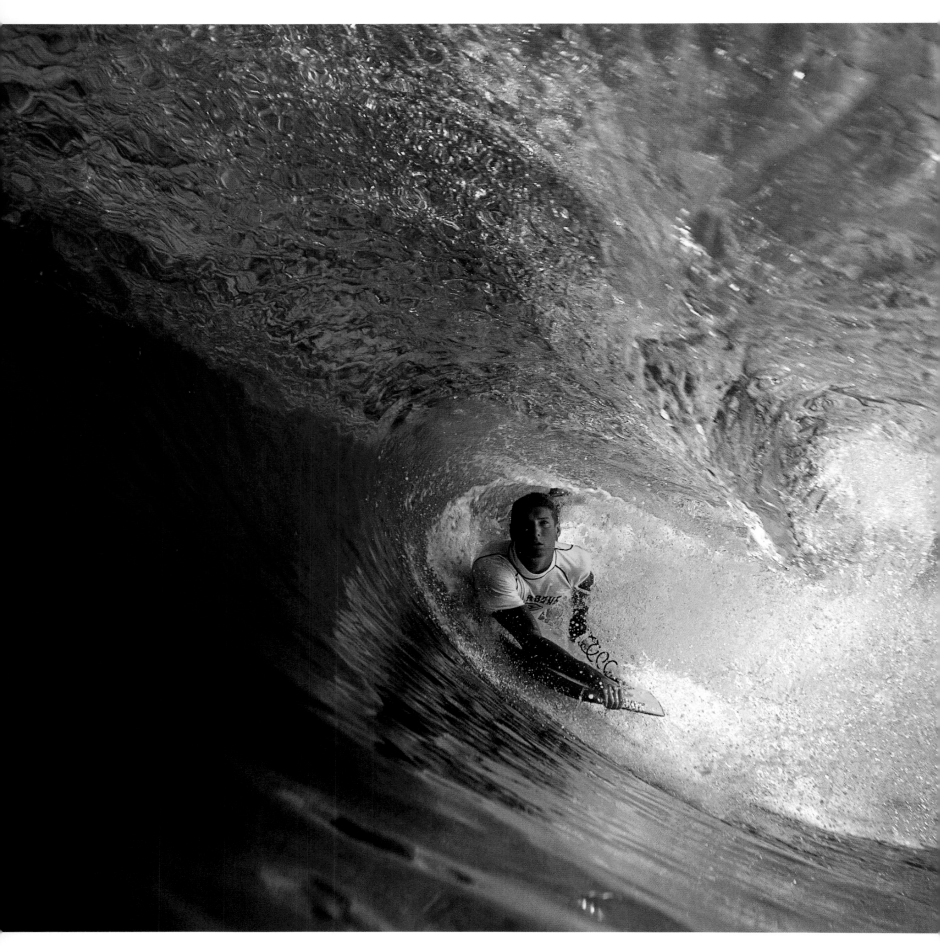

80-81 A lifetime devoted to those few seconds of harmony in the bowels of a wave. More than a maneuver, the tube is a philosophy.

"ART IS NATURE SPED UP
AND GOD SLOWED DOWN."

MALCOLM DE CHAZAL

82-83 The act of starting on a wave is called the Take-Off, just like the taking off of airplanes.

84-85 Sometimes the violence of waves in Europe is just as fierce as those in the Hawaiian reefs. Porthcurno Beach, Cornwall.

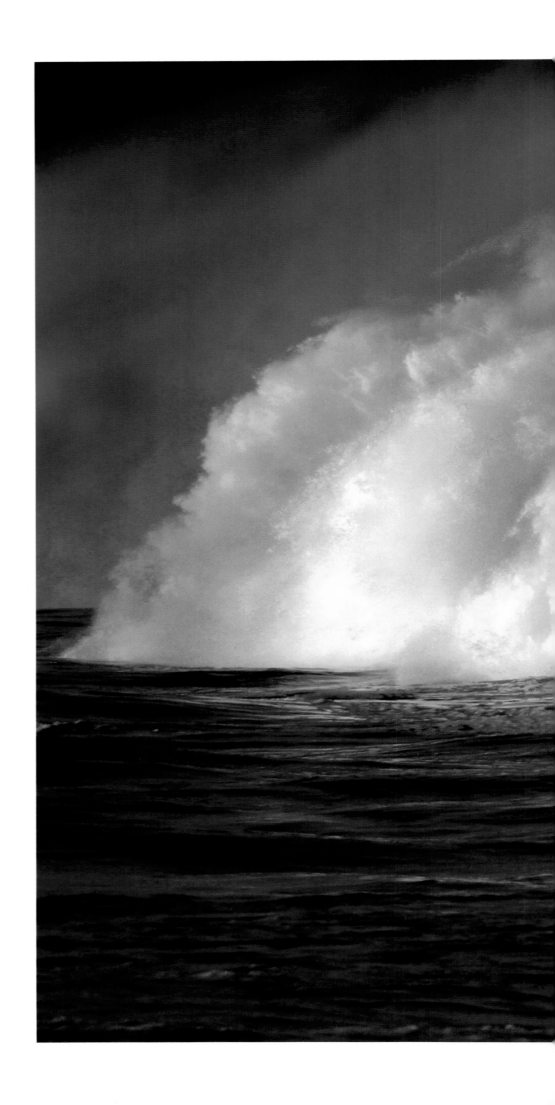

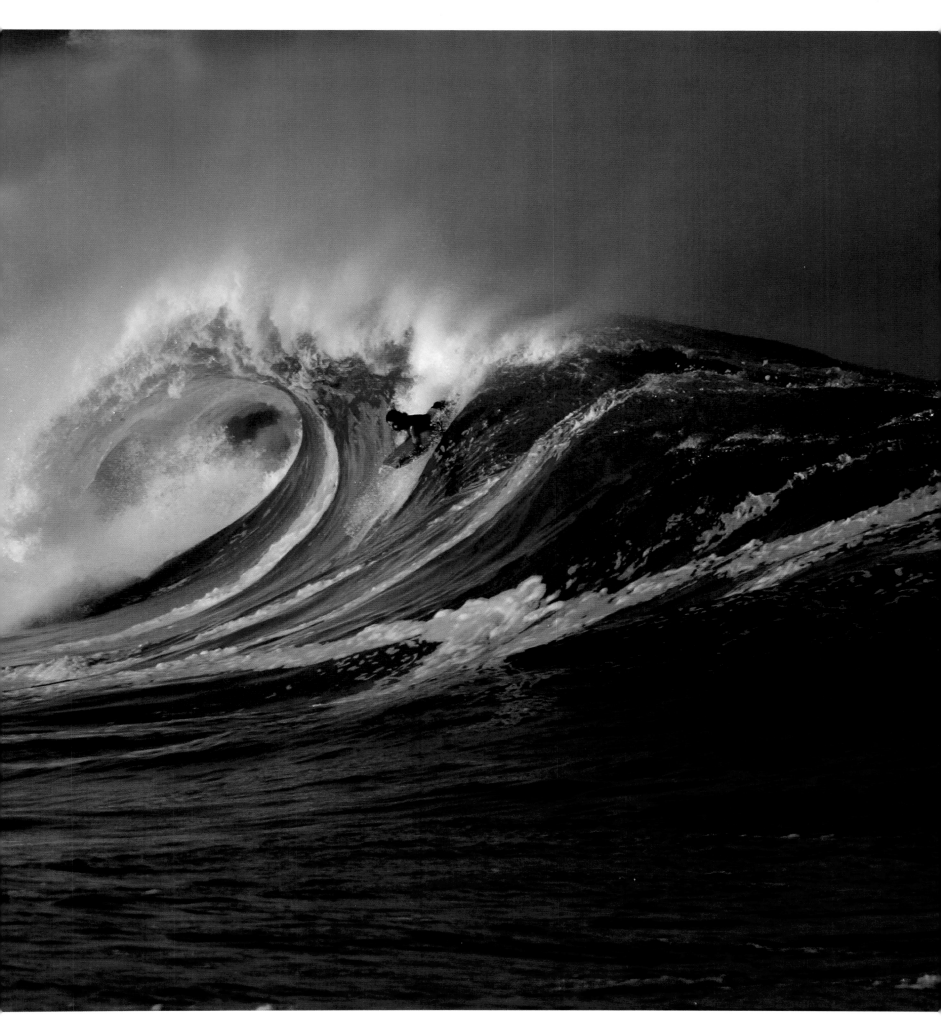

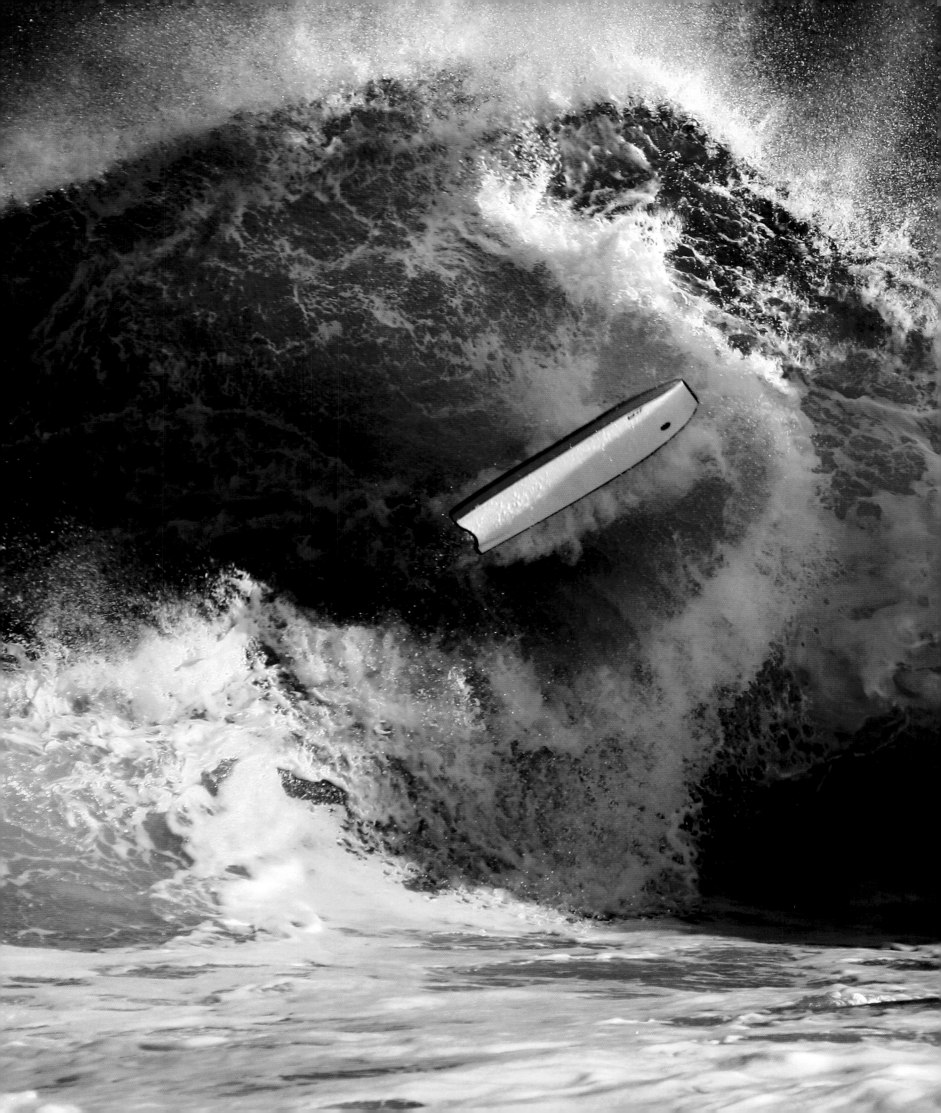

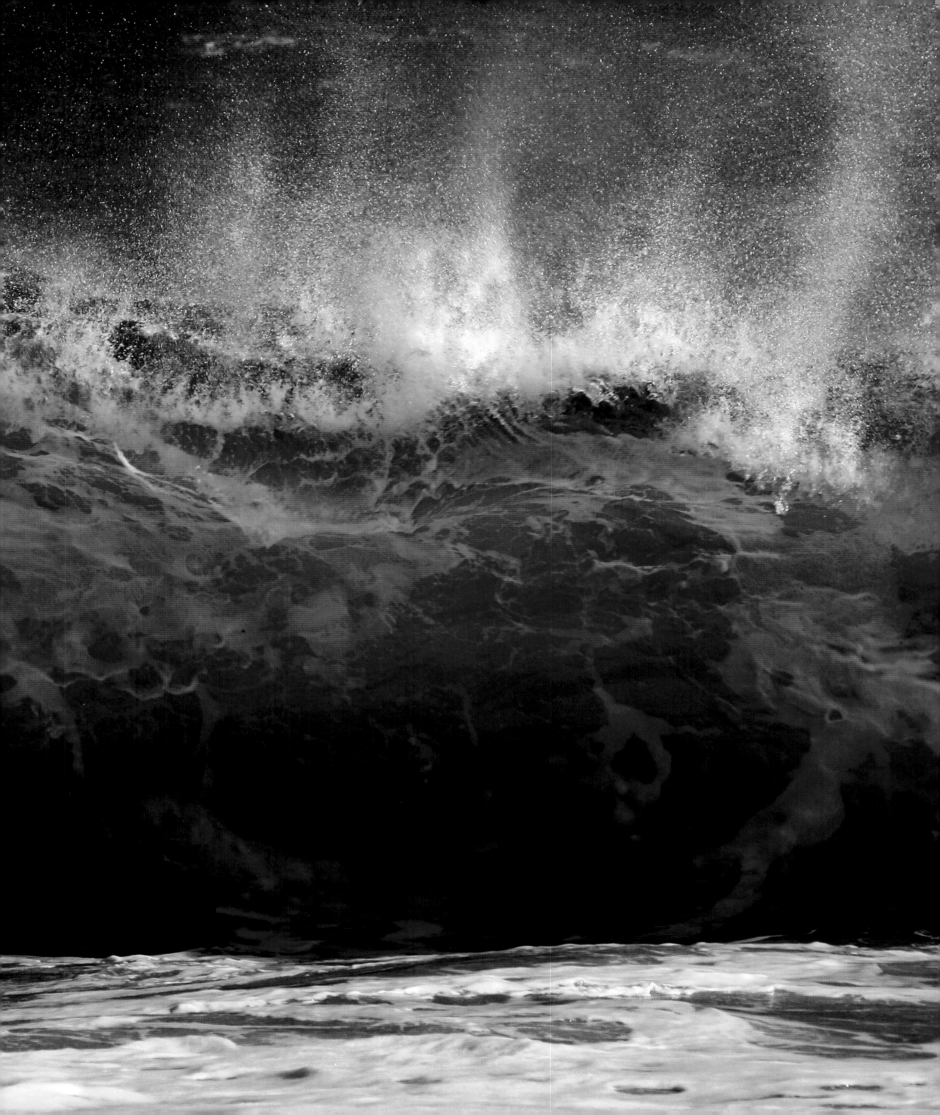

WINDSURFING

"The pessimist complains about the wind, the optimist expects it to change, the realist adjusts the sails."

James Dean

It is a sequence in slow motion, images immediately recognizable as from the 1980s are transformed before our eyes in so many melancholic memories, reminiscences of a golden age that was nothing but a fantasy. Jenna de Rosnay, a blonde bombshell with the body of a goddess, glides on the water in full command of a windsurf that splits the waves. She braces herself on the harness and lowers its sail to graze the surface, then dips her hair a few seconds in the turquoise water before continuing her mad dash — all without regard for the camera. At that time, she embodied the triumph of the sublime natural over the statuesque arrogance of "terrestrial" models. She was the heroine of a decade dedicated to the cult of the body and performance, and she did not have to be glamorous, for she embodied glamour. She held the wind in her hands.

Married at 18, a speed windsurfing world champion at 19, mother at 20 and widowed at 21, she remained faithful to the ocean that took her husband Arnaud in November 1984. Great lovers are always big dreamers. They know how to slow down time, to savor every minute to create a lifetime of thrills. The first windsurfer to successfully cross the Bering Strait alone in 1979, Arnaud de Rosnay liked taking audacious challenges that marked history. The straits fascinated him: Behring, Cuba, Sakhalin, Gibraltar, the English Channel and the Strait of Taiwan, which would prove to be fatal for him. For some, the excessive worldly life of the baron, who traveled in a Rolls, was not compatible with the image of the heroes of the open sea. This dandy could not be the adventurous conqueror of the Marquesas-Tuamotus passage in Polynesia, a feat praised by the great navigator Bernard Moitessier. To those who reproached him for his lifestyle, he replied: "The wind is free." For his long-term goals, though, Arnaud de Rosnay was attempting to reconcile two peoples of the sea: sailors, who are methodical, disciplined and trained, and surfers, who are self-taught, independent and rebellious. This challenge has always been the raison d'etre of windsurfing.

SEVERAL INVENTORS CLAIM PATERNITY OF THIS SPORT, BUT IT IS GENERALLY ACCEPTED THAT THE FIRST SUCCESSFUL SAILBOARD WAS THE WORK OF AN AMERICAN, NEWMAN DARBY. IN MAY 1964, ON A LAKE IN PENNSYLVANIA, HE COBBLED TOGETHER A MAST AND A SAIL ON A FLOAT THAT LOOKED MORE LIKE A DOOR THAN A SURFBOARD. TEN FEET (3 M) LONG AND THREE FEET (1 M) WIDE, IT HAD A MAST RESTING AGAINST A DEPRESSION IN THE BOARD AND WHICH COULD ONLY MOVE LATERALLY. FOR TWO YEARS DARBY REFINED HIS INVENTION BUT WAS UNABLE TO CONVINCE INVESTORS OF THE VIABILITY OF THE PROJECT.

IN 1968, HOYLE SCHWEITZER, AN AVID SURFER FROM CALIFORNIA, AND JIM DRAKE, AN AERONAUTICAL ENGINEER, WERE INSPIRED BY THE UNIVERSAL JOINT IN CARS AND SET OUT TO IMPROVE DARBY'S CONCEPT BY DEVELOPING A UNIVERSAL JOINT SYSTEM THAT ALLOWED RIGGING TO MOVE IN ALL DIRECTIONS. THEY ALSO CREATED THE WISHBONE BOOM, A DOUBLE BOW THAT HELD THE RIGGING AND WHOSE SHAPE RESEMBLED THE BONE FROM WHERE IT GOT ITS NAME. THE SAIL, MEANWHILE, WAS TRIANGULAR AND THE BOARD HAD A REMOVABLE KEEL. THIS WAS THE FIRST SAILING CRAFT THAT DID NOT NEED A RUDDER, AS A SIMPLE MOVEMENT OF THE RIGGING FROM FRONT TO BACK ALLOWED YOU TO STEER IT. THIS MODEL, CALLED THE WINDSURFER, WAS PRESENTED THAT SAME YEAR AT THE LOS ANGELES BOAT SHOW AND BECAME A HUGE ATTRACTION.

SOON, THE CONCEPT WOULD SURFACE ON BODIES OF WATER AROUND THE WORLD, AND IT BECAME THE ABSOLUTE REFERENCE POINT FOR THE NASCENT SPORT. BEGINNERS AND EXPERTS ALIKE WERE USING IT IN ALL SORTS OF CONDITIONS, AND THEY BEGAN TO FORM A CLOSE-KNIT INTERNATIONAL COMMUNITY. SCHWEITZER, WHO BOUGHT THE PATENT RIGHTS BACK FROM DRAKE, BEGAN MASS PRODUCTION OF THE WINDSURFER. AS HE ONLY HAD THE MEANS TO FILE THE PATENT IN TWO EUROPEAN COUNTRIES, HE CHOSE ENGLAND AND GERMANY OVER FRANCE, WHICH WOULD SOON BECOME THE SECOND HOME OF WINDSURFING, PARTICULARLY IN BRITTANY, WHERE MANY MANUFACTURERS TOOK THE WINDSURFER CONCEPT AND CREATED THEIR OWN BRANDS.

ONCE SOLITARY FIGURES, SAILING ENTHUSIASTS BECAME THE HEROES OF A PARTY THAT EVERYONE WAS

INVITED TO. "IN 1976 AND 1977, IT WAS CRAZY IN EUROPE," RECALLED SCHWEITZER, THROUGH WHOM WINDSURFING BECAME A MAINSTREAM SPORT. "IN GERMANY OR FRANCE, ALMOST EVERYBODY HAD A WIND-SURFER IN THEIR GARAGE. PEOPLE WERE ORGANIZING FAMILY OUTINGS ON THE LAKES OR SEA REGATTAS, AND AT LARGE GATHERINGS IT WAS NOT UNCOMMON TO SEE 800 SAIL BOARDS TOGETHER." WINDSURFING WOULD SOON BECOME A POPULAR AND GLOBAL PASTIME. EASY TO HANDLE IN LIGHTS WINDS, IT WAS MUCH SPORTIER IN WINDS OF FORCE 4 AND ABOVE ON THE BEAUFORT SCALE, WHERE THE BOARD WAS CAPABLE OF LIFTING AND GLIDING ON THE SURFACE OF THE WATER. WINDSURFING SHOWED ENORMOUS POTENTIAL FOR DEVELOPMENT, BUT COMPETITIONS TOO OFTEN ASSUMED, IN THEIR SPIRIT AND THEIR ORGANIZATION, THE TRADITIONAL VALUES OF YACHTING. OVERCOMING THIS SLIGHTLY CONDESCENDING ATTITUDE WOULD BE VITAL FOR THE FUTURE OF THE SPORT.

THE YEAR 1977 MARKED A TECHNOLOGICAL TURNING POINT FOR THE SPORT. HAWAIIANS, FRUSTRAT-ED AT NOT BEING ABLE TO MASTER THE POWER OF THE WINDS AND WAVES OF THEIR ISLANDS, WHICH MADE WINDSURFERS UNCONTROLLABLE, HAD THE IDEA TO INSTALL FOOT STRAPS ON THE FLOATS. WITH THIS IN-NOVATION, THEY WERE SOON ABLE TO DRAMATICALLY LIFT THEIR BOARDS SEVERAL FEET ABOVE THE WATER. WINDSURFERS, THOUGH, WERE STILL TOO BULKY AND DIFFICULT TO MANEUVER IN WAVES. AN INTENSE GANG, THE KAILUA KIDS (SO NAMED BECAUSE THEY ARE ALMOST ALL FROM KAILUA, ON THE ISLAND OF OAHU) THEN DECIDED TO DRASTICALLY SHORTEN THE BOARDS AND REMOVE THE CENTRAL KEEL, LEAVING ONLY A FIN AT THE BACK. ALWAYS KEEN TO MAINTAIN CONTROL OF THIS GROWING BUSINESS, SCHWEITZER PRODUCED A "JUMPING" BOARD NAMED "THE ROCKET", WITH FOOT STRAPS AND A MAST THAT WAS PUSHED BACK. ALSO, WITH A NOD TO HOMEMADE SURFBOARDS, STYLING WAS COMPLETELY CUSTOMIZ-ABLE. THIS WAS ALSO THE YEAR OF THE HARNESS, WHICH WOULD SOON BE USED AROUND THE WORLD, AND OF THE CREATION OF WIND MAGAZINE IN FRANCE, WHICH WOULD REDEFINE THE SPORT AND CAP-TURE THE MOOD OF THOSE WHO WISHED TO MOVE IT CLOSER TO THE ORIGINAL SPIRIT OF SURFING BY IN-STILLING A MEASURE OF CRAZINESS IN LOOK AND ATTITUDE. THE FUNBOARD ERA WAS ABOUT TO BEGIN.

WHILE THE APPEARANCE OF FREESTYLE ON THE OLD WINDSURFER BOARDS WAS MORE OF A CIRCUS ACT

THAN A TRUE SPORTS DEVELOPMENT (YOU HAD TO SAIL ON THE EDGE OF THE BOARD, AGAINST THE GRAIN), THE NEW BOARDS COULD BE EDGED WHILE INCLINING (OR "JIBE"), A BIT LIKE A WATER SKIER WHO CUTS AN ARC. THIS TYPE OF TURN DONE BY EDGING IS NOW A BASIC WINDSURFING MANEUVER. VERY QUICKLY, THE BEST OF THE BEST WERE ABLE TO "DIVE" UNDER THE WISHBONE IN THE MIDDLE OF A JIBE, PRODUC-ING AN EFFECT THAT WAS SIMILAR BUT FASTER AND MORE STYLISH: THE DUCK JIBE. ANOTHER ESSENTIAL MOVE IN THE FUNBOARD REPERTOIRE APPEARED IN THE '80S: THE WATERSTART. WHILE IT BEGAN AS A STY-LISTIC TRICK, IT QUICKLY REPLACED THE EXHAUSTING AND DIFFICULT RITUAL OF LIFTING THE SAIL OUT OF THE WATER TO GET IT IN THE WIND.

THESE NEW TECHNIQUES WERE APPLIED TO ALL TYPES OF BOARDS, BUT THEY WERE NECESSARY ON BOARDS THAT WERE TOO LIGHT TO SUPPORT THE WEIGHT OF THE RIDER WHILE STOPPED. THESE BOARDS, IN FACT, WOULD SOON SHED A THIRD OF THEIR LENGTH, GOING FROM 12 FEET (3.5 M) TO 6 FEET-10 INCHES (2 M) IN A FEW MONTHS. IN DOING SO, THEY RECONNECTED WITH THE SPORT'S ANCESTOR, SURF-ING, WHILE GAINING MANEUVERABILITY AND LIGHTNESS. ALSO, THE WISHBONE WAS SHORTENED, THE MAST LENGTHENED AND SAILS WERE DEVELOPED THAT WERE MUCH TALLER, NARROWER AND MORE RECTANGULAR. THIS REVOLUTION WAS TAKING SHAPE ON THE HO'OKIPA SPOT, WHICH BECAME THE WINDSURFING MECCA ON THE ISLAND OF MAUI, HAWAII. A GOLDEN GENERATION STARTED TO SURF REALLY POWERFUL WAVES OR USE THEM AS A SPRINGBOARD. THIS INCLUDED MIKE WALTZ, MARK ANGULO, MIKE ESKIMO AND OF COURSE ROBBY NAISH, WHO HAS SINCE BECOME A LEGEND.

"AT THAT TIME, BETWEEN 1980 AND 1985, THERE WAS SOMETHING NEW COMING OUT EVERY WEEK", SAID NAISH, THE UNDISPUTED KING OF THE SPORT. "IF A TECHNICAL INNOVATION OR MANEUVER HAD THE SLIGHTEST CHANCE OF WORKING, WE TRIED IT IMMEDIATELY. THE COMPETITIVE SPIRIT WAS AMAZING, AND THE OPPORTUNITIES OFFERED BY TECHNOLOGICAL ADVANCES IN EQUIPMENT SEEMED LIMITLESS." IN 1976, AT THE AGE OF THIRTEEN, ROBBY NAISH WON THE FIRST UNIFIED WORLD CHAMPIONSHIP IN HISTORY, AND HE WOULD END UP WINNING OVER TWENTY TITLES IN HIS CAREER IN DIFFERENT FUNBOARD SPECIALTIES: WAVE, SLALOM AND RACING. AS AN AMATEUR, HE WON THE WORLD CHAMPIONSHIP FROM 1977 TO 1979, AND

IN THE PROFESSIONAL ERA HE WAS CROWNED WORLD CHAMPION OF ALL CATEGORIES FROM 1983 TO 1987. PUT SIMPLY, HE WAS THE KING OF THE WAVES IN THE '80S, AND HE WOULD EVENTUALLY WIN THREE WORLD TITLES IN 1988, 1989 AND 1991, THANKS IN PART TO SOME OF HIS OWN INVENTIONS, LIKE THE "FORWARD LOOP," A FORWARD SOMERSAULT THAT LEFT A LASTING IMPRESSION. "*AT THE TIME, IT WAS SAID THAT A WINDSURFER WAS A GUY WHO SLEPT IN HIS VAN, AND A PRO WINDSURFER WAS THE SAME THING EXCEPT THAT THE VAN COULD START! BUT SOME OF US HAVE BEGUN TO EARN BIG MONEY. AT SYLT IN GERMANY OR THE TORCH IN FRANCE, THE COMPETITION GATHERED TENS OF THOUSANDS OF SPECTATORS. WE WERE THE KINGS OF THE WORLD.*"

IN ADDITION TO THE PRESTIGIOUS WORLD CUP CIRCUIT, WINDSURFING WAS RECOGNIZED AS AN OLYMPIC SPORT FOR THE LOS ANGELES GAMES IN 1984. TWO YEARS LATER, FRENCHMAN PASCAL MAKA WAS THE FIRST WINDSURFER TO BEAT A SPEED SAILING RECORD WITH A SPEED OF 38.86 KNOTS OR 45 MPH (71.96 KM/H). EXCELLENCE IN COMPETITION, HOWEVER, WOULD SOON BE DIMINISHED, AS A NEW PHILOSOPHY IN WINDSURFING TOOK HOLD, ONE THAT SOUGHT TO REPLACE COMPETITION WITH THE SIMPLE PLEASURE OF NAVIGATION AND ACHIEVEMENT. MOST NATIONAL SAILING FEDERATIONS WERE INCAPABLE OF UNDERSTANDING THIS SHIFT IN MENTALITY, AND IT LED TO THE MARGINALIZATION OF ELITE, HARDLINER WINDSURFERS.

MEANWHILE, BJÖRN DUNKERBECK, A WINDSURFER OF DUTCH ORIGIN, MONOPOLIZED THE PODIUM, WINNING A RECORD 34 TITLES IN DIFFERENT DISCIPLINES. IN 1990, THE FIRST INDOOR COMPETITION WAS ORGANIZED IN THE PALAIS OMNISPORTS DE PARIS-BERCY, BUT THIS SEEMINGLY LARGE EVENT WAS JUST A FACADE. IN LESS THAN TEN YEARS, GLOBAL SALES OF WINDSURFERS HAD HALVED. THE EXPLOSION OF WINDSURFERS ON THE WAVES RUSHED THE SPORT'S DEVELOPMENT AND IT WAS UNABLE TO CATCH UP. WITH THE INVENTION OF KITE SURFING AND THE EVER-PRESENT GLOBAL CRAZE FOR REGULAR SURFING, THE SPORT STRUGGLED TO FIND NEW FOLLOWERS. NEVERTHELESS, IT IS STILL PRACTICED BY NEARLY TWO MILLION PEOPLE AROUND THE WORLD AND, ACCORDING TO ROBBY NAISH, HIMSELF "*HAS NOT YET SAID ITS LAST WORD.*" YOU HAVE BEEN WARNED.

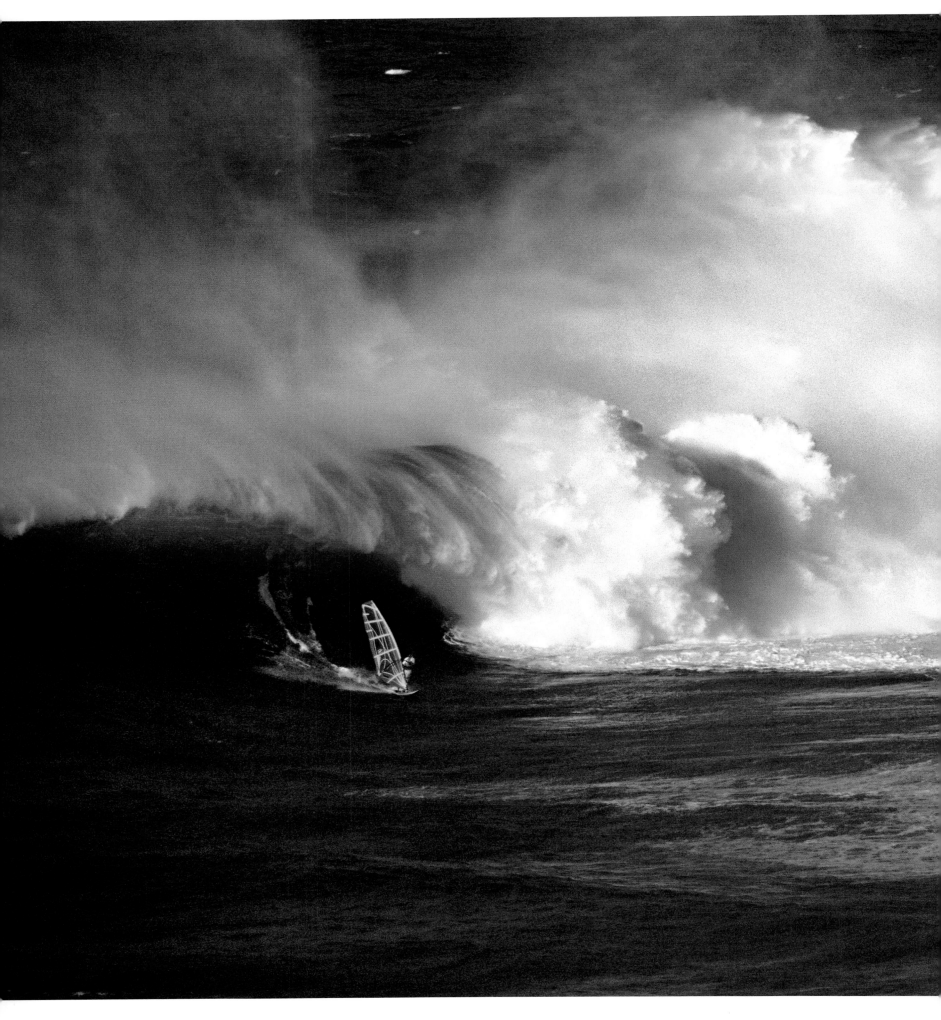

92-93 It was the windsurfers who, thanks to the speed generated by the wind, first conquered the impossible-to-surf liquid summits. Jaws, Maui.

94-95 While the bottom-turn is the most basic maneuver in surfing, it requires precise technical skill in windsurfing. Penalties are immediate and severe.

96-97 and 97 After conquering the air in the 1980s, windsurfing led to the funboard, which had no limitations outside those of the rider.

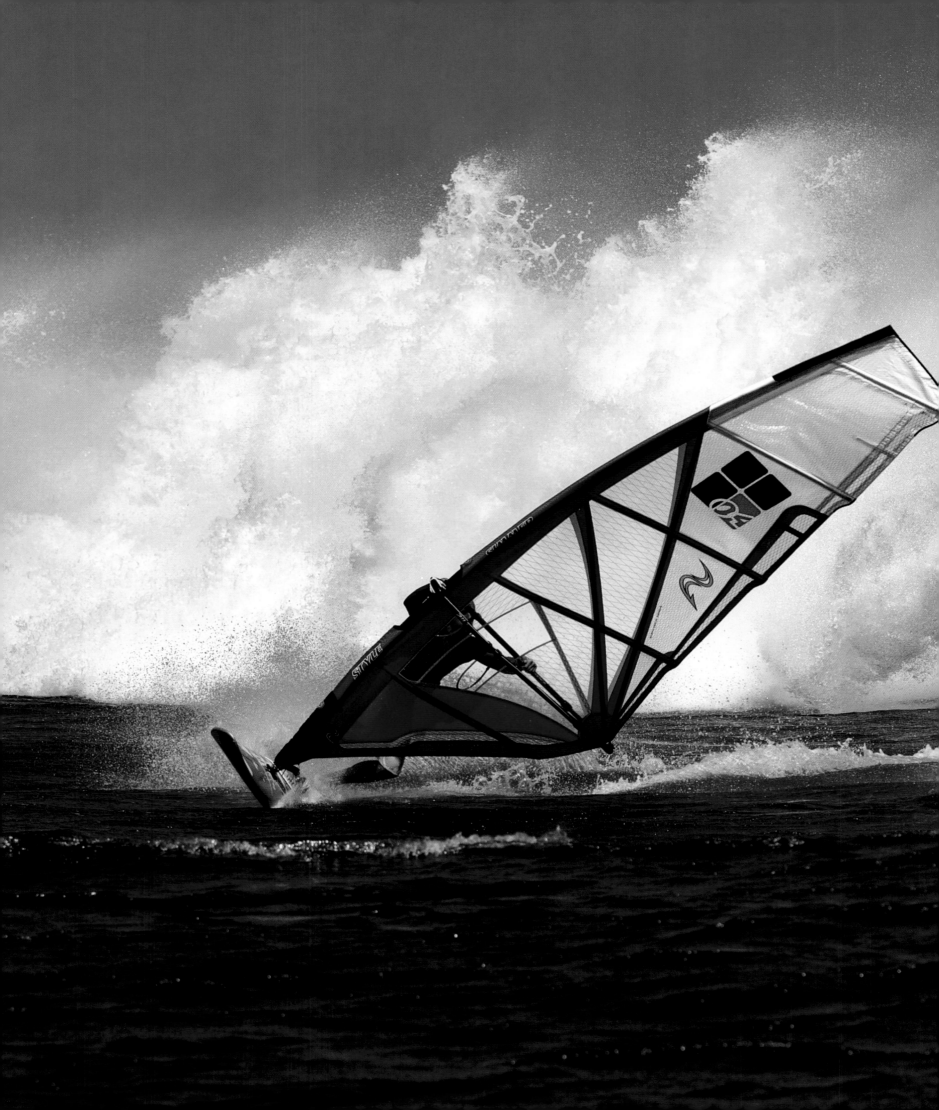

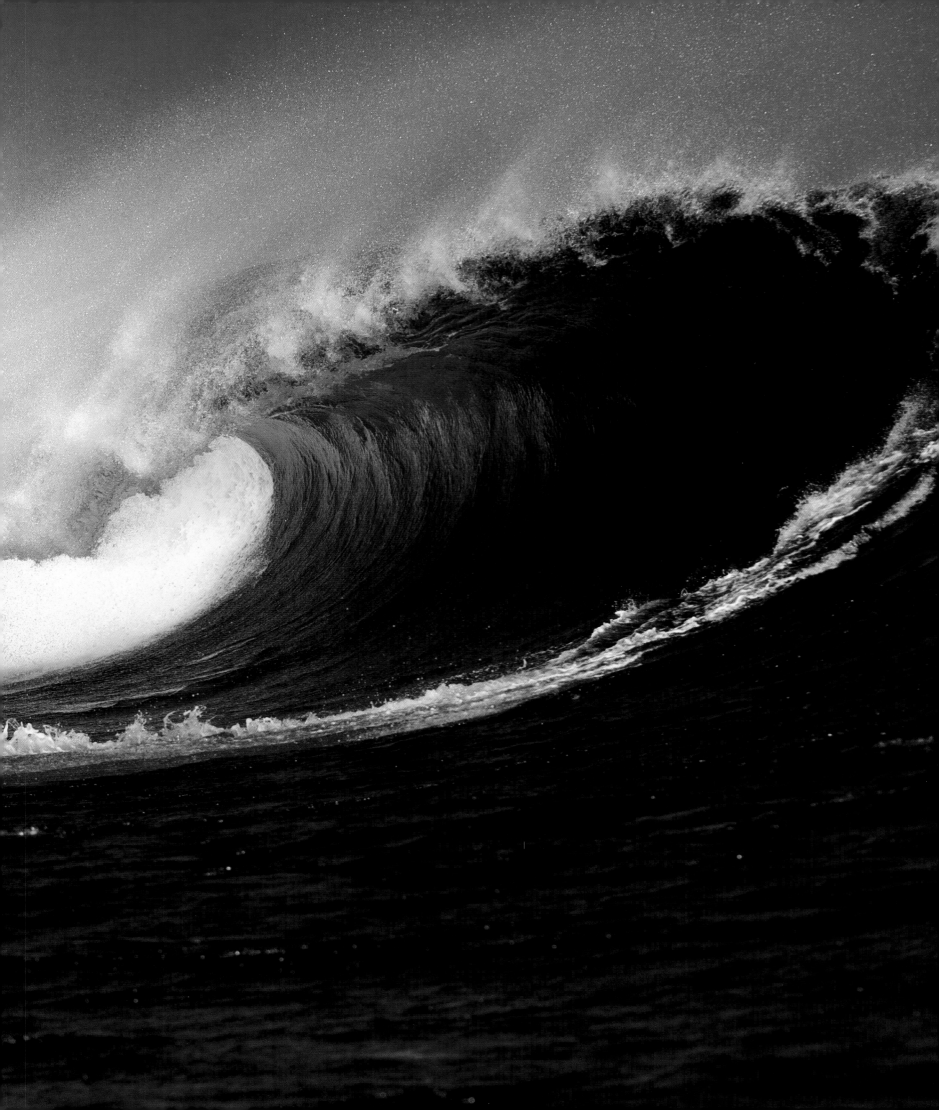

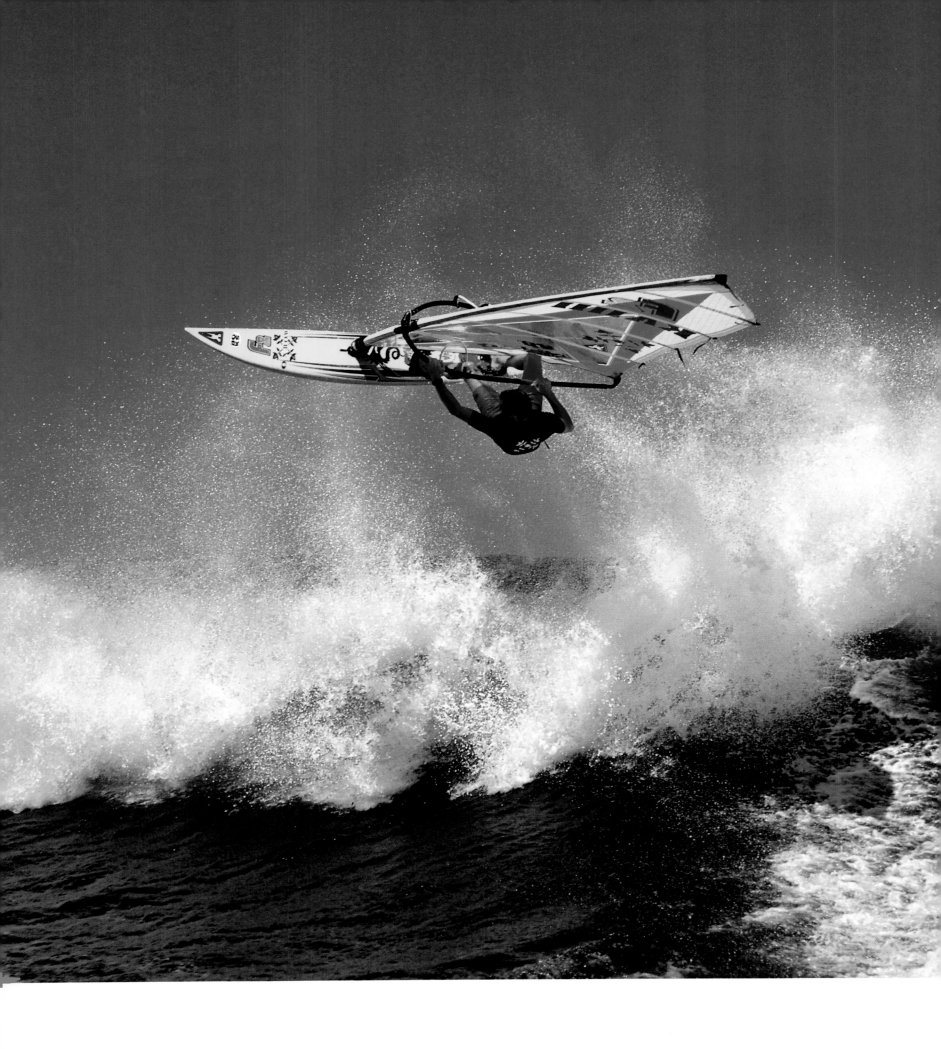

"You want to be free of all the things
that tie you back — routine, authority,
boredom, gravity. What you haven't realized
is that you're already free, and you
always have been."

Richard Bach,
Illusions: The Adventures of a Reluctant Messiah

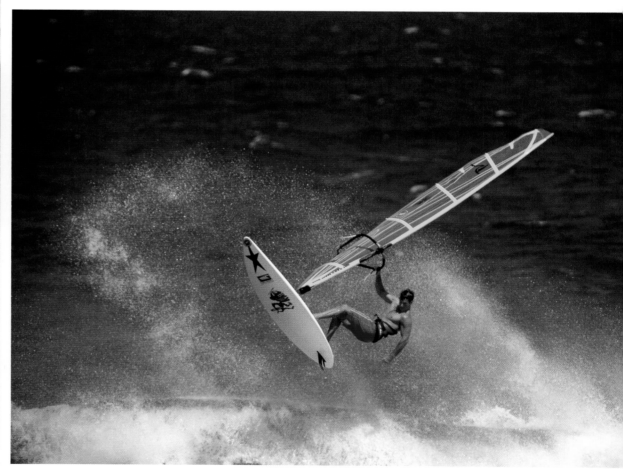

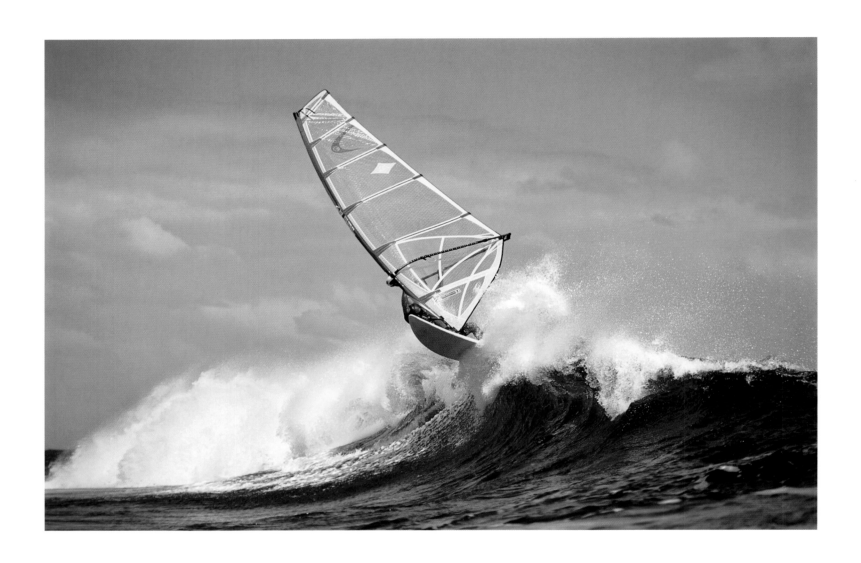

98 Whether navigating towards the sea or surfing near the beach, in windsurfing the waves form a natural springboard.

99 If the foam is about to devour you, hang on to the sail or the mast with all your strength.... and take a deep breath.

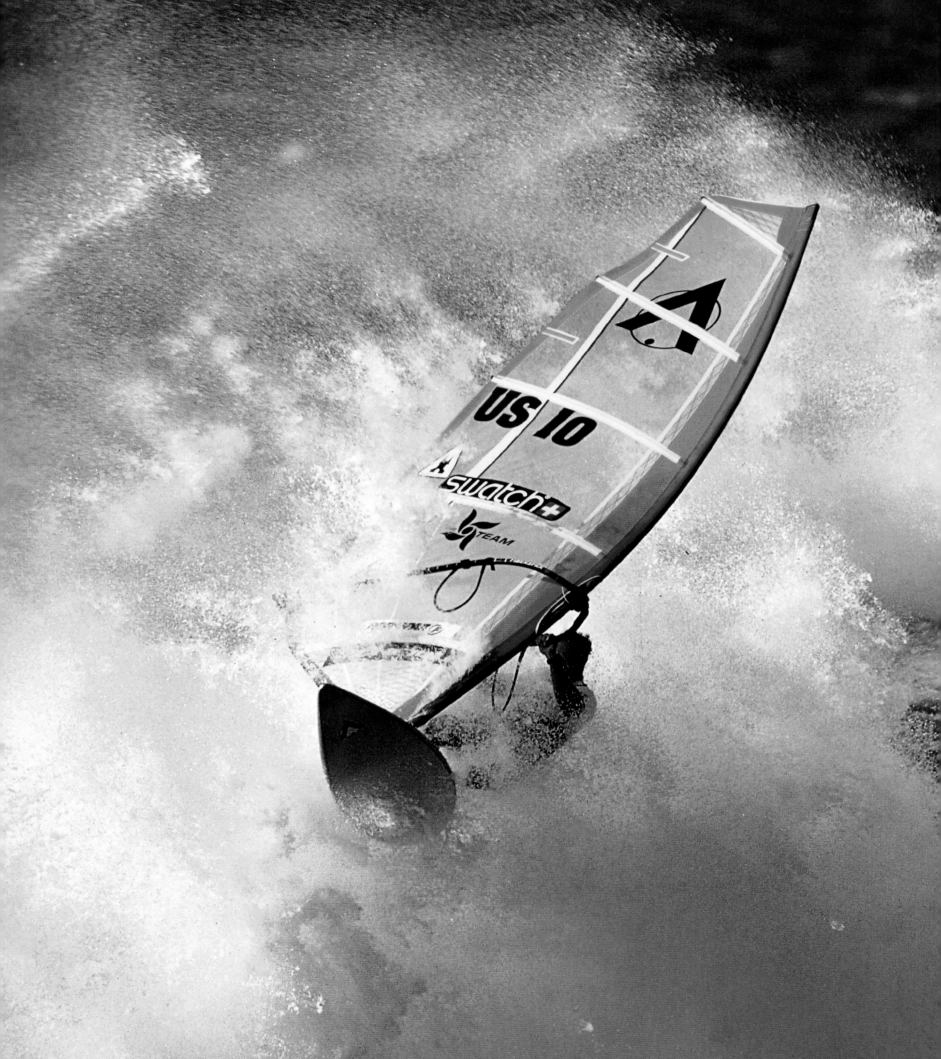

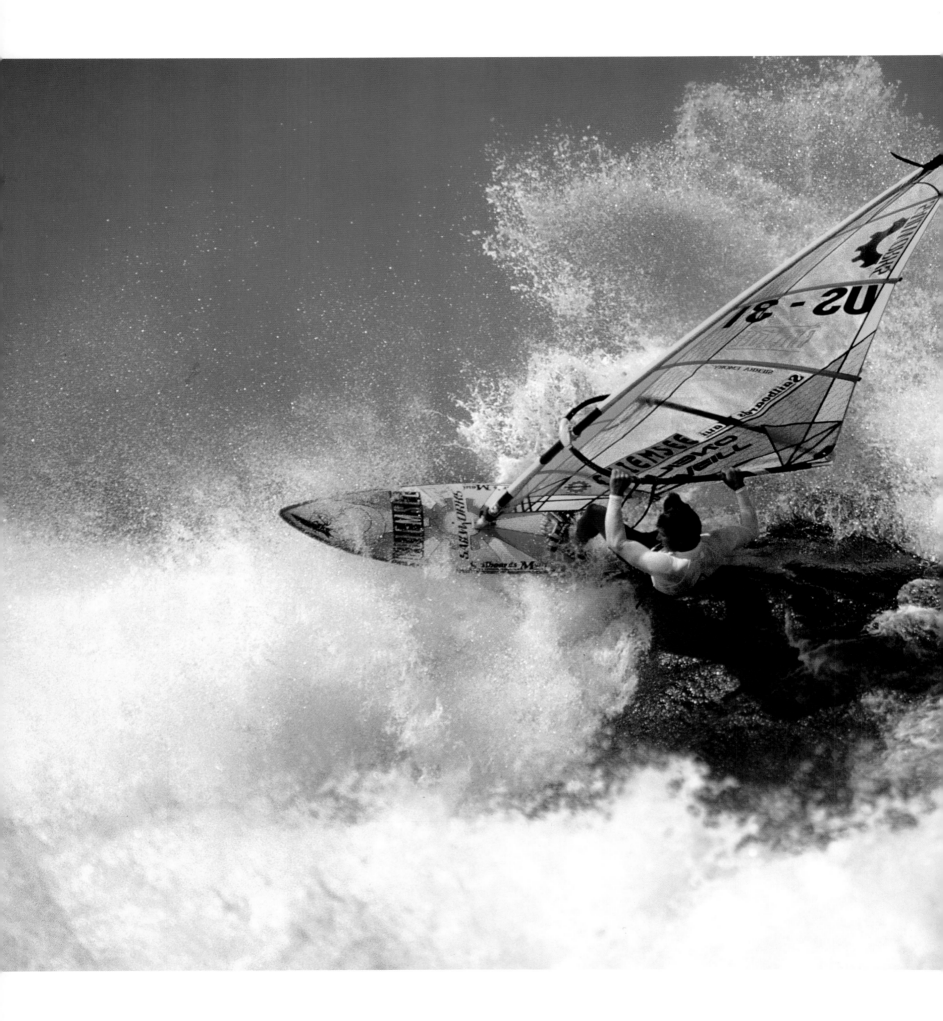

100-101 To stand out from the regular Joes, windsurfers in the '80s adopted fluorescent-colored boards and sails. A visual impact was guaranteed.

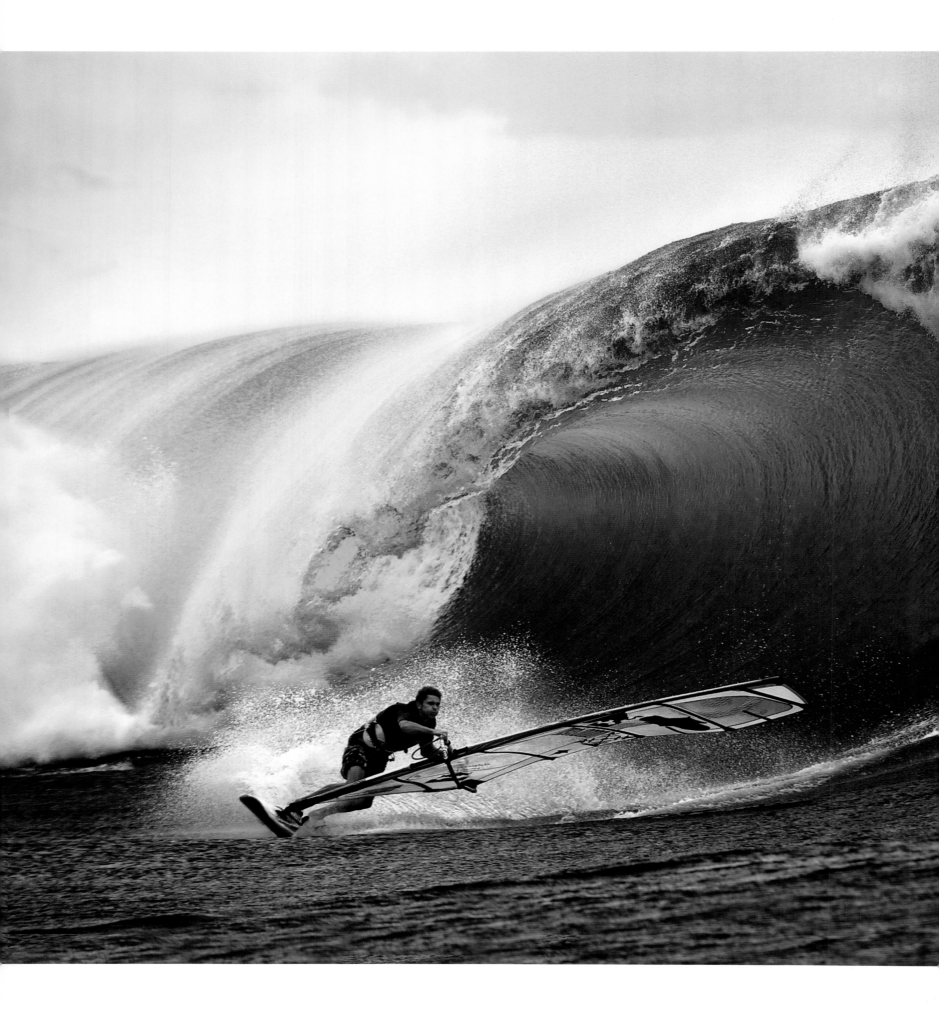

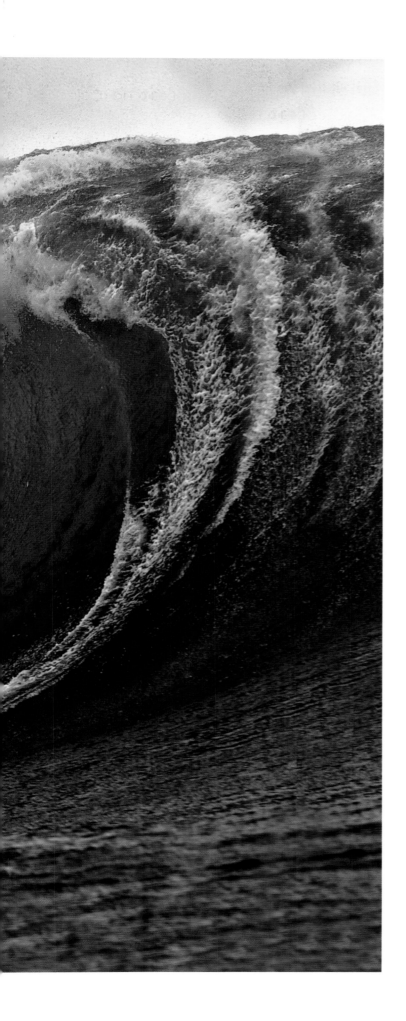

102-103 ATTRACTED BY THE MEDIA ATTENTION OF SURF SESSIONS AT TEAHUPOO, SOME BOLD WINDSURFERS DECIDED TO TRY THEIR LUCK THERE, OFTEN WITH SUCCESS.

104-105 ABOVE ALL, DO NOT LOOK BEHIND YOU. HOLD TIGHT, EVEN IF YOUR ARMS ARE BURNING, AND COUNT ON THE GOODWILL OF THE WIND TO GET YOU OUT.

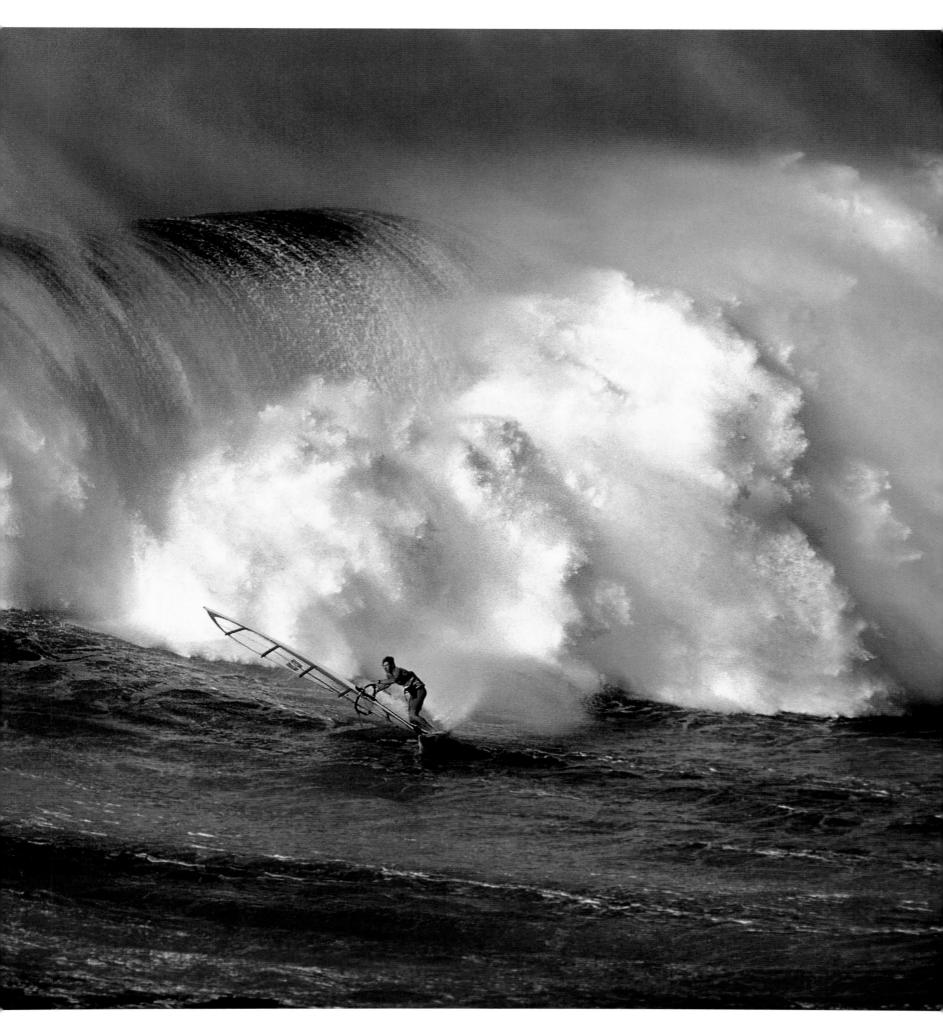

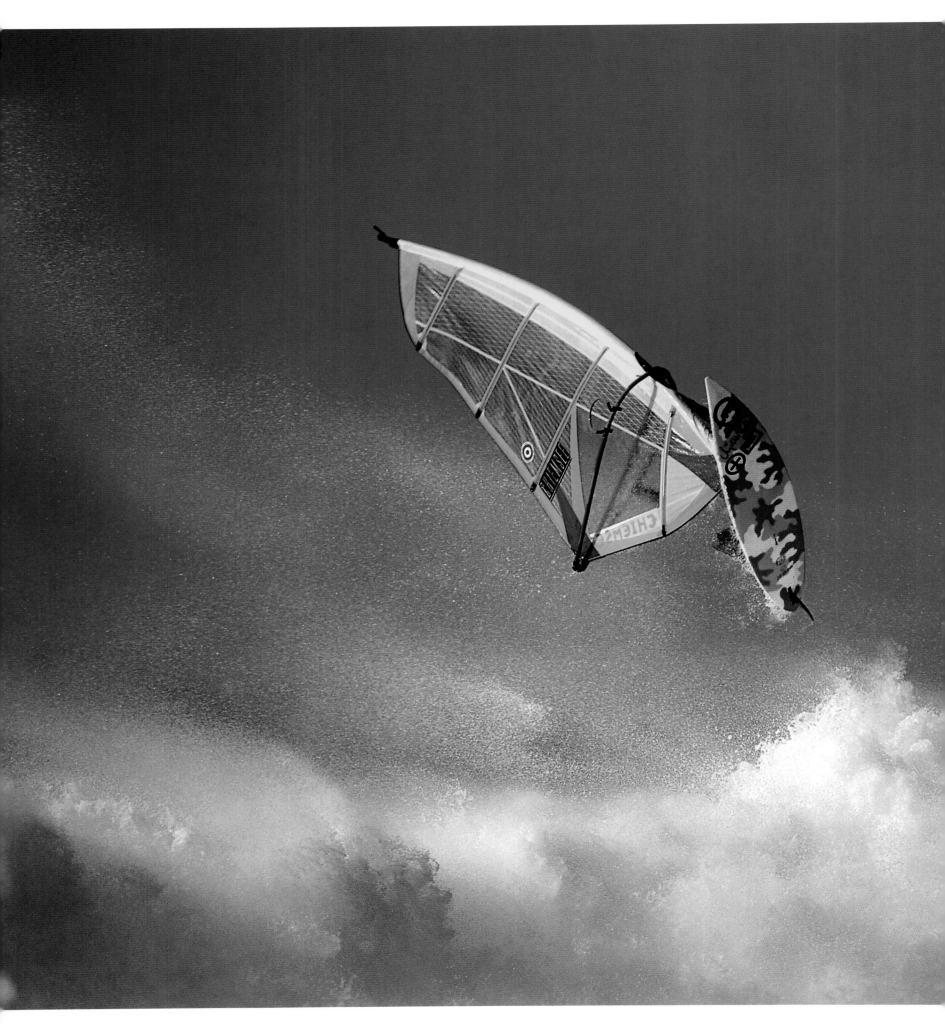

106-107 THE HOOKIPA SPOT, A VERITABLE WINDSURFING MECCA ON THE ISLAND OF MAUI IN HAWAII, REMAINS THE ABSOLUTE REFERENCE POINT FOR HIGH PERFORMANCE FUNBOARDING.

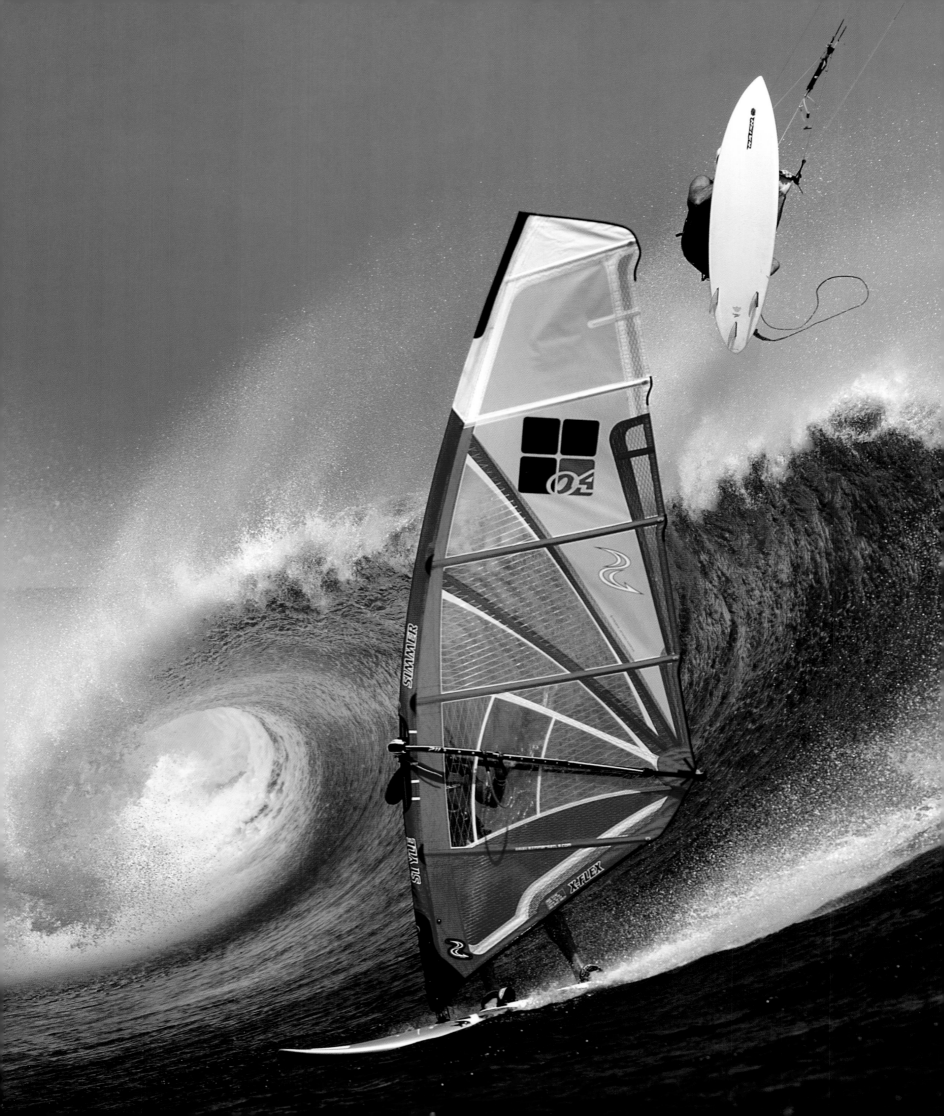

108-109 A KITESURFER SOARS OVER A WINDSURFER IN TEAHUPOO, PROOF THAT THE TWO SPORTS CAN COEXIST.

110-111 COURSE RACING, THE QUEEN OF THE FUNBOARD WORLD CUP, STILL HAS MANY FOLLOWERS, EACH ONE RIDING FASTER THAN THE WIND.

112-113 JASON POLAKOW, STANDOUT WINDSURFER AND BIG WAVE SURFER, IS AN ACCOMPLISHED WATERMAN.

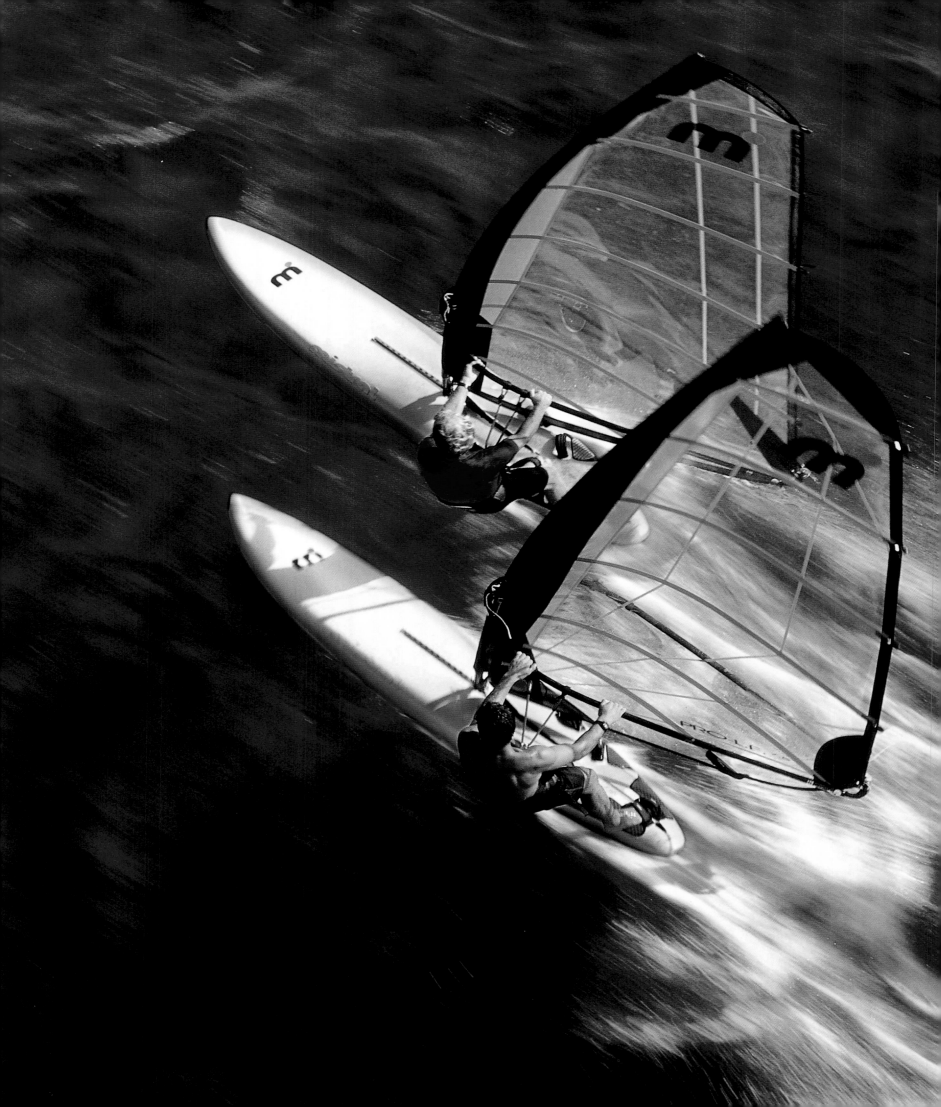

"No bird soars too high if he soars with his own wings."

William Blake

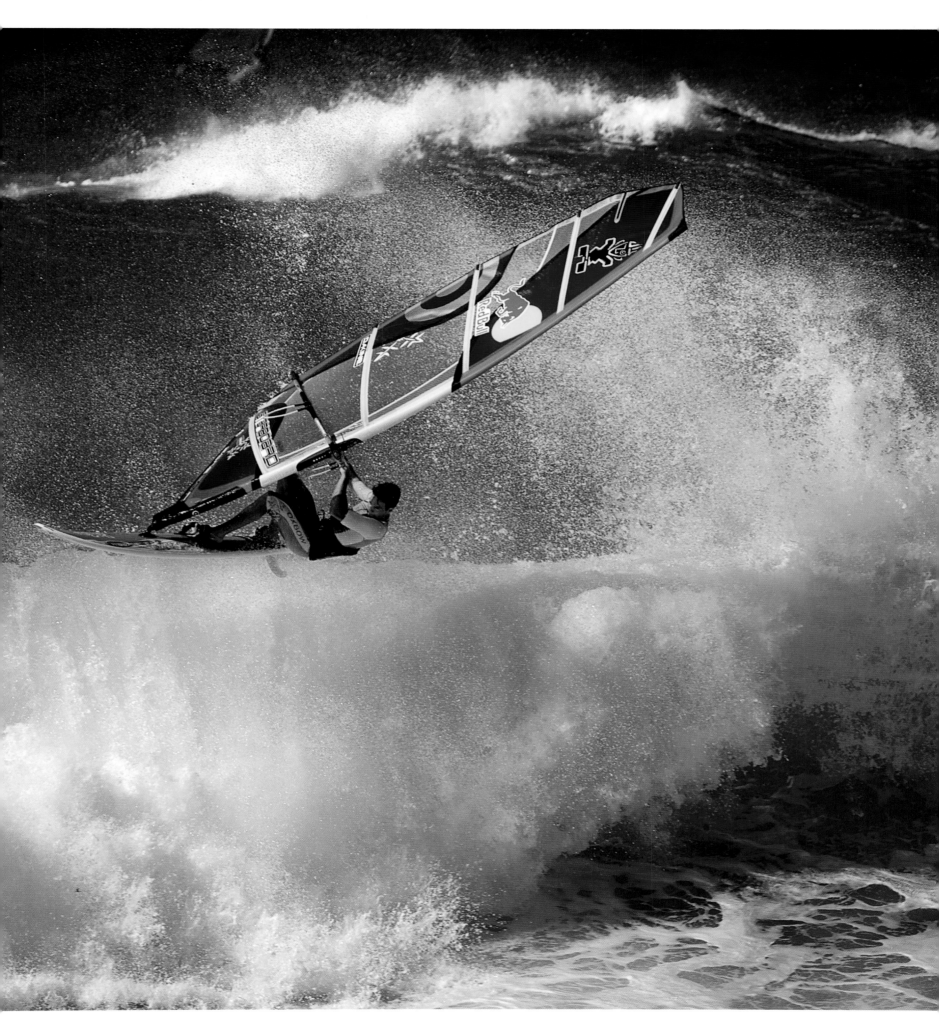

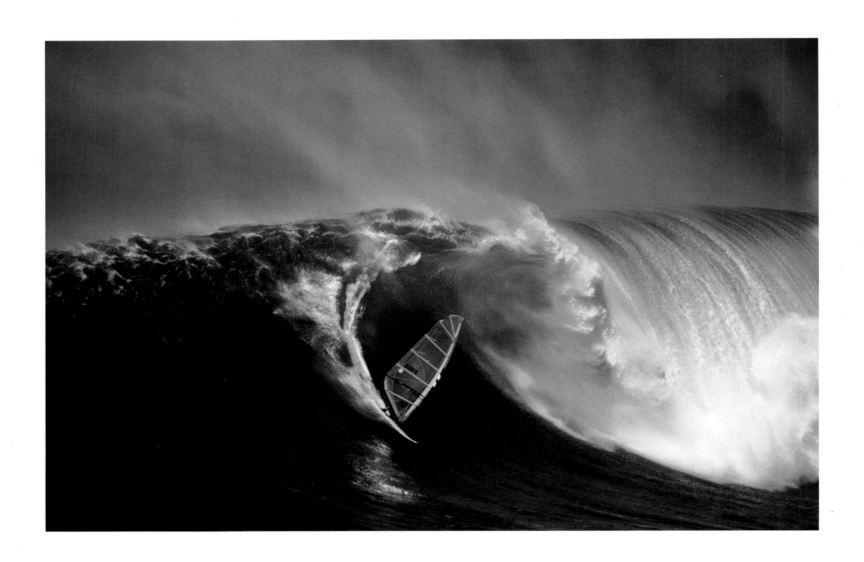

114 Despite the flotation vest, even minor falls in a wave of this size can have tragic consequences.

115 Small sail, small wave, but huge thrills: the magic of windsurfing.

116-117 An "old school" sail with the logo of Baron Bic, a brand from the early 1980s.

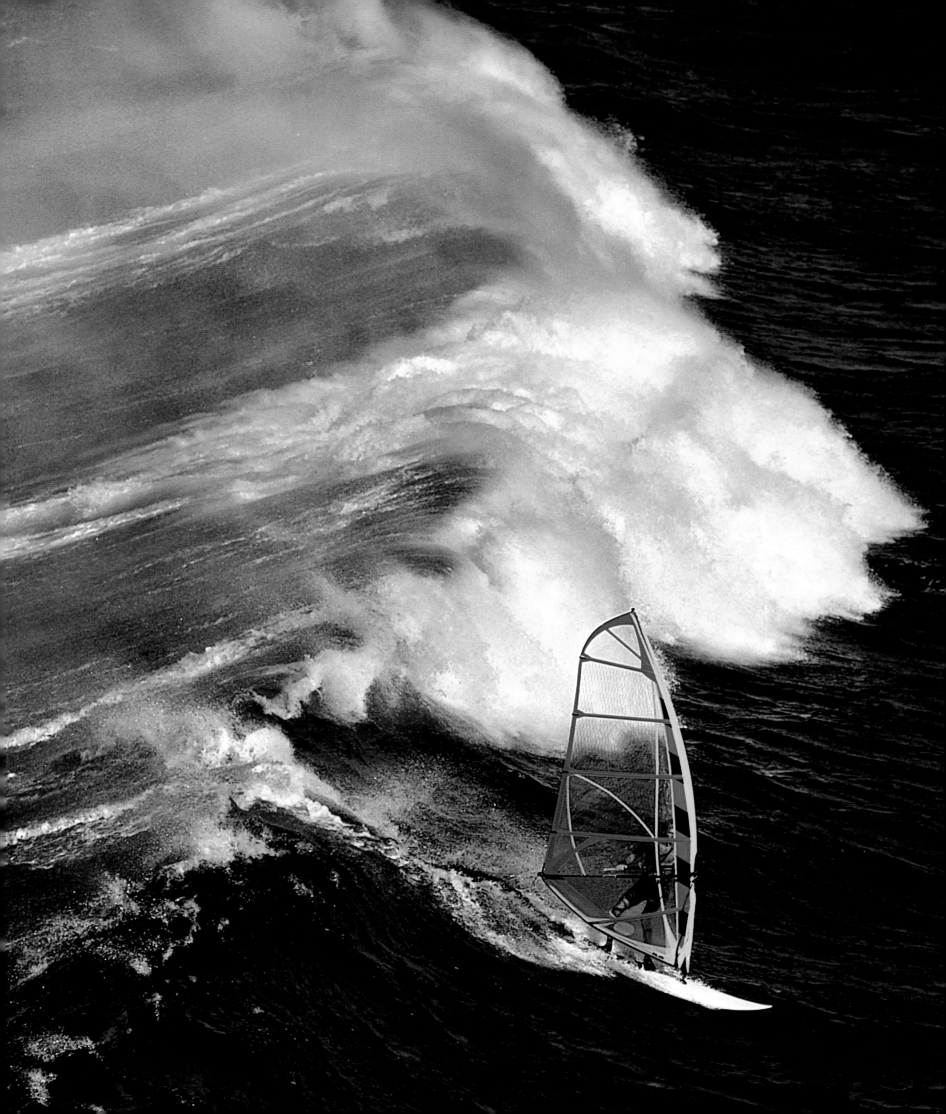

"I SEE A PORT FILLED WITH SAILS
AND RIGGING, STILL UTTERLY WEARIED
BY THE WAVES."

CHARLES BAUDELAIRE,
THE FLOWERS OF EVIL

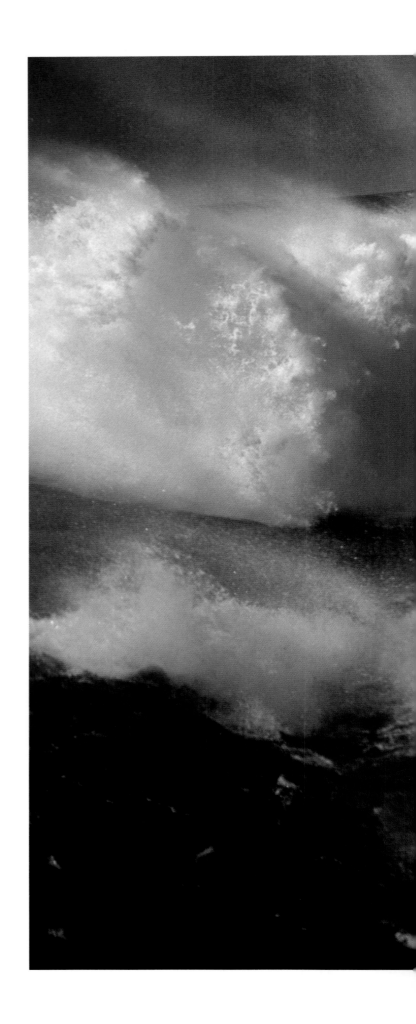

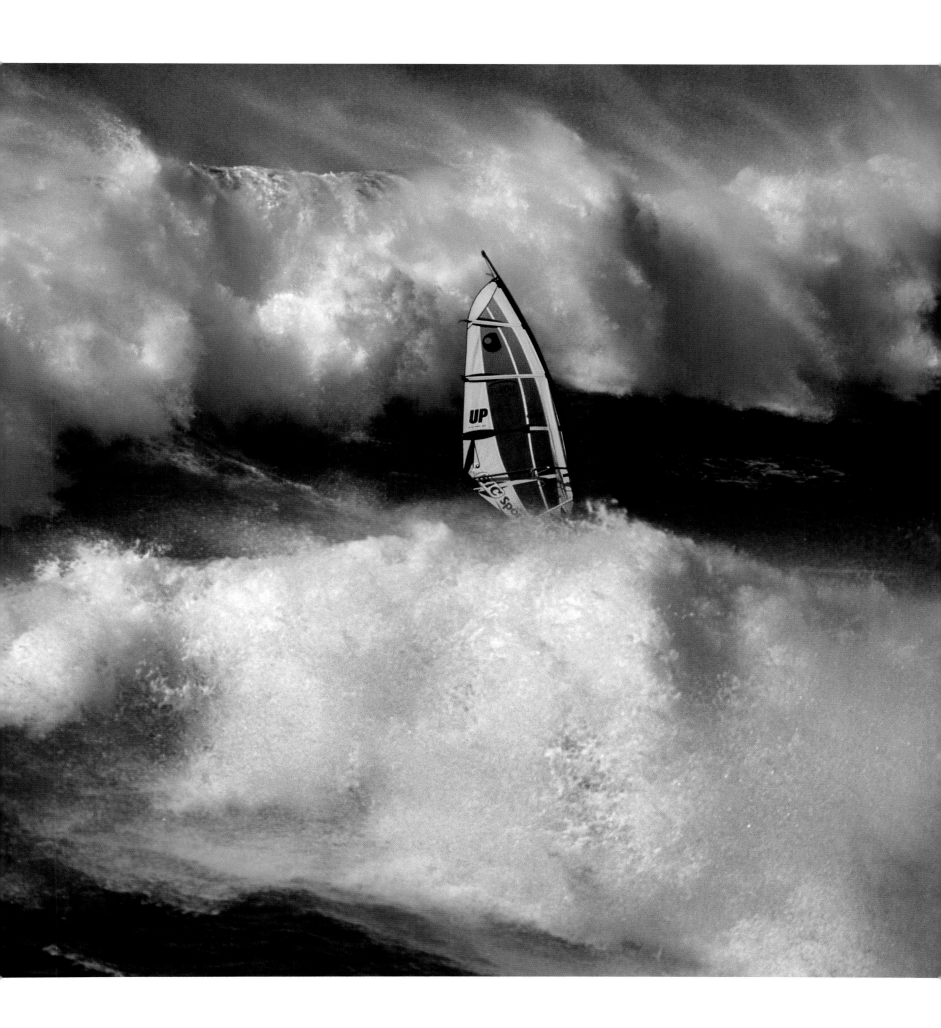

118-119 AN AERIAL VIEW OF THE LEGENDARY DAVE KALAMA, PIONEER OF MODERN WINDSURFING AND TOW-IN SURFING, IN ACTION IN HAWAII.

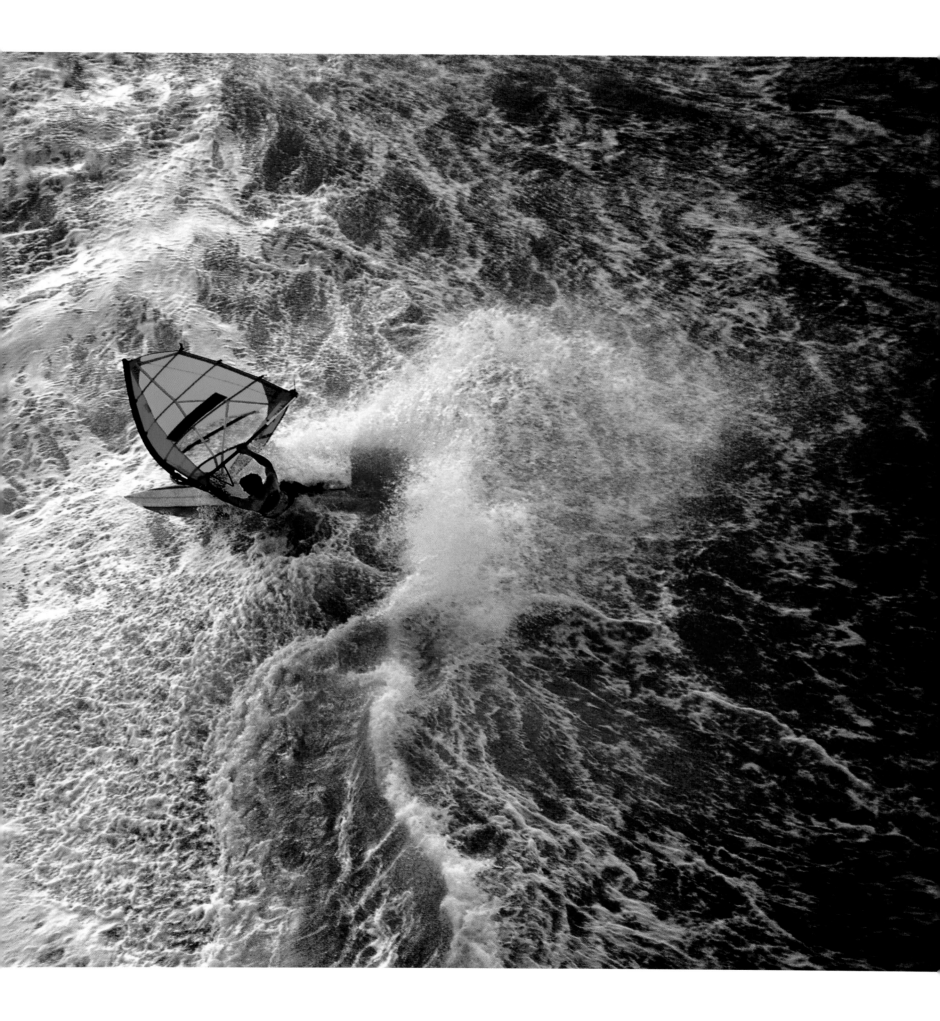

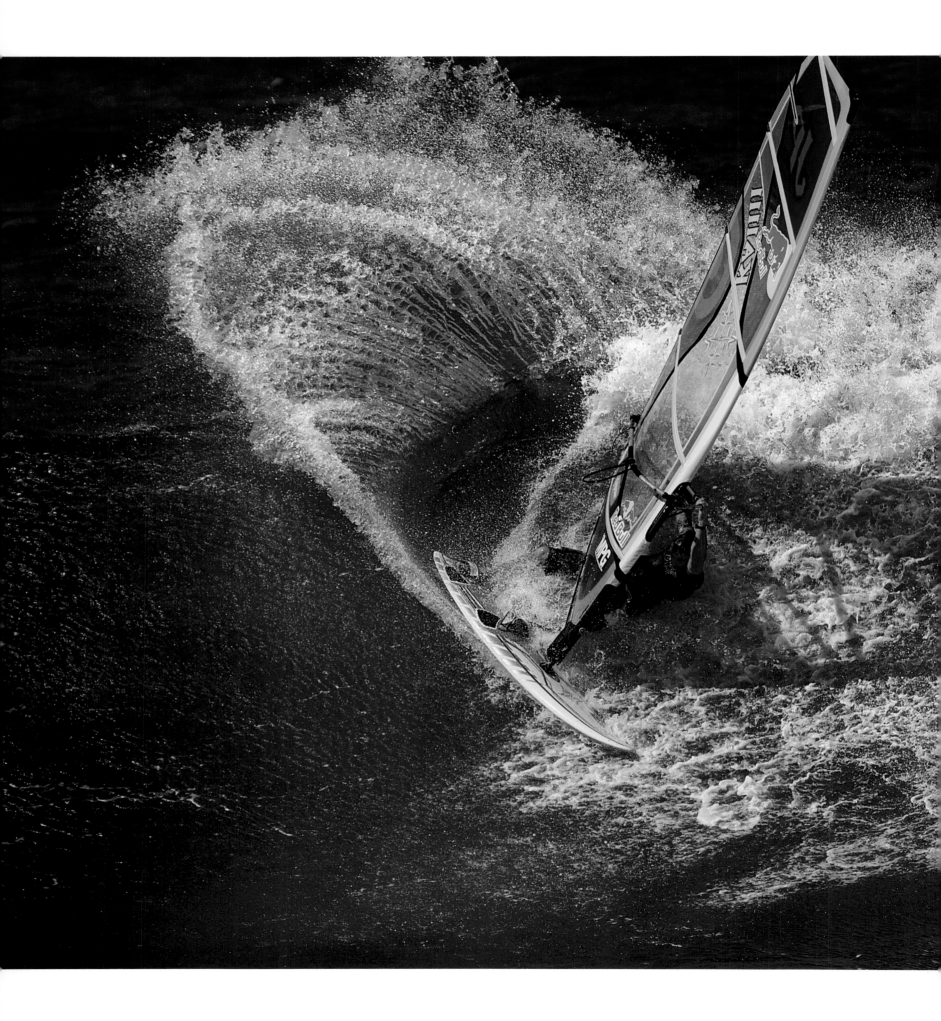

120-121 Jason Polakow executes a perfect tail-slide, a radical maneuver that speaks volumes about his surfing experience.

123 JASON POLAKOW TWENTY YEARS BEFORE WITH HIS LEGENDARY SAIL NUMBER KA 1111. KA STANDS FOR KAUAI, THE NAME OF THE HAWAIIAN ISLAND WHERE THIS POWERFUL WINDSURFER IS FROM.

124-125 A PHOTO TAKEN FROM A HELICOPTER SHOWS THE SHADOW OF THE SAIL IN THE TUBE OF THE WAVE, LIKE THE GHOST OF THE WINDSURFER.

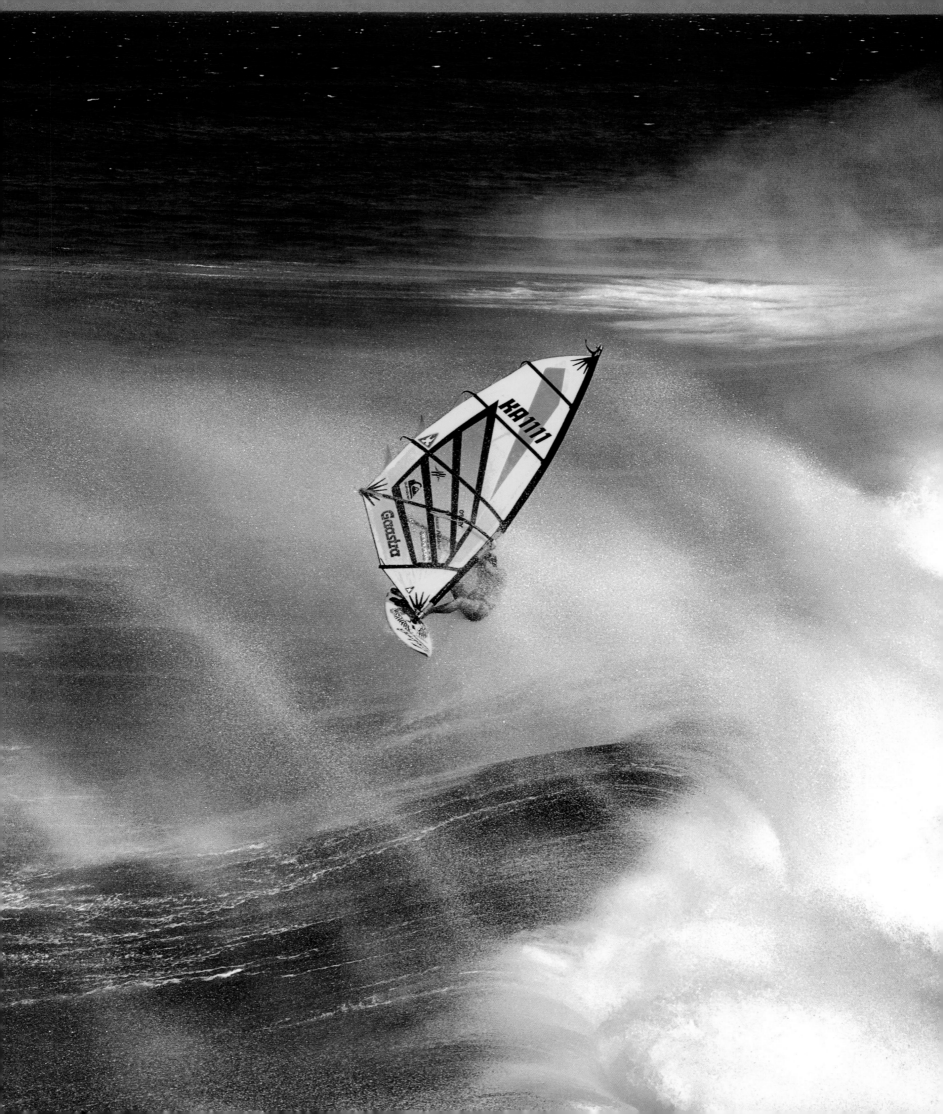

"Hung in the air,
balanced by the wind —
you've accomplished
your giant dreams."

Erich Beaud

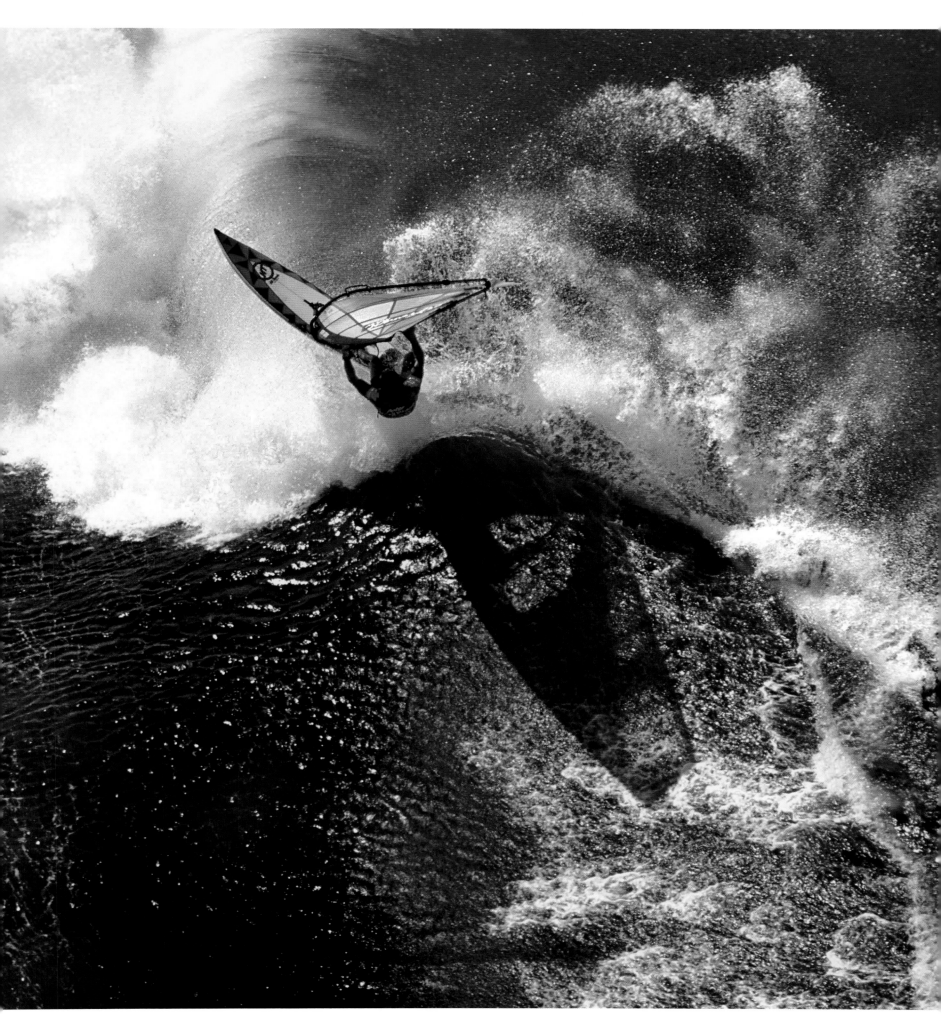

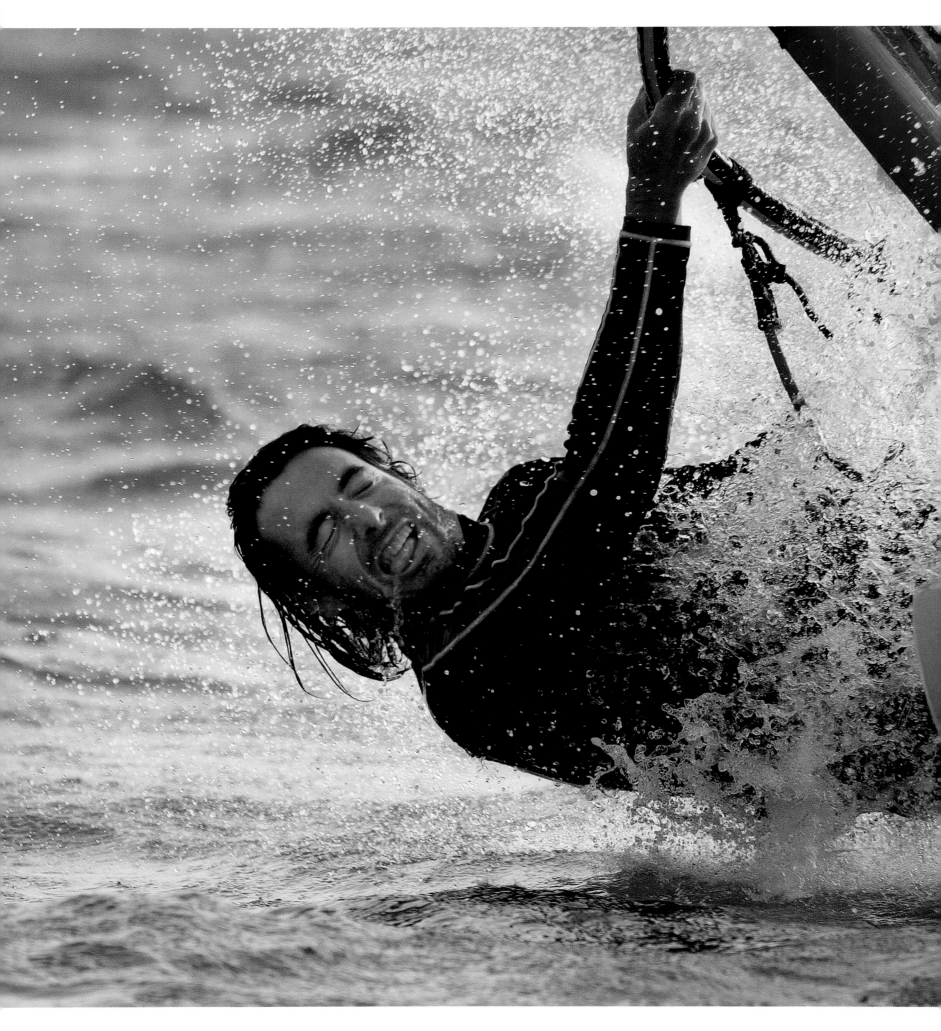

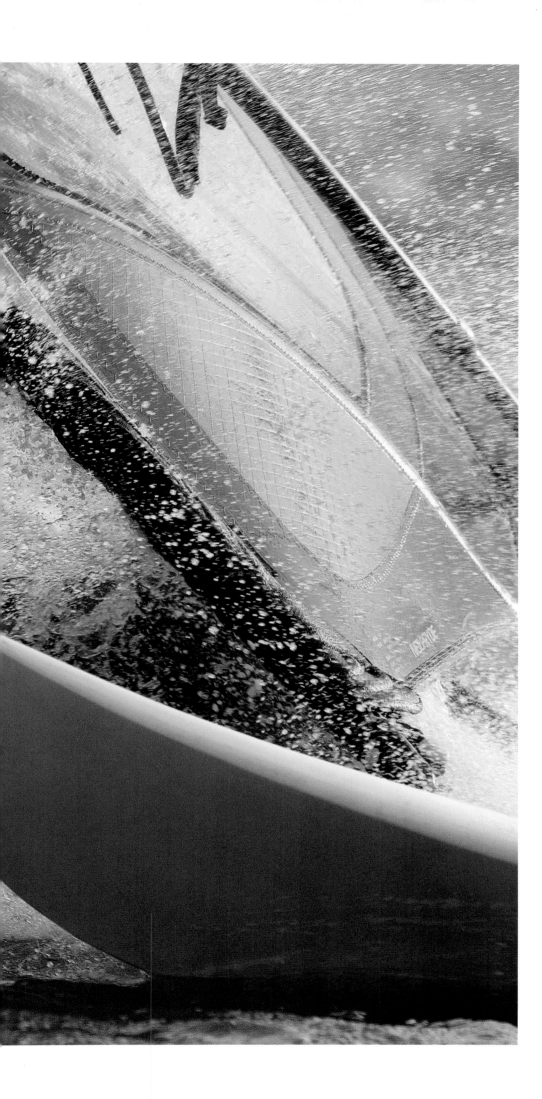

126-127 PULLING ON THE HARNESS AND THE WISHBONE TO DIP HIS HAIR IN THE WATER, OR ENJOYING A QUICK "SHAMPOOING."

128-129 A DOUBLE ROTATION SPIN. THE EXTENDED TONGUE IS A SIGN OF RELAXATION...OR A CHALLENGE.

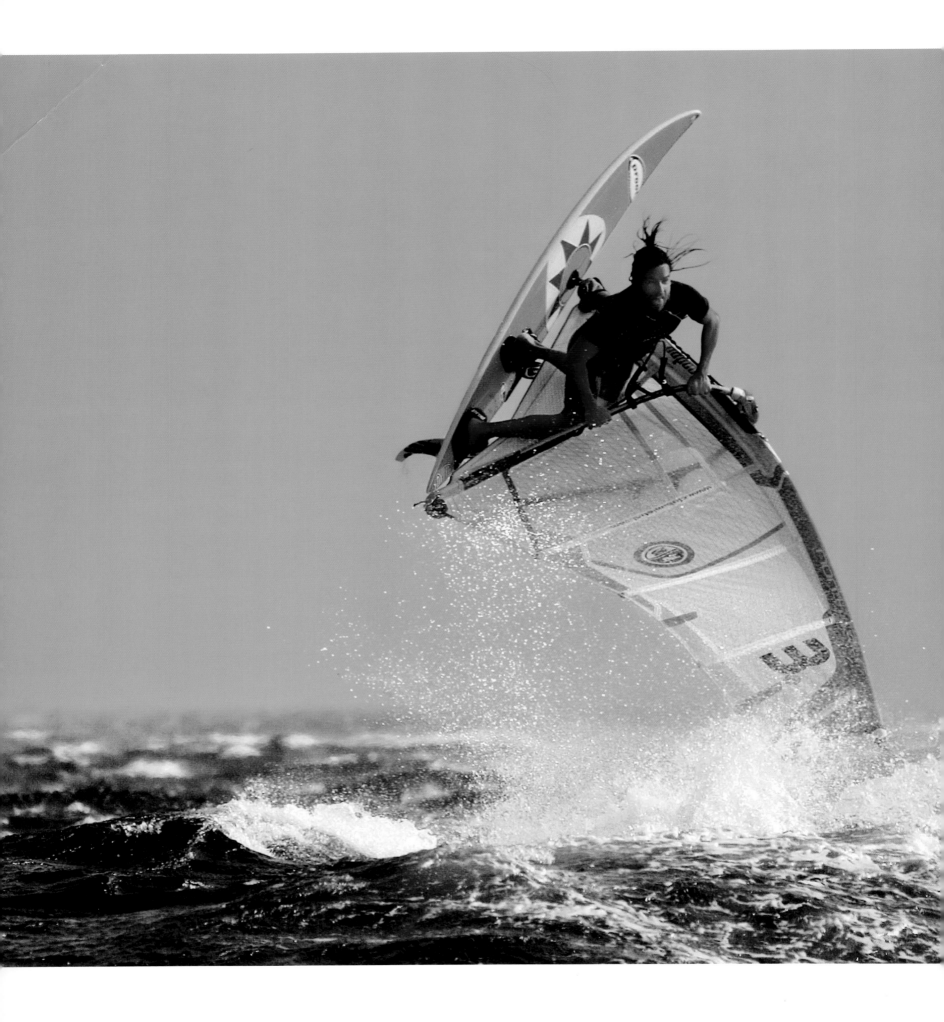

"THE GREATEST COURAGE IS THE SON
OF THE GREATEST FEAR."

FRANCISCO DE QUEVEDO

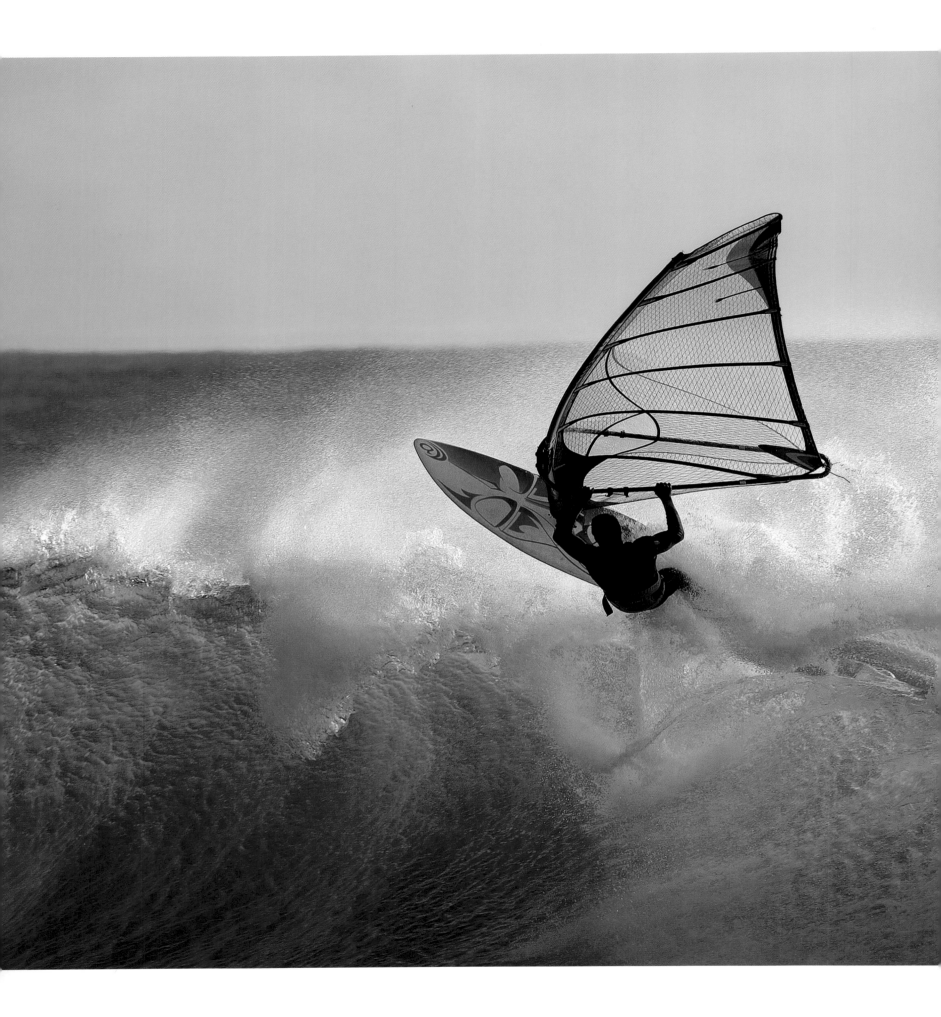

130-131 When the wind is offshore, meaning it's coming from the sand banks, it hollows out the waves perfectly and suspends the windsurfer in the air.

133 Alone in the face of the Pacific Ocean's immensity, the wind is your only travel companion.

"Speed is the form of ecstacy

the technical revolution

has bestowed on man."

Milan Kundera

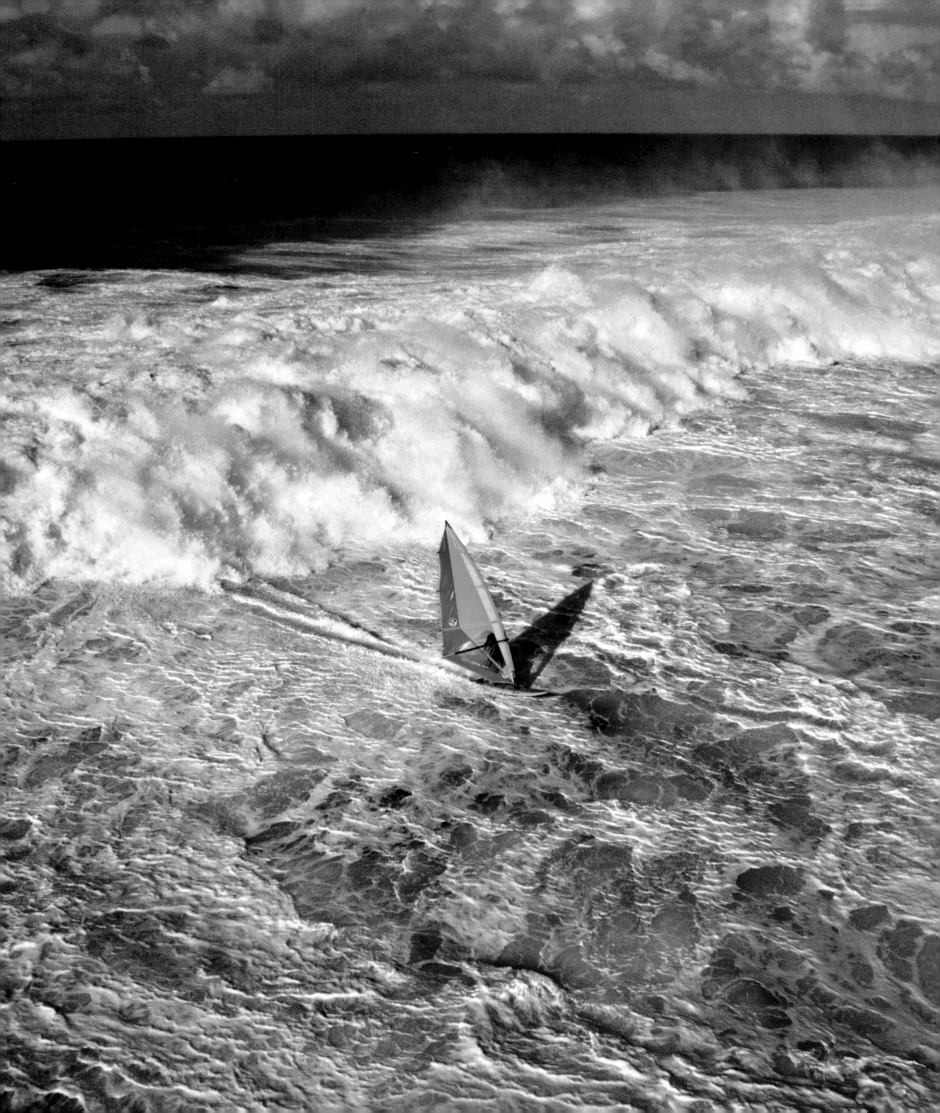

KITESURF

"Throw your dreams into space like a kite, and you do not know what it will bring back, a new life, a new friend, a new love, a new country."

Anaïs Nin

SOME SAILORS SPEAK POETICALLY OF A "WALL OF WIND," THE NEAR MYTHIC STANDARD OF 60 MPH (100 KM/H) ON WATER, A MARK THAT WAS SURPASSED FOR THE FIRST TIME IN OCTOBER 2010 BY FRENCH KITESURFER ALEXANDRE CAIZERGUES. OFFICIALLY TIMED ON THE LÜDERITZ SPOT IN NAMIBIA AT AN AVERAGE SPEED OF 54.10 KNOTS (62.2 MPH OR 100.19 KM/H) OVER 1600 FEET (500 M), THE OFFICIAL DISTANCE MEASUREMENT FOR SAILING RECORDS OF ALL CATEGORIES FOR THE WSSRC (WORLD SAILING SPEED RECORD COUNCIL), CAIZERGUES HAD RECAPTURED HIS RECORD, WHICH HAD BEEN HELD FOR OVER A YEAR BY THE HYDROFOIL, A 60-FOOT TRIMARAN EQUIPPED WITH "FOILS" — INCLINED FINS ON THE SIDE FLOATS THAT ALLOW THE BOAT TO "GLIDE" AT VERY HIGH SPEEDS. THIS EXCITING DUEL BETWEEN TWO OPPOSING CONCEPTS OF ULTIMATE SAILING PERFORMANCE SEEMED TO MAKE A CLEAN SWEEP OF PAST QUARRELS BETWEEN SAILORS AND SURFERS, PUTTING THE HUMAN FACTOR AT THE HEART OF THE DEBATE. A FLOATING LABORATORY LOADED WITH TECHNOLOGY OPERATED BY AN EXPERIENCED CREW, THE HYDROFOIL IS ABOVE ALL A CONCEPT FOR ENTHUSIASTS, DESIGNED TO SHATTER ALL THE CERTAINTIES OF A CENTURY OF RACING. AS SUCH, ITS DESIGNERS HAVE HAD TO FACE MUCH CRITICISM. IT'S THE SAME FOR KITESURFING, LONG DERIDED BY HARDCORE WINDSURFERS WHO ARE THE SELF-APPOINTED GUARDIANS OF A CERTAIN IDEA OF ACADEMIC NAVIGATION. THE BIGGEST DIFFERENCE BETWEEN THE TRIMARAN OF THE FUTURE AND THE KITE RESIDES ULTIMATELY IN THEIR "WEIGHT": AFTER TERRIFYING STOPWATCHES, CAIZERGUES CAN STORE HIS EQUIPMENT IN HIS CAR.

"FOR THE LAST THIRTY YEARS, THE SPEED SAILING RECORD HAS BEEN A GREAT FORM OF EMPOWERMENT FOR YOUNG SPORTS THAT ARE RAPIDLY DEVELOPING," EXPLAINS CAIZERGUES. "IF THE WINDSURFING PERFORMANCE OF PASCAL MAKA IN 1986 [43.06 KNOTS, 49.5 MPH OR 79.74 KM/H] MADE AN IMPRESSION, IT WAS PARTLY BECAUSE IT WAS PERFORMED ON MASS-PRODUCED EQUIPMENT, WHILE THE CROSSBOW CATAMARAN OF TIM COLEMAN, A RECORD HOLDER IN THE 70'S, WAS A VERITABLE CONCENTRATION OF TECHNOLOGY. THE KITESURF WAS THE FIRST TO SAIL BEYOND 50 KNOTS, WHICH EARNED IT THE WRATH OF THOSE IN ITS OWN CAMP. SOME HAVE EVEN ATTEMPTED TO OPPOSE THE CONCEPT OF KITE FLYING FOR THE SAILING VERSION. WHEN IT COMES TO WINDSURFING, THOUGH, I THINK THAT UNFORTUNATELY THIS IS NOT A QUESTION OF EQUIPMENT, SURPASSED OR NOT, BUT RATHER

WILL, INDIVIDUAL AND COLLECTIVE. *THE LAST ATTEMPT TO BREAK THE WINDSURFING WORLD RECORD WAS IN 2008, AND TODAY, NOBODY DREAMS OF BEING THE WORLD'S FASTEST WINDSURFER, PERHAPS BECAUSE THE SPORT FEELS IT HAS NOTHING LEFT TO PROVE WITH FEATS LIKE THIS.*"

FIRST NAMED FLYSURF, THEN KITEBOARD AND FINALLY KITESURF, THIS NEW SPORT COMBINED SURFING AND SAILING TO LET PRACTITIONERS GLIDE OVER THE WATER WITH THE HELP OF A KITE CONNECTED BY LINES AND A HARNESS. THE SPORT WAS BORN IN THAT GLORIOUS STRONGHOLD OF SEAFARERS, BRITANNY. IN BREST IN 1985, A PROTOTYPE MADE WITH PLYWOOD SKIS PULLED BY A FLYING KITE TRIGGERED LAUGHTER FROM THE AUDIENCE AT SPEED WEEK, A COLORFUL ANNUAL GATHERING OF SAILING ENTHUSIASTS THAT SERVES AS A BREEDING GROUND FOR THE MOST WACKY AQUATIC DESIGN IDEAS. THE CRAFT, DESIGNED BY THE LEGAIGNOUX BROTHERS, TWO BRETON SAILORS WHO LEARNED THEIR CRAFT IN DINGHY REGATTA RACING, WON THE INGENUITY PRIZE. MORE IMPORTANTLY, THOUGH, IT CAUGHT THE EYE OF ANOTHER BRETON, MANU BERTIN, A PROFESSIONAL WINDSURFER WHO, TEN YEARS LATER, WOULD PLAY A KEY ROLE IN THE GLOBAL EXPLOSION OF KITESURFING.

EVER SINCE MARCO POLO, THE KITE HAS BEEN A FANTASY OF EUROPEAN NAVIGATORS. MOST LIKELY INVENTED BY THE CHINESE, IT WAS ALREADY USED IN THE 13TH CENTURY BY THE FISHERMEN AND SAILORS OF THE ISLANDS OF SOUTHEAST ASIA AND PARTICULARLY BY THE INDONESIANS, WHO WERE PAST MASTERS IN THE ART OF SAIL MAKING. IN THE 18TH CENTURY, AN ENGLISHMAN NAMED GEORGE POCOCK TRIED A SERIES OF EXPERIMENTS WITH OVERSIZED KITES CONNECTED TO THE GROUND BY SETS OF FOUR LINES, A METHOD STILL USED TODAY. IT WAS FOUND THAT THE KITE COULD GENERATE ITS OWN WIND TO TOW VEHICLES ON WATER, LAND AND EVEN ON ICE OR SNOW. RECORDS OF THE TIME REPORT THAT, THUS EQUIPPED, CARTS AND BOATS COULD EVEN LAUNCH UPWIND.

DESPITE THIS PRESTIGIOUS HERITAGE, BRUNO AND DOMINIQUE LEGAIGNOUX STARTED ALMOST FROM SCRATCH WHEN DESIGNING A MARINE APPLICATION TO KITE TRACTION. DURING THE SUMMER OF 1983, THE BROTHERS FOUND THEMSELVES IN SENEGAL AFTER A YEAR OF BLUE WATER CRUISING AROUND THE WORLD. THEY

SPENT HOURS DISCUSSING HIGH-SPEED WATER CRAFTS AND HIGH PERFORMANCE SAILS AND CAME TO THINK OF KITES AS A NATURAL EXTENSION OF TILTED WINGS. BOTH HAD MEMORIES OF JACOB'S LADDER, THE CATAMARAN TOWED BY A KITE THAT HAD APPEARED AT THE BASE OF BREST. IN HANN BAY IN DAKAR, ANOTHER RIGGING SYSTEM INSPIRED THEM, ONE THAT WAS HALFWAY BETWEEN THE SAIL BOARD AND THE KITE: THE BIRD-SAIL. THIS SYSTEM, PATENTED AND MANUFACTURED BY ANOTHER BRETON, ROLAND LE BAIL, IN 1982, COULD SUSTAIN THE RIDER AND ACHIEVE HIGHER AND LONGER JUMPS THAN A NORMAL SAILBOARD.

NEITHER LEGAIGNOUX BROTHER HAD EVER FLOWN A STUNT KITE. DOMINIQUE AND BRUNO BEGAN BY MAKING A MODEL TO UNDERSTAND THE THEORY OF FLYING KITES, INCLUDING HOW IT MAY BE POSSIBLE TO LAUNCH UPWIND. THEY FIRST DESIGNED A TRAIN OF KITES, WITH A 3-FOOT (1 M) LONG CONTROL BAR AND REEL LINES. SOON THEY CONCLUDED THAT A SINGLE WING WAS MORE EFFICIENT THAN A TRAIN OF MULTIPLE KITES AND THAT AN INFLATABLE STRUCTURE WAS MORE COMPETITIVE THAN A RIGID STRUCTURE. THEY THEN IMAGINED A FRAME MADE OF INFLATABLE TUBES WHICH WOULD ALLOW THE SAIL TO FLOAT ON WATER BUT ALSO TO RE-LAUNCH UPWIND.

THEY FILED A PATENT FOR THIS FIRST CURVED WING WITH AN INFLATABLE STRUCTURE IN OCTOBER 1984. A LONG PERIOD OF RESEARCH AND DEVELOPMENT FOLLOWED TO IMPROVE THE CONCEPT, WITH THE PRIORITY OBJECTIVES BEING TO GO UPWIND, GO FAST AND LAUNCH OFF THE WATER WITHOUT PROBLEMS. WHEN THEY PRESENTED THEIR INVENTION IN BREST IN 1985, THEIR WINGS WERE STILL ONLY PROTOTYPES AND DID NOT GO UPWIND, EITHER ON BOARDS OR SKIS, SO THEY CONTINUED TO WORK FOR YEARS ON THE EQUIPMENT. DURING THIS PERIOD, THEY WOULD PRODUCE SEVERAL PROTOTYPES WITH DIFFERENT EXTENSIONS AND PROFILES. AT THE TORCH IN 1987, DURING THE FUNBOARD WORLD CUP, BRUNO LEGAIGNOUX DEMONSTRATED THE LARGEST WING THEY'D EVER MADE: 56 SQUARE FEET (17 SQUARE M). WINDS WERE TOO WEAK FOR WINDSURFERS TO SAIL. HOWEVER, THE BROTHERS' KITESURF PROVED IT WAS POSSIBLE TO GLIDE WITH JUST 5 TO 6 KNOTS OF WIND, EVEN IF THE ABILITY TO LAUNCH THE KITE FROM THE WATER IN LIGHT WINDS REMAINED A PROBLEM. IN ADDITION, THE WINDSURFING MARKET, WHICH WAS STILL QUICKLY GROWING AT THAT TIME, WAS

POWERFUL AND NO ONE IN THAT SECTOR WANTED TO INVEST IN SUCH A PROJECT. MANU BERTIN AND THE LEGAIGNOUX BROTHERS WERE, AT THE TIME, THE ONLY ONES WHO BELIEVED IN THE ENORMOUS POTENTIAL OF THIS EQUIPMENT THAT HAD NOT YET BEEN NAMED.

AFTER HUNDREDS OF PROTOTYPES AND FIFTEEN YEARS OF RESEARCH, THE WINGS BECAME MORE STABLE, LIGHTER AND EASIER TO FLY AND CONTROL. AT THIS POINT, THEY WERE VIRTUALLY READY TO BE MASS PRODUCED. THE BOARDS AND SKIS, ON THE OTHER HAND, WERE NOT, AND THEY SUFFERED FROM POOR LIFT UPWIND. BERTIN IMPORTED THE EARLY WIPIKA ("KA" FOR KITE AIRCRAFT) MODELS TO HAWAII AND HAD THEM TESTED BY LAIRD HAMILTON, THE BIG WAVE SURFER AND WINDSURFER STAR, WHO WAS WORKING IN MAUI ON THE TOW-IN CONCEPT IN ORDER TO FACE GIANT WAVES. *"THE FIRST TIME WE DEPLOYED THE WINGS IN LAIRD'S GARDEN, WE WERE FORCED TO STRAP ON THE CARCASS OF AN OLD CAR SO THAT WE WEREN'T BLOWN AWAY BY THE MAUI WIND,"* SAYS MANU BERTIN, WHOSE FIRST NAME MEANS, PERHAPS AS A FORM OF PREMONITION, "BIRD" IN HAWAIIAN. *"THEN WE WENT OUT TO SEA AND LAIRD BEGAN SAILING WITH HIS TOW-IN BOARD. WE WERE IN THE KAHULUI AIRPORT AIR CORRIDOR AND PILOTS ON APPROACH PANICKED WHEN THEY SAW THE WINGS 160 FEET (50 M) FROM THE SURFACE OF THE WATER! THE CONTROL TOWER WAS REASSURING THEM: 'IT'S NOTHING, JUST LAIRD HAMILTON AND HIS GANG TESTING A NEW CRAZY TRICK.'"*

IN 1996, WIND MAGAZINE PUBLISHED THE FIRST ARTICLE ON THIS NEW SPORT AND PUT IT ON THE COVER UNDER AN IRONIC TITLE — "FLYSURF, KÉZACO?" — WHICH ENCAPSULATED THE DOUBTFUL PERCEPTION HELD BY A MAJORITY OF OLD-SCHOOL WINDSURFERS. IN THE ARTICLE, BERTIN WAS ECSTATIC ABOUT THE POTENTIAL OF THIS INVENTION: *"IT FEELS COMPLETELY NEW. THE SKY BECOMES A PLAYGROUND AS WELL AS THE WAVES AND THE ABSENCE OF GRAVITY GIVES YOU A FEELING OF INCREDIBLE FREEDOM. ONE FLIES A KITE, BUT A WING FLIES YOU! THAT'S A BIG DIFFERENCE."* ON THE WATER, THE KITE ALSO PROVED TO HAVE A FORMIDABLE EFFICIENCY. LIKE A SNOWBOARDER, A KITESURFER WEDGED IN HIS FOOT STRAPS DOES NOT CHANGE THE POSITION OF HIS FEET AFTER A TURN. BERTIN WORKED WITH DIFFERENT SHAPERS, INCLUDING MICHEL LARRONDE IN HAWAII AND ITALY'S ROBERTO RICCI, TO DEVELOP A LONG BOARD 7 FEET (2 M) LONG AND 15 INCHES (38 CM) WIDE

INSPIRED BY SURFING, WAKEBOARDING (EXTREME NOSE KICK) AND SNOWBOARDING (SHARP RAILS).

MEANWHILE, THE WINGS CONTINUED TO GROW WITH THE DEVELOPMENT OF THE ATK, WHICH WEIGHED 2 POUNDS (1 KG) ONCE IN THE AIR. FROM NOW ON, IF THE SURFER FELL THE KITE ROSE VERTICALLY, A POSITION THAT ALLOWED MAXIMUM TRACTION WITH MINIMAL EFFORT. THE FIRST MASS PRODUCED MODELS — WIPIKA, KITESKI, F-ONE, CONCEPT AIR, C-QUAD — COULD ALSO BE CALLED INTO ACTION AFTER BEING THROWN INTO THE WATER WITHOUT WIND. THE PIONEERS OF THE FIRST GENERATION OF KITESURFERS WERE QUICK TO DISCOVER THAT, IN BAD WEATHER, THE KITE COULD STILL BE PROPELLED SEVERAL FEET INTO THE AIR. SPECTACULAR MANEUVERS AND AERIAL ROTATIONS INSPIRED BY GYMNASTICS SOON APPEARED ON THE WATERWAYS. ROBBY NAISH, MASTER OF THE AIR IN WINDSURFING FOR OVER TWENTY YEARS, WAS LEFT SPEECHLESS: *"THE FIRST TIME I TRIED A MOVE, I REMEMBER FINDING MYSELF CATAPULTED 26 FEET (8 M) HIGH AND TELLING MYSELF: 'OH MY GOD ... IT'S HUGE!' IN WINDSURFING, YOU WOULD HAVE NEEDED THREE TIMES MORE WIND AND A SIX-FOOT (2 M) WAVE TO GET AS HIGH, WITH NO GUARANTEE OF CONTROLLING THE LANDING. IT WAS THE FUTURE."* NAISH BOUGHT A LICENSE FROM THE LEGAIGNOUX BROTHERS IN 1997 AND BEGAN PRODUCING KITESURFS UNDER HIS BRAND, NAISH SAILS. *"THEY CRITICIZE ME TODAY FOR HAVING PUT MY REPUTATION AT THE SERVICE OF KITESURFING INSTEAD OF TRYING TO HALT THE DECLINE OF WINDSURFING,"* HE SAYS. *"THE TRUTH IS THAT, BEYOND THE BUSINESS, I COULDN'T SEE MYSELF TURNING MY BACK ON A SPORT THAT LET ME HAVE SO MUCH FUN, AND WHICH COMPLEMENTED MY PRACTICE OF WINDSURFING AND SURFING."*

KITESURFING EXPLODED IN THE LATE '90S DESPITE THE DANGER TO KIDS IN A STILL DEVELOPING SPORT THAT GENERATED ACCIDENTS AND FATALITIES. SERIOUS INJURIES OCCURRED BECAUSE OF THE SHARP LINES OF THE WINGS OR BECAUSE OF UNCONTROLLABLE JUMPS. MORE EFFICIENT SAFETY SYSTEMS WERE THUS DEVELOPED AND, LIKE WINDSURFING IN THE '80S, KITESURFING HAD ITS GOLDEN AGE. SINCE THEN, MULTIPLE CATEGORIES OF THE SPORT HAVE ARISEN — SPEED, FREESTYLE, WAKE STYLE, WAVE — AND THE SPORT HAS IMPOSED ITSELF AS THE REVOLUTION OF THE DECADE IN WATER SPORTS. FROM SOME 50 PRACTITIONERS IN 1998 TO 300,000 TODAY, KITESURFING HASN'T STOPPED BREAKING RECORDS.

141 NAVIGATING BETWEEN THE PEACEFUL WATERS OF THE LAGOON TO THE MORE TUMULTUOUS WAVES OF THE OCEAN — THE MAGIC OF KITESURFING IN TAHITI.

142-143 WHAT DO MARINE BIRDS THINK OF THESE WONDERFUL FLYING FOOLS THAT SOMETIMES ACCOMPANY THEM IN THE AIR? NO DOUBT THEY ARE FILLED WITH A RESPECTFUL CURIOSITY.

"Imagination is the highest kite one can fly."

Lauren Bacall

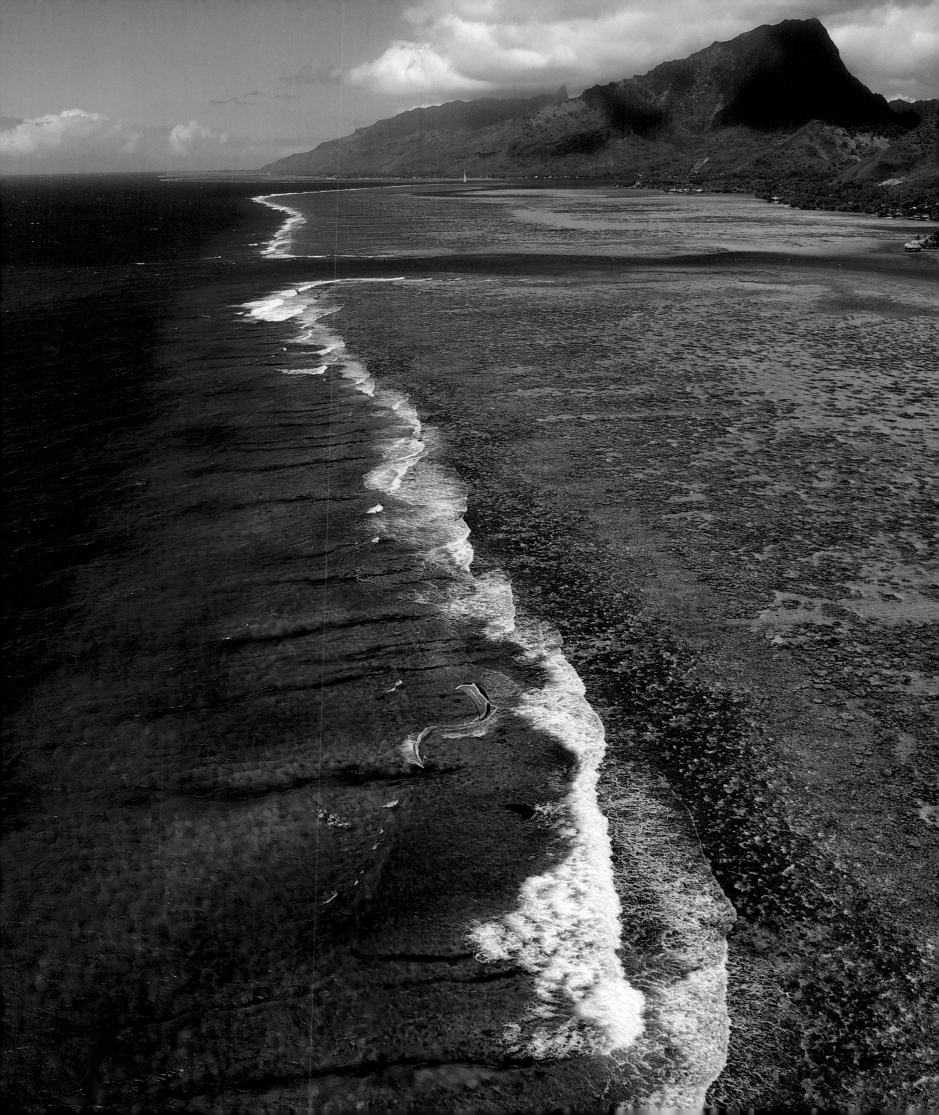

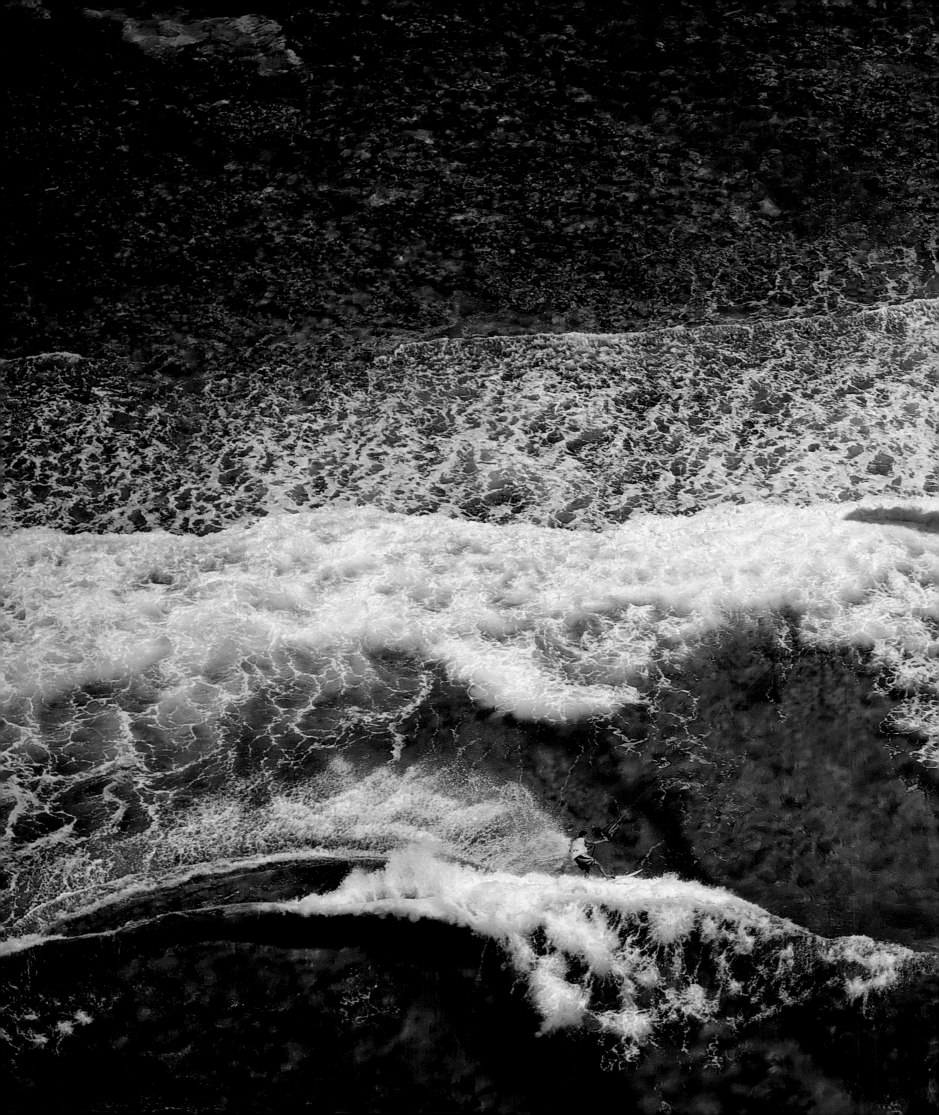

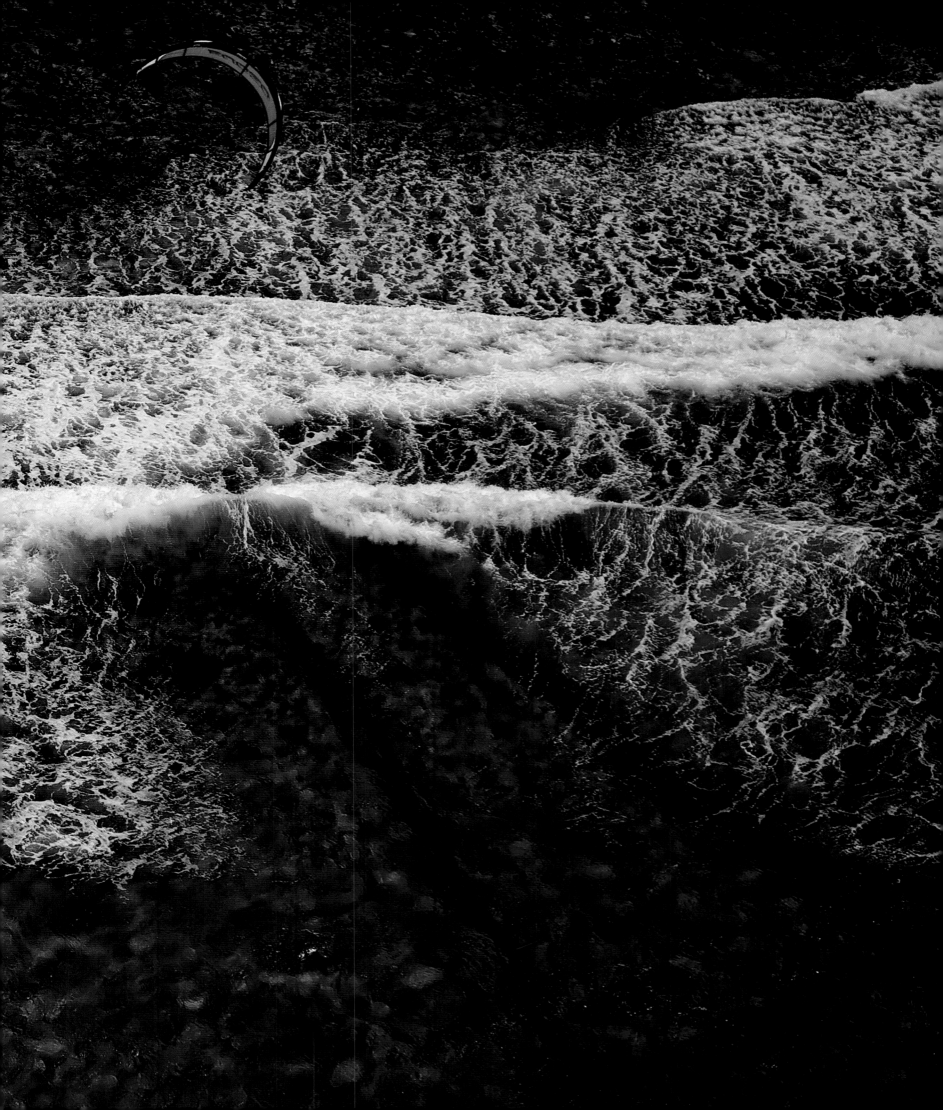

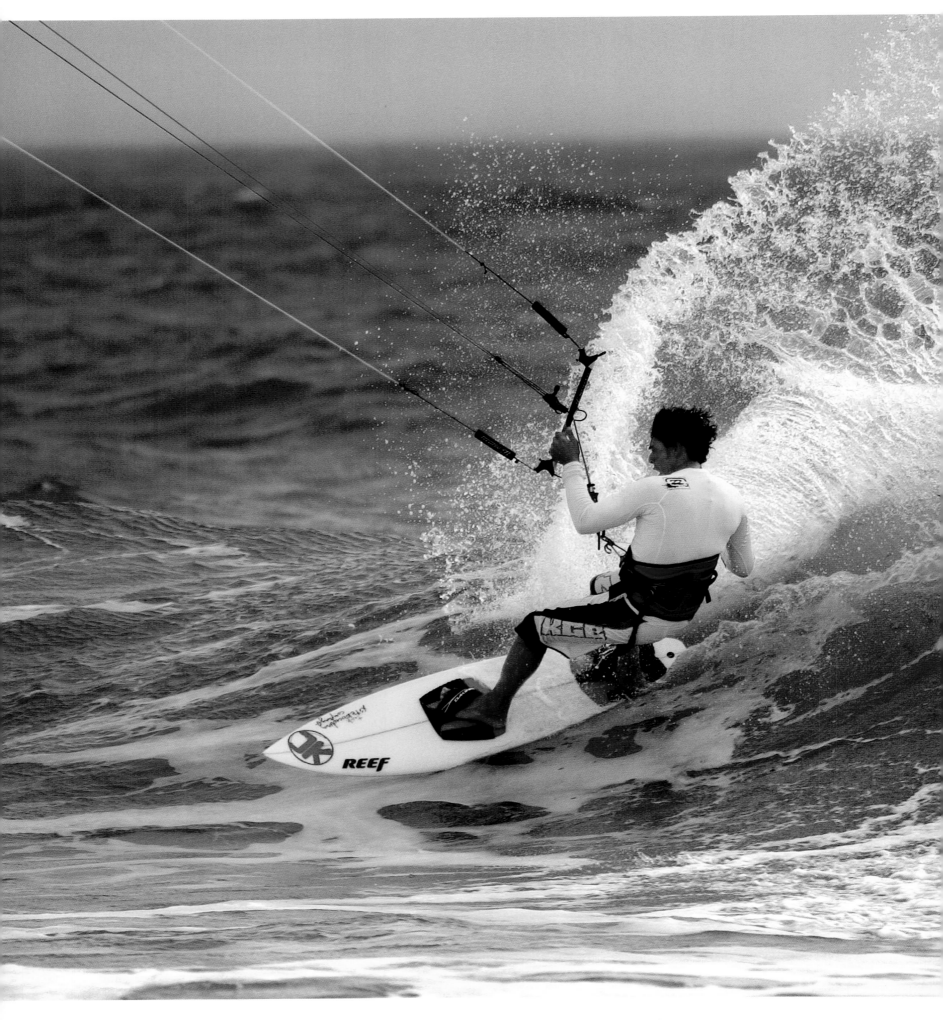

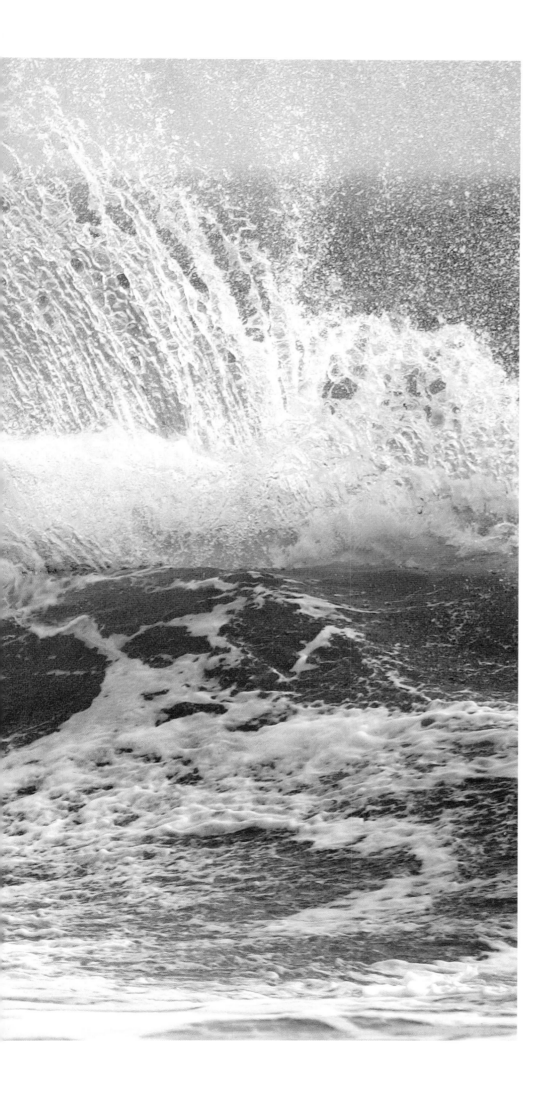

144-145 Kitesurf boards often resemble wakeboards, which is a derivative of water skiing. But in the waves nothing is worth more than a design inspired by surfing.

146-147 Several wings flying in the skies of Maui. A perfect ballet that, every day, showcases the strength of the wind.

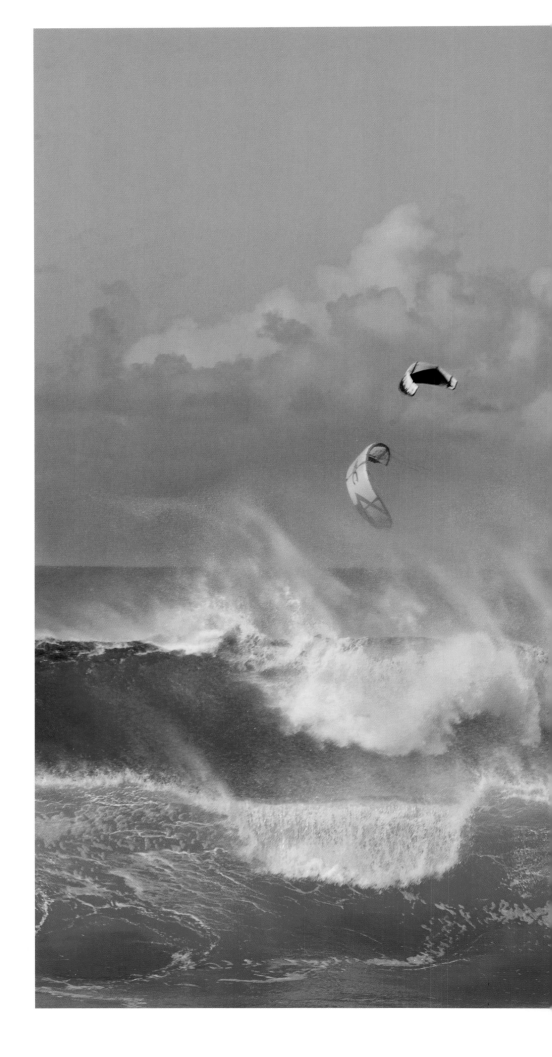

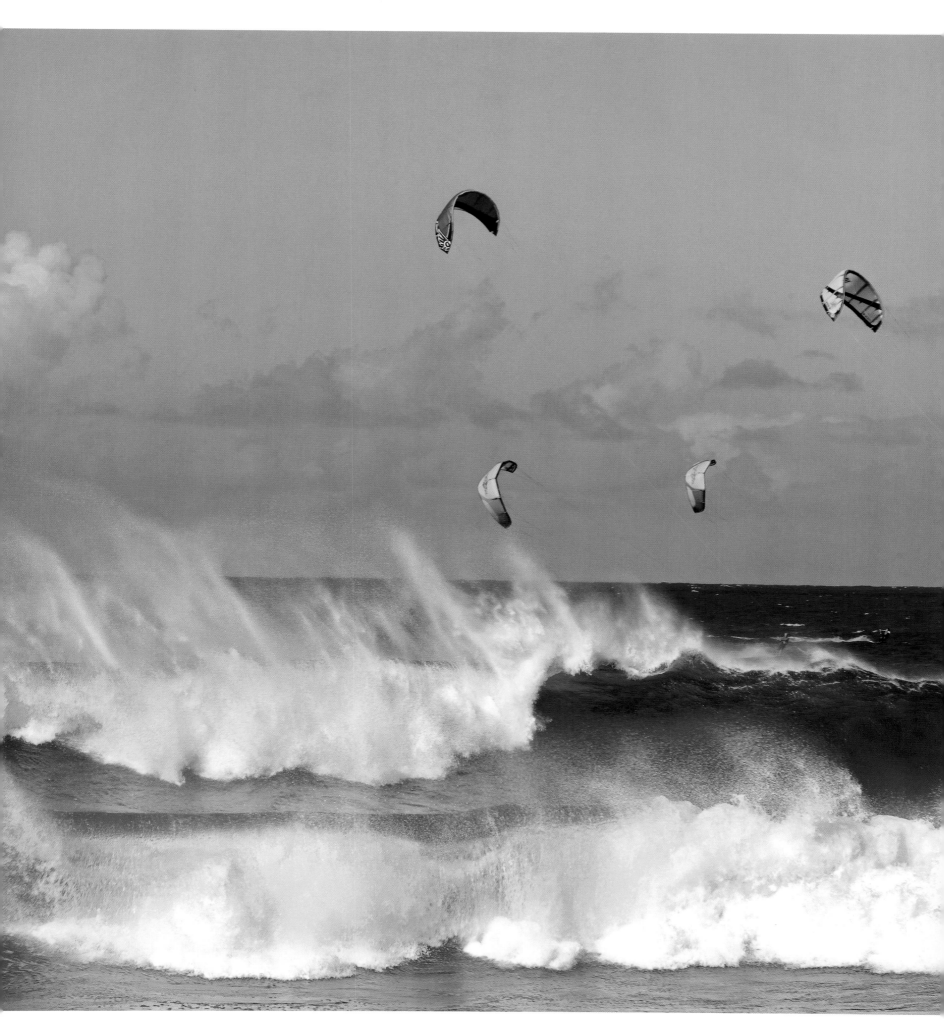

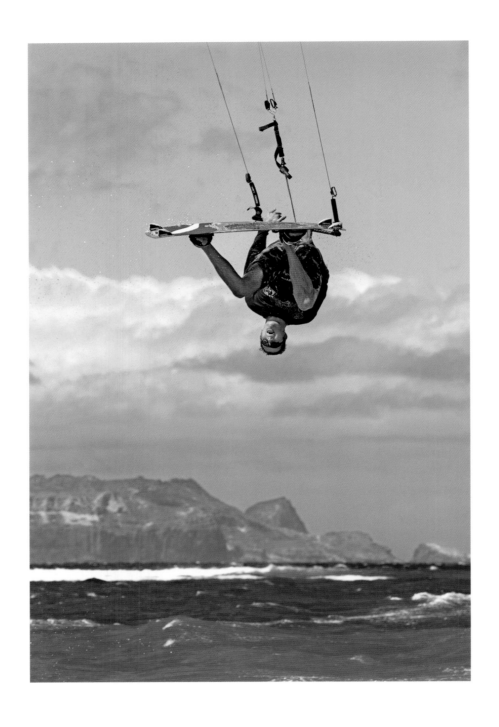

148 THE SUCCESS OF KITESURFING LIES IN ITS ABILITY TO DRAMATICALLY PROPEL THE RIDER MANY FEET IN THE AIR.

149 A VERITABLE TECHNICAL REVOLUTION, THE KITESURF CONTROL BAR LETS KITESURFERS WIND AND UNWIND LINES ACCORDING TO THE FORCE OF THE WIND.

151 IF YOU USED PHOTO-EDITING SOFTWARE TO REMOVE THE LINES AND THE KITE OF THE KITESURF, YOU'D BE LEFT WITH A PICTURE OF A SURFER RIDING WITHOUT WAVES.

152-153 A KITESURFER MAY BE LIKE A GYMNAST WHO'S ALWAYS IN THE AIR, BUT HE IS, ABOVE ALL ELSE, A SURFER ROOTED IN THE CLASSIC TRADITION OF THE SPORT.

154-155 KITESURFING IN TEAHUPOO, THE MOST FAMOUS AND DANGEROUS SURFING SPOT ON THE PLANET.

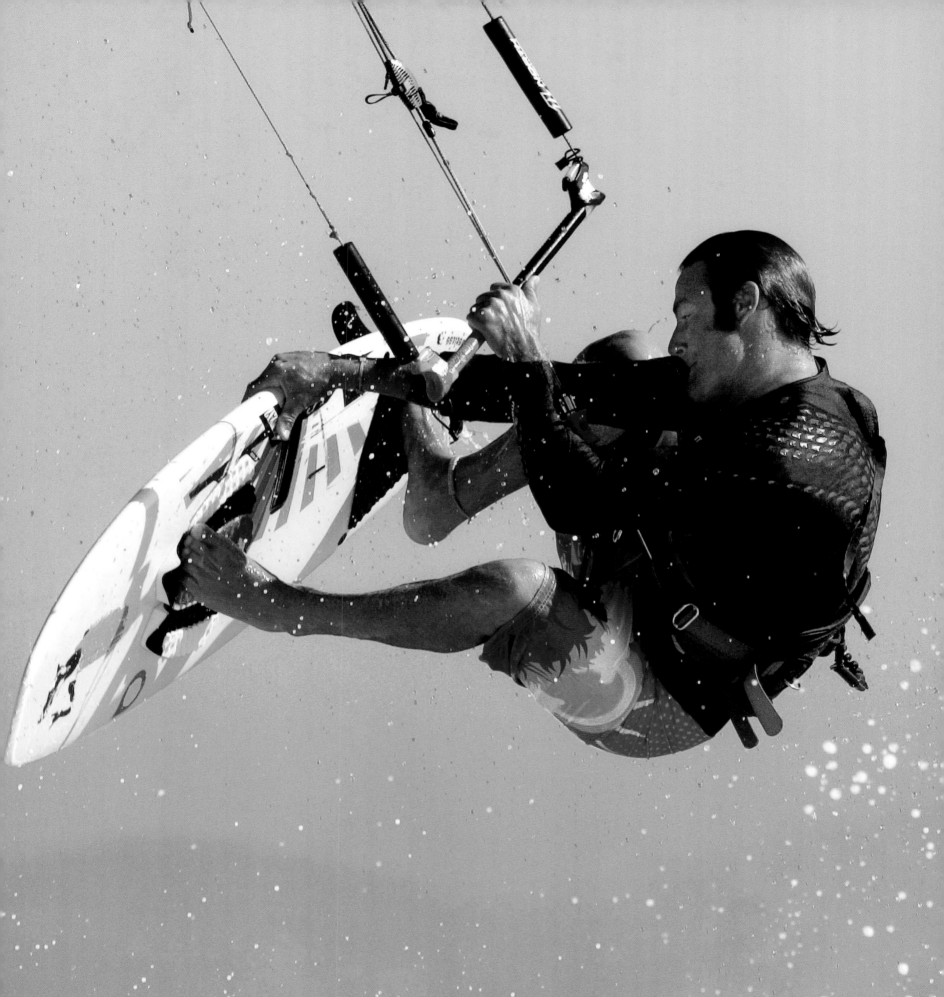

"TRUE COURAGE IS LIKE A KITE —
A CONTRARY WIND RAISES IT HIGHER."

JOHN PETIT-SENN

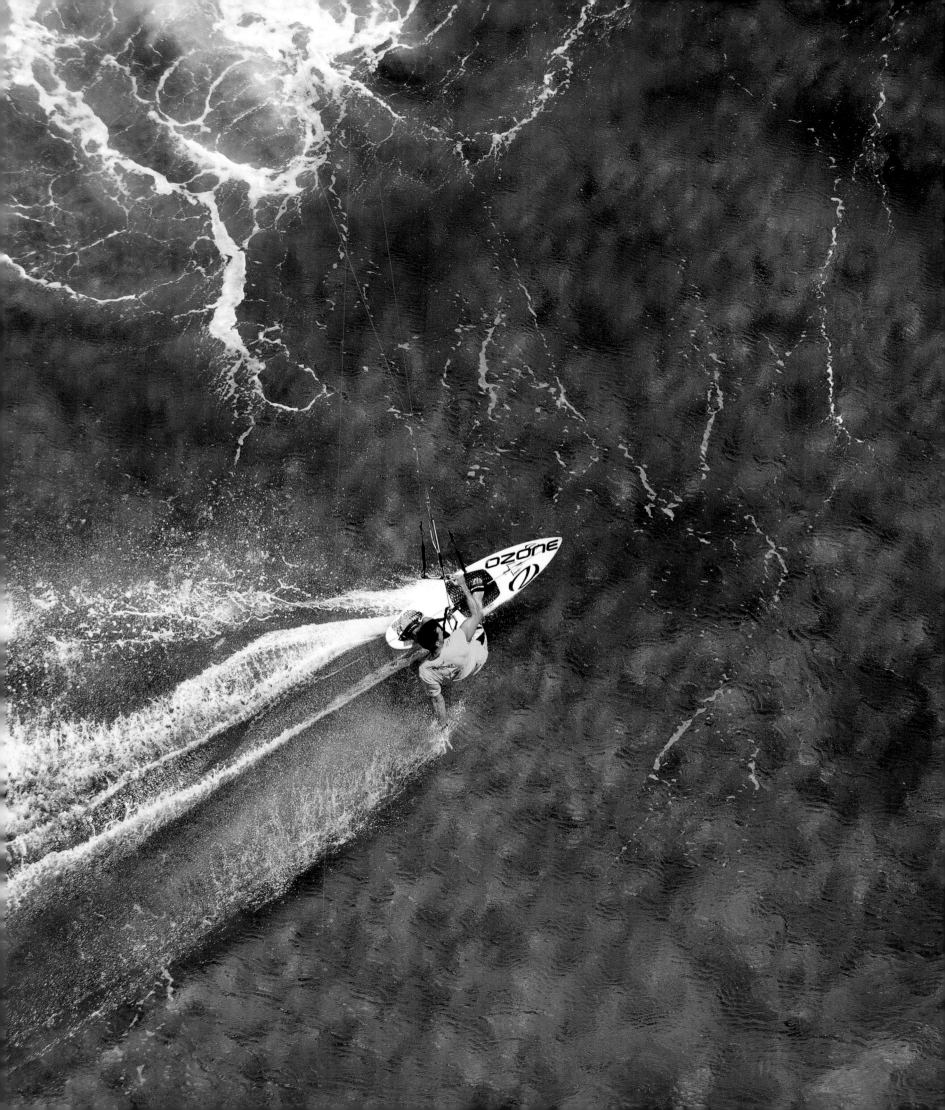

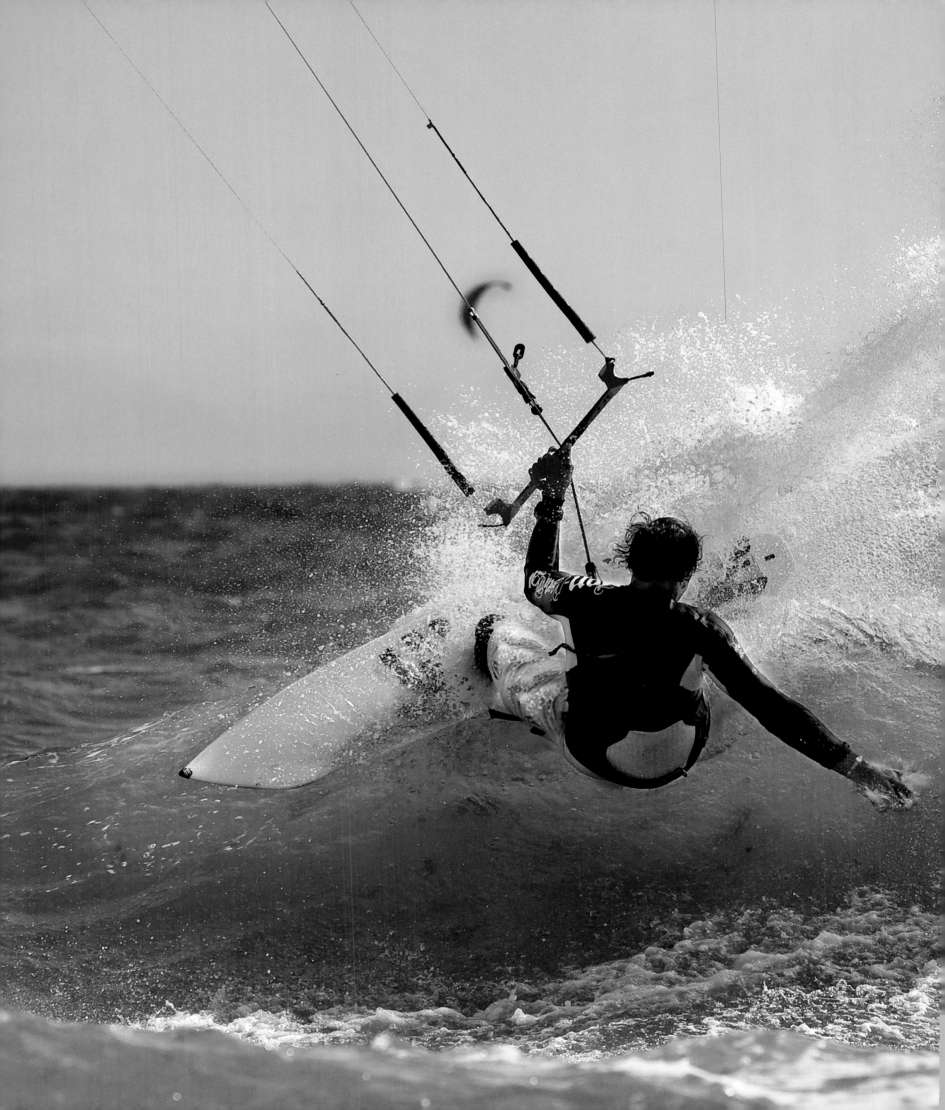

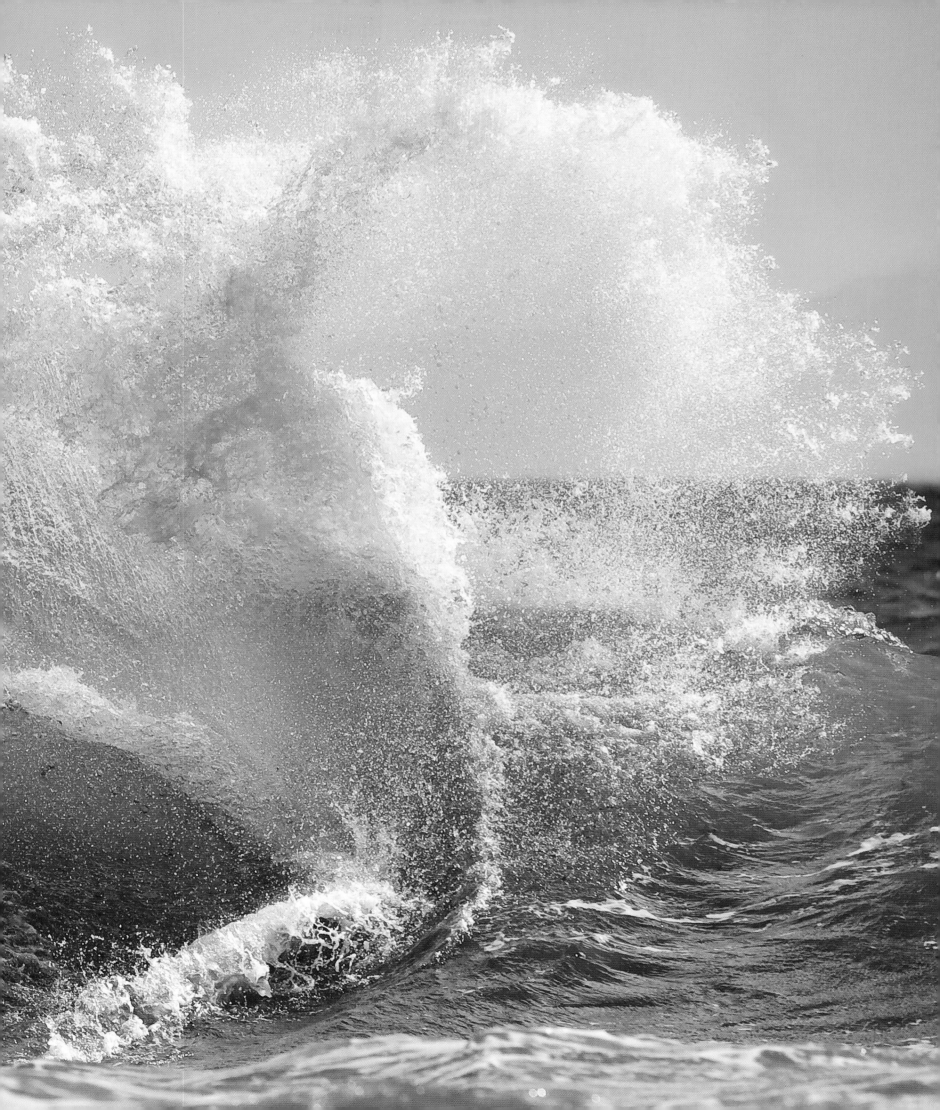

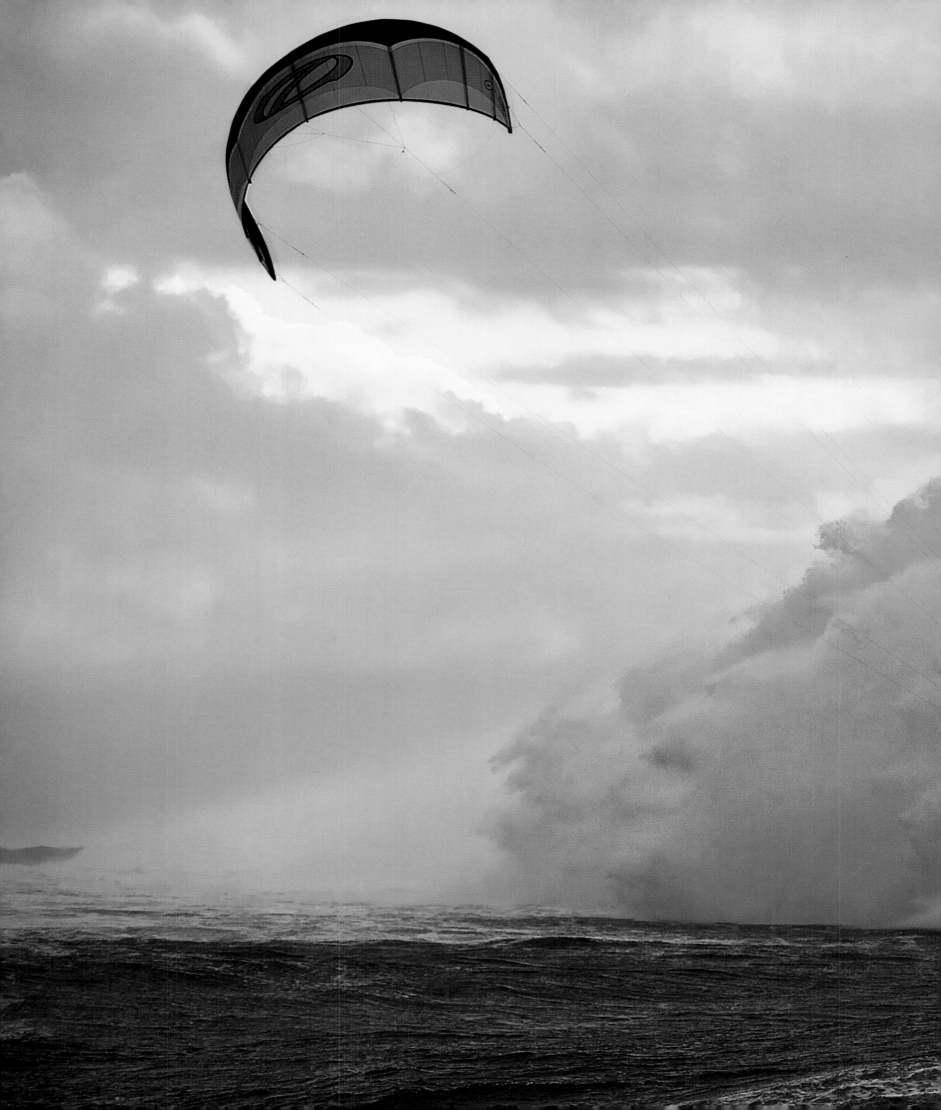

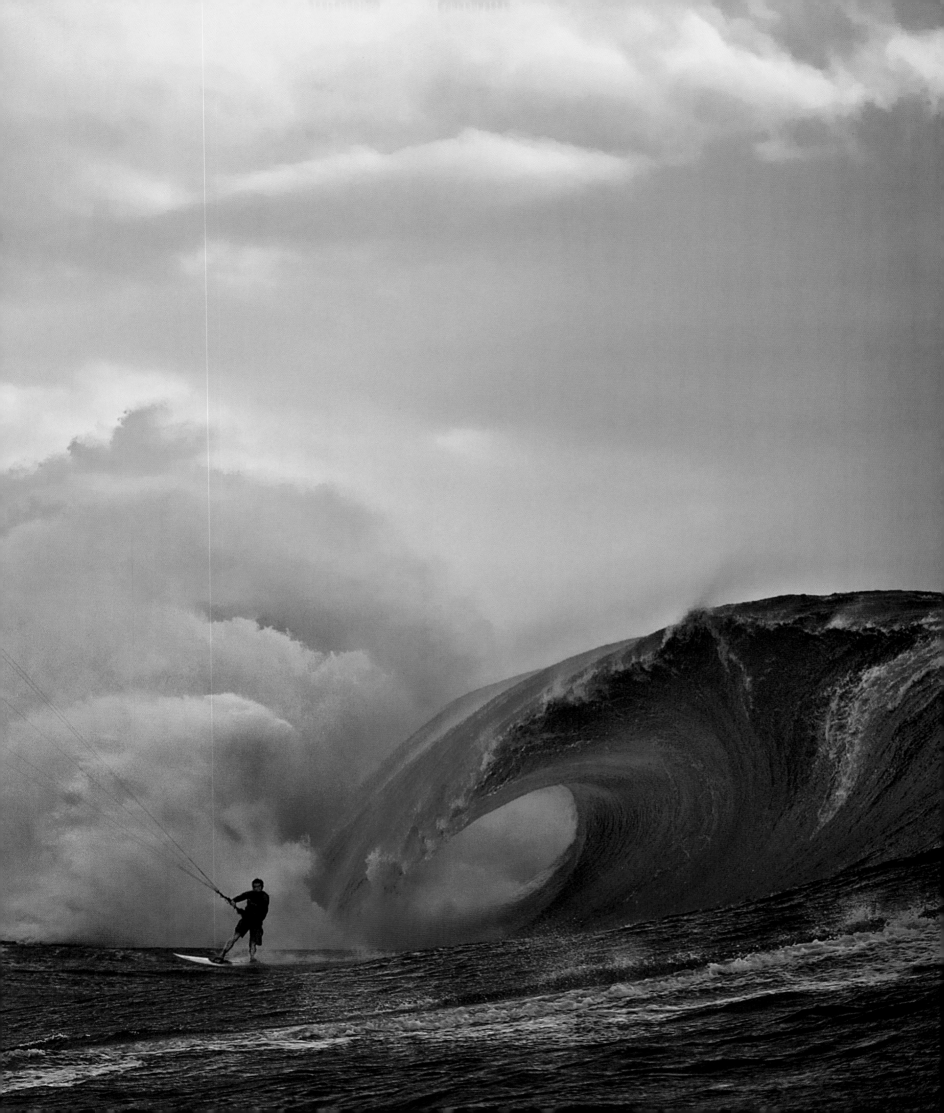

THE POWER OF IMAGINATION

"WHAT DOES IT MEAN TO BE MODERN? BEING MODERN IS NOT A TREND. IT IS NOT A STATE OF BEING. WE MUST UNDERSTAND HISTORY SINCE HE WHO UNDERSTANDS HISTORY KNOWS HOW TO ESTABLISH A CONTINUITY BETWEEN WHAT WAS, WHAT IS AND WHAT WILL BE."

LE CORBUSIER

DOES MAN'S GREATEST ABILITY LIE IN HIS EXTRAORDINARY POWER OF IMAGINATION? THIS WAS THE OPINION OF ALBERT EINSTEIN, WHO BELIEVED THAT IMAGINATION WAS "MORE IMPORTANT THAN KNOWLEDGE." BUT HAVING IMAGINATION ALSO MEANS HAVING MEMORY. FOR SURFERS, UNDERSTANDING THE PAST AND CONNECTING SPIRITUALLY WITH THE ORIGINAL RIDERS OF THE SPORT INCREASES THE INSTINCT AND DESIRE FOR FUTURE CHALLENGES. RISING TO THE CHALLENGE OF WAVES MEANS MOBILIZING ALL THE RESOURCES OF INTELLIGENCE, IMAGINATION, SENSATION AND MEMORY TO PROPERLY BALANCE WHAT WE SEEK WITH WHAT WE KNOW.

"I BELIEVE THAT I AM NOT THE ONLY CRAZY ONE TO HAVE THIS RIDICULOUS DESIRE TO SURF LIKE AN HAWAIIAN KING," SAYS AUSTRALIAN TOM WEGENER, THE CHIEF ARCHITECT BEHIND THE REVIVAL OF THE *ALAIA* — REPLICAS OF THE SOLID AND FIN-LESS WOOD BOARDS USED BY THE ANCIENT POLYNESIANS. HIS CRUSADE BEGAN IN 2004 AFTER A VISIT TO THE BISHOP MUSEUM IN HAWAII, WHICH HAD RALLIED THOUSANDS OF SURF FANS INTRIGUED BY THESE PRIMITIVE BOARDS. *"IT ISN'T NOSTALGIA THAT GUIDES ME, BUT CURIOSITY,"* WEGENER SAYS. *"KNOWING WHERE WE COME FROM HELPS US UNDERSTAND WHO WE ARE. I LOVE THE CULTURAL DIMENSION OF ALAIA: CHOOSING SPECIES OF WOOD, REVIVING ANCIENT CRAFTS, MAKING THINGS THAT WILL SURVIVE ME AND THAT PEOPLE CAN STILL SURF IN A CENTURY. I'M VERY PROUD OF THAT. BUT WHAT FASCINATES ME MOST IS THIS SEARCH FOR A RIDE THAT'S TOTALLY NEW FOR US, BUT THAT IS STILL A PART OF THE GENETIC MAKEUP OF SURFERS."*

THE ALAIA'S STYLE ALSO FITS IN WITH TODAY'S ENVIRONMENTAL AWARENESS AND ANTI-CONSUMERIST MOOD. THE MANUFACTURE OF THESE BOARDS IS IN FACT MUCH MORE ENVIRONMENTALLY FRIENDLY THAN MODERN SURFBOARDS, WHICH ARE GENERALLY MADE FROM POLYURETHANE FOAM AND POLYESTER RESIN. ALAIA BOARDS ARE INEXPENSIVE, RECYCLABLE AND BIODEGRADABLE BUT ALSO VERY FAST AND SURPRISINGLY VERSATILE ON THE WATER. *"THE ALAIA DOESN'T FLOAT LIKE THE CURRENT BOARDS AND THE ABSENCE OF A FIN REQUIRES YOU TO TOTALLY RETHINK WHAT WE KNOW ABOUT SUPPORT AND TRAJECTORIES,"* SAYS BRIAN KEAULANA, A BELIEVER RIGHT FROM THE START AND AN HEIR TO A GREAT DYNASTY OF HAWAIIAN SURFING LEGENDS. *"YOU HAVE TO FOCUS ON THE WAVE, FINDING THE BEST PLACEMENT TO SURF IT. I THINK ALL THOSE WHO HAVE TRIED THESE GORGEOUS ANTIQUES HAVE COME TO BETTER UNDERSTAND THE OCEAN AND SURF CULTURE."* BUILDING A REPLICA OF A

BOARD FROM A BYGONE ERA, THEREFORE, SHOWS A RESPECT FOR TRADITION AS WELL AS AN OPEN MIND. "*THE ALAIA IS A BOARD THAT GOES VERY FAST, IT'S AN UNBEATABLE FEELING,*" SAYS WEGENER. "*THIS DESIGN IS VERY FLAT AND IT REQUIRES INCREDIBLE FINESSE. THE RESULT IS A BOARD THAT DOES NOT MOVE THE SLIGHTEST DROP OF WATER. IT'S MAGIC, A BIT LIKE FLYING ON THE SURFACE. THIS RETURN TO GRACE FOR A FORGOTTEN RIDE PROVES THE IMPORTANCE OF BEING CREATIVE, FOR THE 21ST CENTURY WILL NOT BE ABOUT SPEED, BUT IDEAS. SPEED IS NOTHING WITHOUT CONTENT.*"

THIS SUBTLE EQUATION OF SPEED AND BALANCE WHICH EPITOMIZES THE SURFING PHILOSOPHY MAKES MOST SENSE IN THE REVOLUTIONARY DISCIPLINE OF TOW IN SURFING. THE SPEED, POWER AND AMOUNT OF WATER THAT MOVES IN A WAVE ARE EXPONENTIAL WITH RESPECT TO ITS SIZE. THEREFORE, IF THE LENGTH OF THE BOARD FAVORS THE PADDLE, AND TAKING INTO ACCOUNT THE FACT THAT A WAVE CAN EXCEED 12 MPH (20 KM/H) AT THE TIME OF BREAKING, THERE IS A LIMIT, ESTIMATED AT 25 FEET (7.5 M), WHICH BY A SIMPLE LAW OF PHYSICS PROHIBITS THE RIDER, REGARDLESS OF HIS POWER AND TECHNIQUE, TO ROW FAST ENOUGH TO POSITION HIMSELF ON THE SURFABLE PART OF THE WAVE. WHEN IT COMES TIME TO GET UP, A SURFER'S MOMENTUM WILL OFTEN BE NO MATCH FOR THE ENERGY OF THE WAVE AND HE WILL GET STUCK AT THE TOP BEFORE BEING THROWN INTO THE ABYSS. THIS IS THE "UNRIDDEN REALM."

FOLLOWING THE EXAMPLE OF SOME WINDSURFERS WHO, THANKS TO THE SPEED GENERATED BY THE WIND, RODE IMPOSSIBLE-TO-SURF WAVES IN THE 1980S, THREE PIONEERS DEVELOPED THE ART OF TOW IN SURFING IN 1992. LAIRD HAMILTON, DARRICK DOERNER AND BUZZY KERBOX, FAMOUS THRILL-SEEKING HAWAIIAN WATERMEN, FIRST USED A ZODIAC AND A PERSONAL WATERCRAFT FOR WATER SKIING TO CATAPULT, WHILE IN A STANDING POSITION, ON WAVES THAT HAD NOT YET ARRIVED. BEFORE THEM, IN 1986, HERBIE FLETCHER HAD ALREADY TOWED SOME OF THE BEST SURFERS OF THE TIME — TOM CARROLL, MARTIN POTTER AND GARY ELKERTON — AT PIPELINE ON THE HANDLEBARS OF ONE OF THE FIRST MASS-PRODUCED KAWASAKI JET SKIS. IF THIS DIDN'T EXACTLY SPARK A REVOLUTION, IT NEVERTHELESS LEFT AN IMPRESSION ON LAIRD'S GANG, WHO WOULD REMEMBER IT IN THE WINTER OF '94 WHEN THEY BARTERED THEIR UNWIELDY ZODIAC FOR POWERFUL AND RESPONSIVE WAVERUNNERS. UNLIKE SURFING, WHICH IS IN ESSENCE A SPORT FOR THE INDIVIDUAL, TOW IN SURF-

ING REQUIRES TEAMWORK AND STRATEGY TO ENSURE PERFORMANCE AND SAFETY. THE TOWED SURFER AND HIS DRIVER MUST WORK TOGETHER, MAKING CRUCIAL DECISIONS IN A SPLIT SECOND WHILE HUGE WAVES SURROUND THEM. AT THE OPTIMUM MOMENT, THE RIDER LETS GO OF THE ROPE AND KEEPS THE ADVANTAGE OF SPEED ON THE FULLY-FORMED LIQUID MONSTER.

AFTER EXPERIMENTING WITH THIS REVOLUTIONARY TECHNOLOGY ON THE REEFS OFF OAHU, HAWAII, A CORE GROUP OF VERSATILE SURFERS AND SEASONED WINDSURFERS COMPOSED OF HAMILTON, DOERNER, KERBOX, MARK ANGULLO, PETE CABRINHA, DAVE KALAMA, MIKE WALTZ AND RUSH RANDLE CONTINUED TO WORK ON IT. AT THE ADVICE OF THE LEGENDARY GERRY LOPEZ, THEY DECIDED TO CHARGE THE WAVE OF PEAHI ON THE ISLAND OF MAUI, WHICH IS NICKNAMED "JAWS" FOR ITS DANGEROUSNESS AND SEEMINGLY LIMITLESS SIZE. "IN THE TRADITIONAL OF BIG WAVE SURFING, WE USED TO TAKE ONLY THREE OR FOUR WAVES OVER SEVERAL HOURS, AND THE SIZE OF BOARDS, DESIGNED MORE FOR PADDLING THAN FOR SURFING, WAS A HANDICAP," SAYS HAMILTON. "FROM THE BEGINNING OF TOW IN, WE REALIZED THAT WE COULD NOW TAKE TEN TIMES AS MANY WAVES WITH TEN TIMES LESS EFFORT THAN TRADITIONAL SURFERS, BUT NOT UNTIL JAWS DID WE REALLY REALIZE THAT IT WAS NOW POSSIBLE TO SURF WAVES OF ANY SIZE. IT WAS A REVELATION."

VERY QUICKLY, THE MEDIA SEIZED ON THE PHENOMENON AND INSANE 60-FOOT (18 M) WAVES MONOPOLIZED THE COVERS OF MAGAZINES. JAWS EVEN APPEARED ON THE COVER OF NATIONAL GEOGRAPHIC. SUDDENLY, NOTHING WAS IMPOSSIBLE AND SOME BEGAN TO DREAM OF ONE DAY SURFING A WAVE LARGER THAN 100 FEET (30 M). ON JANUARY 28, 1998, HAWAIIAN KEN BRADSHAW WAS TOWED ON A MONSTER ESTIMATED AT 85 FEET (26 M), A WORLD RECORD.

THE SAME WEEK, TOW IN SURFING APPEARED IN CALIFORNIA ON THE MAVERICKS SPOT, WHICH WOULD BECOME SOMETHING OF A TEMPLE FOR TOW IN DEVOTEES. BIG WAVE RIDING, WHICH HAD STALLED SINCE THE 1960S, REGAINED ITS GLOBAL AURA, AND THE XXL CHALLENGE, WHICH REWARDS A $50,000 (36,000 EURO) PRIZE TO WHOEVER RIDES THE BIGGEST WAVE OF THE WINTER, ASSUMED A ROLE AS THE OSCARS OF SURFING. ON AUGUST 17, 2000, HAMILTON SURVIVED THE MOST INCREDIBLE WAVE OF ALL TIME AT TEAHUPOO ON THE PENINSULA OF TAHITI. A MUTANT TUBE, AS WIDE AS IT WAS HIGH AND WHICH JOURNALISTS SOON

CALLED THE MILLENNIUM WAVE, BROUGHT THE HAWAIIAN GLORY AND A PLACE IN HISTORY THANKS TO A BALANCING ACT INCHES AWAY FROM A REEF AS SHARP AS A BLADE. AFTER A SHORT SUICIDAL RIDE ON THE RAZOR'S EDGE, HAMILTON, PROJECTED BY AN INCREDIBLY VIOLENT BLAST, REALIZED HE NOT ONLY JUST RODE THE WAVE OF HIS LIFE, HE HAD COMPLETED HIS QUEST TO CONQUER THE UNSURFABLE. HIS PARTNER, DOERNER, LATER SAID OF THAT ETERNAL MOMENT: *"THERE WAS AT THAT TIME ONLY ONE MAN ON EARTH ABLE TO SURF A WAVE LIKE THAT. AND IF YOU WANT PROOF, THERE HE WAS ON TOP OF IT."*

IF ALAIA EMBODIES THE MEMORY OF MOVEMENT IN SURFING AND TOW IN THE STRENGTH OF IMAGINATION, THERE IS A DISCIPLINE THAT FINDS ITS ORIGIN MIDWAY BETWEEN THESE TWO PHILOSOPHIES: STAND UP PADDLE, OR SUP. DESIGNED TO BE MANEUVERED STANDING UP AND USING A PADDLE, SUP HAS ITS ROOTS WITH THE FAMOUS WAIKIKI "BEACHBOYS" — HAWAIIAN INSTRUCTORS WHO INITIATED TOURISTS TO THE JOY OF SURFING IN THE 1920S AND '30S. THESE SURFING NEOPHYTES OFTEN BEGGED FOR A PHOTO OF THEIR FIRST SURFING EXPLOITS BUT, AT THE TIME, PHOTOGRAPHIC EQUIPMENT WAS HEAVY AND CUMBERSOME AND THERE WAS NOTHING TO PROTECT IT FROM SEA WATER. AS THE STORY GOES, ONE OF THE BEACHBOYS DECIDED TO BORROW A PADDLE FROM A CANOE CAPTAIN TO STAND ON HIS BOARD WITH A CAMERA AROUND HIS NECK. THE PHOTOGRAPHS TAKEN THAT DAY, WHICH SHOW SEVERAL SURFERS ON THE SAME WAVE, CAUSED A SENSATION AND SOME WAIKIKI LOCALS MADE THIS FORM OF SURFING THEIR SPECIALTY. LOGICALLY, THIS NEW STYLE WAS CALLED BEACHBOY SURFING AND THE PRACTICE CONTINUED IN HAWAII UP TO THE '60S AND '70S, WHEN LONGBOARDS GOT SHORTER AND CAMERAS BECAME WATERPROOF. BUT SOME BEACHBOYS, LIKE JOHN ZABATOCKY, NO LONGER SURFED ANY OTHER WAY. HE, IN FACT, LIVED LONG ENOUGH TO SEE HIS FAVORITE STYLE BECOME POPULAR WORLDWIDE AND HE EVEN APPEARED AT THE FINAL OF ONE OF THE FIRST STAND UP PADDLE COMPETITIONS OF THE MODERN ERA IN 2007 AT 80 YEARS OF AGE AND ONLY A FEW WEEKS BEFORE HIS DEATH.

THE TREMENDOUS EXCITEMENT CAUSED BY THE RENAISSANCE OF SUP IS REMINISCENT OF THE CONTAGIOUS PASSION FOR WINDSURFING IN THE '70S, BUT THE DIFFERENCE IS THAT SUP IS PROBABLY THE MOST DEMOCRATIC RIDE EVER INVENTED. IT CAN BE PRACTICED ON LAKES OR RIVERS OR ON WAVES RANGING FROM 12

INCHES (30 CM) TO 10 FEET (3 M). JUST A FEW MINUTES OF LEARNING ARE NEEDED TO FAMILIARIZE YOUR-SELF WITH THE BOARD, WHOSE RENAISSANCE DATES BACK TO THE SUMMER IN 2000, WHEN THE HAWAIIAN AR-CHIPELAGO WAS LOW ON WAVES.

SIMULTANEOUSLY, HAMILTON AND DAVE KALAMA ON MAUI AND KEAULANA, MEL PU'U AND BRUCE DE SOTO IN MAKAHA BEGAN TO USE AN OAR TO PADDLE THEIR HUGE TANDEM BOARDS, MOSTLY AS A WAY TO STAY FIT. FOUR YEARS LATER, KEAULANA ORGANIZED HAWAII'S FIRST SUP COMPETITION DURING THE BUFFALO'S BIG BOARD CLASSIC, AND IN FEW MONTHS THE SPORT BECAME EXTREMELY POPULAR WORLDWIDE. *"THE IDEAS FOR NEW WATER SPORTS OR NEW SURFING TECHNIQUES ARE OFTEN BORN OF A DESIRE TO ESCAPE MONOTONY,"* HAMIL-TON SAYS. *"THE PASSION SPEAKS AND WE MUST CONSTANTLY INNOVATE TO KEEP THE SPARK. WHEN A DISCIPLINE THAT I PRACTICE ALONE IN MY CORNER BECOMES POPULAR, I OFTEN WANT TO MOVE ON. THIS IS HOW I CULTIVATE MY UNIQUENESS, AND IF I INSPIRE OTHER SURFERS, EVEN BETTER."*

FOR OCEAN LOVERS WHO ARE INTIMIDATED BY THE WIDE RANGE OF WATER ACTIVITIES AVAILABLE, THERE IS A DISCIPLINE THAT TRANSCENDS THE PURITY OF SURFING AND OUTLASTS ALL OTHERS: BODYSURFING. ITS BASIC PREMISE, EXPERIENCED NOW BY MILLIONS OF BEACH-GOERS, IS TO CATCH THE WAVE AT THE RIGHT TIME AND USE ITS ENERGY TO PROPEL YOURSELF, WITHOUT ANYTHING BETWEEN YOU AND THE WATER. THIS IS THE VERY PRINCIPLE OF SURFING — SURFING IN A PRIMITIVE STATE, BEFORE THE APPEARANCE OF BOARDS. FOR MARK CUNNINGHAM, A HAWAIIAN LIFEGUARD WHO BROUGHT THIS SPORT TO THE LEVEL OF A MAJOR ART FORM, THERE IS NOTHING MORE PURE THAN RELYING ON YOUR FITNESS, FLIPPERS AND SWIMMING EXPERIENCE TO TACKLE A WAVE. *"IT'S SO EXCITING TO BE IMMERSED IN THE OCEAN, TO FEEL THE HARMONY, THE SENSATION OF WATER RUN-NING OVER YOUR CHEST,"* HE SAYS. *"IN BODYSURFING, THE SENSATION OF SPEED IS PHENOMENAL: WE CROSS HUR-RICANES OF FOAM, CURRENTS THAT WANT TO KNOCK YOU DOWN AND YOU MUST LEARN TO REPSECT THEM, WAVES THAT BREAK IN FRONT OF YOU AND FORCE YOU TO DIVE UNTIL THE CHAOS GIVES WAY TO QUIET ... IT'S A SUBLIME METAPHOR FOR LIFE, ITS JOYS AND SORROWS, AND THE COURAGE TO CONFRONT ITS FEARS AND DOUBTS. SURFING IN ALL ITS FORMS IS NOT THE STRUGGLE OF MAN AGAINST NATURE, BUT THE MERGER OF THESE TWO ENTITIES IN A CONSTANT SEARCH FOR BEAUTY. SURFING IS LOVE."*

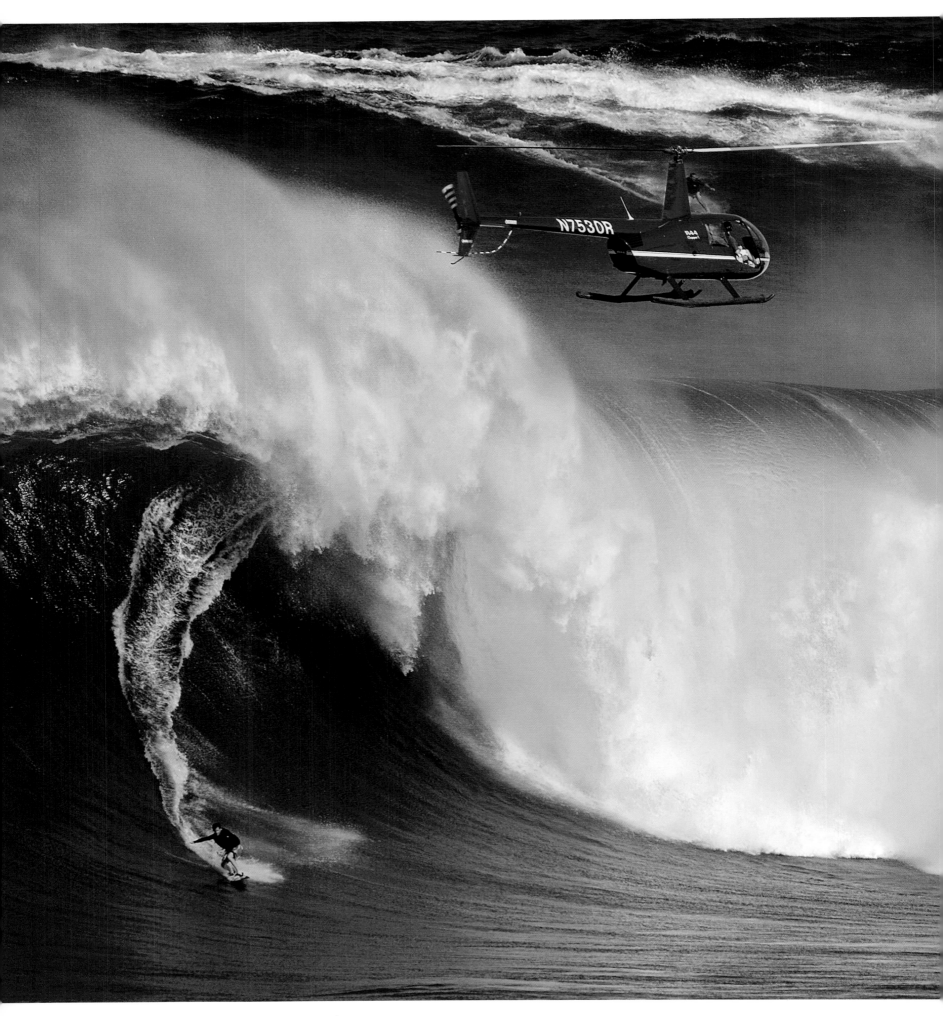

162-163 Jet skis, helicopters and giant waves — Jaws, the original tow in surfing spot, is a veritable waterworld.

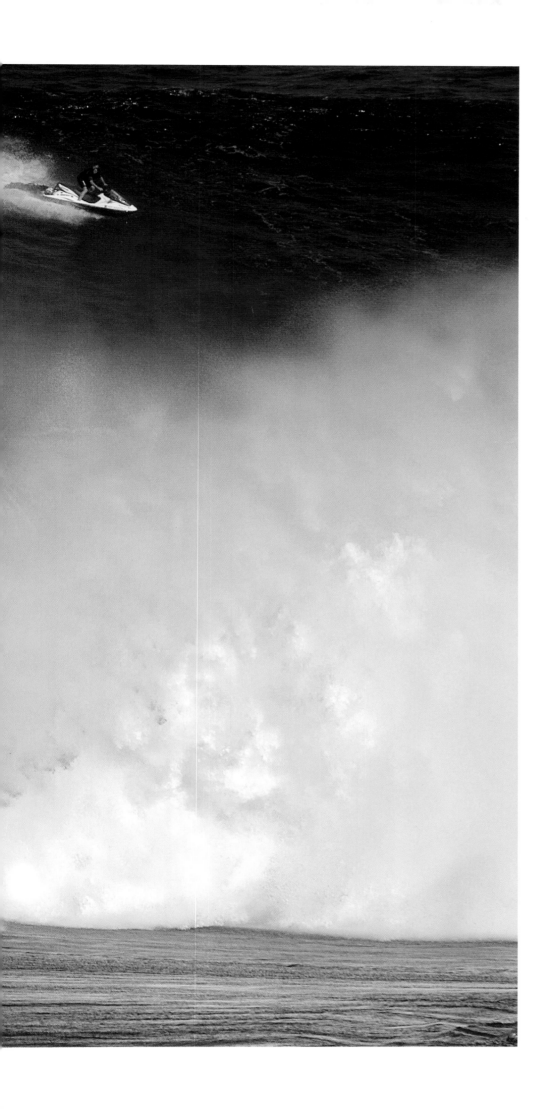

TOW IN

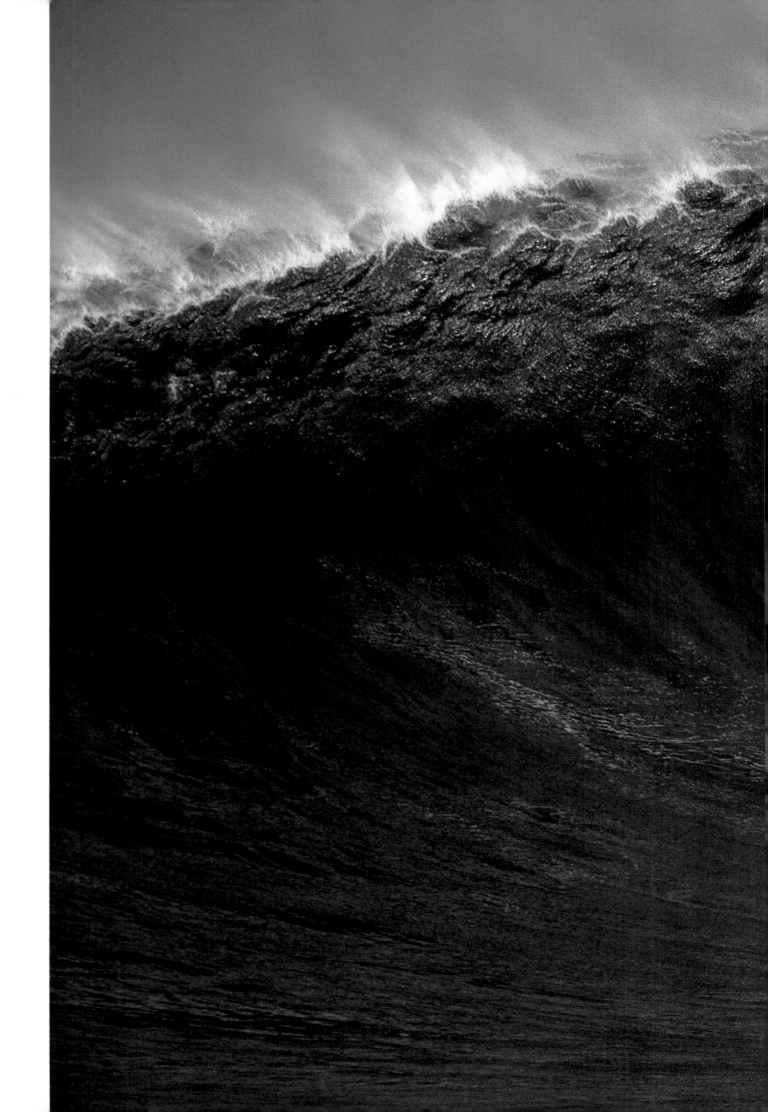

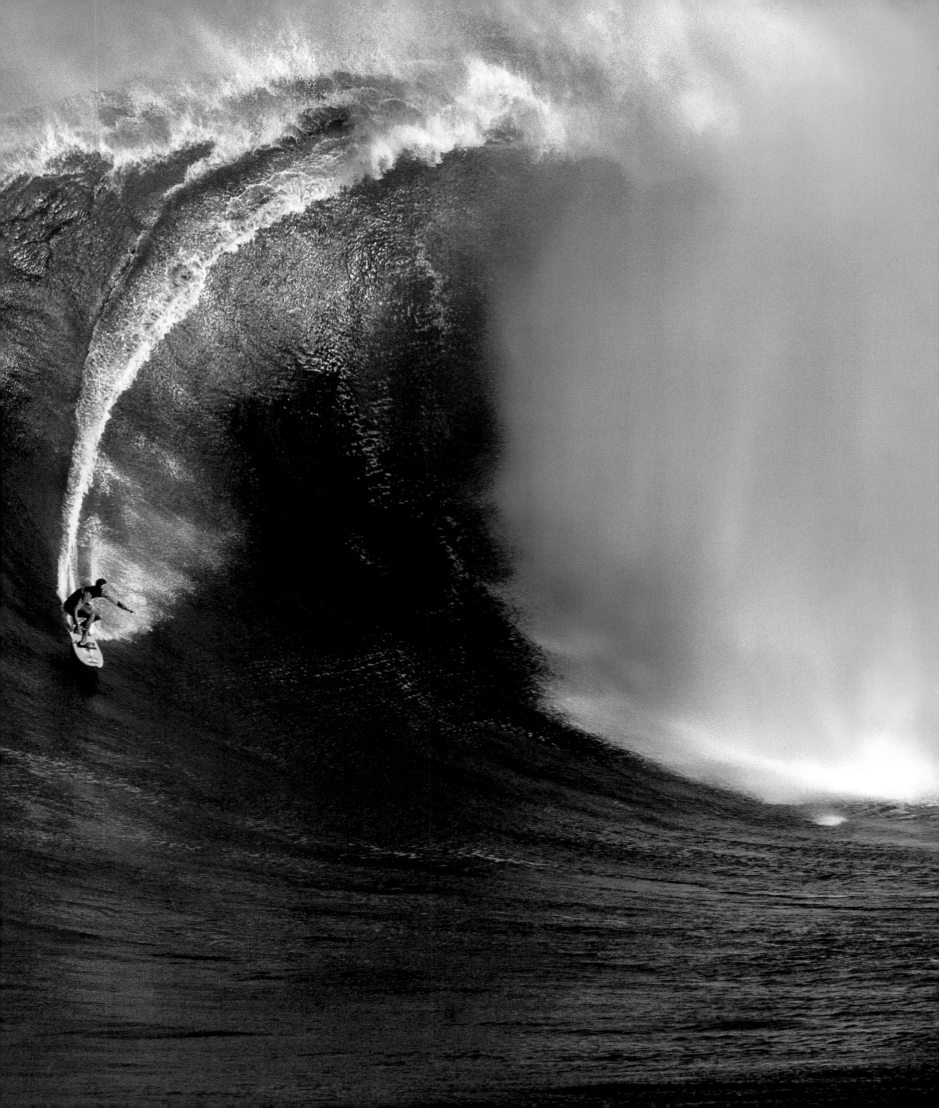

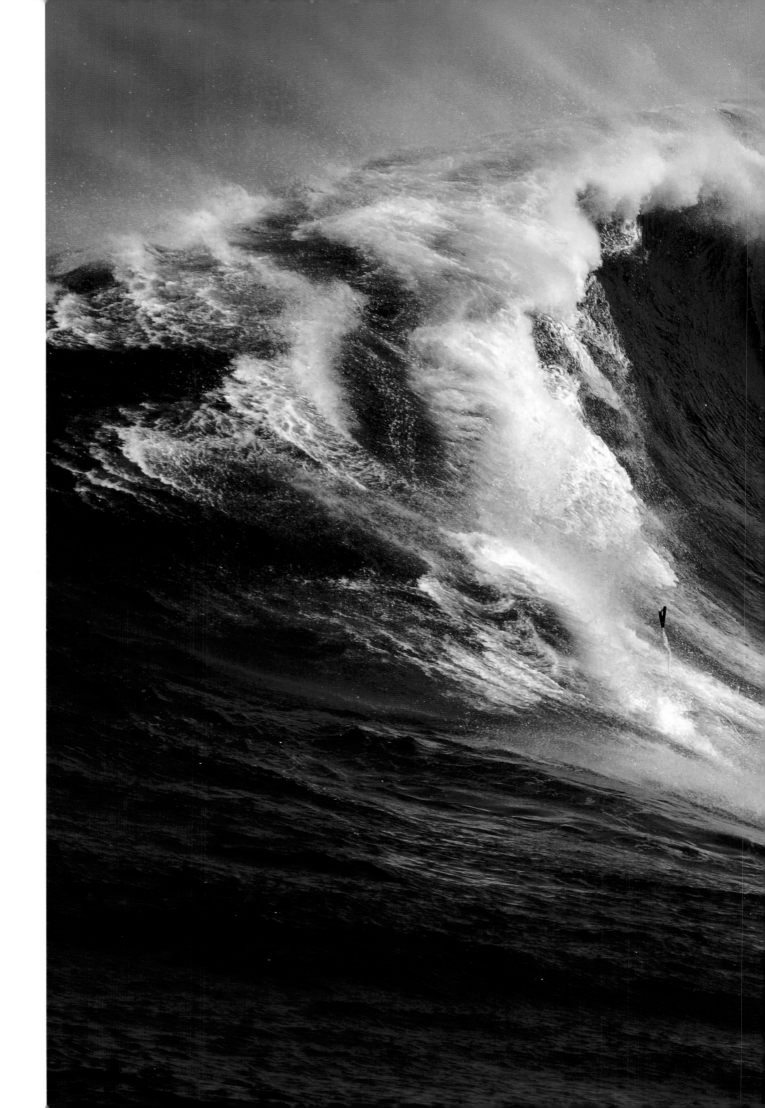

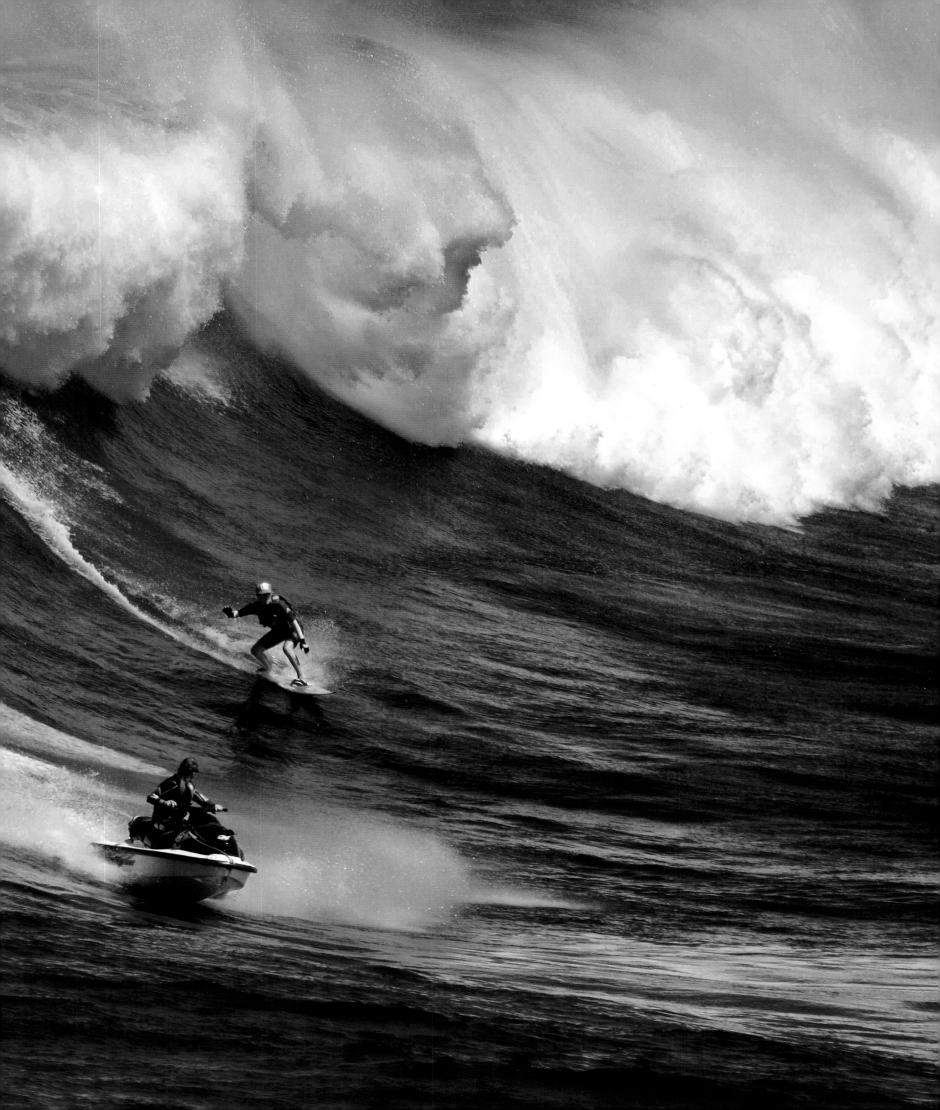

164-165 Knowing that a surfer, with his knees bent, measures approximately 5 feet (1.5 m), one can legitimately estimate the size of this wave to be over 30 feet (10 m).

166-167 This wave is considered small for tow in surfing but it's close to the size limit for paddle in surfing. Note the safety equipment of the surfer and his driver.

168 and **168-169** This photo of Raimana Van Bastolaer in the tube below his own jet ski (the driver had lost control) was seen around the world.

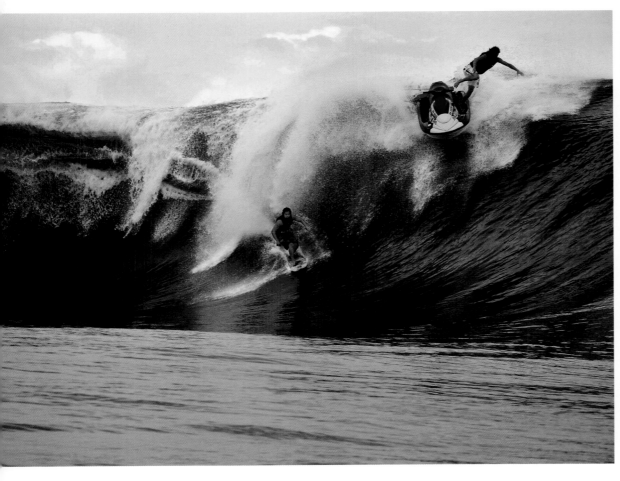

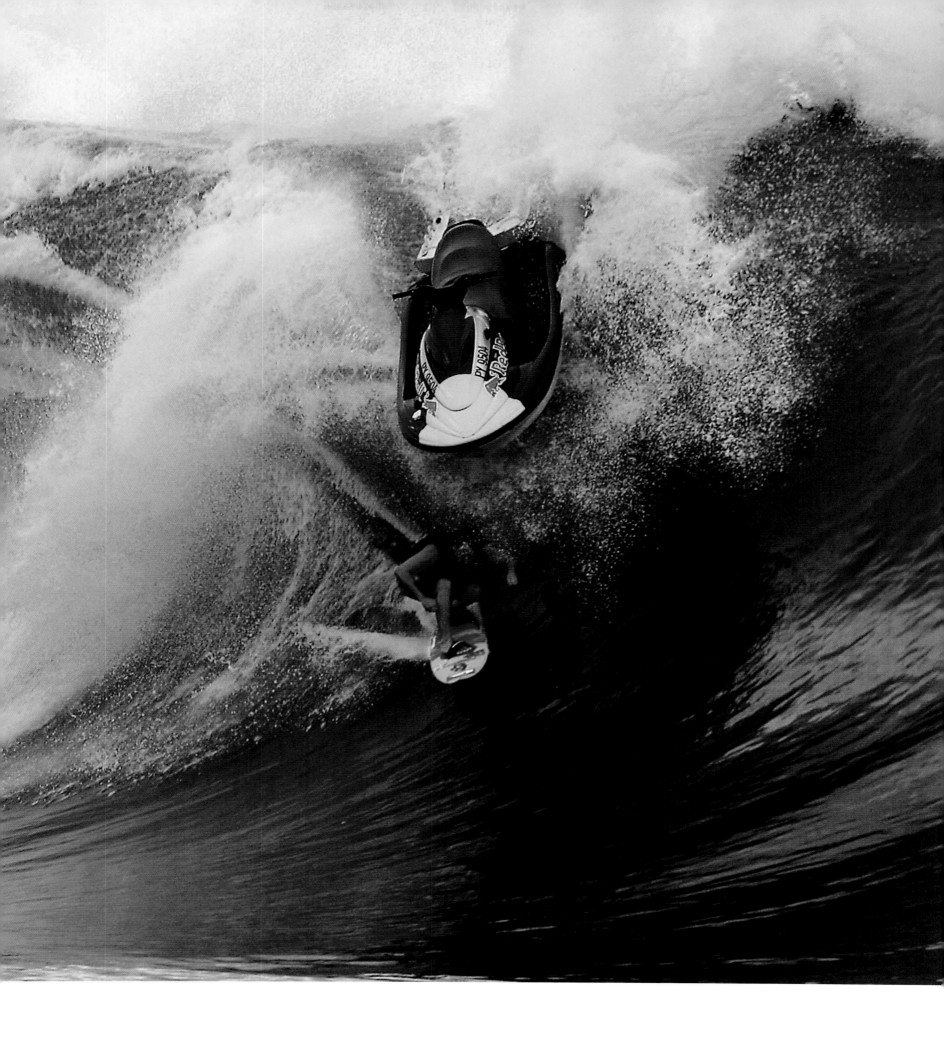

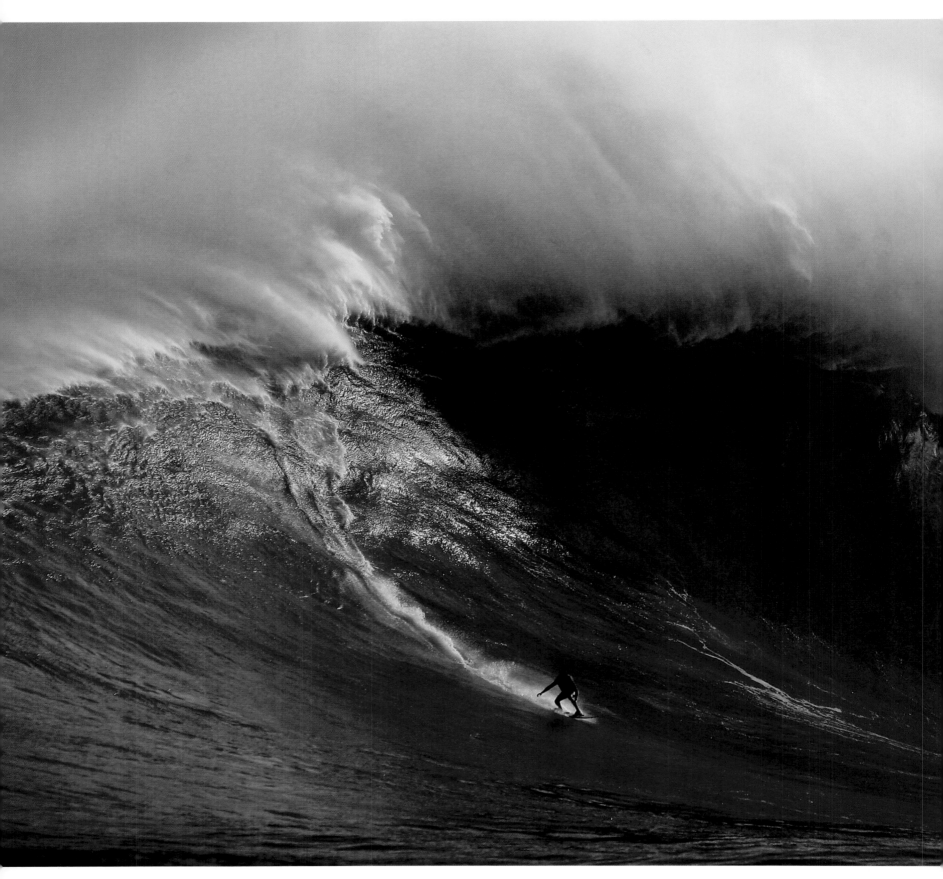

170-171 AND 171 GRANT BAKER IS THE UNDISPUTED KING OF THE CAPE TOWN SPOT IN SOUTH AFRICA, WHERE HE WON THE 2008 XXL TROPHY FOR BIGGEST WAVE OF THE WINTER.

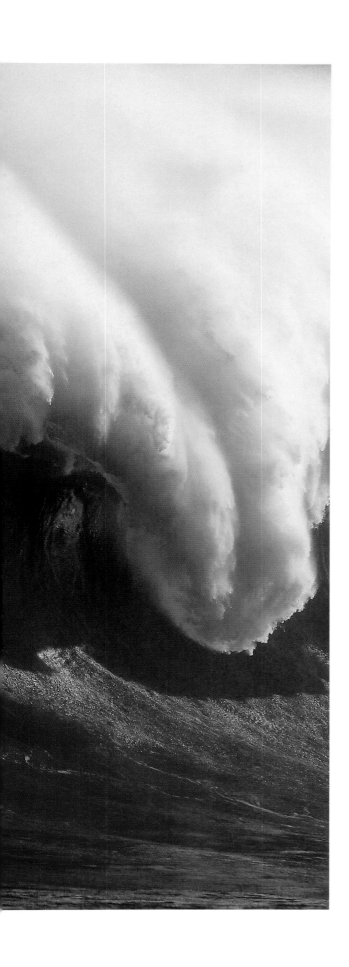

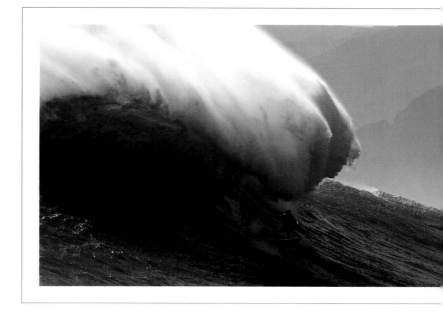

172-173 As if the danger of the feared Cape Town wave is not a sufficient challenge, the water is icy and shark-infested.

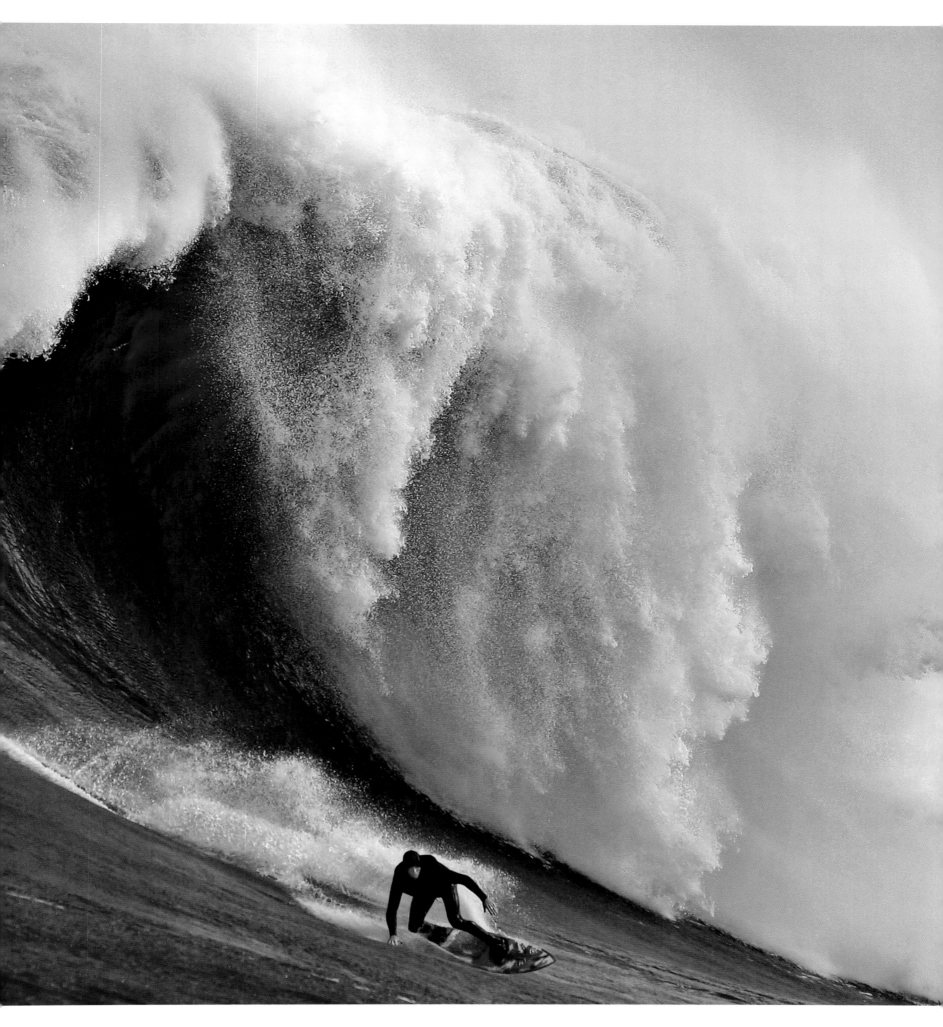

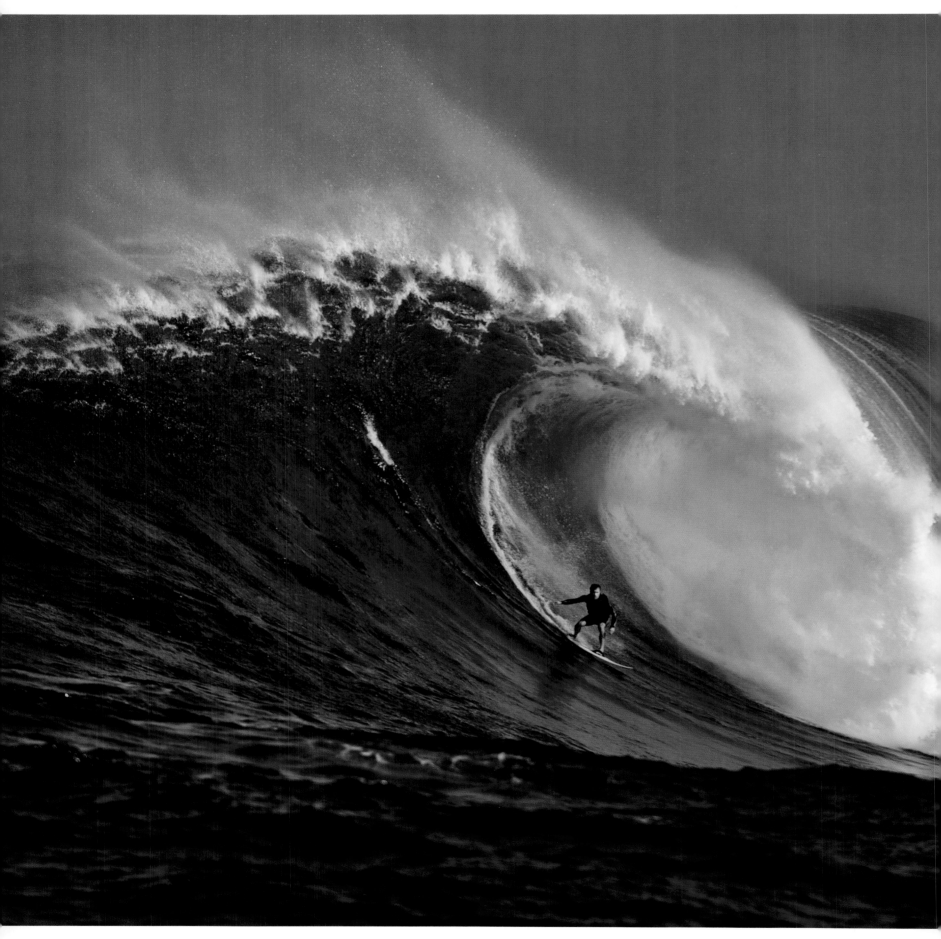

174-175 They say that Brazilian surfers like small waves. Carlos Burle puts that adage to bed at Jaws.

176-177 Laird Hamilton, the co-inventor of tow in surfing, back on the Teahupoo spot where he survived the Millennium Wave in 2000.

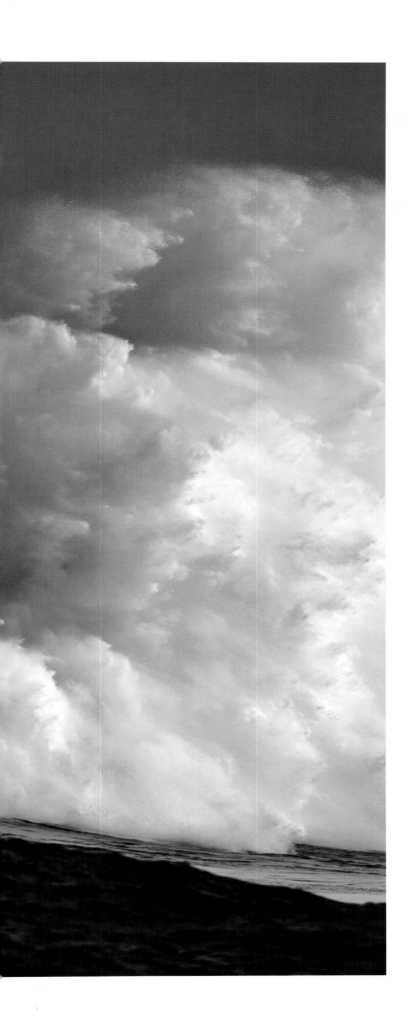

"EXPOSE YOURSELF TO YOUR DEEPEST FEAR;
AFTER THAT, FEAR HAS NO POWER, AND THE FEAR
OF FREEDOM SHRINKS AND VANISHES. YOU ARE FREE."

JIM MORRISON

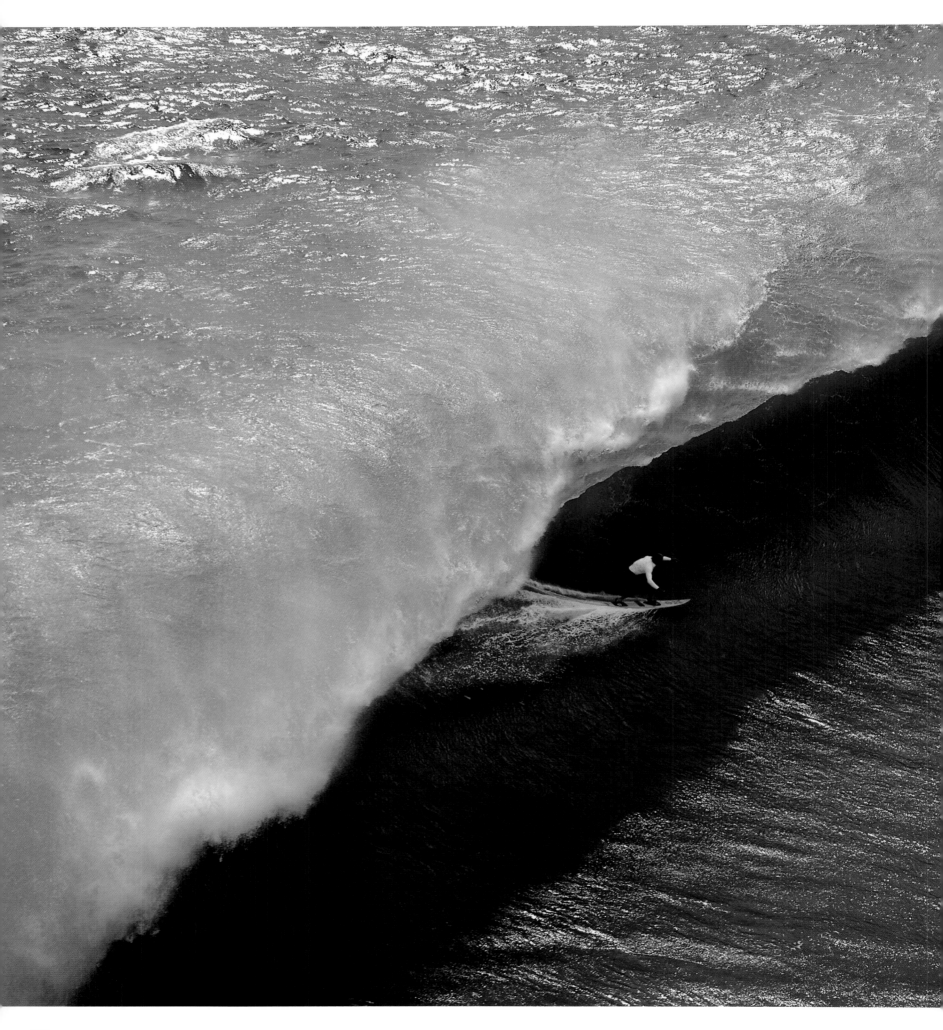

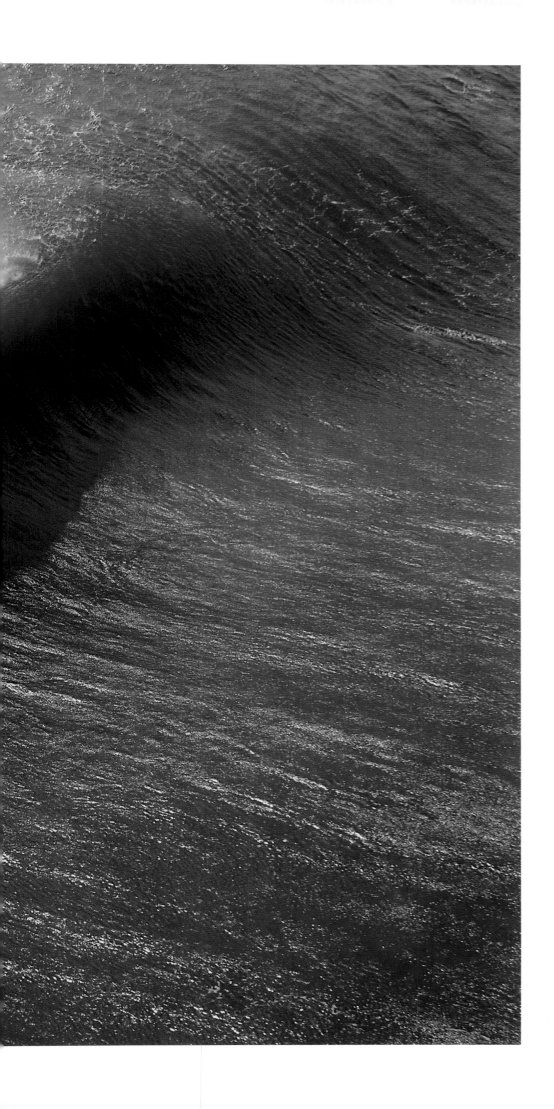

"WE LAY IT ALL DOWN, INCLUDING
WHAT OTHERS CALL SANITY, FOR JUST
A FEW MOMENTS ON WAVES LARGER
THAN LIFE. WE DO THIS BECAUSE WE
KNOW THERE IS STILL SOMETHING
GREATER THAN ALL OF US. SOMETHING
THAT INSPIRES US SPIRITUALLY."

LAIRD HAMILTON,
BIG WAVE RIDER

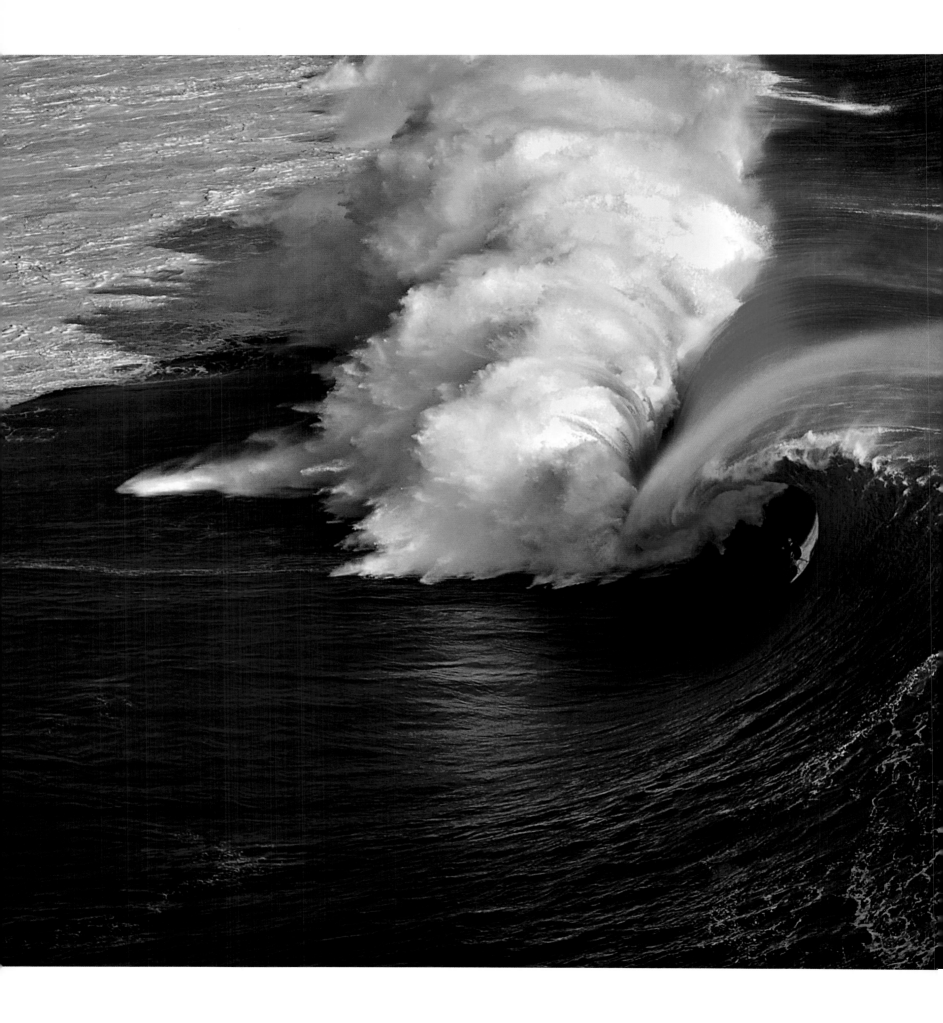

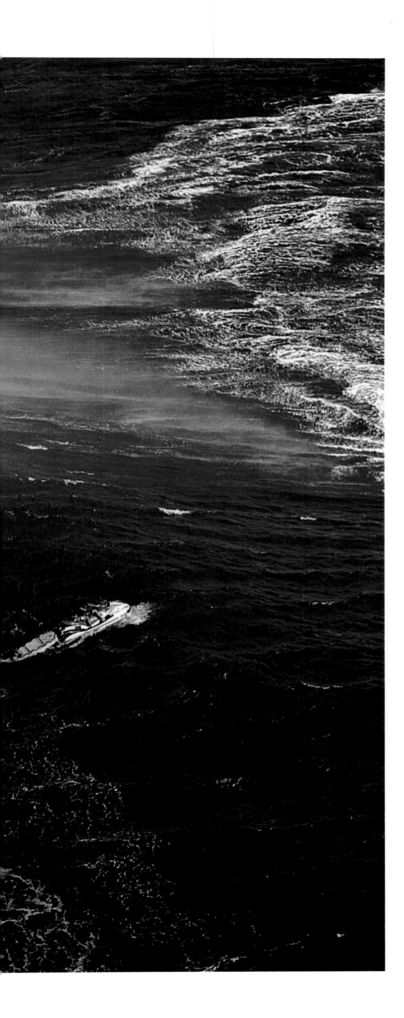

178-179 In big waves, jet skis are not only used to propel the surfer but also to ensure his safety and recovery in case of a fall.

180-181 A jet ski team recovers a surfer in the impact zone.

183 Choosing the right trajectory at the bottom of the wave is the first rule of survival in tow in surfing. There is no margin for error.

184-185 Miniscule in the face of the wave at Peah, Hawaii, this big wave rider tries to stand on the shoulder of the beast.

"In surfing, coming to terms with death, or at least the possibility, is an ongoing crisis in big waves. The set is building outside, and it's so beautiful, aesthetically. If you're out there with nothing but your body, your wits and a surfboard, that set can be your coffin."

Bruce Jenkins,
North Shore Chronicles

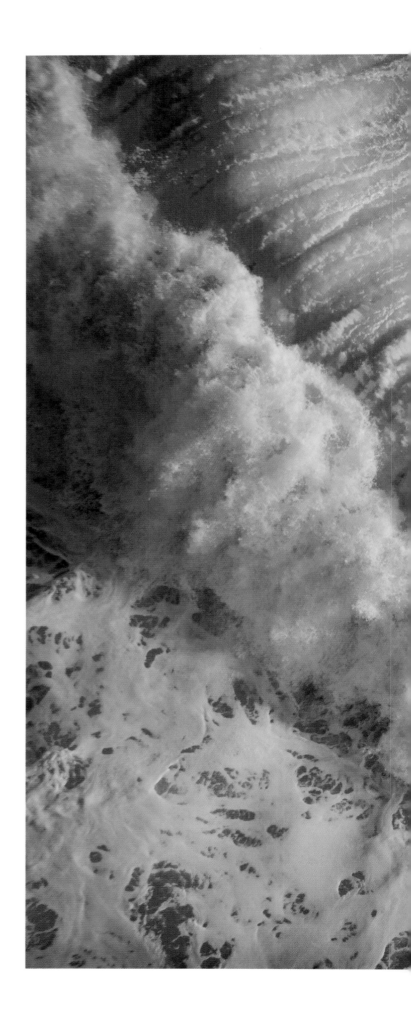

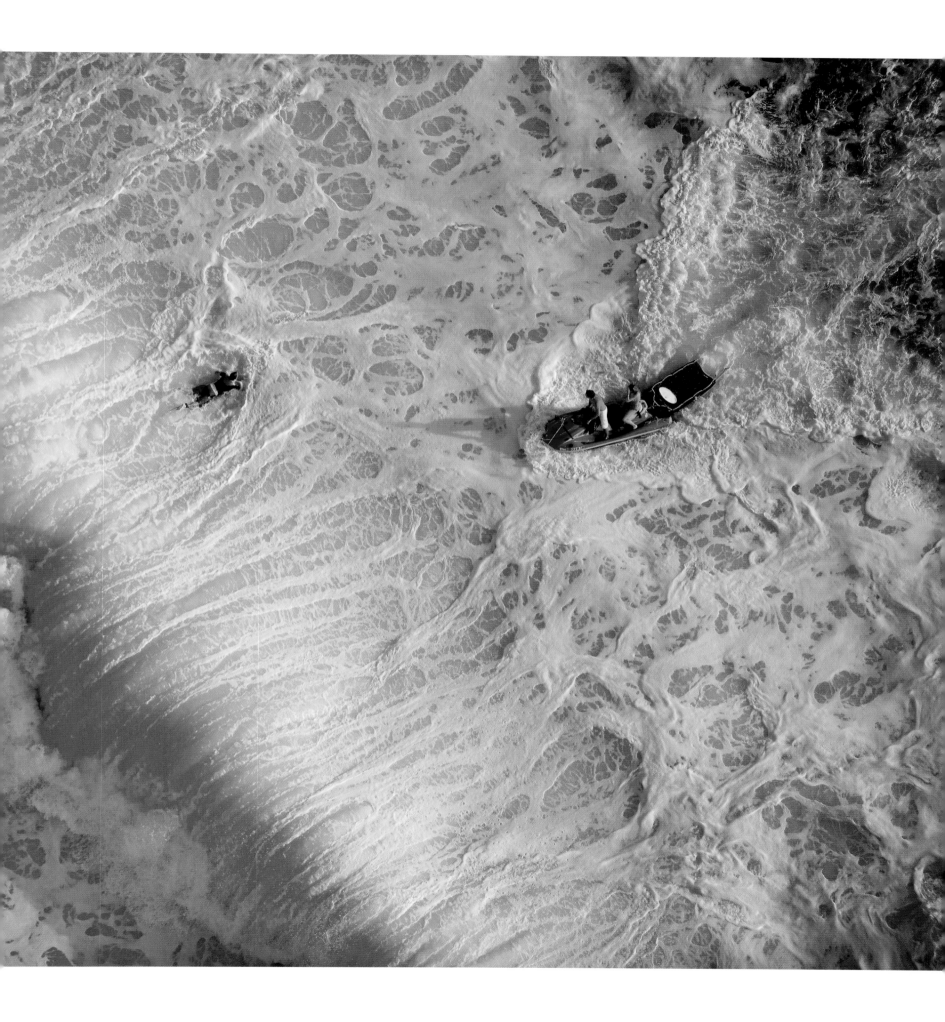

"Sliding a wave removes our brains out of the ordinary and slips us into the extra-ordinary of being there now. No more worries about mortgages or strife, of being poor or rich. When you enter the domain of an ocean cylinder, that moment, those split seconds belong to the Zen part of just being. Period."

Bill Hamilton
(Surfer/Shaper)

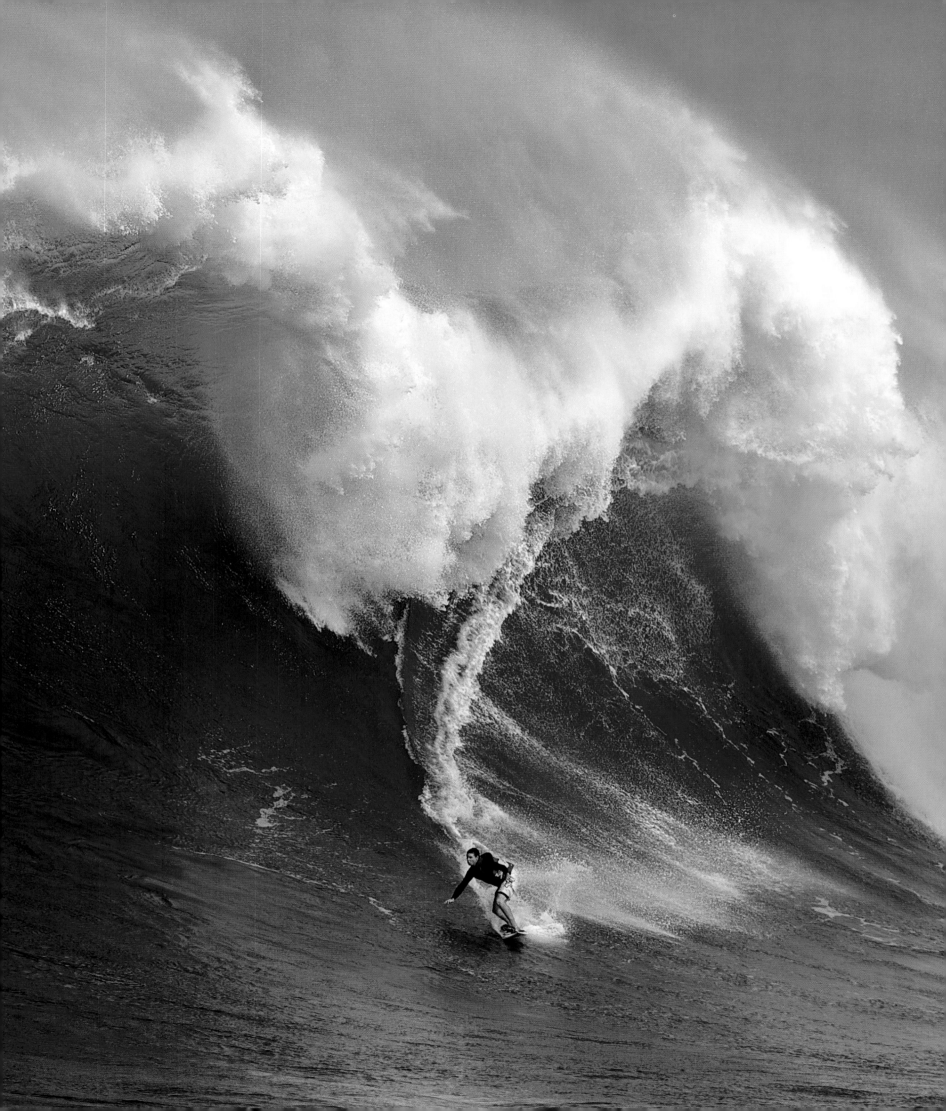

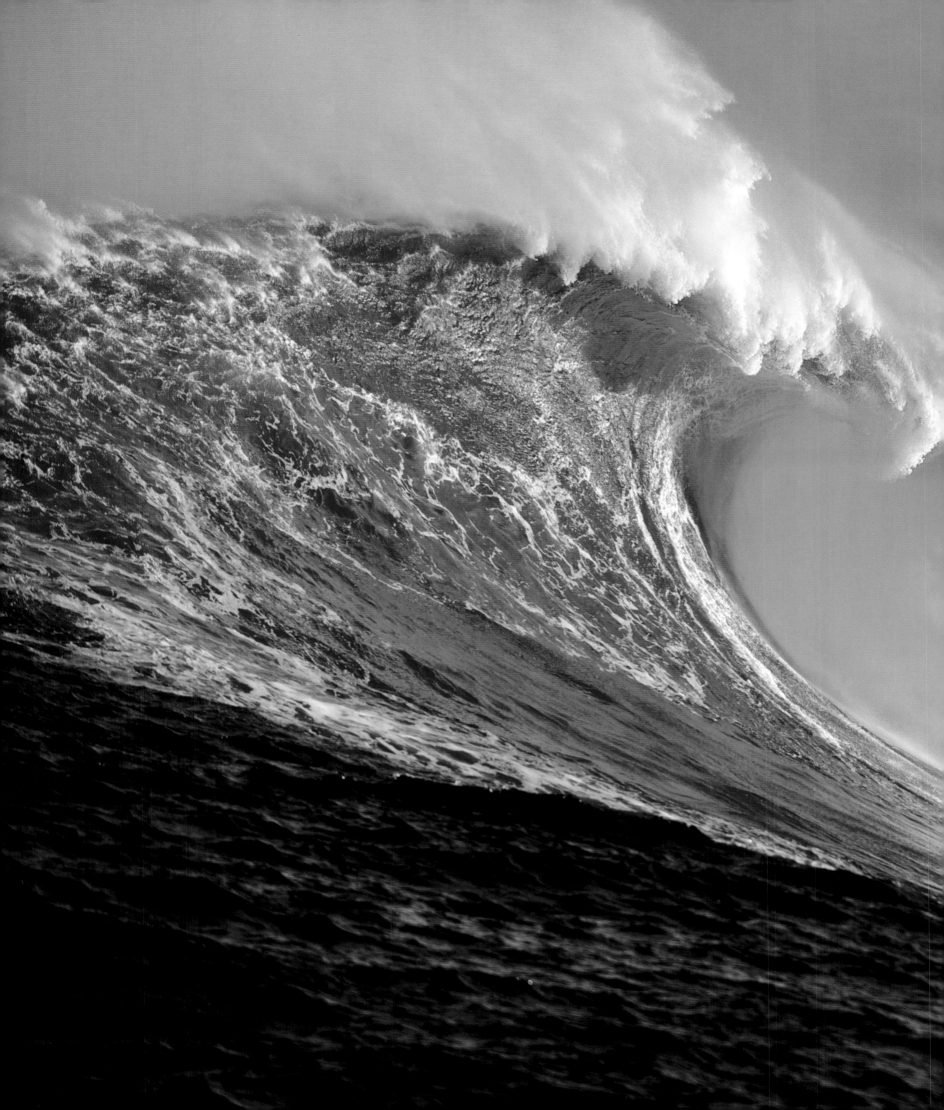

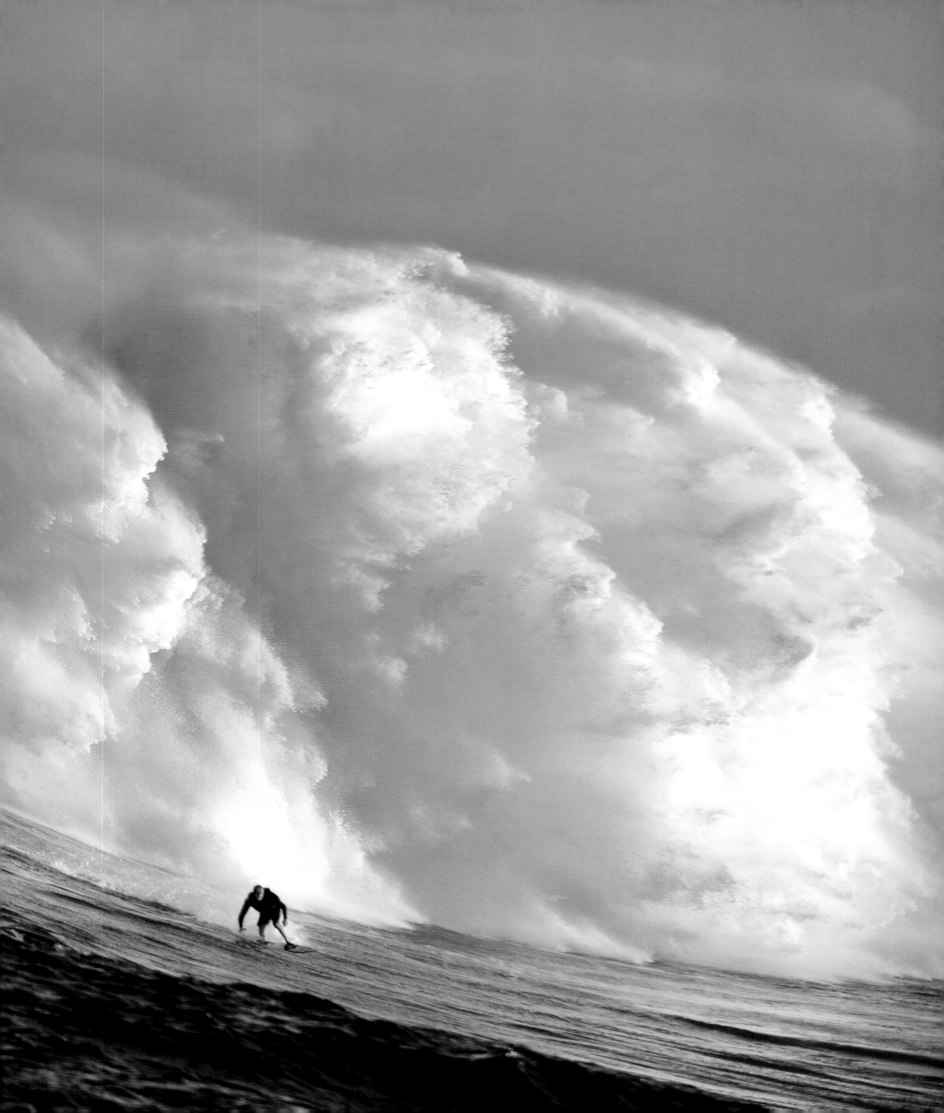

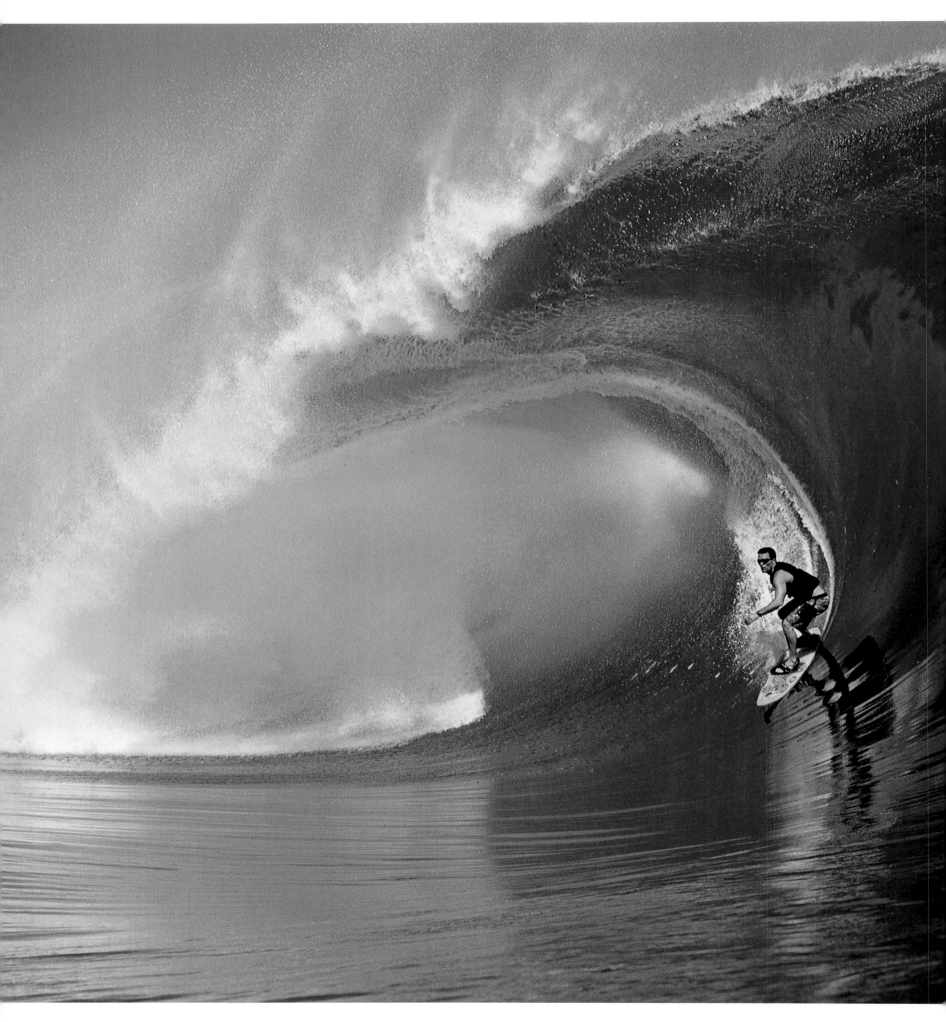

186-187 VETEA "POTO" DAVID IS THE FIRST TAHITIAN TO DISTINGUISH HIMSELF ON THE PROFESSIONAL SURFING CIRCUIT. HE IS NOW A BIG WAVE SPECIALIST ON HIS NATIVE ISLAND.

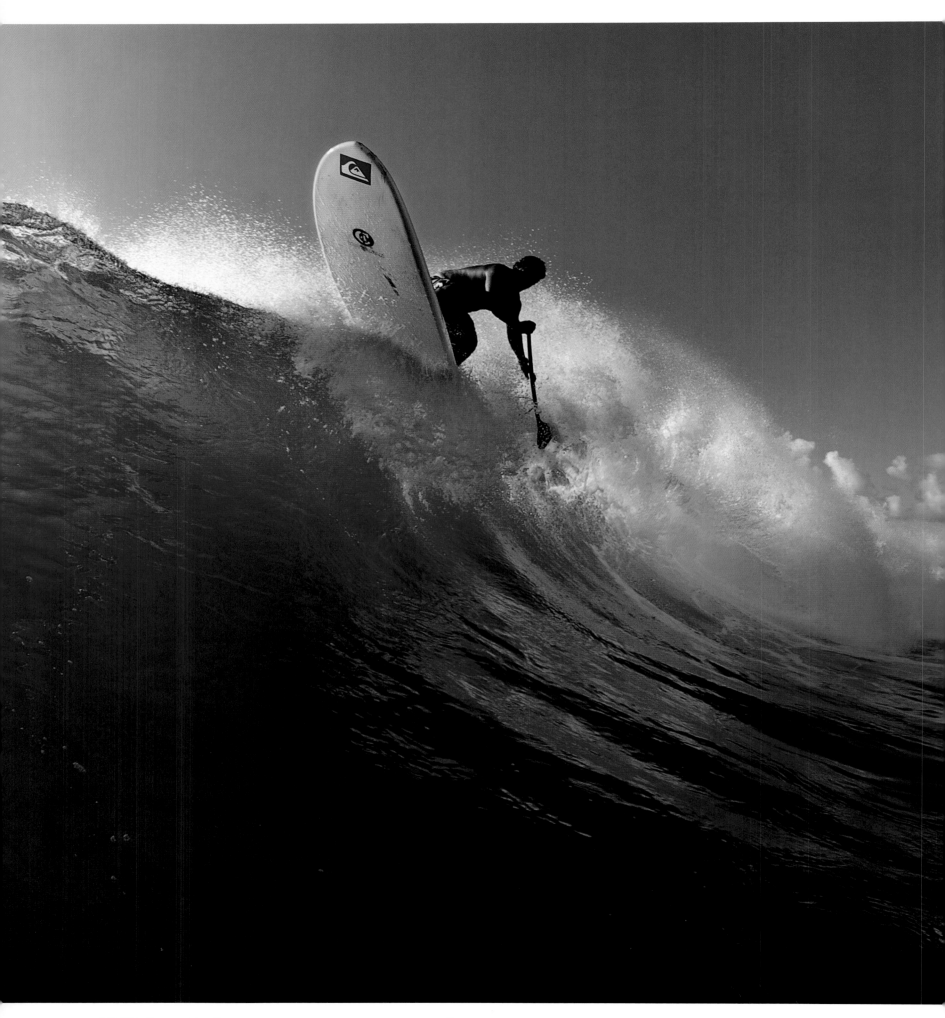

188-189 Raimana Van Bastolaer stand up paddles on a secret spot in Tahiti.

STAND UP
PADDLE

190 DESPITE ITS SIZE AND SUBSTANTIAL THICKNESS, THE STAND UP PADDLE BOARD IS SURPRISINGLY EASY TO MANEUVER.

190-191 BASQUE HERO PEYO LIZARAZU USES HIS PADDLE TO TURN ON THE PARLEMENTIA SPOT IN FRANCE.

192-193 LAIRD HAMILTON, THE PRINCIPAL ARCHITECT OF THE SUP REVIVAL, IN THE TUBE AT TEAHUPOO.

194-195 SURFING WITH A PADDLE, THE LEGACY OF THE FAMOUS WAIKIKI BEACH BOYS, EXPERIENCED AN AMAZING REVIVAL IN HAWAII AND AROUND THE WORLD.

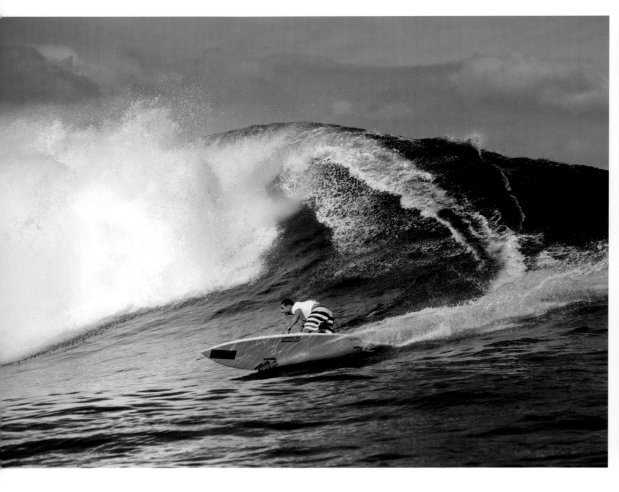

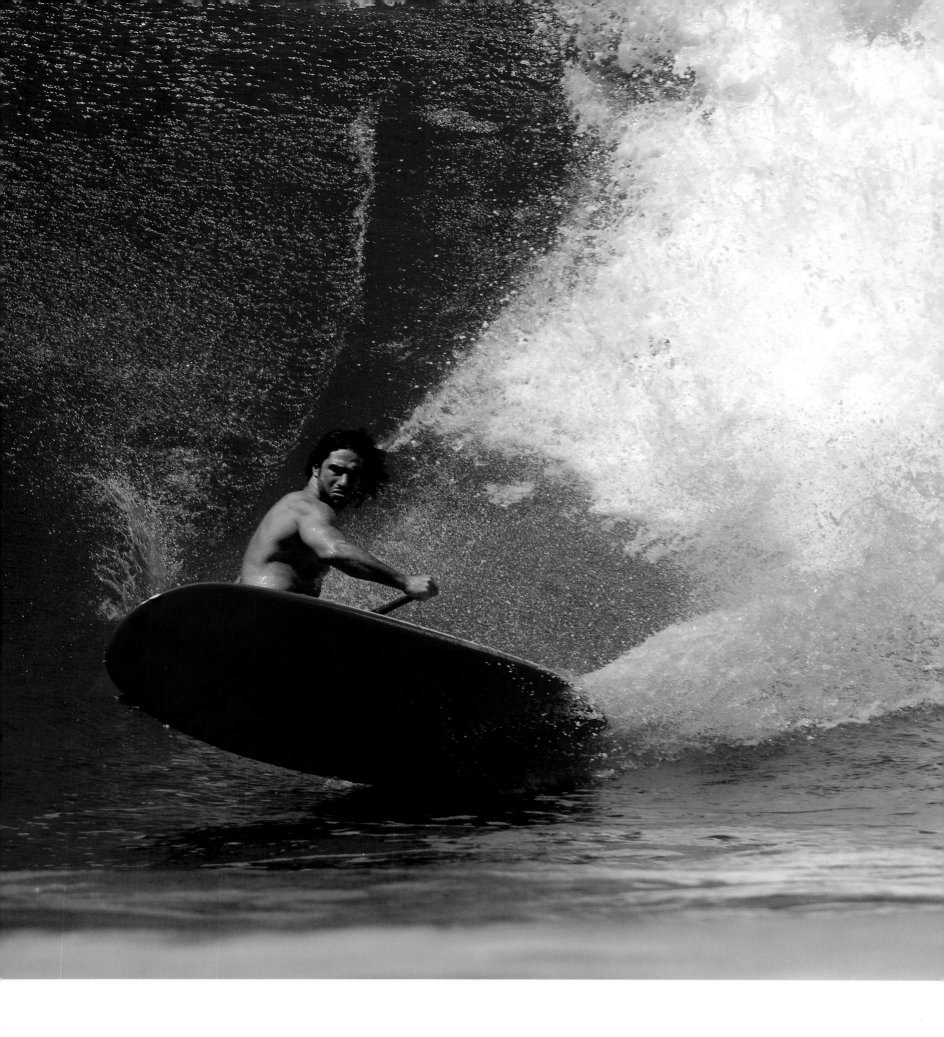

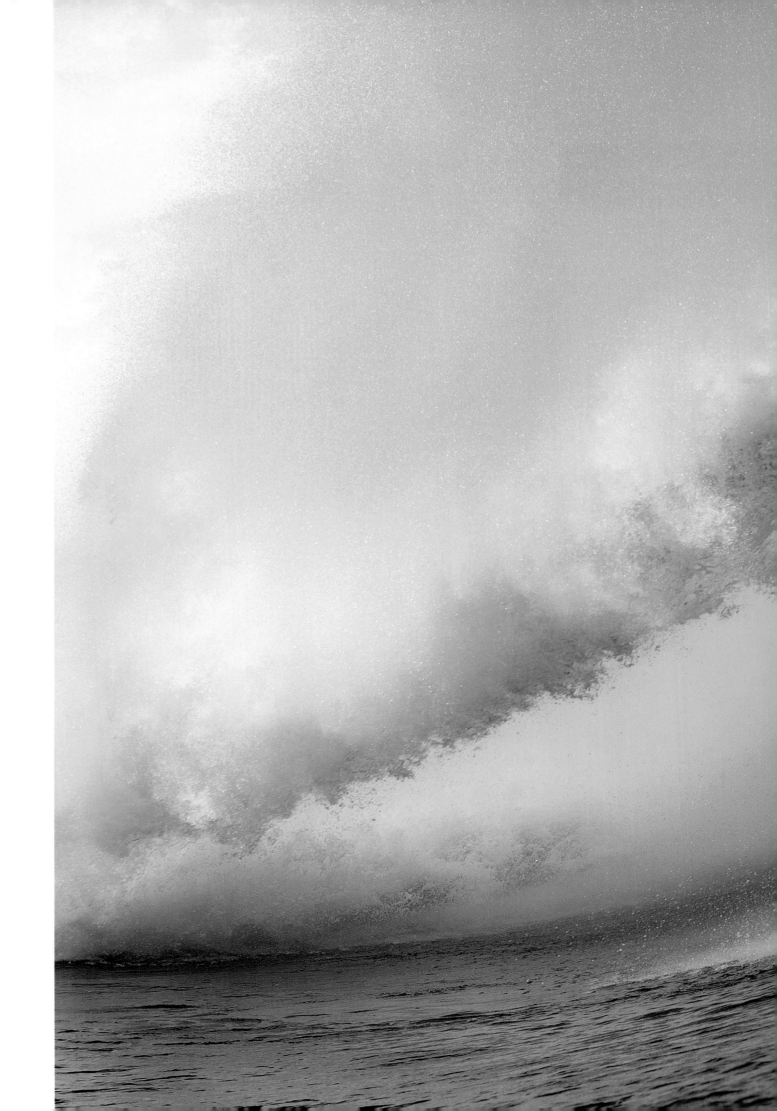

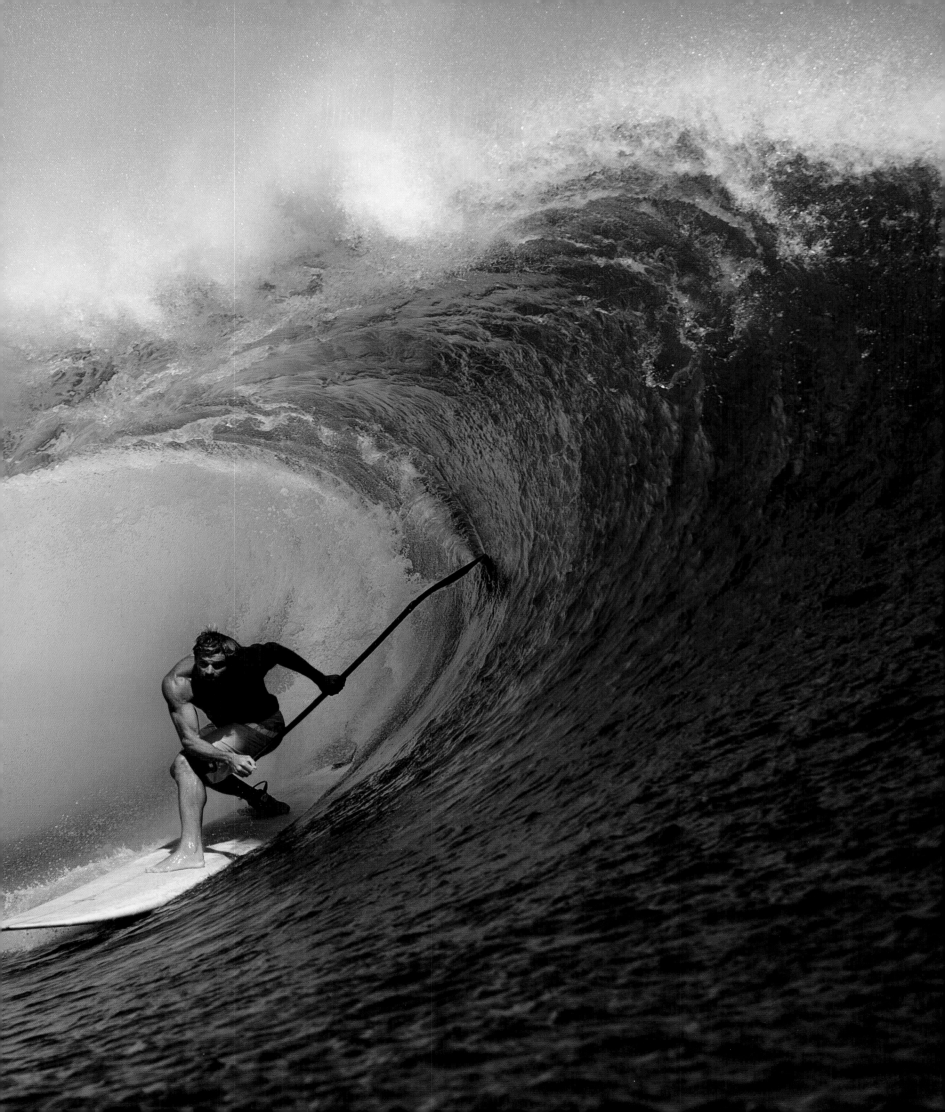

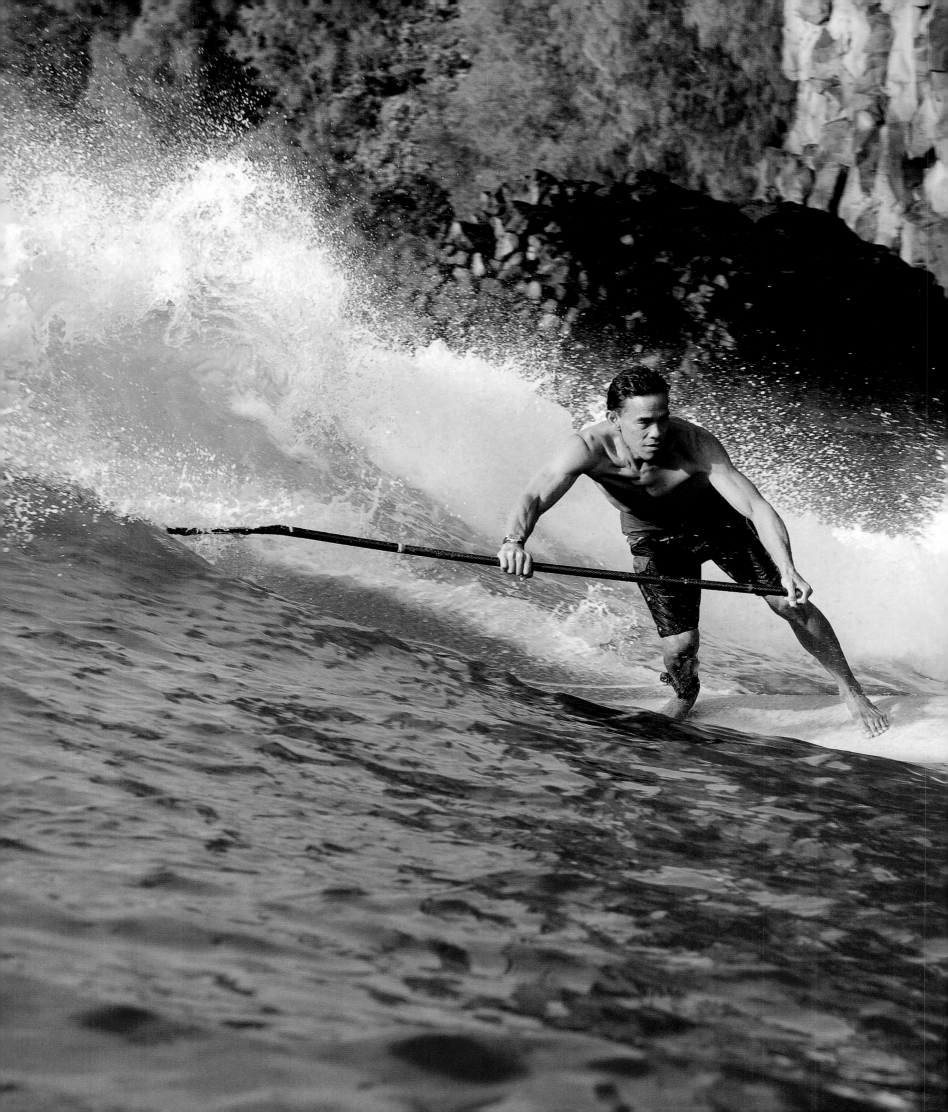

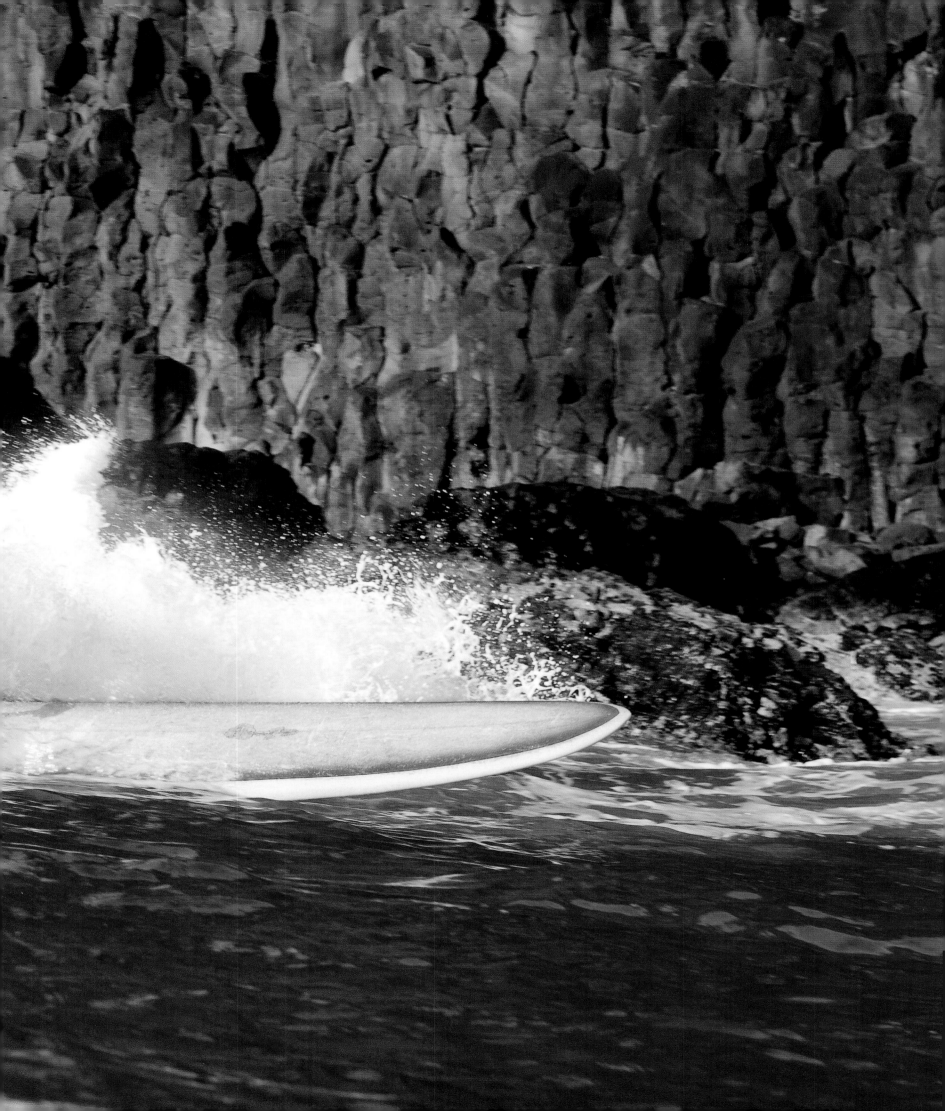

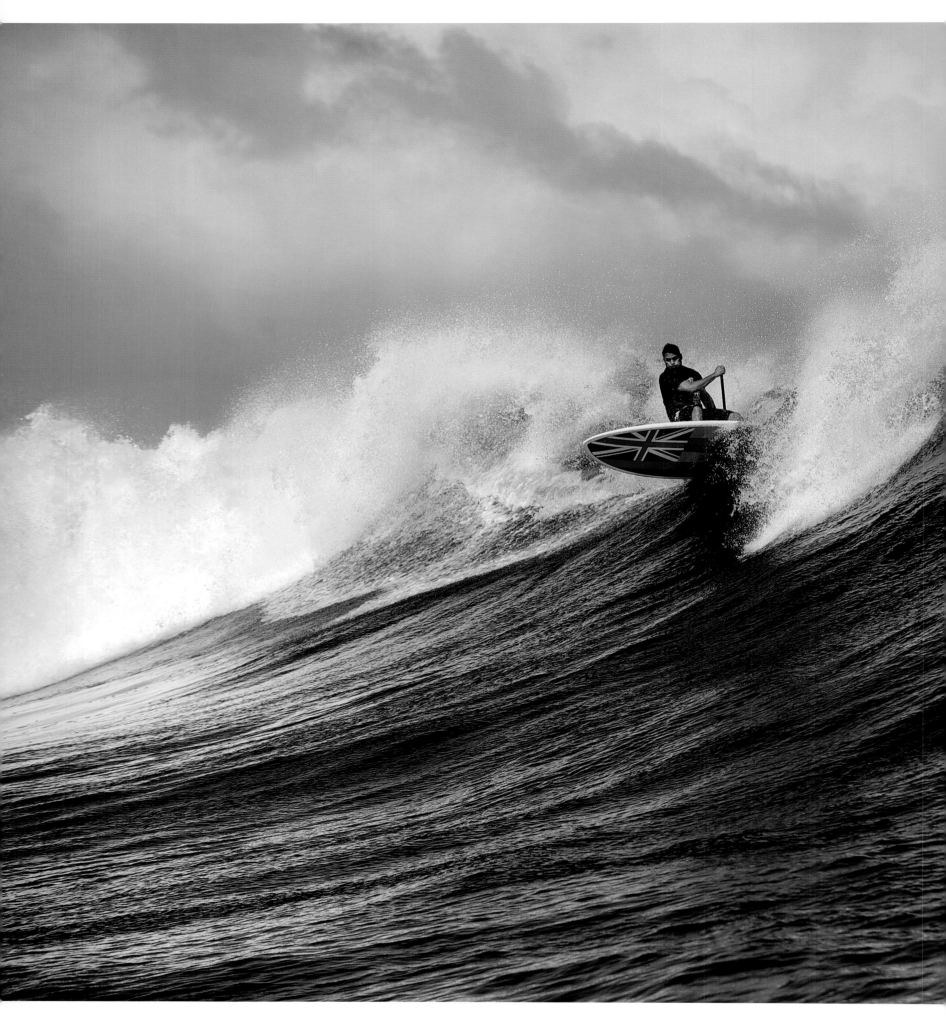

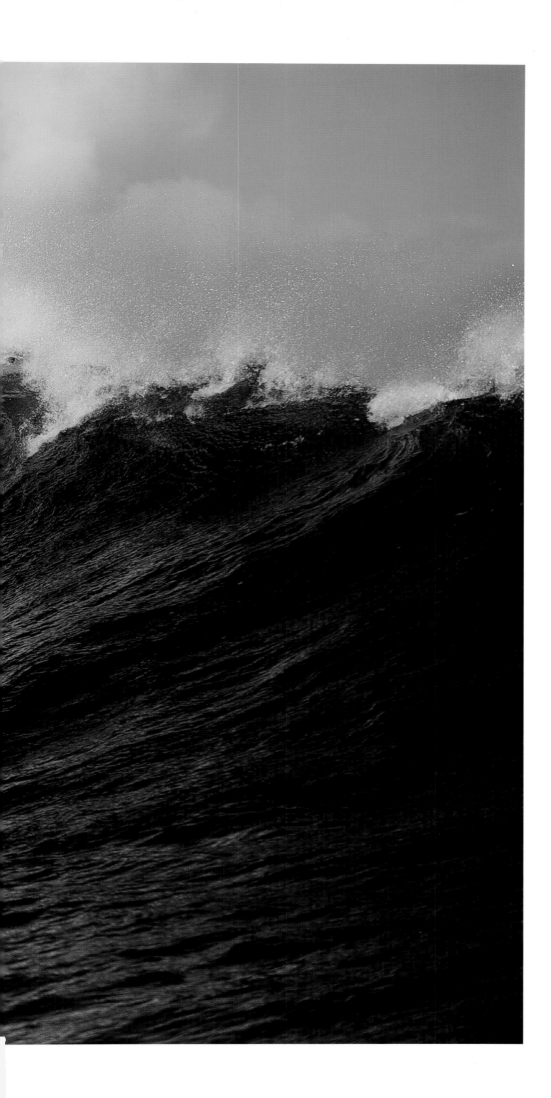

196-197 IDEAL IN SMALL WAVES, STAND UP PADDLE HAS PROVEN TO BE EFFECTIVE IN MORE SERIOUS CONDITIONS.

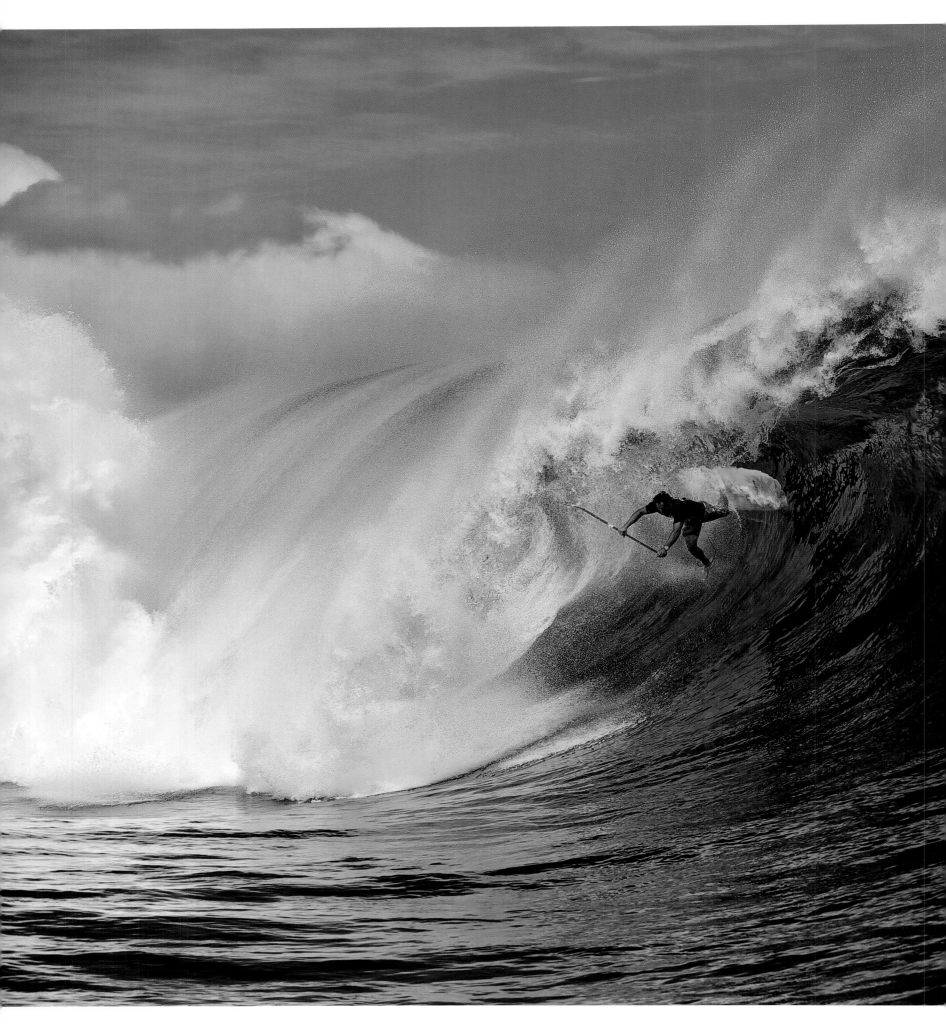

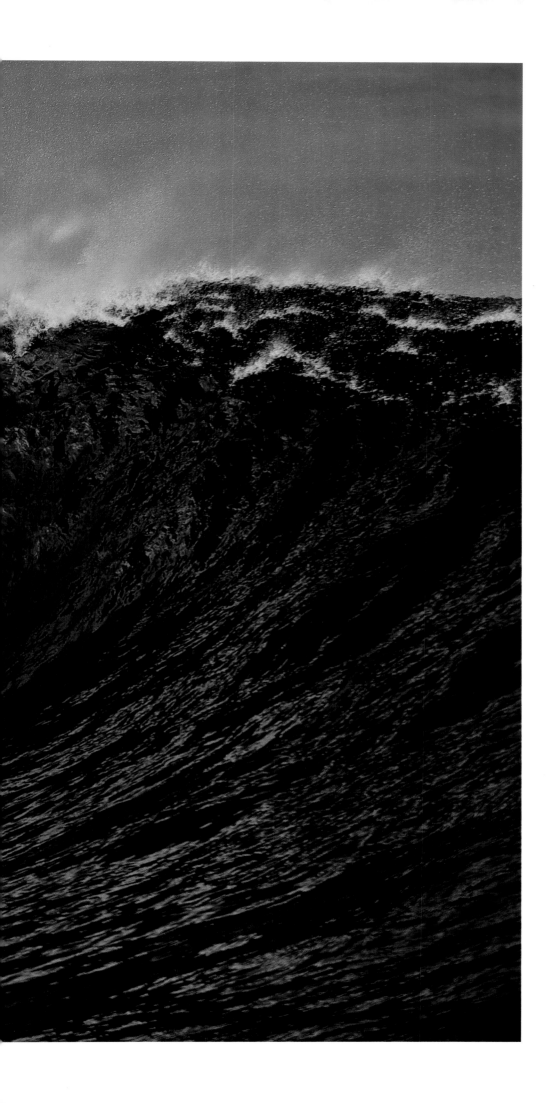

198-199 A STAND UP PADDLE SURFER CAN SPEND HOURS IN THE WATER AND NEVER FALL. BUT WHEN IT HAPPENS, THE CONSEQUENCES ARE JUST AS SEVERE.

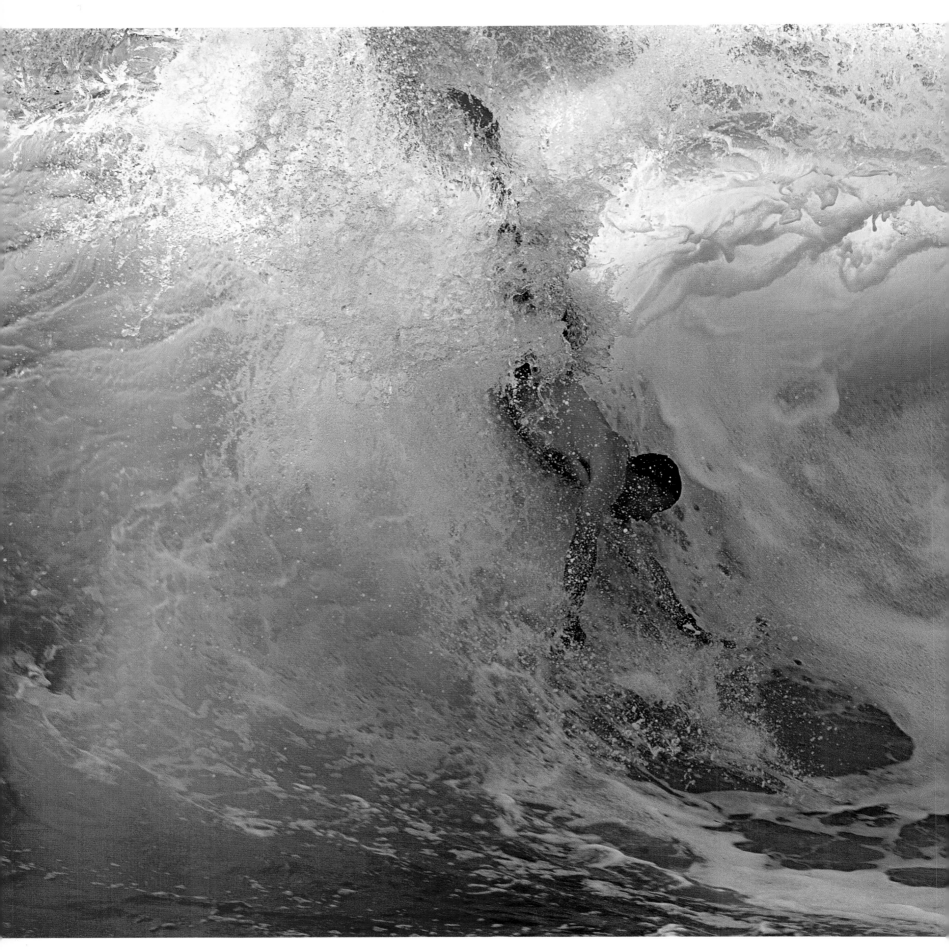

200-201 A PAIR OF FLIPPERS, YOUR BODY AND THE OCEAN – BODYSURFING REMAINS THE PUREST WAY TO RIDE THE WAVES.

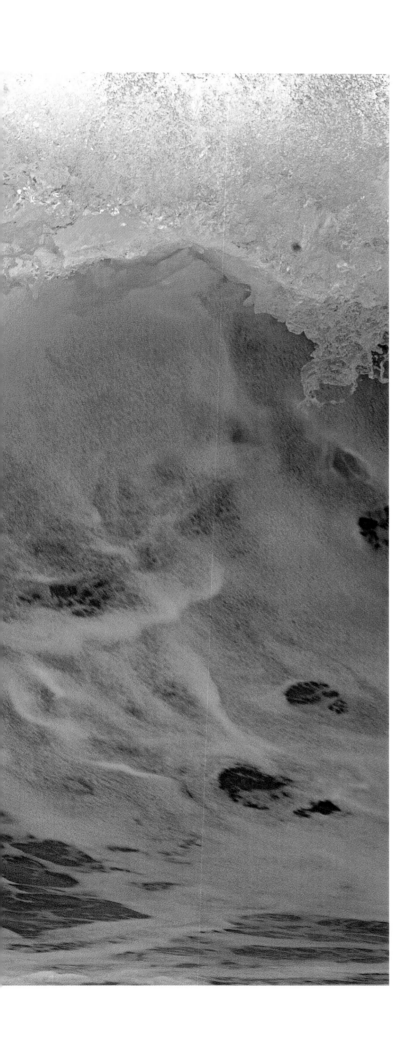

BODYSURF

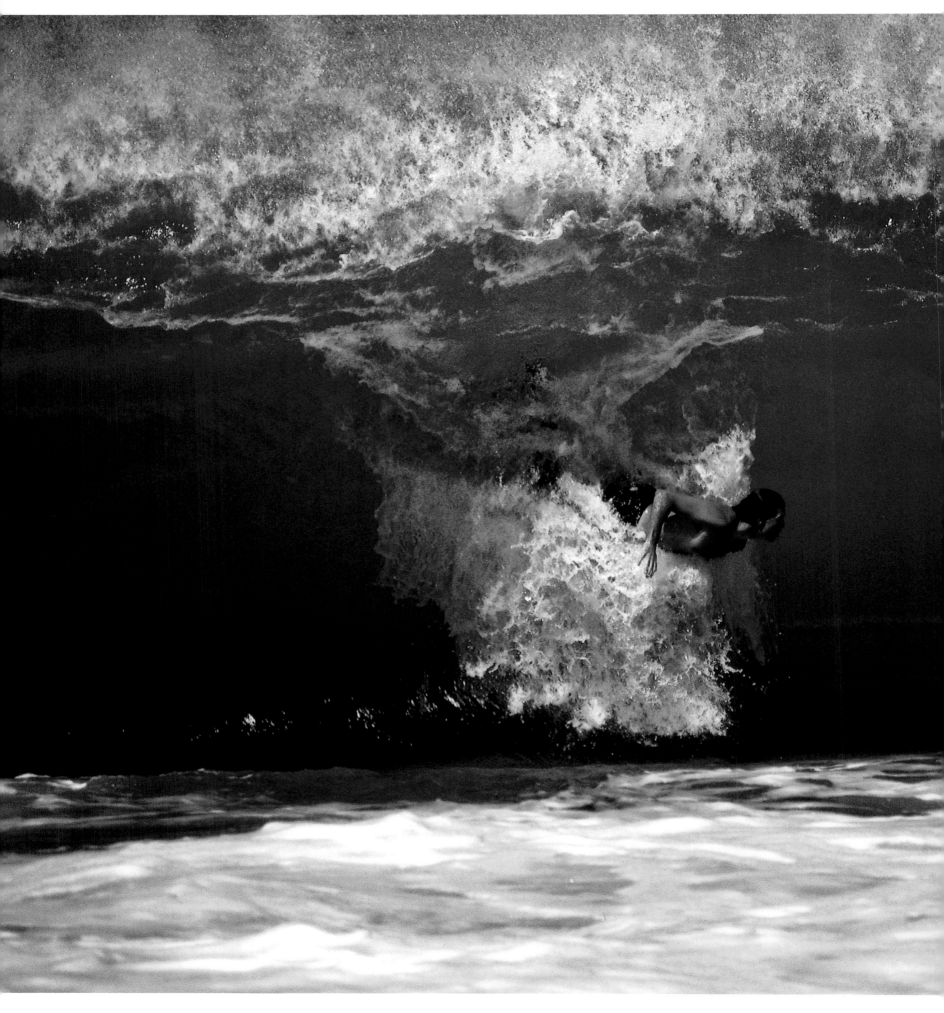

202-203 Bodysurfing offers its practitioners a surreal view inside the tube, something surfers rarely experience.

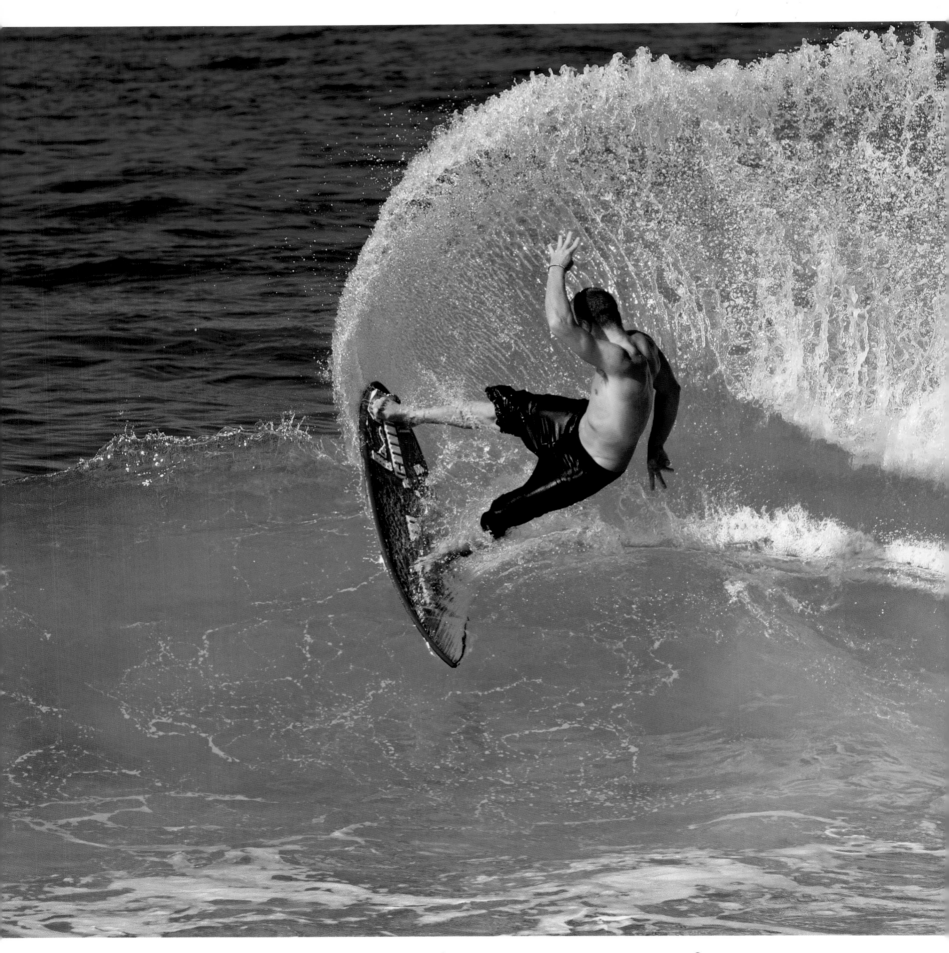

204-205 SKIMBOARDING CONSISTS OF THROWING THE BOARD ON THE WATER'S EDGE AND THEN JUMPING ON IT TO GLIDE A FEW FEET. GUARANTEED FUN.

SKIMBOARD

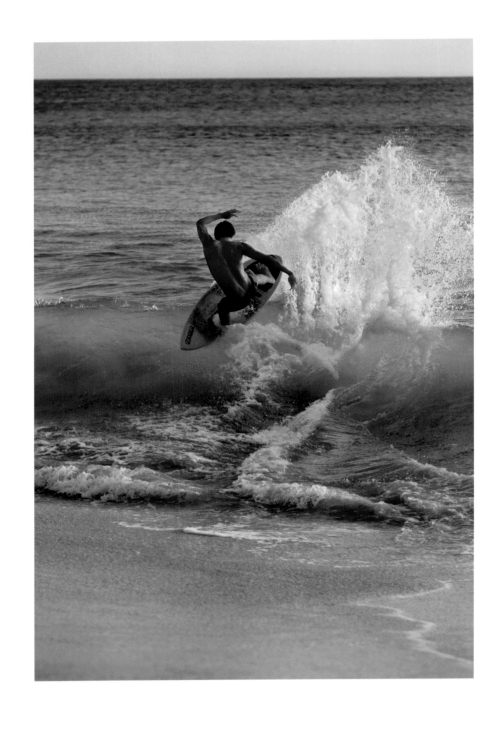

206 LIKE BODYBOARDING AND BODYSURFING, SKIMBOARDING HAS PROVEN TO BE AN EFFECTIVE WEAPON IN THE WAVES OF THE SHOREBREAK.

207 USING THE WAVES AS A NATURAL SPRINGBOARD IS ONE OF THE BIGGEST CHALLENGES OF WATERSPORTS.

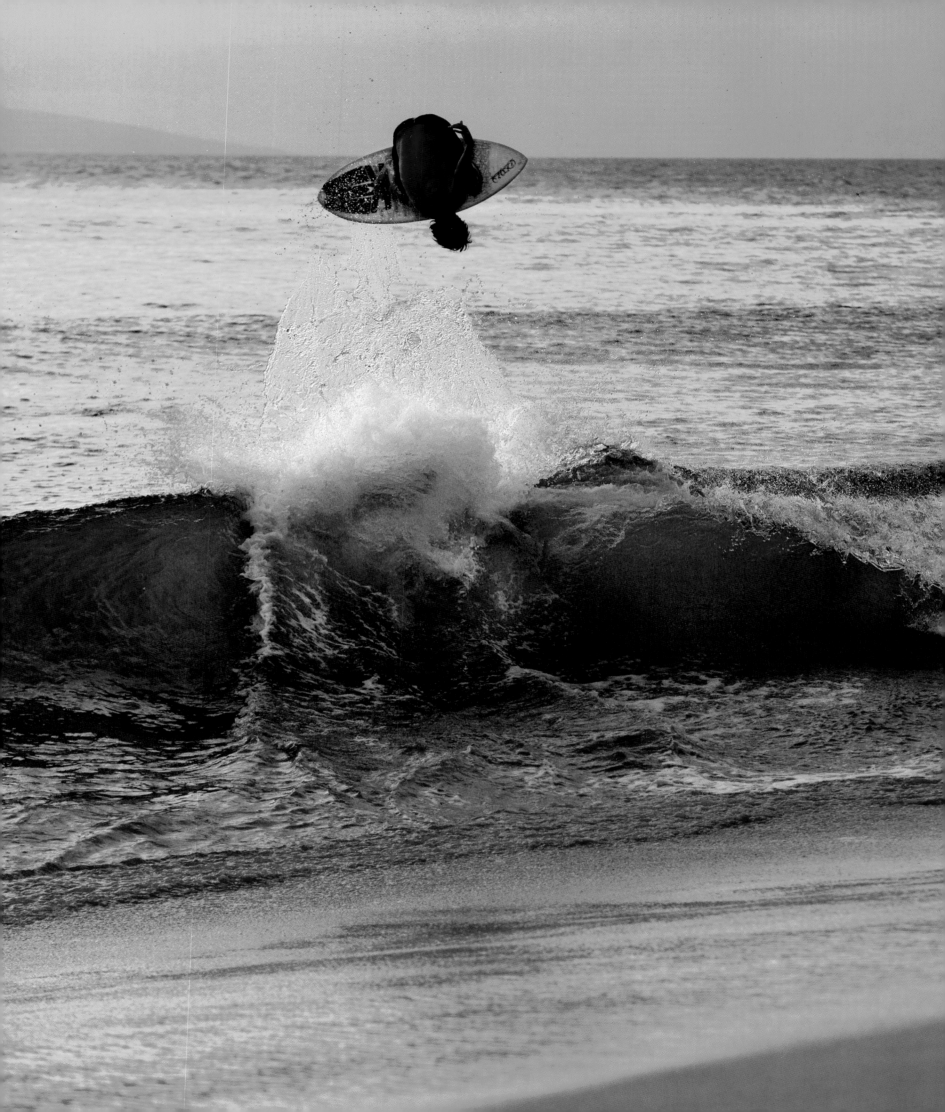

PHOTO CREDITS

Page 1 Tim McKenna * Pages 2-3 Darrell Wong/Getty Images * Pages 4-5 Tim McKenna * Pages 6-7 Greg Huglin/Photolibrary Group * Page 9 David Pu'u/Photolibrary Group * Page 11 Benjamin Thouard * Pages 18-19 Ron Dahlquist/Photolibrary Group * Pages 20-21 Alberto Guglielmi/Photolibrary Group * Pages 28-29 Tim McKenna * Pages 30-31 Jack Englishcom/Photolibrary Group * Page 32 Sean Deavey/Getty Images * Page 33 Ed Freeman/Getty Images * Pages 34-35 Kirstin Scholtz/ASP/Getty Images * Pages 36-37 Warren Bolster/Getty Images * Pages 38-39 Gregory Boissy/AFP/Getty Images * Pages 40-41 Carlos Avila Gonzalez/San Francisco Chronicle/Corbis * Pages 42-43 Tim McKenna * Pages 44-45 Rob Palmer/Photolibrary Group * Pages 46-47 Buzz Pictures Ltd./Photolibrary Group * Pages 48-49 Tim McKenna * Pages 50-51 Tim McKenna * Page 52 Kaz Mori/Getty Images * Pages 52-53 Kaz Mori/Getty Images * Pages 54-55 Tim McKenna * Pages 56-57 Tim McKenna * Pages 64-65 Vince Cavataio/Photolibrary Group * Pages 66-67 Warren Bolster/Getty Images * Pages 68-69 Tim McKenna/Corbis * Page 70 James Watt/Panda Photo * Pages 70-71 James Watt/Panda Photo * Pages 72-73 Mark Rightmire/Corbis * Page 74 Mark Rightmire/Corbis * Page 75 Juan Herrero/Corbis * Pages 76-77 Tim McKenna * Pages 78-79 Victor Fraile/Corbis * Pages 80-81 Vince Cavataio/Photolibrary Group * Pages 82-83 David B. Fleetham/Getty Images * Pages 84-85 SOulsurfing/Jason Swain/Getty Images * Pages 92-93 Dave Fleethman/Photolibrary Group * Pages 94-95 Tim McKenna * Pages 96-97 Erik Aeder/Photolibrary Group * Page 97 INC. SUPERSTOCK/Photolibrary Group * Page 98 Mark A. Johnson/Photolibrary Group * Page 99 Eric Sanford/Photolibrary Group * Pages 100-101 Ludovic Franco/Photolibrary Group * Pages 102-103 Tim McKenna * Pages 104-105 Erik Aeder/Photolibrary Group * Pages 106-107 Ulli Seer/Photolibrary Group * Pages 108-109 Tim McKenna * Pages 110-111 Ulli Seer/Photolibrary Group * Pages 112-113 Tim McKenna * Page 114 Brian Bielmann/Photolibrary Group * Page 115 Digital Vision/Photolibrary Group * Pages 116-117 Ron Dahlquist/Photolibrary Group * Pages 118-119 Aflo Foto Agency/Photolibrary Group * Pages 120-121 Tim McKenna * Page 123 Erik Aeder/Photolibrary Group * Pages 124-125 Erik Aeder/Photolibrary Group * Pages 126-127 Pixtal Images/Photolibrary Group * Pages 128-129 Ben Welsh/Photolibrary Group * Pages 130-131 Purestock/Photolibrary Group * Page 133 Darrell Wong/Getty Images * Page 141 Tim McKenna * Pages 142-143 Tim McKenna * Pages 144-145 Ben Welsh/Photolibrary Group * Pages 146-147 Riccardo Savi/Getty Images * Page 148 Karl Weatherly/Photolibrary Group * Page 149 Ben Welsh/Photolibrary Group * Page 151 Tim McKenna * Pages 152-153 Ben Welsh/Photolibrary Group * Pages 154-155 Tim McKenna * Pages 162-163 Dave Fleethman/Photolibrary Group * Pages 164-165 Eric Sanford/Photolibrary Group * Pages 166-167 Ron Dahlquist/Photolibrary Group * Page 168 Joli/A-Frame/ZUMA Press/ZUMA/Corbis * Pages 168-169 Joli/A-Frame/ZUMA Press/ZUMA/Corbis * Pages 170-171 Nic Bothma/epa/Corbis * Page 171 Nic Bothma/epa/Corbis * Pages 172-173 Nic Bothma/epa/Corbis * Pages 174-175 Tim McKenna * Pages 176-177 Tim McKenna * Pages 178-179 Tim McKenna * Pages 180-181 Tim McKenna * Page 183 Tim McKenna * Pages 184-185 Tim McKenna * Pages 186-187 Buzz Pictures Ltd./Photolibrary Group * Pages 188-189 Tim McKenna * Page 190 Tim McKenna * Pages 190-191 Sylvain Cazenave/Corbis * Pages 192-193 Tim McKenna * Pages 194-195 Mark A. Johnson/Corbis * Pages 196-197 Tim McKenna * Pages 198-199 Tim McKenna * Pages 200-201 James Watt/Photolibrary Group * Pages 202-203 Sean Davey/Australian Picture Library/Corbis * Pages 204-205 Quincy Dein/Photolibrary Group * Page 206 Quincy Dein/Photolibrary Group * Page 207 Quincy Dein/Photolibrary Group

BIBLIOGRAPHY *Surfer's Journal* (French edition) N° 22, 30, 42, 50 * *Waikiki Beach Boys* (Grady Simmons, Royal Hnl) * *Encyclopedia of surfing* (Matt Warshaw, Harcourt) * *Kornog* (David Bianic, Coop Breizh) * *Bodysurfing* (Laurent Masurel, Hugo Verlomme, Atlantica) * *The world of surfing* (Sylvain Cazenave, Gibus de Soultrait, Minerva)

WHITE STAR PUBLISHERS

WS White Star Publishers® is a registered trademark
property of Edizioni White Star s.r.l.

© 2011 Edizioni White Star s.r.l.
Via Candido Sassone, 24
13100 Vercelli, Italy
www.whitestar.it

Translation: Salvatore Ciolfi
Editing: John Schaefer

ISBN 978-88-544-0583-7
1 2 3 4 5 6 15 14 13 12 11

Printed in China

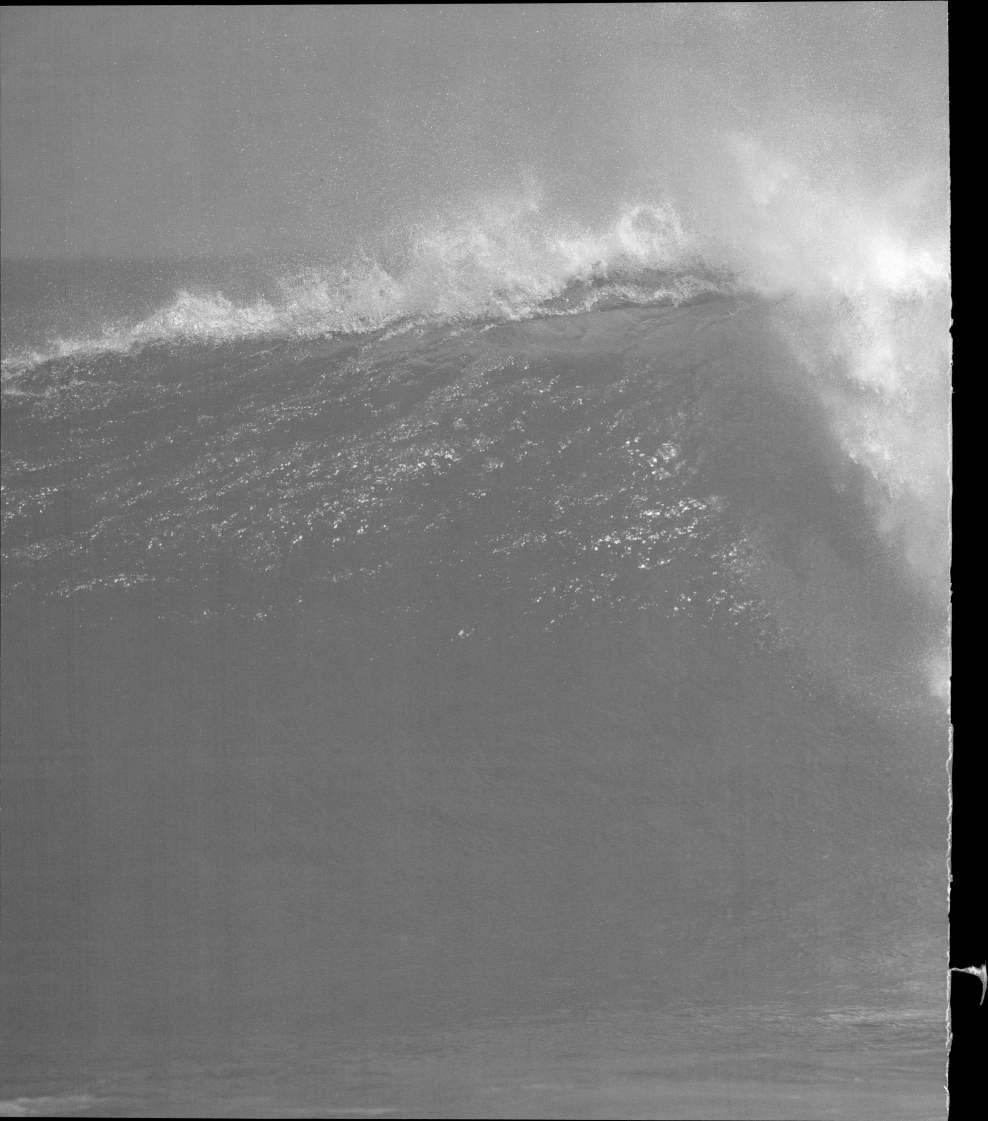